Contents

Preface

Disposable People is a collaborative project involving several organisations. An initiative of Autograph ABP, it began with an approach to the Magnum Photo Agency in London in 2005, which resulted in the selection of eight international photographers – all Magnum members with a strong commitment to human rights – who were invited to undertake a new commission documenting aspects of contemporary slavery. Hayward Touring welcomed the opportunity to work with Autograph ABP on the organisation of the exhibition, which opens at the Royal Festival Hall in London before touring nationally and internationally. The project's aims coincide with Autograph's mission to educate the public in photography with a particular emphasis on issues of cultural identity and human rights, and with Southbank Centre's belief that difficult issues can be tackled creatively, with artists playing a central role in revealing the contradictions and injustices of our time.

The title, *Disposable People*, has been borrowed from a book by Professor Kevin Bales, one of the world's leading authorities on contemporary slavery, who has been our advisor on this project from its inception. Kevin Bales is President of the US-based Free the Slaves, which, like its British counterpart Anti-Slavery International, is dedicated to the eradication of slavery worldwide. According to his estimates, the number of people held in slavery today is 27 million. The photographers here have chosen eight specific situations where people are working in conditions of slavery, or situations of economic servitude close to slavery: trapped by poverty and seemingly powerless to escape. The fact that none of the situations represented is in Western Europe or North America does not mean that the prosperous Western nations are free from the scourge of slavery. The project does not attempt to provide an exhaustive survey of the subject, but rather to show, though examples, how the poor and excluded live their lives unseen and uncared for.

The exhibition is on one level a reaffirmation of the continuing value and relevance of documentary photography. In recent years,

Documenting
Disposable People
Contemporary Global Slavery

LOTTERY FUNDED

HAYWARD
PUBLISHING

the status of the still photograph as evidence of social reality has been thrown into doubt; firstly because digital manipulation has rendered the truth value of the image questionable, and secondly because the ubiquity of television and video as sources of information and the proliferation of cameras (now on many mobile phones) mean that the professional photographer is not alone as a recorder of events, as a moral witness in the classic sense. Paradoxically, while traditional photojournalism may have been undergoing a crisis, many contemporary artists have appropriated the documentary mode – sometimes, one might suspect, merely for aesthetic or stylistic effect. The revival of interest in the real as opposed to the explicitly fictitious has opened up the possibilities for a re-evaluation of the genre of documentary. The variety of approaches here demonstrates the amazing vitality and scope of the medium of photography, even in an era like our own which is satiated with imagery of all kinds and rendered cynical by constant exposure to news of disasters and misfortune.

Roger Malbert
Senior Curator, Hayward Touring

Mark Sealy
Director, Autograph ABP

Acknowledgements

In devising the exhibition we have worked closely with the photographers to present their work effectively in a gallery context. We are indebted to them all for their dedication and professionalism, which have inspired us and confirmed our belief that the project has something new and important to say about the condition of slavery today. Magnum's role, from the initial selection and approaches to the photographers, through to practical support during their travels and help with production, has been crucial. In particular, Chris Steele-Perkins, who at the time of the first discussions was President of Magnum, has been a key advisor and guide in the selection of photographers. Brigitte Lardinois, then Magnum's Cultural Director, provided essential encouragement and practical support. (Other members of Magnum staff are thanked below.) A Grant for Arts from Arts Council England made the commissioning and production of new work possible, and this has been supplemented by support from three charitable organisations. MTV Europe Foundation has contributed generously to the show, specifically providing support for the photographers in the production of their work, as part of their Free Your Mind campaign, which aims to inform Europe's young people of critical social issues. Christian Aid gave financial and practical support for Ian Berry's documentation of trade injustice in Ghana. The charity Concern Worldwide, which works internationally to help poor people achieve sustainable improvements to their lives, supported Abbas' documentation of child labour in Bangladesh. Free the Slaves provided documentary contextual material.

We thank the following for their help: Autograph ABP: David A. Bailey, Emma Boyd, Indra Khanna, Tom O Mara, Renee Mussai, Lois Olmstead; Magnum: Beth Allan, Paul Hayward, Alice Muhling, Fiona Rogers, Francesca Sears, Sophie Wright; MTV Europe Foundation: Tom Ehr, Simon Goff; Christian Aid: Joseph Cabon, Karen Hedges, Kevin McCullough; Concern: Sarah Molloy, Lyndall Stein; Free the Slaves: Kevin Bales, Peggy Callahan; Anti-Slavery International: Michaela Alfred-Kamara; in addition: Annalisa D'Angelo, Ashley V. Fischer, Elizabeth Moy, Ariadne Van De Ven.

Our appreciation goes to all staff at the exhibition venues, particularly: Sarah Chapman and Liz Wells, Peninsula Arts, Plymouth; Mara Helen Wood, Northumbria University; Jim Robertson and Dave Thomas, New Art Exchange, Nottingham; Fiona Venables, Tullie House Museum and Art Gallery; Eve Ropek, Aberystwyth Arts Centre.

We thank Caroline Wetherilt and Giselle Osborne for their skill and care in editing and managing the production of this book, which has been designed by Herman Lelie and Stefania Bonelli. Violetta Boxill has designed the exhibition graphics. Michael Vale designed the installation of the exhibition in the Royal Festival Hall, which has been constructed by Sam Forster Ltd.

Many staff at The Hayward and Southbank Centre have contributed to the exhibition and its related programme and tour. The Hayward's Director, Ralph Rugoff, has given unstinted encouragement at every stage, as has Jude Kelly, Artistic Director of Southbank Centre, and Chief Executive Michael Lynch. Thanks are due to: Dave Bell, Geock Brown, Peter Brown, Steve Bullas, Jeremy Clapham, Becca Connock, Sarah Davies, Helen Faulkner, Gilly Fox, Pamela Griffin, Mark King, Alice Lobb, Helen Luckett, Alison Maun, Dave Palmer, Sarah Sawkins, Ed Smith and Southbank Centre production team, Laura Stevenson, John Wallace and Imogen Winter.

Map of Contemporary Slavery Worldwide

UNITED STATES
People from around 60 countries – with the majority from Latin America and China – feature among victims of human trafficking into the US. There they can be trapped in servitude as domestic workers, as pickers or processors of food products, or coerced into the sex industry. (Whereas people-smuggling involves migrants' consent, trafficking involves deception and ongoing exploitation – both marks of slavery.)

WESTERN EUROPE
In 2003, an estimated 400,000 people a year were trafficked (as distinct from smuggled voluntarily) into western Europe for subjugated labour. Victims come from all over the world, with the largest current group from eastern Europe. Those caught in the system are chiefly sent to work in agriculture, food processing, domestic service and the sex industry – often having been lied to by recruiting agents.

UK

WESTERN EUROPE

MALI NIGE

MAURITANIA

BURK FASO

IVORY COAST

NI

GABON

BRAZIL
Officials say 40,000–50,000 people are enslaved in Brazil, although such state estimates tend to be low. Slave workers are effectively kept captive, mainly in the Amazonian region, through beatings, death threats and the withholding of pay. Brazilian timber, beef, pig iron, steel and gold are among the products tied to slavery. An offensive by President Luiz Inacio Lula da Silva has geared up laws and Labour Ministry inspection squads, resulting in 6–7,000 freed from slavery each year, more than in any other country in the world.

WEST AFRICA
Internal slavery in this region is hig – brokers buy and traffic children within and between Mauritania, Mali, Ivory Coast, Burkina Faso, Gabon, Ghana, Nigeria and the surrounding area. Those enslaved are forced to work in cocoa, coffee and cotton agriculture, fishery, mining, domesti service or the sex industry. Nigeria, particular, traffics onward to Europe

Number of slaves*

- More than 250,000
- 25,000 to 250,000
- 5,000 to 25,000
- Less than 5,000
- No data

 Slave labour used both internally and exported

Mainly a receiver of slave labour and products

*All estimates are conservative

SOURCE: FREE THE SLAVES: KEVIN BALES

RUSSIA AND EASTERN EUROPE

The Soviet Union's break-up makes fertile ground for enslavement involving traffickers and gang masters. Trafficking within – and out of – Russia and eastern Europe (particularly including black spot Moldova) involves the coercion of women into prostitution in Europe, Israel, the Gulf states and Japan. In ex-Soviet central Asian republics, children and women are increasingly being sold into the sex trade.

JAPAN

Large numbers of women are trafficked into Japan for the sex industry, making it the top user of slave labour among rich nations. Special 'entertainment visas' sanction systems are in use. Until recently, about 100,000 young women a year were brought in. Despite a partial crackdown, the trade still involves an estimated 40–50,000 women a year.

RUSSIA

EASTERN EUROPE

CENTRAL ASIAN REPUBLICS

NEPAL

PAKISTAN

CHINA

INDIA

BURMA

THAILAND

SUDAN

UGANDA

INDONESIA

CHINA AND BURMA

China and Burma are among a handful of countries where the state engages in slavery. In China, the prison system now comprises a vast network of factories using forced labour under harsh punishment regimes to make a range of products, including those for export. The inmates have never been tried or convicted. In Burma, the military regime rounds up villagers to work as slaves on army infrastructure and tourism facilities.

SOUTH ASIA

The world's largest enslaved group exists here – estimated at 10–12 million in hereditary debt bondage slavery. Whole families are held as 'collateral', working for nothing in perpetuity after taking emergency loans from landholders or other owners.

INDONESIA

In Indonesia, fisheries buy or abduct children then confine them on offshore platforms to man fishing nets. The EU and US are among buyers of the resulting frozen fish and shrimp exports. For women from Indonesia, Thailand, Malaysia and the Philippines, internal enslavement in domestic services and the sex trade are common; such labour is also exported – the women often sent into domestic and/or sexual servitude in Saudi Arabia, United Arab Emirates and other Gulf states, and Japan.

EAST AFRICA

In Sudan, the state sanctions slavery. Amid ethnic and secessionist conflict, muraheleen militias of Arab Baggara clans – armed by the government – have abducted thousands of women and children of Dinka peoples for slave labour on the land, as household servants or forced into marriage. In Uganda, children are enslaved as soldiers by anti-government Lord's Resistance Army and the Sudanese forces.

Disposable People: Contemporary Global Slavery

Kevin Bales

There are currently 27 million people in slavery – twice the number of people taken from Africa in the entire 350-year history of the transatlantic slave trade. This is real slavery, not poorly paid workers in sweatshops, or people who face difficult choices, but people with no choices at all. Slavery in the contemporary world is what it has been since the beginning of human history – the complete control of one person by another. Violence is at the heart of that control, and the aim is profit. Slaves are used to make money for criminals, but they are paid nothing. However slavery is packaged – as a matter of race, religion or caste – at its core is the violent domination and exploitation of one person by another. It is a theft of life and work that often feeds into the global economy and into the things we buy.

Why so many slaves?

Slavery grows in the worst of times. Armed conflict, environmental destruction, economic collapse, even epidemic disease are all conditions that can give rise to slavery. Population change can also play a role. Over the past 50 years, primarily in the Global South, the world population has exploded from 2 to 6.7 billion. The burgeoning population itself has not made people slaves, but other factors have pushed these added billions toward vulnerability and enslavement. Kleptocratic governments have gutted the infrastructure, leaving many people without healthcare or education. The globalised economy has broken farmers on the rack of competition with vast European Union and American agriculture subsidies. Environmental destruction has driven indigenous people from their homes. War has made refugees, who have been at the mercy of men with guns. And underpinning all of these forces has been corruption. Around the world, in any country, the most powerful predictor of the extent of slavery is the degree of governmental corruption.

On the take

Governments should protect their citizens from violence and slavery, but many governments are incapable of doing so, or worse. When police brutality is up for sale or bribes can be paid so that police turn a blind eye, then the poor and vulnerable can be forced easily into slavery. In many countries, the police don't fight organised crime, they *are* organised crime. And in some countries, like Burma and Sudan, the rot reaches the very top, and slavery becomes government policy. At the village level, it is easy to understand the pressure on police to join forces with slaveholders. With a police salary of $20 or $40 a month, the opportunity to bring in an extra $200 a month is very tempting. Taking the bribe is even easier when the police officer is urged to do so by his boss. Landlords, moneylenders and businesspeople – the solid citizens of the town or village – are also the people most likely to use slavery in their businesses. Does a policeman really want to jeopardise his job, put his family at risk and alienate the most powerful figures of his local community just to protect people no one seems to care about? Since slaves are often migrants, refugees or members of a lower caste, poorer class or different ethnic or religious group, serving their interests offers few rewards and can carry many penalties. Corruption makes possible the violence at the heart of slavery. Yet the hopelessness of the poor is so great that often no violence is needed to take a person into slavery.

Combine population growth and impoverishment and the result is at least one billion people living on a dollar a day. This billion people is the largest pool of potential slaves ever to live on earth. Add into the equation corruption, and this extremely poor billion are even more vulnerable to slavery. Potential slaves, in their economic desperation, are easy to grab. Around the world, slaves tell the same story in many different languages. It is not about kidnapping, it is about luring the hungry with the question: 'Want a job?'. On nearly every continent, recruiters pull into villages and towns and announce that they are hiring. Men and women without work hear the offer and think it sounds dubious, but then they consider their hungry children, or the medicine they need, and decide they have to take the chance. Often against their better judgment they climb into the back of a truck and are driven

away. Far-off, they are put to work, and the job turns out to be nothing like what was promised. In time, still unpaid, they decide to cut their losses and quit. That is the day the gun comes out and the beatings begin, that is the first day they know they are slaves.

Most of the people who are newly enslaved today are captured in this way – not through violent assault, but through trickery. The violence comes soon enough, but they walk into slavery for all the right reasons. In the same situation, most of us would probably take the same chance if we believed it could help us care for our families or make a new life without hunger, fear or desperation. Latino, African-American, Asian, Native-American and Anglo workers made the same decision when they were recruited to work on the American Gulf Coast region after Hurricanes Katrina and Rita. Slavery in domestic service, agriculture, sweatshop work, restaurants, and prostitution in Europe and North America relies on the desire of people to better their lives and the fraud that plays on that desire. And, because these people are walking into slavery, the cost of these new slaves is minimal – just transport and food. This ease of capture reflects the way modern slavery is different to all the other slavery in human history. Unlike the slaves of the past 5,000 years, today's slaves are cheap and disposable.

Price collapse

This new variant of slavery arrived at the end of the twentieth century, and slaves are now cheaper than they have ever been. In 1850, an enslaved field hand on a Mississippi plantation cost the equivalent of $40,000 in today's money. In 2008, a similar healthy young agricultural worker costs less than $100. This dramatic fall in price has altered the basic economic equation of slavery. When the balance of supply and demand is fundamentally changed, the price of any commodity can drop radically. There is currently a glut of potential slaves on the market. A flooded market means slaves cost very little, but they can still generate high returns, since their ability to work has not fallen with their price. The return made on slaves in 1850 Mississippi averaged around 5 per cent. The return on investment from slavery now starts in the double figures and ranges as high as 800 per cent. Even when they

are used in the most basic kinds of work, slaves can make back the cost of their capture (however that acquisition occurred) very quickly.

Until the industrial revolution, oxen were the primary source of motor power. Their value was reflected in the fact that for the price of three or four oxen, a farmer could buy a productive field big enough to support a family and then some, or pay the annual salaries of two or three agricultural workers. Three or four oxen were a big capital investment. Yet, for most of human history, they were worth the price of just one healthy slave. Aristotle summed it up when he wrote, 'The ox is the poor man's slave.' For the price of one slave in the American Deep South in the 1850s, a person could buy 120 acres of good farmland. It should not be any surprise that slaves were expensive; after all, slaveholders were buying the complete productive capacity of a human being, all the work they could squeeze out for as long as they could keep the slave alive.

In India, you can still buy slaves as well as farmland and oxen, which remain the essential 'tractors' that keep farms going. But when we compare the price of a slave to the modern prices of land, labour or oxen in India, the slave costs, on average, 95 per cent less than in the past. This precipitous collapse is unprecedented in all of human history. The inexpensiveness of slaves is good for the slaveholder and great for his bottom line, but disastrous for slaves. A low purchase price means that a slave does not represent a large investment that requires special care; the slave is easily replaced. Slaves today are treated like cheap plastic ballpoint pens, the kind we all have in our desk drawers or pockets. No one worries about the care and maintenance of these pens or about keeping a careful record of their whereabouts. No one files a deed of ownership or takes out insurance on these pens. These pens are disposable, and, because they are so cheap, so are slaves.

Disposable people

If slaves get ill, are injured, outlive their usefulness or become troublesome to the slaveholder, they are dumped — or worse. The young woman enslaved as a prostitute in Thailand is thrown out on the street when she tests positive for HIV. The Brazilian man tricked

and trapped into slavery making charcoal is tossed out when the forest is razed and no trees are left to cut. The boy in India who spends all day weaving carpets is worked to death or until he is crippled and useless and then dumped, and the slaveholder will simply take another child in his place. The young woman in 'ritual slavery' in Ghana, who has been exploited, sexually abused and impregnated again and again by a *trokosi* priest, will be sent back to her parents when the priest tires of her or her health breaks down. Enslaved child domestic workers, like the *restavec* slaves of Haiti, are brutalised, sexually abused and discarded when their 'family' decides they are no longer useful. Like plastic pens or paper cups, slaves and potential slaves are so numerous that they can simply be used up and thrown away.

The fact that slaves are now disposable means that slavery is less permanent. Slaveholders are not interested in keeping an unprofitable slave. Although most slaves are held for years, some are held for only a few months. In countries where sugarcane is grown, for example, people may be enslaved for a single harvest because it is not worth feeding and housing them until the next harvest. Slaves in the American South in the nineteenth century were like valuable livestock; the owner needed to make back his investment. There was also pressure to breed them and produce more slaves, since it was usually cheaper to raise new slaves than to buy adults. Today, no slaveholder wants to spend money supporting useless infants. But in spite of the fall in the price of slaves and the changes this has brought, the fundamental nature of slavery remains the same; control through violence, economic exploitation and no payment beyond subsistence still define the life of a slave. The globalisation of the economy, however, means that the output of slaves flows around the world as never before, and many slave-made products are found in homes across the globe.

Slavery in our homes
Slaves tend to be used in simple, non-technological and traditional work. The largest proportion of slaves works in agriculture. But slaves are used in many other kinds of work – brick making, mining or quarrying, prostitution, gem working and jewellery making,

cloth and carpet making, clearing forests, producing charcoal and working as domestic servants and in shops. Much of this labour is aimed at local sale and consumption, but slave-made goods reach right into our homes. In countries where slavery and industry co-exist, cheap slave-made goods and food keep factory wages low and help make everything from toys to computers less expensive on the world market. The largest trans-national corporations acting through subsidiaries in the developing world take advantage of slave labour, usually unknowingly, to increase their bottom line and the dividends to their shareholders.

Integrated into global markets, slaves produce many of our basic commodities. In Brazil, for example, slaves cut down forests and burn the wood into charcoal to be used to make iron and steel. The European Union imports nearly a million tons of Brazilian steel each year to produce everything from toys to cars to buildings. Cotton is still grown through slave labour in India, West Africa and Uzbekistan, the world's second largest producer. Slaves produce coffee, sugar, beef, tomatoes, lettuce, apples and other fruit. The list goes on – shrimp and other fish products, cocoa, steel, gold, tin, diamonds, jewellery and bangles, tantalum (a mineral used in mobile phones and laptops), shoes, sporting goods, clothing, fireworks, rice and bricks. In the US, the Coalition of Immokalee Workers, a human rights group, has freed dozens of workers like Mexican national 'Miguel' who picked tomatoes and oranges under guard. He had come to the US in the hope of earning more money to support his family, especially to buy medicines for his six-year-old son who was ill with cancer. 'But when I came here I earned nothing,' he said, 'It was a false dream, I was a slave.'[1]

While many goods are tainted by slavery, only a very small proportion of any particular commodity actually has slave input. If American pre-Civil War cotton was primarily a slave-made good, the proportion of today's global cotton harvest cultivated by slaves may be 1 or 2 per cent at most. The International Labour Organization estimates the profits of human trafficking and slavery in the range of $32 billion per year. It is a sizeable sum, but only a drop in the global economic ocean. This small fraction of the global economy represented by slave-made goods poses a challenge to businesses and consumers.

Cocoa, for example, is grown on more than 600,000 small farms in the Ivory Coast, a country that produces about half the world's supply, but only a small fraction of the farms use slaves. Young men, normally from poor neighbouring countries like Mali, come to the Ivory Coast looking for work. In remote rural areas, some are tricked and enslaved into farm work. But in the cocoa supply chain, European and North American companies are not allowed to buy directly from the farmers; instead the cocoa harvest filters through a series of Ivoirian middlemen and shippers before reaching the coast for export. The profits from slave labour are taken at the farm gate by the slaveholder, not by chocolate companies or grocery store chains. As a result, product boycotts, which seem a reasonable response to slave-made goods, can actually make things worse by hurting the majority of farmers who don't use slaves, even pushing the families of honest farmers into the destitution that makes them vulnerable to enslavement. Slaves grow, mine and produce what we eat, use and wear, but the story doesn't stop there. In many cases, a major by-product of the slave labour feeding into the global economy is environmental destruction.

Blood and earth

Around the world, slaves are being used to destroy the natural environment, and, in a vicious cycle, that destruction generates more and more slaves. Criminals who demolish the lives of slaves don't mind wreaking havoc on nature. Forests are illegally cut, strip mines are carved into protected areas, reefs and coastal environments are destroyed, and it is slaves who do the work. In the Amazon rain forests, it is slaves, not bulldozers, who are cutting the lungs from the planet. The timber cut in the Amazon and the mountain forests of Burma is exported to global suppliers. Slaves work in open pit mines for gold, diamonds and other minerals that scar the landscape in Brazil, Ghana, Liberia, India and the Congo. It is easy to see this cycle of slavery and environmental destruction in India. There, dam construction forces farmers from their land without compensation. One dam currently being constructed on the Narmada River will submerge 245 villages and displace 200,000 people.[2] Pushed off their land, these small farmers cannot just start farming somewhere else; the surrounding land is already

taken. Soon, their only alternative is debt. In rural India, this means slavery through debt bondage. Once in bondage, slaveholders will put them to work on land that is 'available' in the national forests, or other protected areas. Here, they cut the trees and dig quarries and more of the natural world is wiped out. The destruction displaces more farmers and the cycle begins again.

The human cost of the link between slavery, trade and environmental destruction can be seen in the global market for fish and shrimp. More than three million tons of frozen shrimp were imported to the US in 2006.[3] The huge demand for shrimp in North America and Europe has generated a gold rush along the coastlines of the developing world. In India, Bangladesh, Indonesia, Ecuador, Guatemala and Brazil, coastal forests, mangrove swamps and natural beaches have been ripped-up to build hundreds of thousands of acres of shrimp farms. In all of these places, adults and children have been enslaved both to construct the shrimp farms and to cultivate and harvest the shrimp.[4] In some cases, whole families are caught in debt bondage slavery, in others, children are kidnapped and hustled off to shrimp and fish farms on remote islands. The mangrove swamps destroyed to build shrimp farms are ecological 'sponges' protecting the coastline from being overwhelmed by the rushing wall of water that is a tsunami. In the devastating tsunami of December 2004, the areas of Sri Lanka where natural coastal ecosystems had been torn apart to install fish and shrimp farms suffered the greatest loss of life. This was especially the case when outlying coral reefs were broken up as well, removing a natural buffer.

In Ghana, boys and men dig shafts into the earth searching out flecks and nuggets of gold. Crawling through narrow makeshift tunnels, they work in cramped, poorly-lit mines. The air thick with dust, the boys and men are constantly at risk of deadly accidents due to falling rock, mine walls collapsing and explosions. Outside the mine, the gold is separated from rock using mercury, a deadly poison. Enslaved men, women and children mine gold in Brazil, the Philippines and Peru. It is estimated that some 25,000 people, many of them enslaved, pan gold from the Amazon, producing seven metric tons a year.[5] Juan Climaco is a judge based in the Amazonian town of Huepetuhe in Peru. 'We are talking about people forced

to work in the worst conditions imaginable', he said, 'without pay, and they really have no way out.'[6] Amazonian gold flows into the global market and can end up in anything from electrical parts to gold bars or even the ring on your finger.

That ring might also have a gemstone that comes from the hands of slaves. In Sierra Leone, adults and children are enslaved in the diamond fields in the Kono district. Olara Otunnu, the Special Representative of the Secretary General of the United Nations, said, 'I was horrified by what I saw', after visiting the mines.[7] These diamonds also flow into the global market. High quality stones go to traditional diamond cutting centres like Antwerp where they are graded and cut for jewellery. Lower quality gems, more than half of global production, are sent to India where, in Gujarat, hundreds, perhaps thousands, of enslaved children cut and polish the stones. These gems move into the market to be used for inexpensive jewellery along with the cheaper zirconium gems the children also process. Set in jewellery or exported raw, these zirconium gems end up in the markets of the rich North, pushed at us in television ads, cheap jewellery stalls and magazine advertisements. With slavery in nearly every country and slave-made products permeating our economy, what hope is there for the slaves of today? Remarkably, many of the features of contemporary slavery suggest ways to bring it to an end once and for all.

The end of slavery?
The sheer number of slaves, their broad geographical distribution, their role in the global economy and the ease of their enslavement, all help to create a paradox. It would seem that slavery would be as intractable at the beginning of the twenty-first century as it has been for millennia, but evidence points to just the opposite. In spite of the size and complexity of contemporary slavery, it is nearer to eradication than it has ever been. If there was ever a tipping point when slavery could be brought to a full stop, it is now. The growing acceptance of human rights and the relatively small part slavery plays in our world economy mean slavery is ripe for extinction. Slavery is a big problem, but it is not as big or as intractable as global warming or global poverty. Yes, 27 million

in slavery is a lot of people, but it is just a fraction of the world's population. Yes, $32 billion a year in slave-made products and services is a lot of money, but it is also the amount expected to be spent by people downloading music onto their mobile phones in the next few years.[8] What slavery generates in profits each year is a tiny drop in the ocean of the world economy.

No industry or corporation, political party, state, country or culture is dependent on slavery. No government or legitimate business would collapse if slavery ended today. The cost of ending slavery is much less than the amount that freed slaves will pump into the global economy. For those of us in the world's wealthy countries, the cost of ending slavery would be so small we'd never notice it – small coins here and there, pennies from our pockets. Never has the world been so rich, has travel and communication been so easy, have so many countries been ready to work together, has the world had the end of slavery so easily within its grasp.

How much will it cost to end slavery?

Debt bondage slavery in South Asia accounts for as many as 10 million of the world's slaves. Since an enslaved family's work is considered collateral, not repayment of their loan, this form of slavery is often hereditary. It is not unusual to find families in their third and fourth generation of debt bondage slavery in Northern India, completely unaware that a life in freedom is possible. All the worst features of slavery mark debt bondage: violence, rape, degradation, malnutrition and hopelessness. The good news is that the programmes for liberation and reintegration are well developed and well tested. Add together the costs of paying outreach workers and their transportation to rural villages, of organising and guaranteeing seed money and maintaining the micro-credit unions, of keeping the local organisation's office ticking over, and so forth, then divide that sum by the number of families they help to freedom in a year, the result is about $130.

So, for the price of a fancy lunch, a family goes from slavery to freedom. None of that money goes to pay off the illegal debt that holds the family in bondage or to give money to criminals to 'buy'

the slave's freedom. What it does include is the cost of helping the family achieve an independent life and getting their children to school, as well as helping villagers to organise themselves and to know and safeguard their legal rights. It leads to families getting control of the means to earn an independent living. Freedom may be precious, but it doesn't have to be expensive.

The cost of freedom is important because governments run on money. It would be possible to look to individuals and charities to bankroll the end of slavery, but since every government agrees it is a crime, and since practically every citizen of every country condemns slavery, could there be a better expression of our common will through our elected governments? Calling for and supporting the increased action by governments will lever the funds needed for real eradication.

Knowing what it will cost to end slavery in a country makes it possible to build an effective strategy for eradication with meaningful government participation. Remarkably, the balance of costs and benefits for ending slavery makes it a great investment. Let's assume a higher cost for freeing slaves than the $130 figure for liberation and a new life in India. In Ghana, it costs about $400 to free a child from slavery in the fishing industry, place them in a shelter, give them the care they need, reunite them with their family, and help that family build its earnings so that they are no longer vulnerable to human trafficking. This is probably closer to an average cost for liberation worldwide. What would that mean in terms of the price of ending all slavery? If there are 27 million slaves then ending slavery on planet earth would cost $10.8 billion. That is far beyond the reach of human rights organisations, but it is just one per cent of the current annual budget of the UK government. Freedom is not just affordable, it's a bargain. And there is no reason to assume that Britain has to pay the whole bill for eradication; shared amongst the rich countries, the cost would be pennies per person – painless and possible.

These cost comparisons are important because they show that money is not the barrier to ending slavery. They demonstrate that with political will and a fairly small amount of input, eradication is

achievable. Of course, it is true that freedom for many slaves will cost more than the $400 per child in Ghana, and helping people who have been trafficked into Europe and North America will be even more expensive. When the human traffickers linked to organised criminal gangs need to be caught and punished, the price will be even higher. These criminal networks are notoriously hard to crack. Likewise, there are many parts of the world where the poverty that increases the vulnerability to slavery is so acute that fundamental changes will need to be made. Then there are the governments that are tacitly supporting slavery, exploiting their own citizens as forced labour. These unelected dictatorships, as 'sovereign nations', will require expensive diplomatic and economic pressure. But even if the cost of global freedom doubles or triples, it is still a relatively low sum, an infinitesimally small fraction of the global economy. And, around the world, liberation leads to a 'freedom dividend', an upward spiralling of local economies as ex-slaves are freed to work for themselves and their families. Sustainable freedom generates economic growth and thus pays for itself.

The botched emancipation

Freedom is a process, not an event. The moment of liberation can be a cruel joke if the freed slave can't achieve human dignity. No other country in the world so dramatically demonstrates the consequences of a botched emancipation as the United States. America has suffered, and continues to suffer, from the injustice perpetrated on ex-slaves. Generations of African-Americans were sentenced to second-class status, exploited, denied and abused. Without education and basic resources it was very difficult for African-American families to build the economic foundation needed for full participation and well-being in America. Today, there are laws that require criminals to make restitution for what they have stolen, for the damage they have inflicted. No such restitution came for the stolen lives of millions of slaves. At the end of the American Civil War, nearly four million ex-slaves were dumped into the society and economy of the United States with little prepara-tion. If freedom can come to the 27 million slaves in the world today, do we really want the next four, five or ten generations to face the problems of emancipation gone wrong? The aim of ending

slavery cannot be the creation of a population whose suffering and anger spills out over the decades. Helping freed slaves realise full lives is one of the best investments a government or society can make. We know the alternative, that way lies a horrible waste of human potential. It also gives birth to anger, retribution, vengeance, hatred and violence.

Ending slavery may not be terribly expensive, but wiping out this crime won't happen overnight. The things we have to do to end slavery in the Western World, such as enforcing existing laws, training police and managing supply chains, are somewhat different from the things we have to do in India, Ghana or Thailand where slavery grows in a context of poverty and corruption. Like a lot of crimes, slavery takes on the colouration and culture of its surroundings. Slavery is tangled up in both local and global economies. Ending slavery means attacking it at all levels: regional police, the United Nations, businesses, local communities and governments, and each of us as citizens – all will have to play a part. It is a big job, but we stand at a moment in human history where our economies, governments, understanding and moral beliefs are aligned in a constellation that can bring slavery to an end.

1 Quoted in the film *Dreams Die Hard*, Peggy Callahan (Director), Free the Slaves, 2006.

2 The Narmada Bachao Andolan, Press Release, 'Supreme Court Directs M.P. Government to Provide Land-based Rehabilitation; Refuses to Stay SSP Construction Despite Incomplete Rehabilitation', New Delhi, India, 17 April 2004.

3 Shrimp imports also reported at: http://www.nmfs.noaa.gov/fishwatch/trade_and_aquaculture.htm.

4 The Narmada Bachao Andolan, Press Release, op. cit.

5 Michael Smith and David Voreacos, 'The Secret World of Modern Slavery,' in *Bloomberg Markets*, December 2006, p. 60.

6 Ibid.

7 Quoted on the website of the Australian Anti-Slavery Society, accessed 11 July 2007, http://www.anti-slaverysociety.addr.com/diamonds.htm.

8 Antone Gonslaves, 'Global Spending on Mobile Music to Top $32 billion by 2010', in *Information Week*, 23 January 2007.

A Dialogue on Documentary Photography

Roger Malbert, Mark Sealy

Roger Malbert Tell us about the genesis of this project. Was it prompted by the activities in 2007 commemorating the abolition of the transatlantic slave trade?

Mark Sealy From late 2005 and throughout 2006 there was a lot of what could be described as 'white noise' produced by various cultural and political institutions about the 200th anniversary of the Abolition of the Slave Trade in Britain. Picking up on the frequency of information circulated by many of the UK's major museums regarding plans for public events and the building of new institutions and memorials aimed at commemorating the 1807 Act, it became clear to me that debates about the condition of contemporary global slavery and the continued economic exploitation of people were not being addressed. I objected to the fact that an act of Parliament in 1807 was being flagged-up as the defining moment marking the beginning of the end of slavery, as if in one great British philanthropic, enlightened moment, African slaves were gifted their freedom.

The national focus on the 1807 Act had the effect of glossing over the political realities and legacy of slavery today. With so much attention focused on anti-slavery campaigners such as William Wilberforce and Thomas Clarkson, what was in fact occurring was a form of selective cultural amnesia. The end of slavery was being celebrated as a purely British affair and historicised in a way that positioned Britain as the great liberator. Other important forms of resistance to slavery were therefore eclipsed or negated – for example, the eighteenth-century revolutionary leader Toussaint L'Ouverture's brilliant military campaigns for freedom, which defeated both the French and British imperial powers and finally led to the establishment of Haiti as the first free black republic. Important campaigns of black resistance to slavery were being rendered insignificant. The battle for freedom that took place on Hispaniola is vital to our understanding of the wider political context that enabled the British government finally to realise that the trading in human beings had to end.

Disposable People is intended to address the here and now, to draw attention to the fact that human trafficking for commercial gain is still a global problem. Now, as in the past, global economic market forces are still the major contributing factor in making human life disposable, and the link between capitalism and slavery remains very active. Today's forced displacement of rural people in the name of progress has echoes of the transatlantic slave trade. This project, therefore, acknowledges that the wretched conditions of slavery have never really left us. It is an enquiry into how slavery has simply evolved.

I wanted to investigate how the subject of slavery could be addressed explicitly through documentary photography, how its victims could be visualised against the grain of historical representations of slavery. Bearing in mind the recognised limits of documentary photography (and its reputation as being less than the innocent carrier of historical truth) this was bound to be a challenge, both curatorially and for the photographers themselves. Addressing the visibility of disenfranchised people has always been a principal concern for Autograph ABP since its very inception over 20 years ago. For two decades, we have been supporting work that unhinges the stereotypes and contests the dominant ideology of Western history. If anything, these concerns will become even more pronounced in the future as the condition of marginalised groups remains a major political issue.

Article 6 of the Universal Declaration of Human Rights states, 'Everyone has the right to recognition everywhere as a person before the law.' The histories of photography and the question of black cultural absence are major problems for photography, which until recently has been dominated by a type of image-making that is susceptible to myriad charges of exploitation. I would argue that everyone has the right to recognition everywhere as a person before the law – and the camera. The question of cultural authority is a vital issue that has haunted documentary photography since its invention. I am not sure if these critical questions have been adequately addressed within postmodern theoretical debates. *Disposable People* affords us the opportunity to revisit a key issue within photography, that of representation.

RM Can we discuss documentary photography's status as a campaigning tool for revealing social reality and implicitly as an instrument for change?

MS Photography's role as a campaigning tool for highlighting forms of social injustice has a long historical tradition, for example in the photographs of Jacob Riis and the Farm Security Administration programmes.[1] Later, the work of contemporary theorists and artists like John Tagg, Martha Rosler and Abigail Solomon-Godeau deconstructed the documentary photograph, revealing it to be not simply the bearer of a given truth. One of the aims of this project is to provide a platform for re-examining some key issues relating to documentary photography: namely, how to represent without exploiting, and whether it is indeed possible to represent a subject's condition in the full knowledge that a photograph is not produced in a political or cultural vacuum. Worthy images of the disenfranchised do several things at once: they make us aware of the tragic circumstances in which people live and they remind us of the victim's helplessness while affirming our own sense of security and power.

RM There is an obvious problem of information overload. When TV and video permeate culture and almost every mobile phone contains a camera, the

traditional role of the photojournalist is surely diminished, if a part of that is to witness, to bring to light unseen and unknown realities. And, in a digital age, we can no longer trust the photograph to provide an authentic record.

MS The notion of image overload is an important issue, and the impact of the digital revolution on the Western world is profound. It is clear that the ease of transmission of photographs is now very different; images appear to leak from places they are not supposed to, which makes them even more compelling or repulsive.

But when we think about mass access to the production and distribution of images in a global context, we need to remember that, for example, in December 2007, internet users in Africa constituted only 3.4 per cent of total worldwide web users.[2] The majority of the world's population does not have access to cameras or the internet. Therefore, we could say that the traditional role of the socially committed photojournalist has not diminished, it has simply changed in relation to how the West consumes and produces images.

RM The realities represented in these images are inflected in all kinds of ways, they are not simply objective reportage. They are framed firstly by the pictorial and journalistic conventions of the age, and secondly they are filtered through the consciousness of the photographer. All the photographers in *Disposable People* are creative individuals whose sensibilities are evident in almost every picture they take. In this sense, they are artists; although they may also be journalists and activists. In the context of contemporary art, there are questions to consider about the relationship between the ethical (or political) and the aesthetic dimensions, particularly now when social documentary modes are often adopted as a strategy by artists whose purpose is less to reveal reality than to create a powerful, highly-charged image. The primary aim of the socially aware documentary photographer is surely to bring reality home; yet many of their images are aesthetically satisfying, beautifully composed and so on. But what does that mean for the viewer? How does the moral urgency, the imperative to act, get transmitted? Or is it really that the role of activist is assigned to the photographer, while the viewer remains a passive, disinterested onlooker?

MS The problem for documentary photography is that it is now increasingly clear that the viewers are not prepared to consume the photograph with the same emphatic blind faith as in the past. As Abigail Solomon-Godeau reminds us in her essay 'Who Is Speaking Thus? Some Questions about Documentary Photography': 'The Photographer's desire to build pathos or sympathy into the image, to invest the subject with either an emblematic or an archetypal impor-tance, to visually dignify labour or poverty, is a problem to the extent that such strategies eclipse or obscure the political sphere whose determinations,

actions, and instruments are not in themselves visual.'[3] Therefore, and with the above quotation in mind, it is not surprising that when we come to think about the image of contemporary slavery, it is often difficult to visualise the political conditions that bind the victims; in many instances they are lost in the text. The challenge for these photographers was to make visible what is concealed.

RM Whatever one thinks of the proposition that the photographer's sympathy actually obscures the underlying political and economic reality, it is certainly true that the visual alone cannot convey it. That is why the images here are not treated as autonomous, but require text to explain the situations depicted. And the photographers have all presented their images in narrative sequence; this too deflects from the aestheticising impulse.

In discussing the split or tension between the ethical and the aesthetic dimensions of documentary photography, the artist Martha Rosler distinguishes usefully between production and consumption. She writes of 'the well-entrenched paradigm in which the documentary image has two moments: the "immediate" instrumental one, in which an image is caught or created out of the stream of the present and held up as testimony ... and the conventional "aesthetic-historical" moment, less indefinable in its boundaries, in which the viewer's argumentativeness cedes to the ... pleasure afforded by the aesthetic "rightness" of the image.'[4] It could be asked why we need images of such profound or subtle beauty to make us aware of injustice. Is the sympathy of the photographer essential to the power of the photograph? You chose to work on this project with socially committed photojournalists rather than with artists using documentary modes. Will you say something about how you see the relation between documentary photography and contemporary art?

MS Working with socially committed photographers who are grounded in the tradition of the documentary allowed us to move away from the idea that contemporary global slavery could be treated as an 'artist in residence'-type project that would end up saying more about the artist than the social conditions in focus. I wanted to work with photographers who actively engage in providing documentary stories for editorial circulation. That is a very specific form of visual intervention. When done well, the documentary photograph is not just in the news, it is the news.

RM On the question of how much an image reveals and what it conceals, it is striking that many of the images in *Disposable People* are quiet and understated by the standards of international photojournalism. We are quite used to seeing photographs of carnage and destruction. We know how to look and look away. Most of the photographs here show ordinary people going about their everyday lives, and if the underlying reality is violent exploitation and a criminal abuse of human rights, it is not always immediately apparent.

MS The latent and less obvious violence within photography is an issue that is rarely discussed. In many instances, photojournalists who desire to get close to the carnage and destruction of an area of tragedy adopt a dualistic position in terms of how the subject is presented. The victim is often identified and represented in rather simplistic terms. The point here is that much of the visual violence we are subjected to functions in a similar way to rumour. Somehow the origins of the situation are never made apparent but the results can be lethal. The codes of how photojournalism renders the victim have become internationally standardised. The victim becomes a universal 'Other'. Therefore, photographers working within a conflict or disaster zone repeatedly fall into an inherent trap of trying to present a sense of horror in order to provoke in the viewer a humanitarian response – which is often momentary, persisting only until we turn away or turn the page.

Good intentions do not guarantee the success of a photograph's message. Often the more covert forms of violence contained within a photograph are quickly legitimised because of the obvious or direct 'good' work the image does for the reader. The image's undercurrents also need to be examined. Is it enough to reproduce yet another image of an African child dying with flies in their eyes? The primary function of a stereotypical image of famine is produced with a particular aim in mind or a prize in sight. This form of image-making is therefore justified because of the results it yields, or the causes it highlights. The fact that many of these images perform acts of erasure is denied. Aid agencies are particularly susceptible to this problem. Therefore, if we have conditions where the visual exploitation of people is accepted as long as it is for a good cause, we have a condition where certain sections of humanity will always be rendered pathetic. So, as far as photography is concerned, we have a condition where the meanings within a photograph become difficult to fix. The 'punctum' ('that which pierces the viewer'), which Roland Barthes famously refers to, fails to function.[5] The violent nature of images gets absorbed into the violence of the everyday. The strength of this project lies in the fact that many of the photographs included in it are not remarkably dramatic; they are quiet and contemplative. They are everyday moments in the lives of those who have experienced one of the most insidious forms of violence: to be made both invisible and disposable.

1 Abigail Solomon-Godeau, *Photography At The Dock. Essays on Photographic History, Institutions, and Practices,* University of Minnesota Press, Minneapolis, 2003.

2 http://www.internetworldstats.com/stats1.htm.

3 Abigail Solomon-Godeau, op. cit., p.179.

4 Martha Rosler, 'In, Around, and Afterthoughts (On Documentary Photography)', in Liz Wells (ed.), *The Photography Reader,* Routledge, Abingdon and New York, 2003.

5 Roland Barthes, *Camera Lucida,* translated by Richard Howard, Noonday Press, New York, 1981.

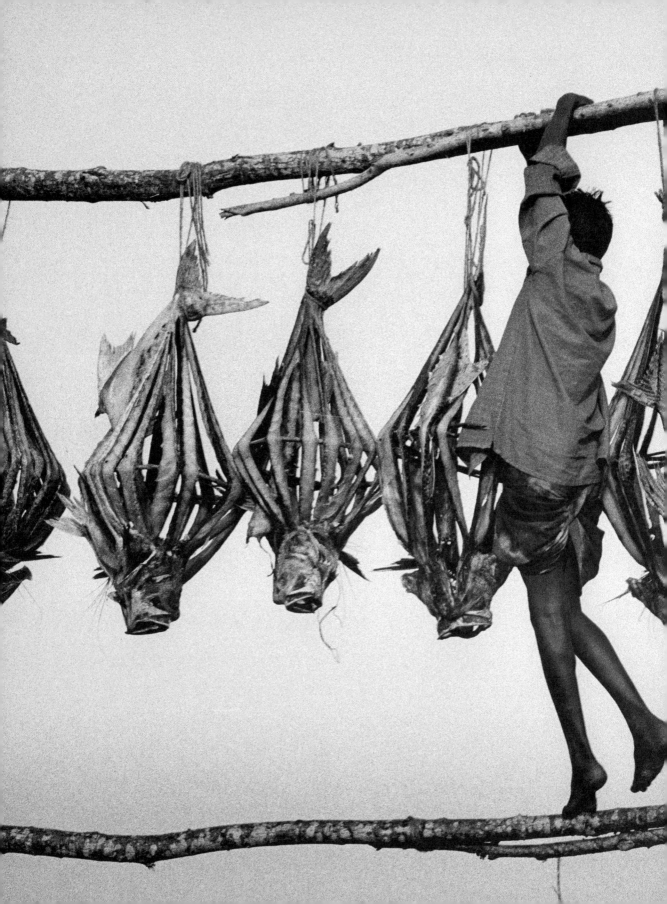

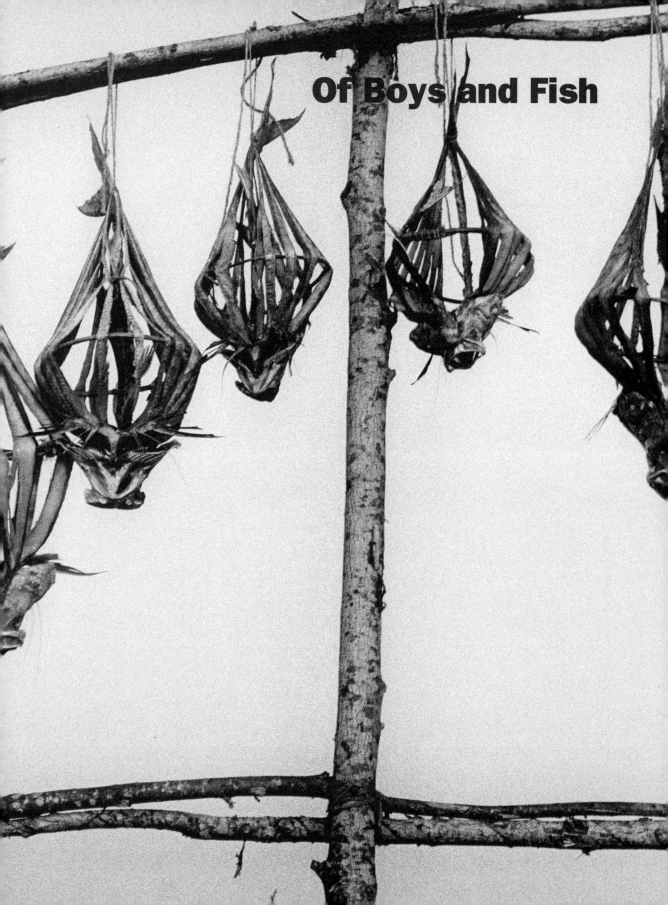

Of Boys and Fish

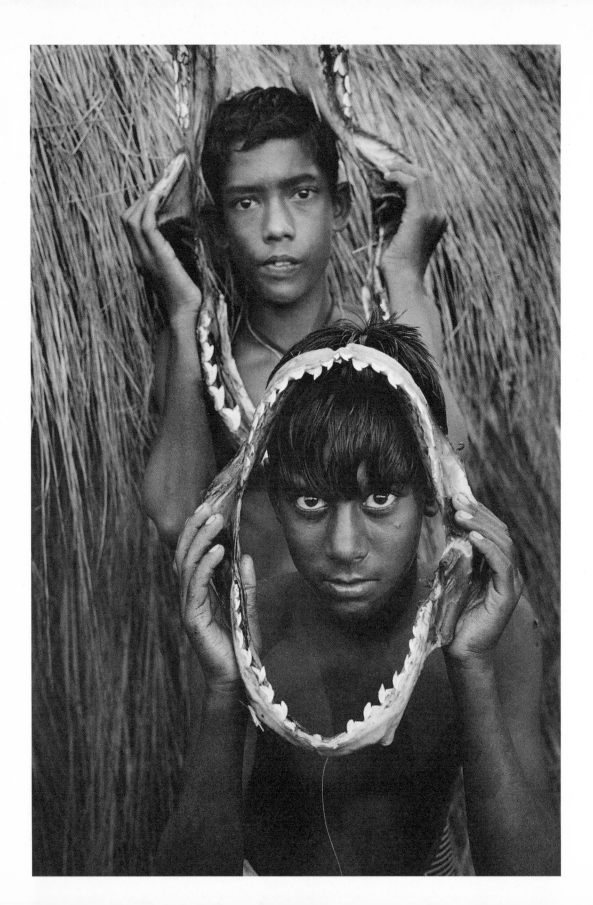

Abbas

Of Boys and Fish
Child Slaves in Bangladesh

Boating down the Passur river, through the *sundarbans* – the mangrove forest – I am reminded of Joseph Conrad's *Heart of Darkness*. Passes checked, armed guards taken on board in Mongla, we reach Dublar Char. Deserted most of the year, this island becomes a hub of activity for the five months of the dry season. Fish caught in the Bay of Bengal are dried here before being sent to markets throughout the country.

Procurers – *dalals* – trick street children onto the islands with the promise of a salary. Once there, the children become virtual slaves, their day-long work rewarded with food and shelter only. It is impossible to run away from the island.

To differentiate slaves from child labourers, I ask the boys if they have come to the island with their family. The way they hesitate before answering 'yes' is eloquent: do they have to lie to protect their masters? On the second day, my translator informs me that adults are becoming suspicious, asking why I photograph so many children, fearing that my photos, once published, will draw the government's attention and make them all end up in jail. The translator reassures them by pretending that I am only interested in the fishing industry.

The fish are unloaded from boats, carried in heavy baskets and put to dry, and then the children take time off to play football. They fool in front of my camera, cover their heads with strings of fish, use shark's jaws as masks, they laugh like all children their age. Should I not show this aspect of their life? The slave of past times, did he not also laugh and feel secure in his master's home, even if his future was not his own?

On an island, poverty, squalor, hardship and sometimes beauty, serenity...

Abbas

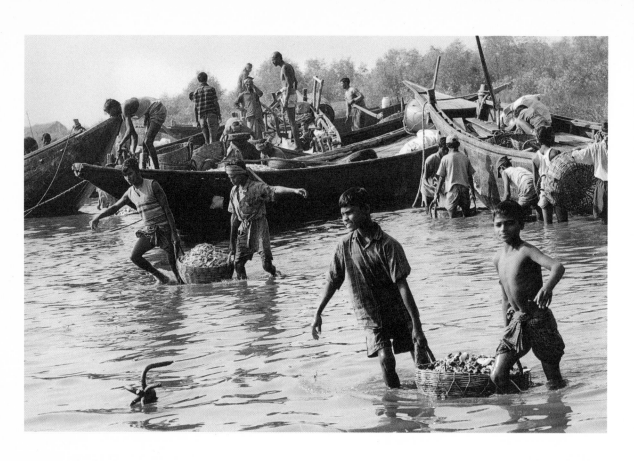

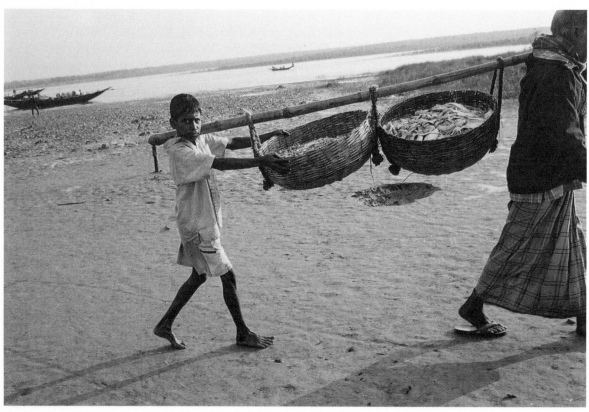

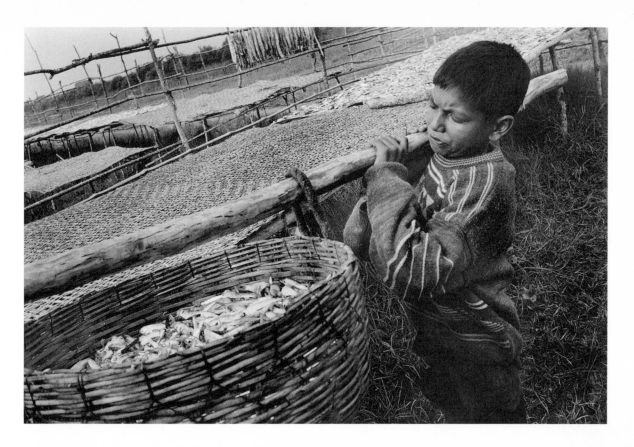

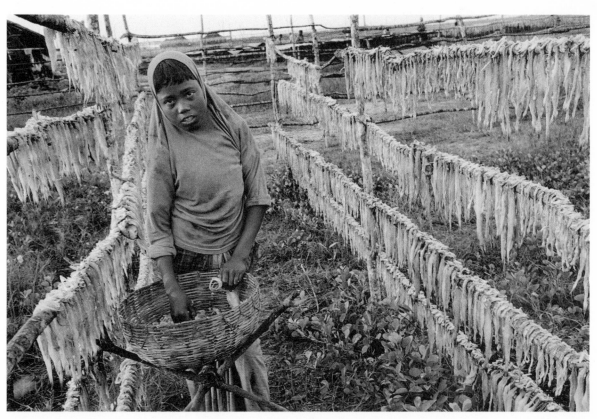

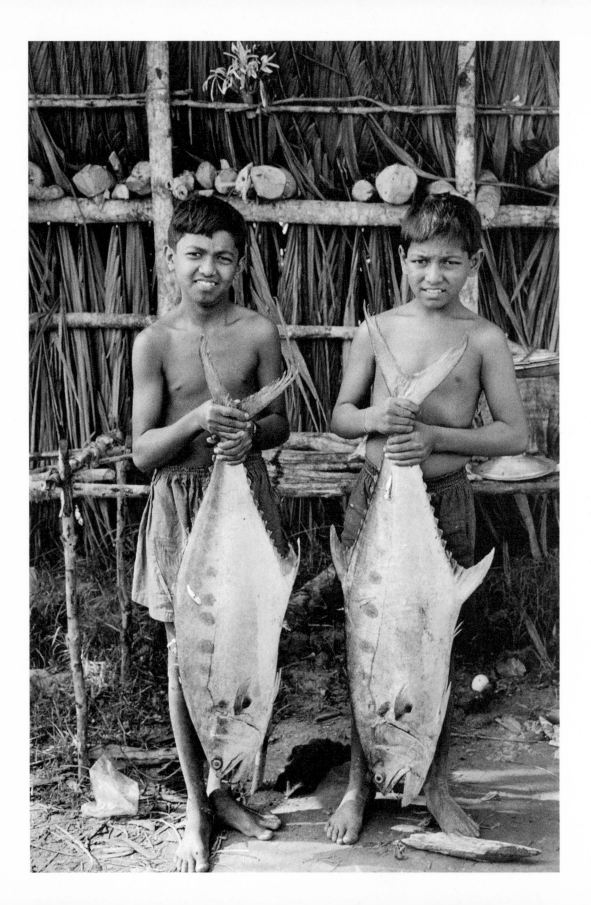

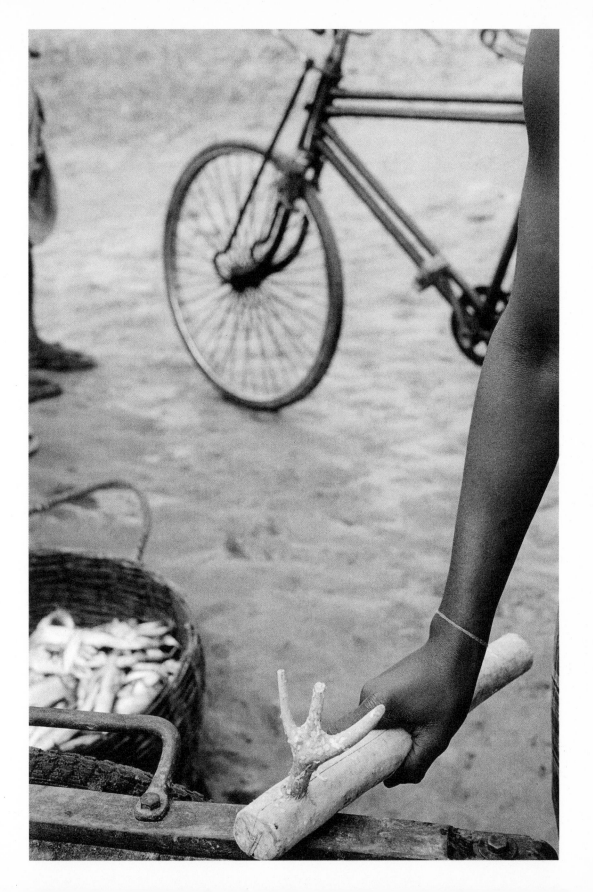

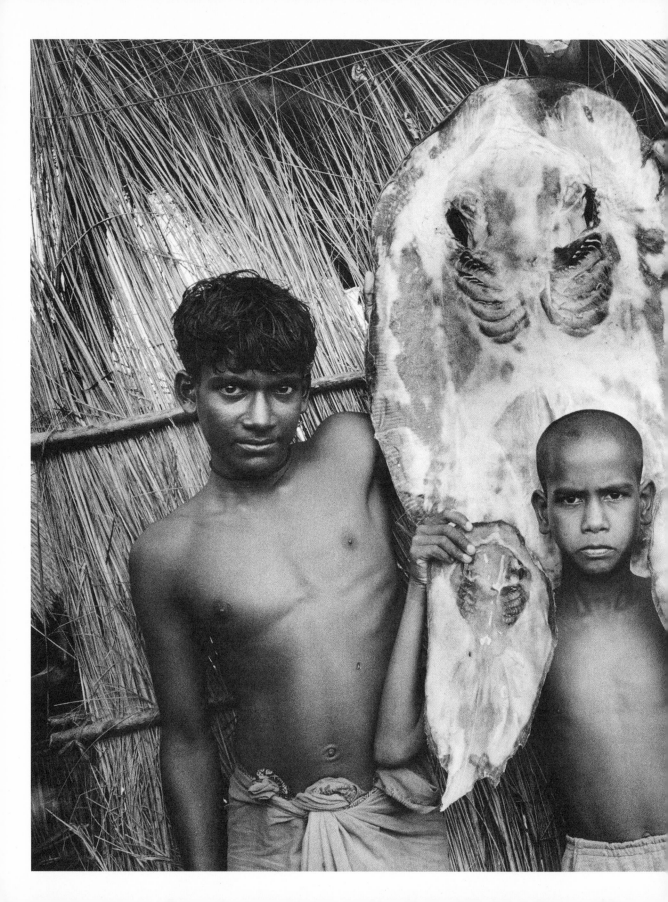

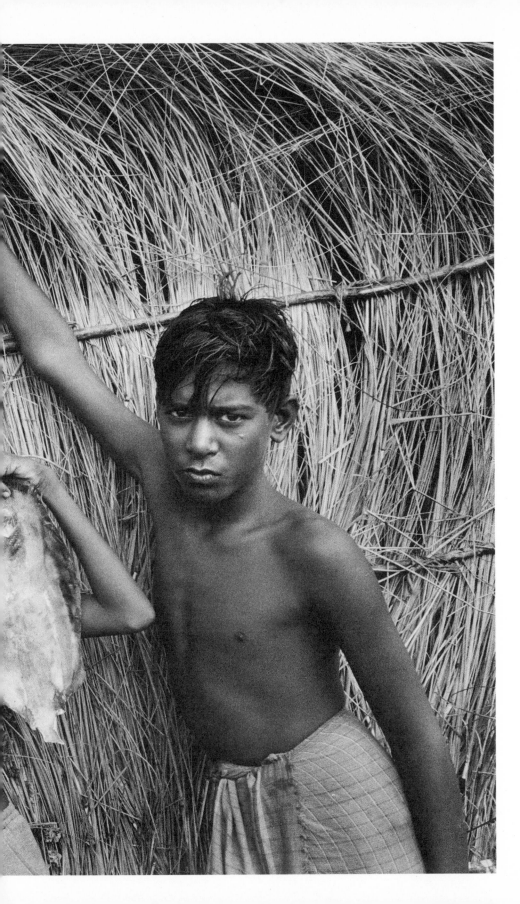

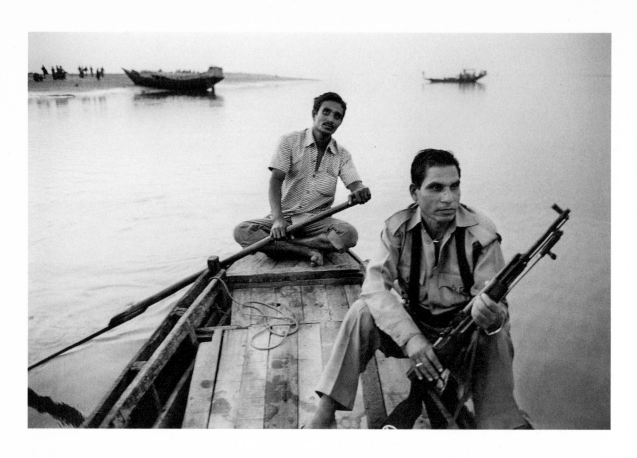

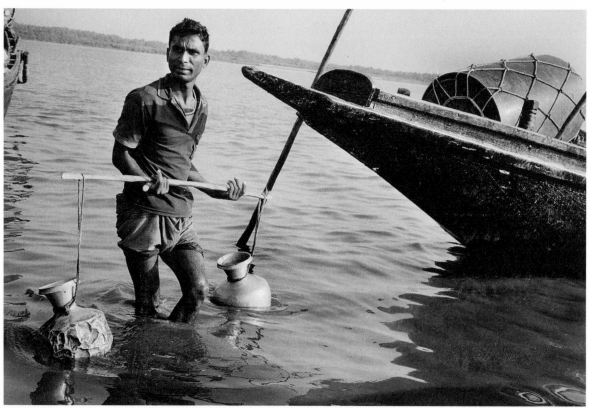

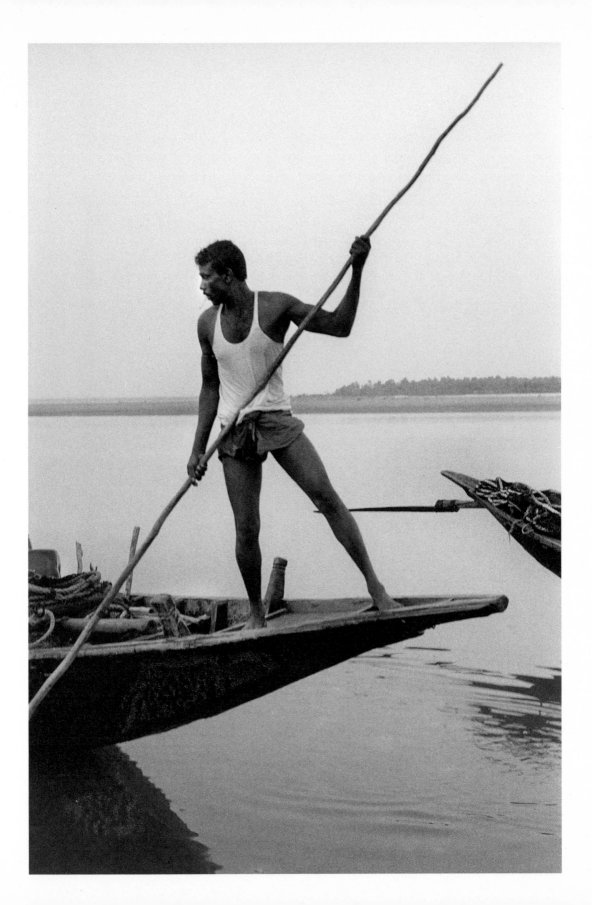

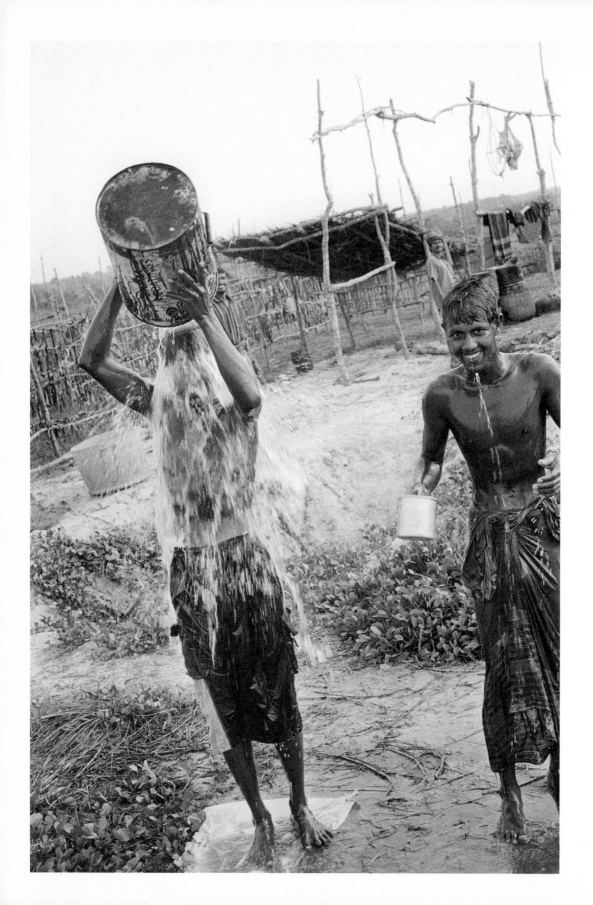

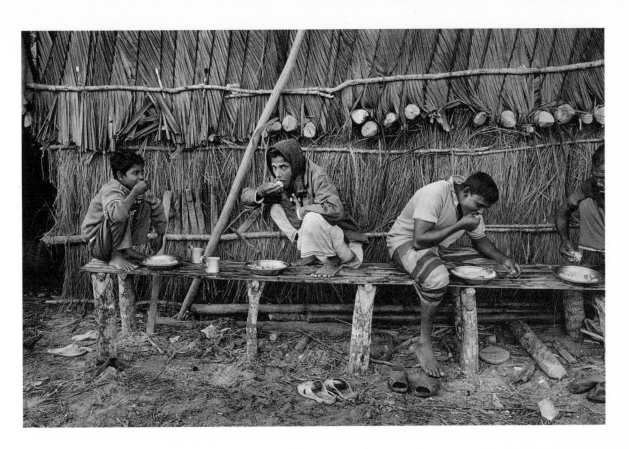

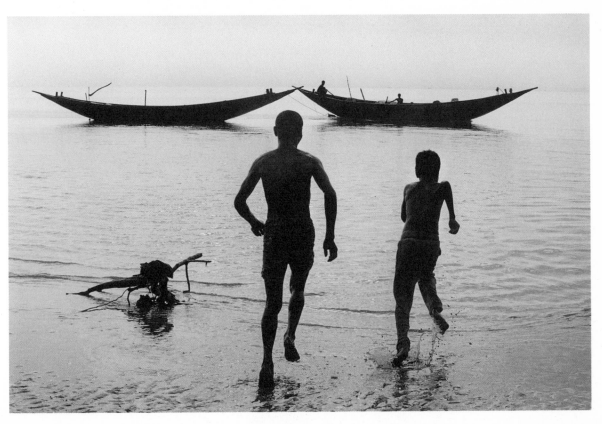

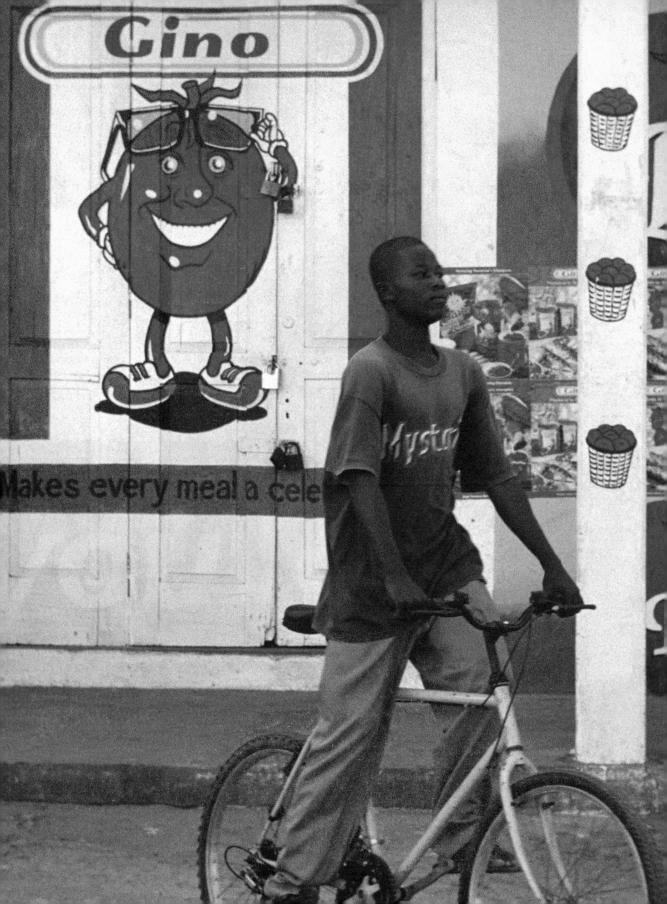

Ian Berry

From Slave Trade to Trade Slaves

'Trade justice for the developing world and for this generation is a truly significant way for the developed world to show commitment to bringing about an end to global poverty.'
Nelson Mandela

Just as the eighteenth-century slave trade was about the abuse of economic power and foreign control, so international trading relations between rich and poor countries continue in the same way today. In the twenty-first century, rich countries and financial institutions like the International Monetary Fund (IMF) and the World Bank exert enormous control over the economies of poor countries like Ghana. Instead of being a means by which countries can work their way out of poverty, international trade often functions against the interests of poor communities.

In Ghana, as in many developing countries, 70 per cent of people earn their living from agriculture. The Ghanaian government has been forced to open its markets to foreign goods and to stop giving support to its own farmers in return for loans, aid and debt relief from the rich world. Visit any market in Ghana today and you will see an abundance of cheap imported goods – American rice, Italian tinned tomatoes and British chicken. This foreign produce is having a disastrous effect on local farmers, undercutting them and putting many out of business. This means that not only can Ghanaians no longer pay for school fees for their children but they also struggle to afford food and healthcare for their families. Some farmers have even had to abandon their land altogether and search for alternative employment.

Ian Berry travelled to Ghana with the international development charity Christian Aid to document the impact of current international trade rules on farmers, traders and poor communities in the country as they struggle to sustain their livelihoods. One of his most striking photographs was taken with Cape Coast Castle as an imposing backdrop to a thriving local fishing community. This fort was captured by the English in 1664 and later became the capital of the British slave trade in West Africa. Today, the castle is a popular tourist attraction.

Ian's journey took him from the rice growing region in the south of the country (Dowena) to the tomato growing farms in the Ashanti region (Akumadan), then on to the poultry farms north of Kumasi and the roadside quarries north of Sunyani. Everywhere he went, farmers, traders and labourers spoke of their

hardships and daily struggle to survive. 'I used to own a tomato farm but I couldn't feed my family,' says Kofi Eliasa. He couldn't make a living competing with cheaper tomatoes imported from Europe flooding local markets. Kofi now works a 12-hour day in the searing heat, breaking stones in a quarry for less than $2 a day.

Many people migrate from the grinding poverty of the north of Ghana to the cities of the south in search of work and a new life. For some, they may be lucky to find low paid work in factories, while others hustle their international wares in the cities' market stalls. They soon discover that their small profits are not enough to pay for a roof over their heads in the city slums or for water bought from the local pumps.

What the slum dwellers don't know is that the World Bank and International Monetary Fund have encouraged Ghana to privatise their public services in return for loans. The privatisation of water has led to higher prices and made accessibility for poor people even more limited. With no prospects of employment or income, some survive but risk their health by scavenging for food or things they can sell from the cities' rubbish dumps.

International trade is worth $10 million a minute, but poor countries like Ghana only account for 0.4 per cent of this trade. According to United Nations estimates, developing countries lose $1.3 billion every day because of unfair trade rules. Christian Aid research suggests that Africa alone is $275 billion worse off as a result of the trade policies implemented over the last 20 years.

Trade Justice is the best chance for developing countries to combat poverty. It calls on the European Union, International Monetary Fund, World Bank and World Trade Organisation to change the rules that govern international trade, to allow poor countries to have the freedom to help and support their vulnerable farmers and industries by choosing their own trade policies. Trade Justice would allow developing countries to have the opportunity to work their way out of poverty.

Kevin McCullough
Global Campaigner for Special Initiatives, Christian Aid

Christian Aid works in 50 countries with some of the world's poorest communities where the need is greatest, regardless of race or religion. It campaigns in the UK and Ireland for an end to the unjust rules governing international trade. For more information on Christian Aid's Trade Justice campaign visit www.christianaid.org.uk.

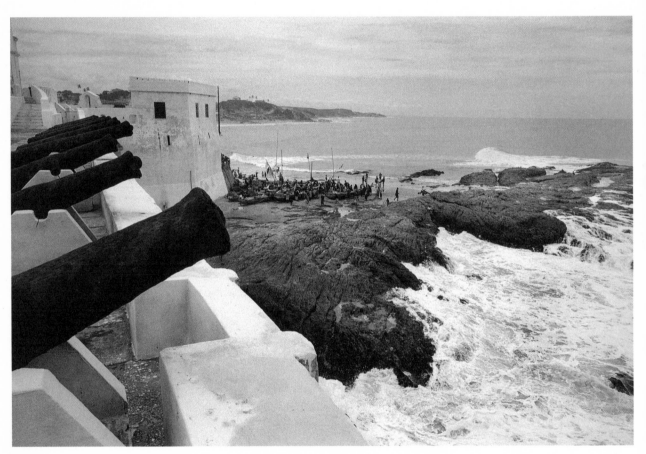

Built in the 17th century, Cape Coast Castle in Ghana was the largest trading post of the British slave trade in West Africa for more than a century.

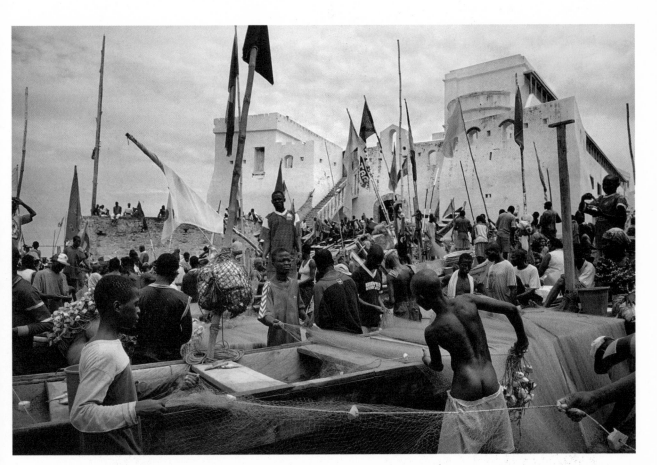

Cape Coast Castle is the backdrop for a thriving local fishing industry.

Advertising for Italian tomato products dominates local markets.

Imported tinned tomatoes sold at Makola market in the capital Accra displace locally produced tomatoes, forcing many farmers out of business.

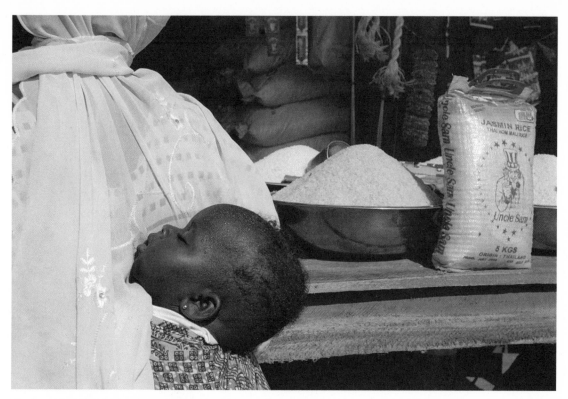

Cheap subsidised rice from the United States floods Ghanaian markets, leaving local rice farmers unable to compete.

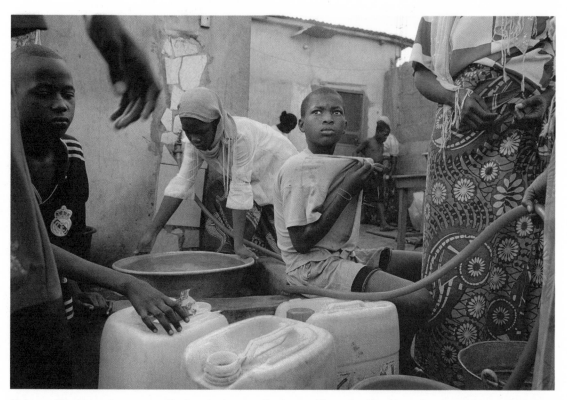

Water collection at a community tap in inner-city Accra. The privatisation of water has meant higher prices and limited availability for poor communities.

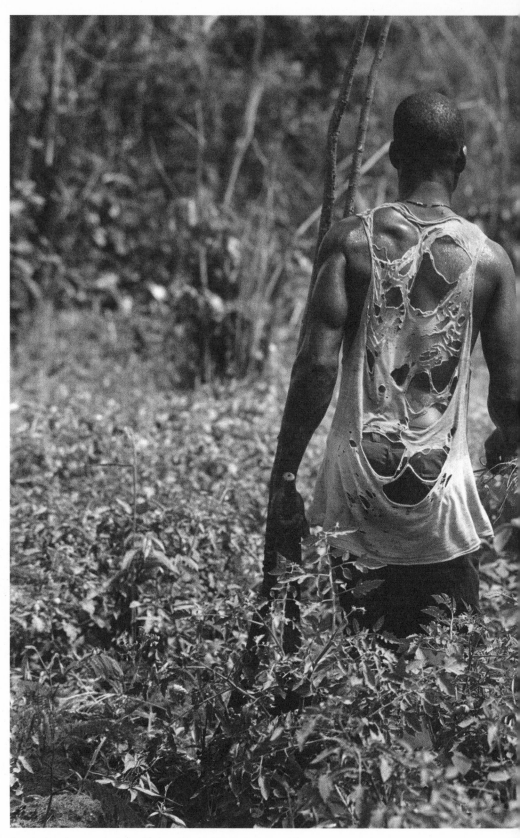

Ghanaian farmers struggle to make a decent living growing tomatoes.

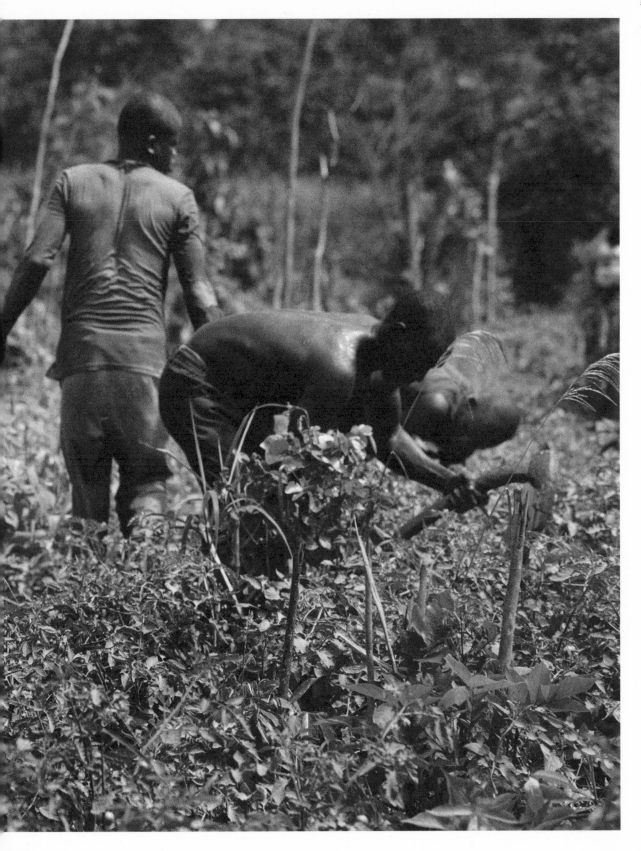

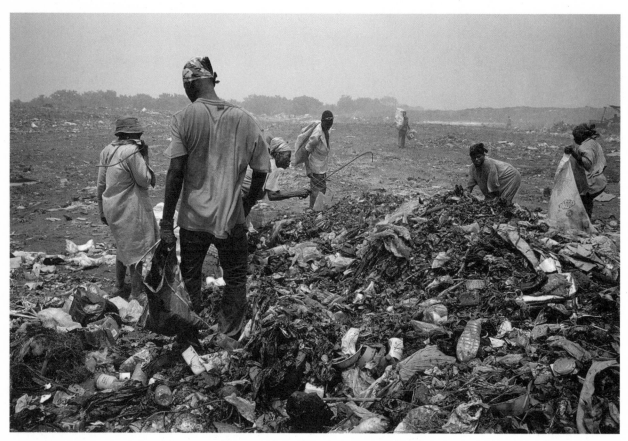

Risking their health, people scavenge amongst the rubbish dumps of Accra in a desperate search for things they can sell to make some money.

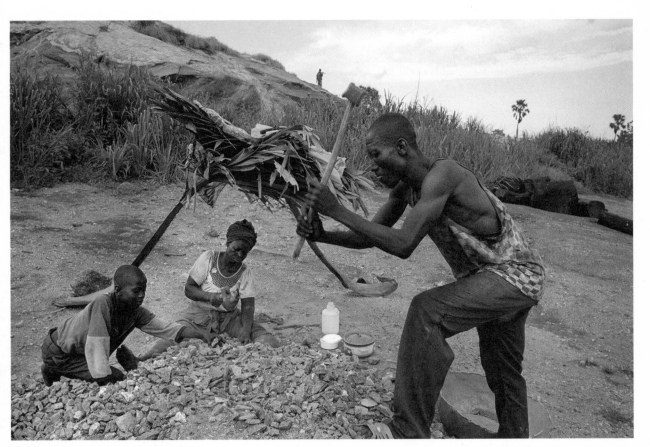

Now unable to make a decent living farming, Fatti Sawla (centre) sits breaking rocks into small stones. 'It is hard work. I do this to earn my daily bread.'

Women, many with children strapped to their backs, toil in the sweltering heat carrying heavy rocks at a quarry in the Brong Ahafo region of north west Ghana.

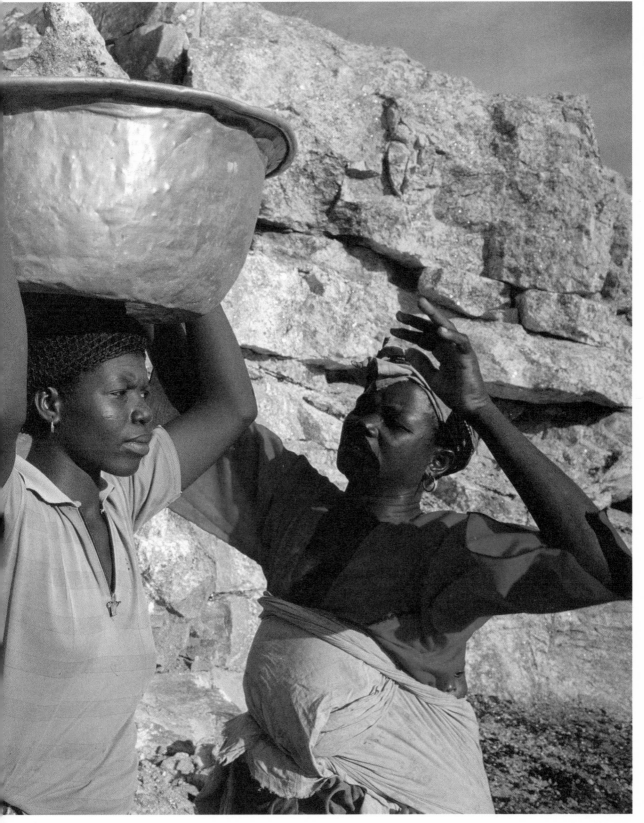

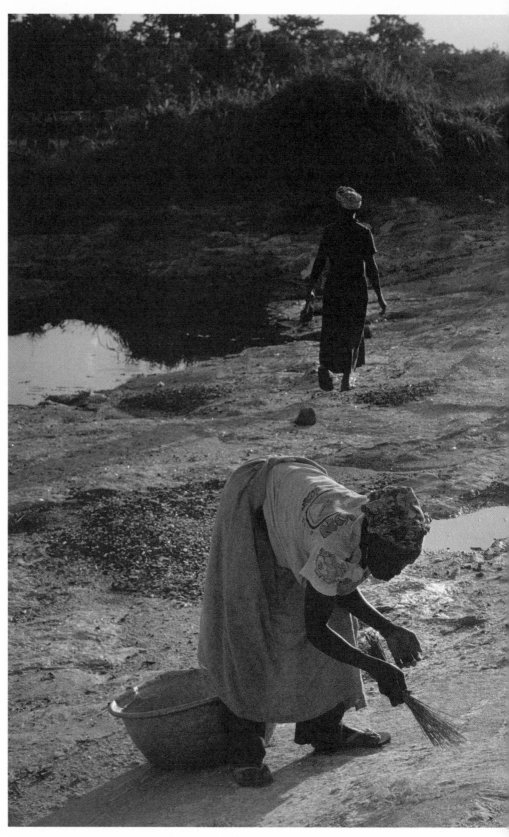

For 12 hours of back-breaking labour, these workers earn just $2 a day.

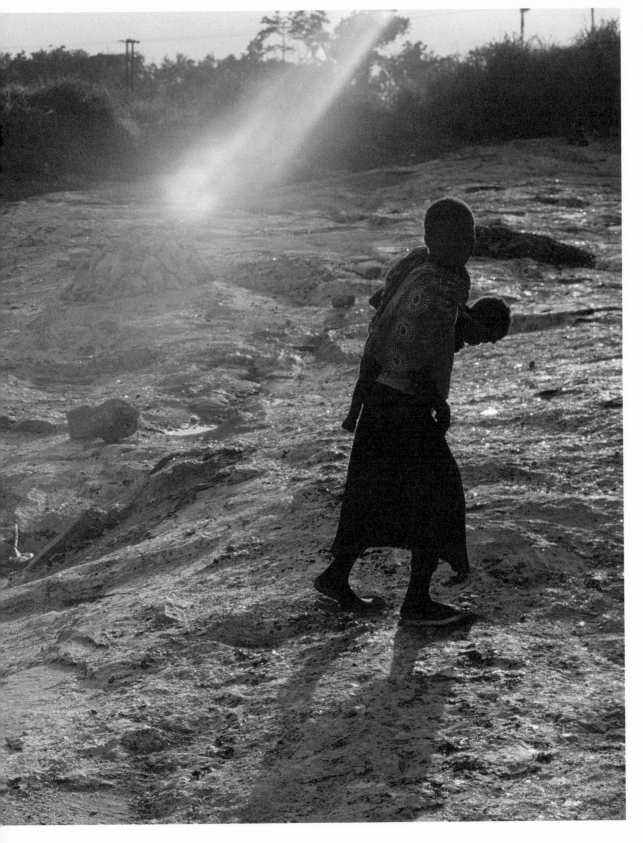

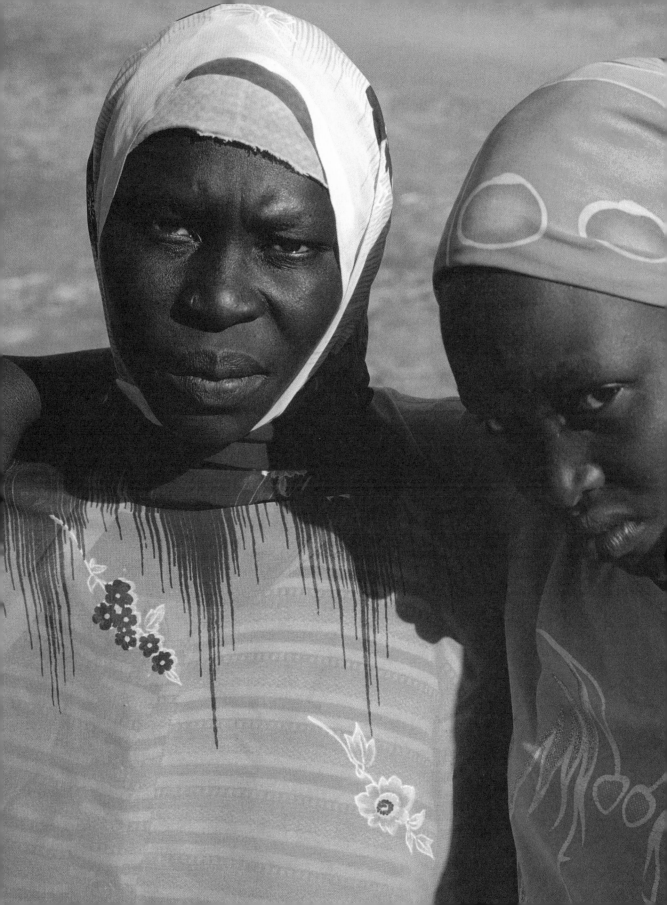

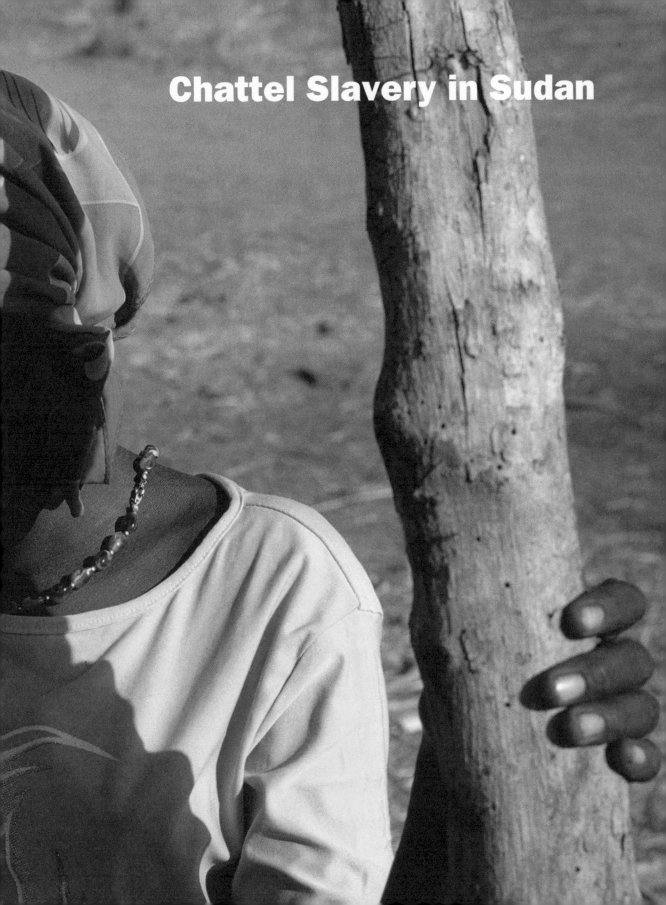

Chattel Slavery in Sudan

Stuart Franklin

Chattel Slavery in Sudan

Chattel slavery has existed in Sudan for hundreds of years. Although abolished during the nineteenth century, it continues today following an upsurge during the second Sudanese civil war (1983–2005). Sudanese militia and Baggara tribesmen from the north, armed during the war, conduct raids into southern Sudan, capturing and enslaving women and children.

In January 2007, I interviewed and photographed about 20 ex-slaves living in the region of Bahr El Ghazal, near the border with Darfur. These people are the lucky ones who have either escaped or been redeemed under an initiative by the Sudanese justice ministry. However, there are about 10,000 southern Sudanese still living in slavery in Darfur, Kordofan and as far away as Libya, who have very little hope of freedom during their lifetime, and who will never see their families again.

To say these people are lucky is only applicable to their escape. As slaves they endured atrocious conditions. They were teased and beaten, frequently tortured and maimed, and sometimes threatened with murder for a minor offence such as losing some goats or a camel. One boy I photographed and interviewed had been crucified – nailed to a tree – for such an offence. Another had his arm cut off with a machete for refusing to look after the cattle.

All slaves in Sudan are coerced into Islam and fed left-over food. The women are habitually raped or forced into co-habitation and all rights are denied. The spate of recent redemptions (the paying of cash to slave-owners in exchange for a slave's release) has led to further abductions and to the capturing of slaves as a business, since the slave masters are paid 2,000–3,000 Sudanese dinars ($960–1,400) per slave at the time of redemption.

These photographs, with the accompanying testimonials, bring some light to the hidden and horrifying human rights violations that continue, as a matter of course, every day in Sudan.

Stuart Franklin

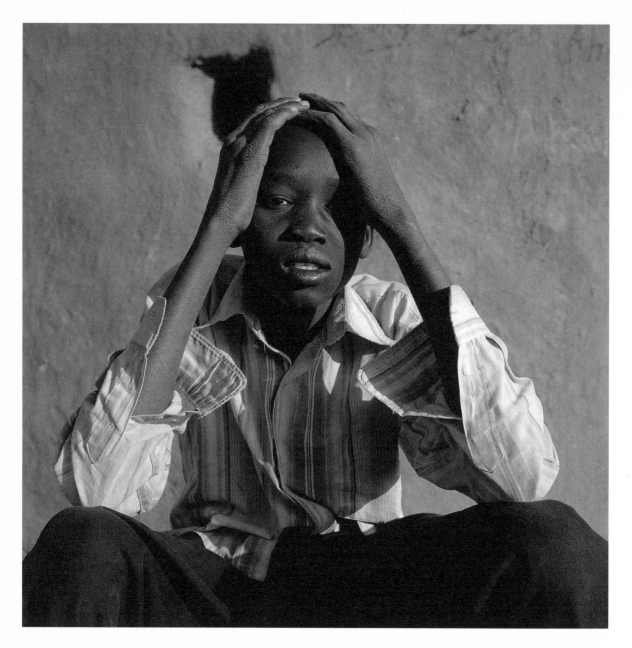

WOL DENG
Marail Bai, Southern Sudan

'The Arabs were not fair to me, they beat me every day and one day they injected me in the left leg to paralyse me to stop me escaping.'

Wol Deng was captured when he was very young. During his time as a slave, the slave master's children teased him, called him names and fought with him. Eventually he escaped – he sneaked out of the farm to a nearby village where he worked as an unpaid dishwasher, just for food. He doesn't know where he's from, nor does he know his parents.

He was redeemed by the Committee for the Eradication of Abduction of Women and Children (CEAWC).

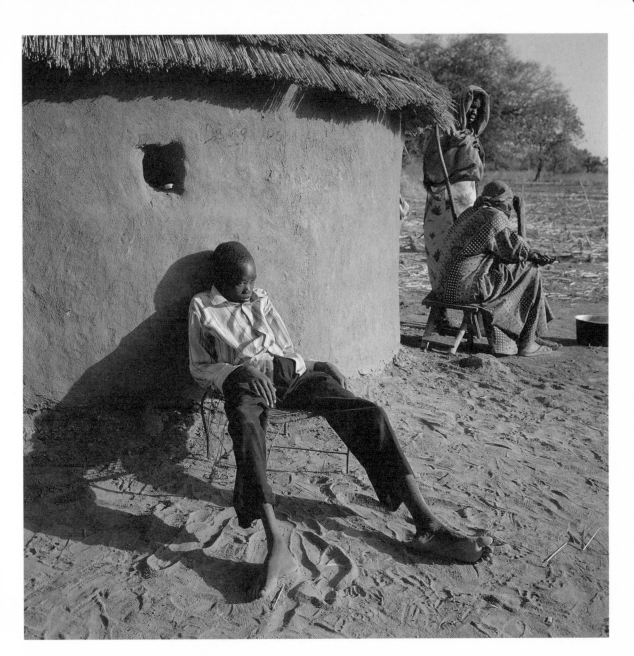

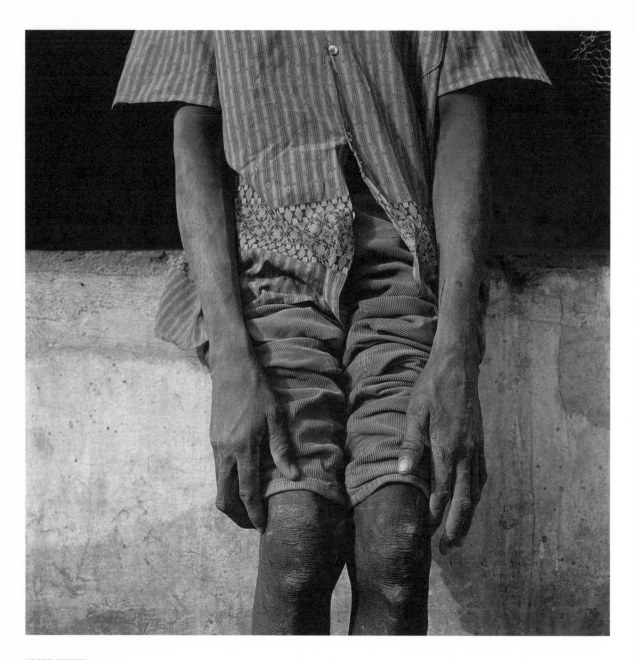

JOSEF (YAFFR)
Aweil, Southern Sudan

Josef is a very traumatised boy of about 17. He was captured as a young child by the *murahaleen* in southern Sudan and taken by horseback to Am Dreif in Darfur where he was enslaved by Arabs. He was treated badly, fed only the leftovers from the plates of his masters and beaten regularly. On one occasion, after losing a camel that was later found, he was crucified to a tree with nails hammered through his knees, his hands were tied, and he was tortured. The scars of the entry and exit points of the nails are still visible behind his kneecaps. He tried to escape once when the family took him to Wara Was. A fight occurred when a bystander asked Josef's master to release him, and during the melée Josef tried to run off, but he failed to get away. His master then asked him, 'which is better, to kill you or to take you back?', to which Josef replied, 'It will be better for you to kill me if you don't release me.' Josef eventually escaped in 2000. Today, he limps, speaks with a stammer and lives in a home in Aweil with another severely traumatised ex-slave. Both have been fostered.

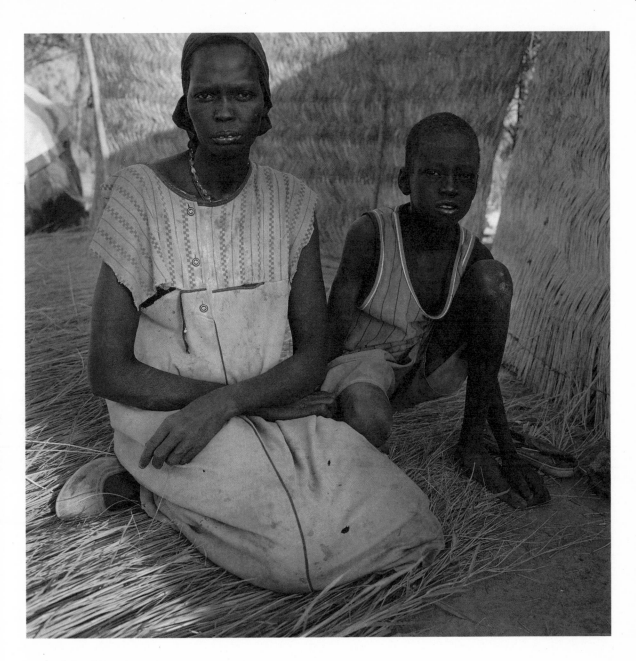

ATHIAN NHIAL WOL (left)
Nyamlell, Southern Sudan

Athian was taken into slavery in 1988 and redeemed by CEAWC. She was mistreated by her Arab masters who raped her, was fed only leftovers and was made to convert to Islam. She was eventually forced to live as a concubine to her slave master. While in the north, she had five children, three of whom died. She has a scar on her arm from her beatings and says, 'I was beaten whenever I was assigned to do something and failed to accomplish it at the time mentioned.' She did meet other slaves who escaped before she was redeemed, but she failed to escape. Today, she lives in a camp outside Nyamlell for internally displaced people (IDPs). She faces the serious problem of not being able to find enough food to eat and does not feel strong enough to plant crops. She is happy to be free and is not worried about being recaptured.

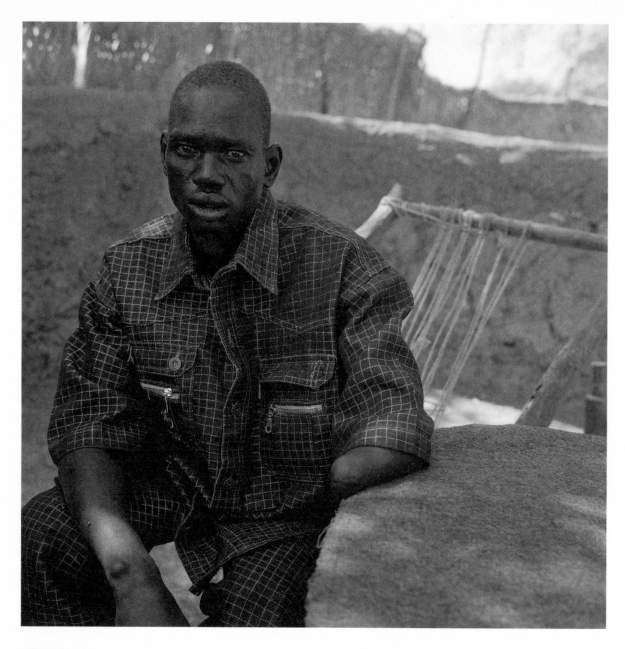

DENG DENG AKOL
Nyamlell, Southern Sudan

Deng was born in Wed Weil. In 1998, he was captured
by Baggara Arabs, made a slave and taken to El
Geneina. He was a slave for two years and was beaten
when he refused to look after cattle. In one incident,
Deng had his arm cut off with a panga knife by the
slave masters while wrestling with them. During
this fight they also cut his back and left him
for dead. He escaped slavery when bystanders
intervened; he was taken to hospital, from where
he later sneaked out. According to Deng, there are
a lot of people still left in slavery in that area.

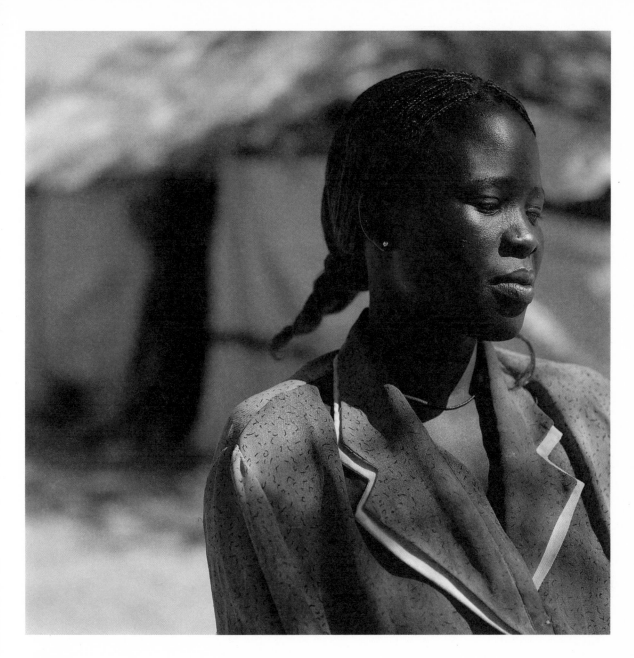

ABUK DUT
Marial Bai, Southern Sudan

Abuk was captured in Marial Bai in a village called Kwach. 'There was an attack in Aichoro. They captured me and took me to a village that few south Sudanese have been taken to before. This happened in 1985.' Abuk was redeemed in 2004 by CEAWC. Abuk spent about 19 years in the same village with the same master. They used her to look after cattle and babysit the children. She had two children with the slave master, a boy and girl, but the boy died. The slave master, who is the same age as her father, didn't mistreat her, but turned her into one of his four wives – the others wives were Arab. Last year, the slave master went to her village to try to get her back, but her father was not around and the villagers wouldn't let her go. 'I just feel good to be back at home where there is no discrimination and to be free … This is the place I am from and I feel free and happy to be here.' She was held in Saladira, Darfur.

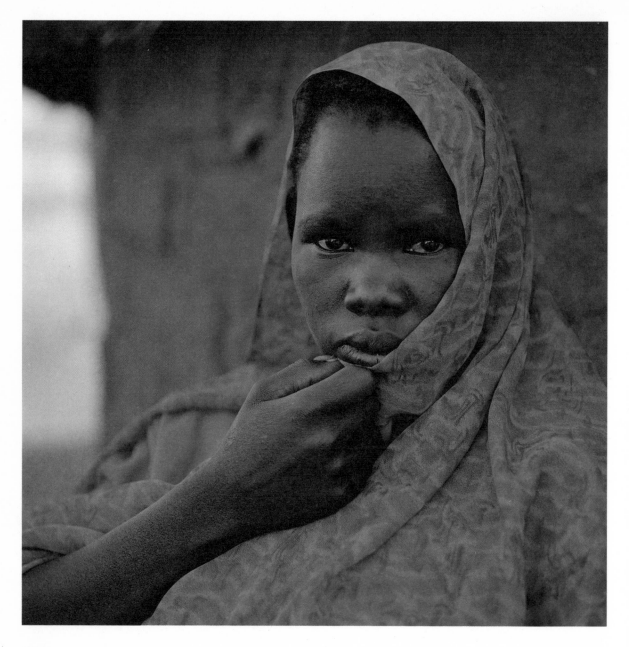

NYUOT
Nyamlell, Southern Sudan

Nyuot was taken into slavery in Thaan with her
mother when she was about four or five years old.
She was raped several times while a slave and was
beaten repeatedly by the entire slave-owning family.
She has one child with her Arab master. In March
2006, she was redeemed by CEAWC. Nyuot does not
know where her parents are now and speaks almost
no Dinka – only Arabic. She dreams of the opportunity
to have some education.

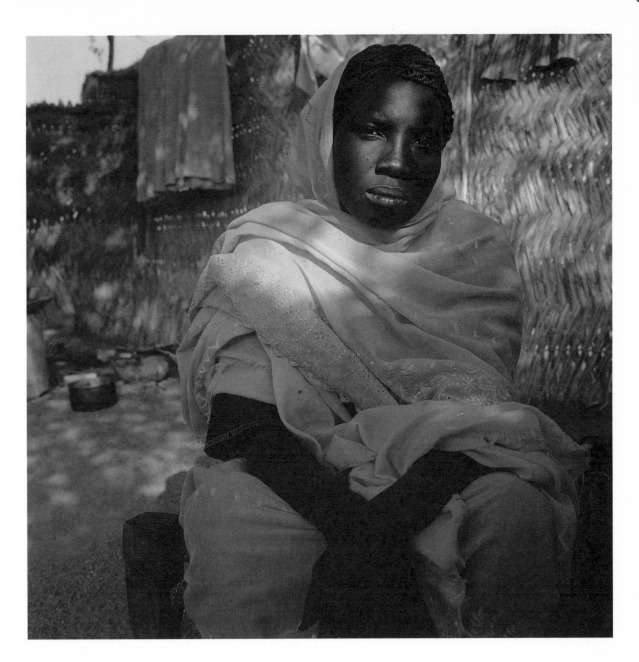

ACOK DENG

Acok Deng's mother was a slave and she was born
into slavery. While enslaved, her mother was shot
by her Arab master. Her aunt was also slaughtered.
Acok was redeemed by CEAWC in 2003.

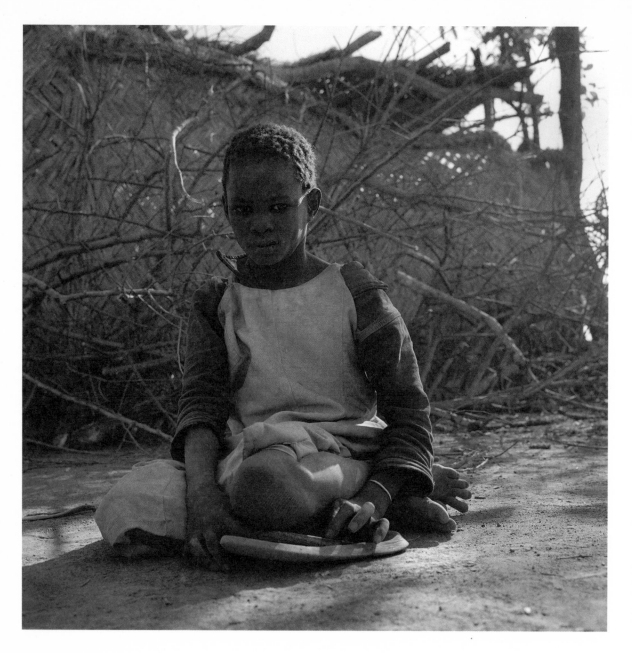

ZENAB
Nyamlell, Southern Sudan

Zenab was born into slavery to her mother Ahok
who had been forcibly taken into slavery in 1988.
Despite being the daughter of the slave master, Zenab
was not regarded as a member of his family but
treated like her mother and beaten by her father.

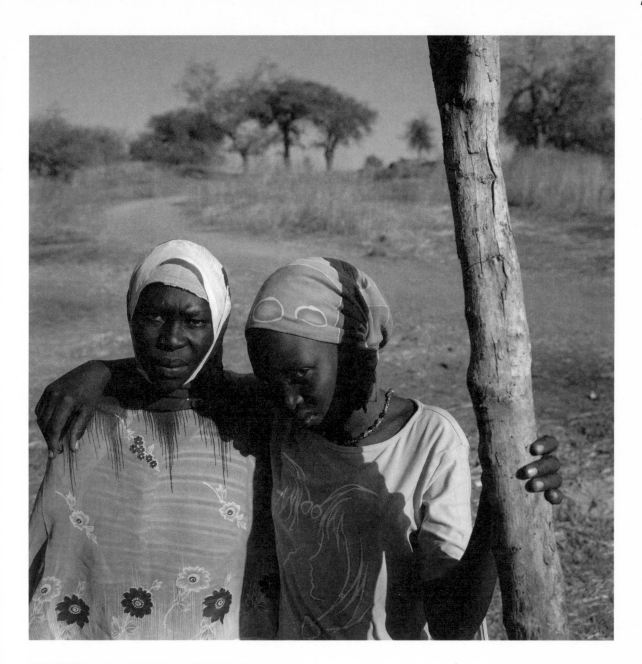

ATAK HAMEDA (left) with MASTOORA AHMED (right)
Nyamlell, Southern Sudan

Atak was captured in 1994 and lived as a concubine
to an Arab slave master until she was redeemed in
2005 by CEAWC, together with her daughter, Mastoora.

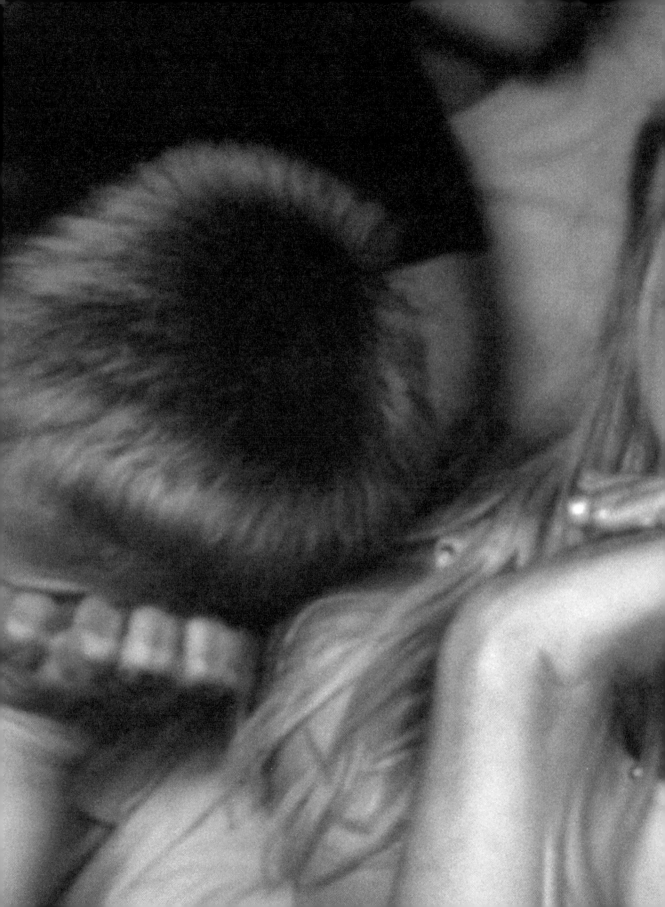

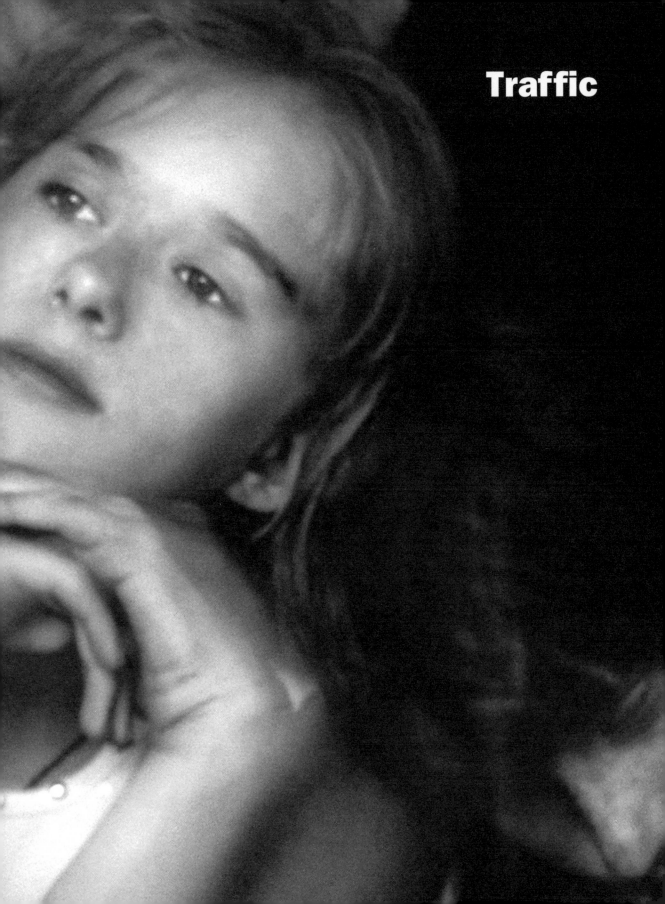

Traffic

Jim Goldberg

Traffic

28 February 2007

One week ago:

I'm in the waiting room of Istanbul airport, tired, with too much time before my plane leaves for Kiev. I snap out of my daze and notice a man and woman pacing back and forth, not talking. He is Turkish, maybe 55 or 60, a bit short and squat, has a large gold chain around his neck and is wearing dark sunglasses.

The woman with him is younger, maybe 35? She is tall, with streaks of blonde highlights on her brown hair. My guess is that she is Ukrainian. She is wearing trendy, probably knock-off, over-sized sunglasses. She is over the top — with all kinds of glitzy embroidery on the ass of her jeans. I notice a scar running down the side of her face. She looks like she hasn't smiled in a long time.

A voice announces the boarding of our plane. The man tells the woman something. She listens, nods her head and then says goodbye. She enters the plane.

Today, one week later:

I am at the Kiev airport cafeteria, filling time, eating a cold sandwich, waiting for my four-hour-delayed plane home via Istanbul.

The woman with the scar and the embroidery on her jeans is also there. She is carrying lots of packages and a big stuffed animal. She is with a younger woman — blonde, pretty, wearing plain jeans and a purple sweater with flowery decorations all over it. She is wearing fake leather ankle boots.

We get on the plane and I end up sitting in the same row, across the aisle from them.

I notice the younger woman. She is excited about sitting next to the window and looks out at the land below. I suppose this must be her first time on a plane. I smile at the thought.

We land in Istanbul and the younger woman has become noticeably nervous. The tall glitzy woman's hand is on her shoulder as if to hold her down. She guides the young woman off of the plane.

The young blonde woman becomes increasingly agitated. The tall woman tries to calm her down.

They are directly in front of me in the customs line. The woman with the scar gives instructions in Russian to the blonde. It is their turn to step up to the customs officer. The tall woman hands her passport to the agent and all seems fine. She then passes the pretty blonde woman's passport to the agent and says something. He is not listening to her, and instructs her to step back, behind the yellow line. The young pretty blonde woman is squirming.

The agent asks her questions, she shakes her head back and forth, saying no, becoming more flustered and distressed. The situation seems to be deteriorating quickly.

Ignoring the instructions of the customs officer, the tall woman steps across the yellow line and approaches him. She smiles broadly, and calmly takes her hand and slips him something.

He looks down, and then up, and then down again at the young woman's passport and up again to both of their faces. He smiles and waves them through.

The taller woman puts her arm around the younger girl's shoulders and laughs. They walk towards baggage claim.

I catch up with them there. Stuffed animal and overflowing packages in hand, they push their bags through to the exit point and are met there by the small Mafia-looking man and his taller 'twin' with matching gold chain.

Both men kiss the tall woman on the cheek. They look the younger woman up and down and indicate approval. The three of them are smiling – celebratory. The girl is obviously uncomfortable with this kind of attention. She wraps her arms around her body.

Is the girl scared? Is she in over her head?

I look around to see if anyone else is noticing what is going on.

I hear my name announced over the loudspeaker to report to the ticket counter. My stand-by seat must have come through...

Jim Goldberg

Translations

p. 77
Larysa, 39 years old.
I was a dancer and sold to a man who was a terrorist – he held a gun to my head.
Somehow I was rescued and escaped.
But the fear has left scars on my heart (and I will never be the same).

p. 82
My name is Victor. I'm married and I am from [Ternopil] Ukraine. In 1999, my son was born and we had no place to live. My salary was $12 per month. I thought I had no choice but to go abroad. I was taken to a factory in Germany by a stranger who promised me [a good salary] $2,500 per month.
Instead, they took my passport and guards watched my every move. If I protested, I was kicked and punched.
I was scared. I realised I'd been sold.
NO ONE HELPED ME.
I prayed everyday to be back home.
One night I jumped a fence and escaped.
I am OK now and work in construction.
My dream is to go to America and live in Miami where it is warm.

p. 83
I am Nina, age 29.
My dream was to be a 'belly dancer', see the world, buy a house, and have a good life.
But they lied to me and sold me to Turkey.
There, I was treated like trash and forced into intimacy, to be a prostitute (8-10 men a day with no pay).
I have learned the lesson not to trust people.

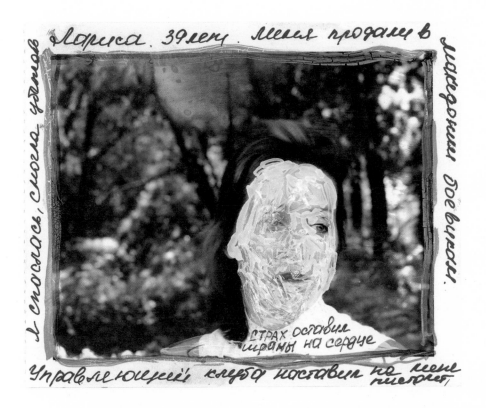

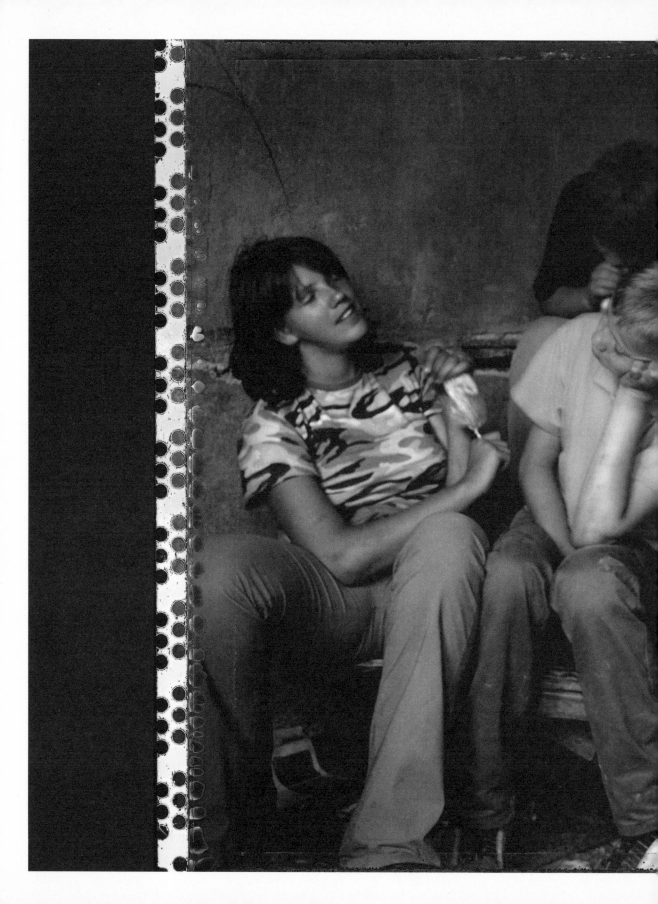

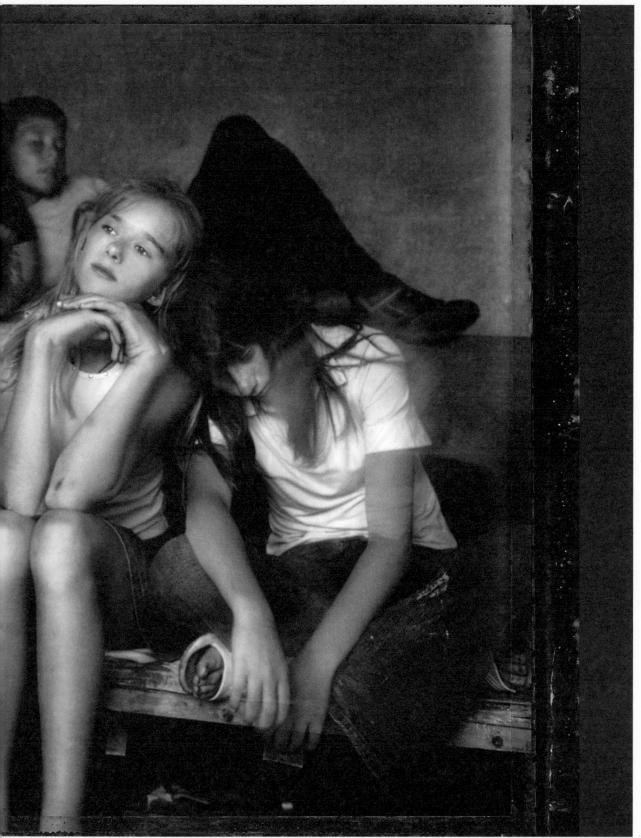

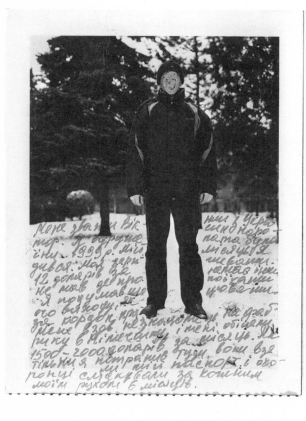

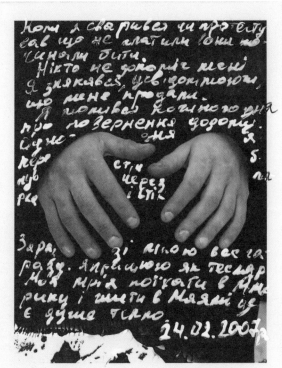

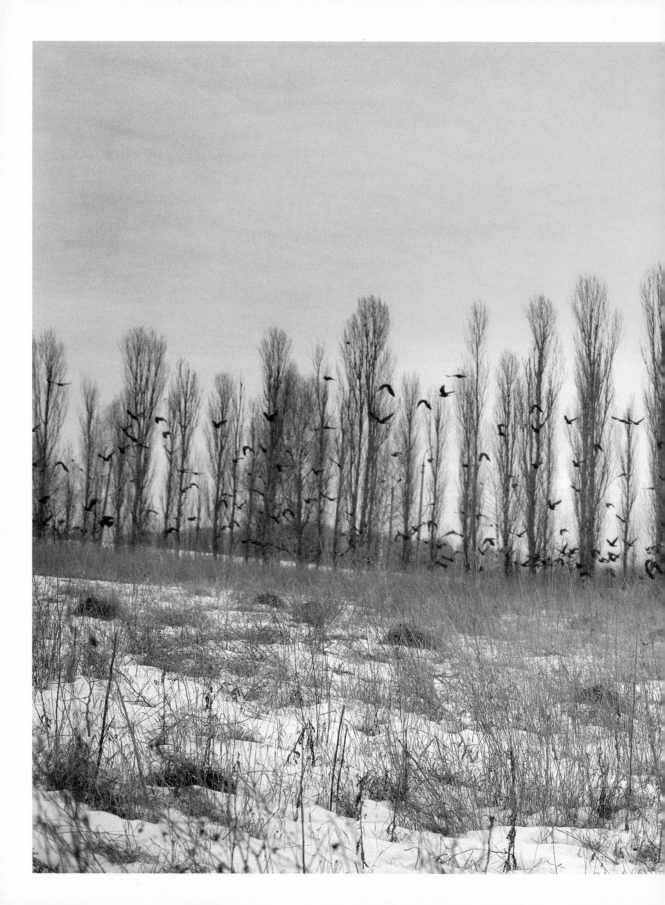

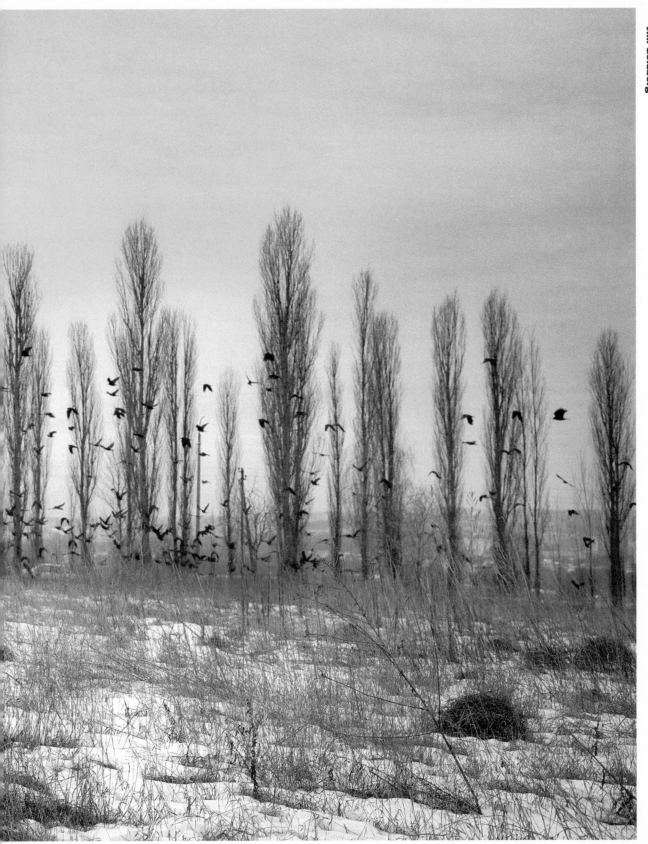

Моє життя
хворобливе зараз
через те, що
вони зробили
зі мною

MY LIFE IS

SICK BECAUSE

of wHAT

THEY DiD

TO ME

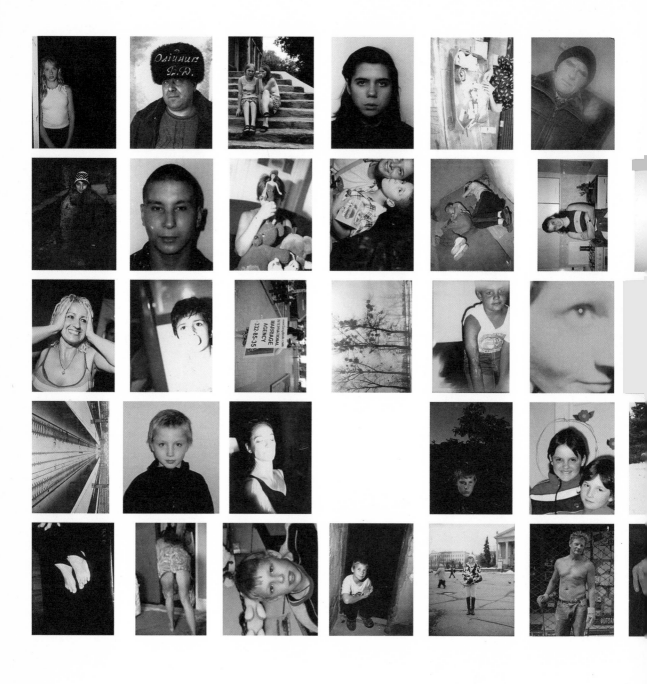

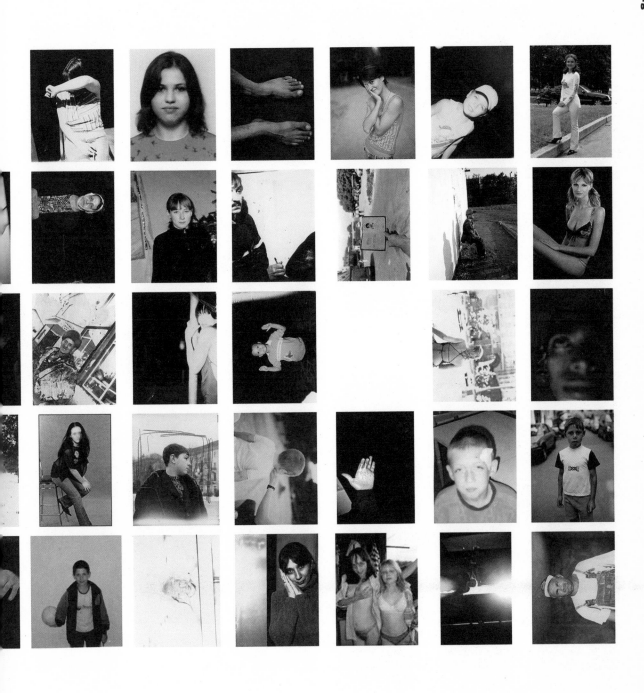

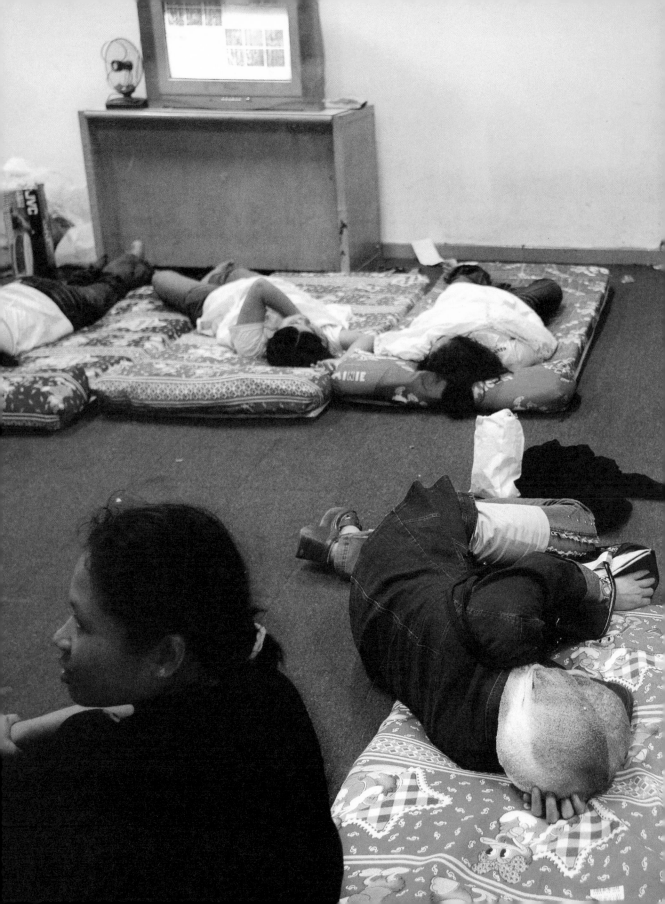

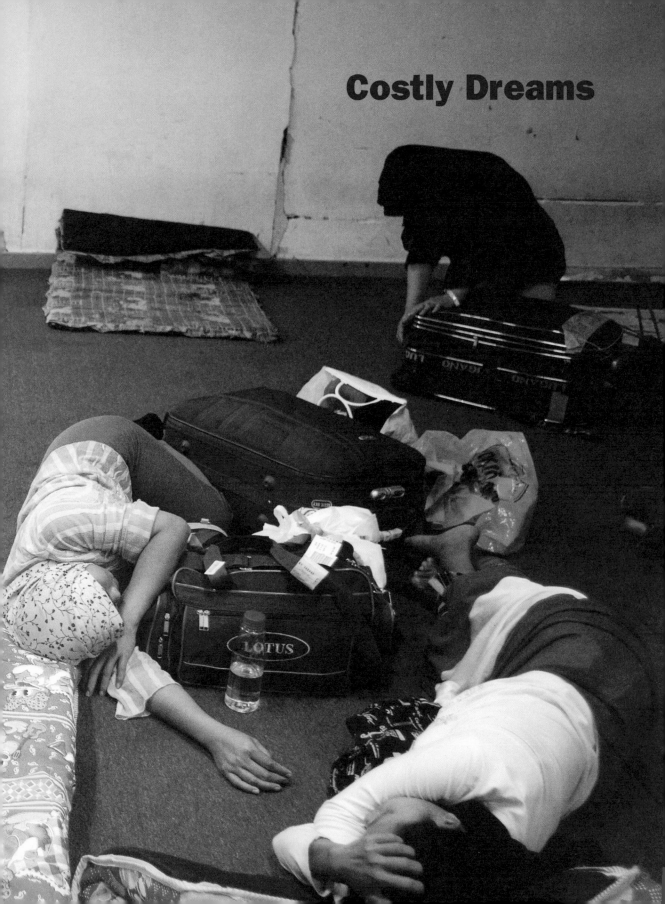

Costly Dreams

Susan Meiselas

Costly Dreams
Indonesian Domestic Workers in Singapore

Worldwide, millions of women and girls turn to domestic work as one of the few options available to provide for themselves and their families. Their dreams of earning money to educate their children or build a new house often come with grave risks and costs.

I focused on Indonesian maids migrating to Singapore as live-in domestic workers. The narrative dissects the process, to portray how it operates and how people feel being caught within it, to visualise what is most often invisible and perceived as legitimate.

The women typically sign two-year contracts and must forego the first eight to ten months of their salaries to repay huge recruitment fees. Their contracts often provide only one day off per month and a monthly wage of $200.

Some women find ethical labour recruiters and good employers who pay them regularly and treat them well. They are the success stories, coming home laden with gifts and cash.

Others are not so lucky. They can be cheated by unscrupulous labour agents or exploited by their employers. Their isolation in private homes and their exclusion from standard labour protections, like a minimum wage and weekly rest days, place domestic workers at particular risk of abuse.

Often, after years away from home, they come home to unfaithful husbands or children who have grown up without them.

Migration holds many promises, but at what price?

Susan Meiselas

in collaboration with *Nisha Varia*, Human Rights Watch, for the 2006 report 'Swept Under the Rug: Abuses against Domestic Workers around the World'

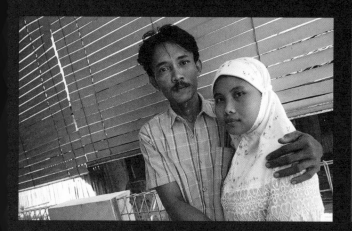

'I have heard all the info. I know that there are several maids being tortured and raped, but I pray that I will be ok and be successful.'

Suti Nining, 21-year old woman hoping to work in Malaysia who has waited in a training centre for five months. Jakarta, 18 May 2006.

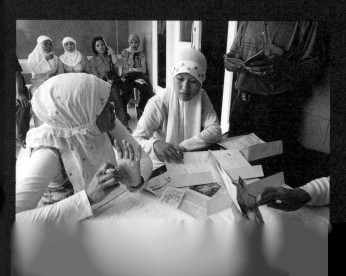

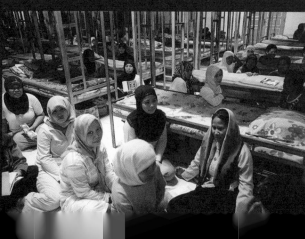

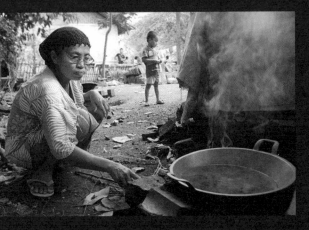

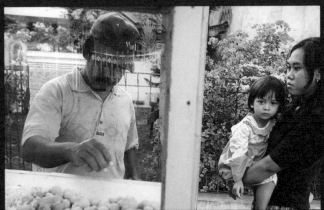

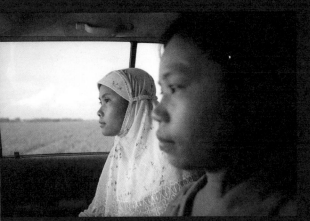

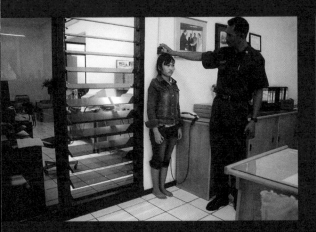

'We ask the employer what their criteria are, what their demands are. We try our best to match them. We cannot guarantee the thoughts and attitudes of the maids. We can guarantee that they know how to work.'

An employment agent in Singapore who specialises in Indonesian workers. 28 May 2006.

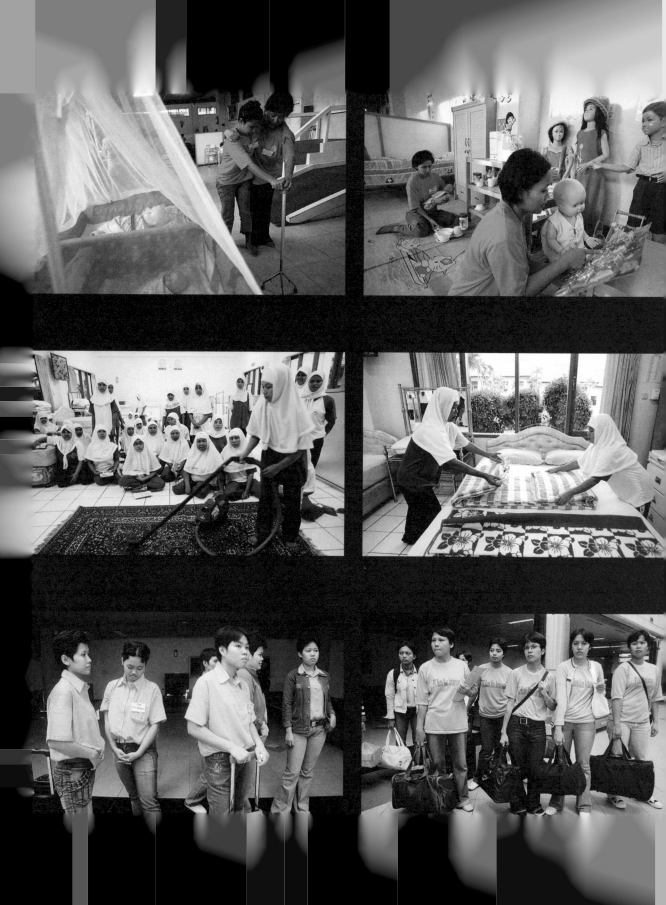

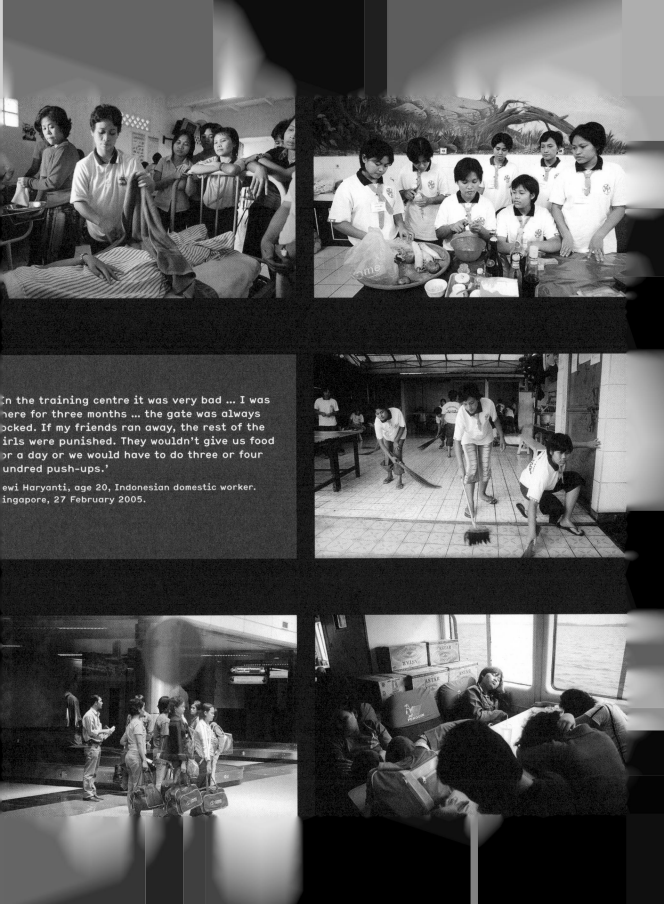

'In the training centre it was very bad ... I was here for three months ... the gate was always locked. If my friends ran away, the rest of the girls were punished. They wouldn't give us food for a day or we would have to do three or four hundred push-ups.'

Dewi Haryanti, age 20, Indonesian domestic worker. Singapore, 27 February 2005.

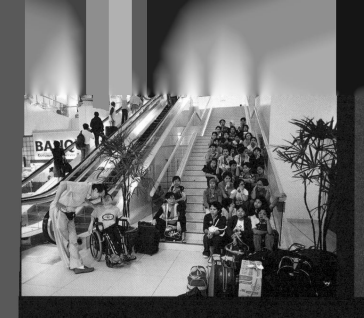

'They have no idea what to expect, except what their sub-recruiter tells them. (And they haven' been out of their own *kampung* [village]). So these girls come here and they know so little. They have no choice. Their choices are taken away from them.'

An employment agent in Singapore with more than 20 years of experience. Singapore, 26 May 2006.

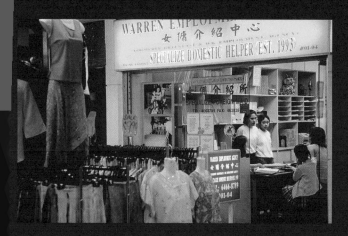

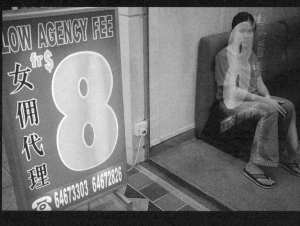

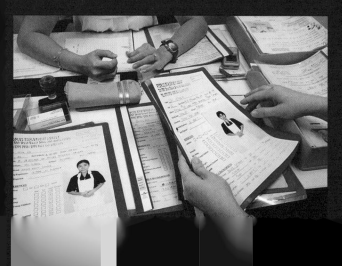

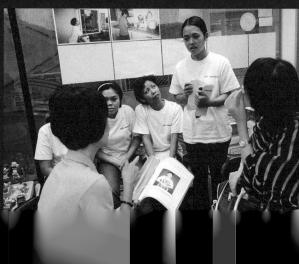

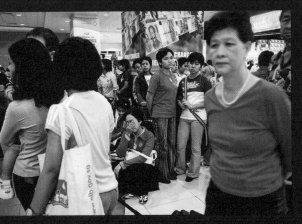
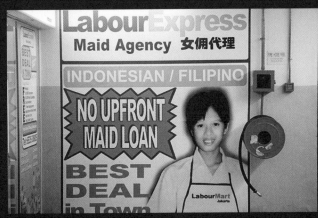

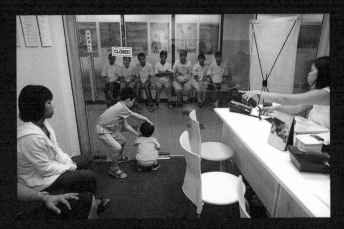

Between 1999 and 2005, at least 147 migrant domestic workers in Singapore died from jumping or falling from tall residential buildings, most due to workplace accidents or suicide. Of these, 122 were Indonesian.

Maid to Order: Ending Abuses Against Migrant Domestic Workers in Singapore, Human Rights Watch, December 2005.

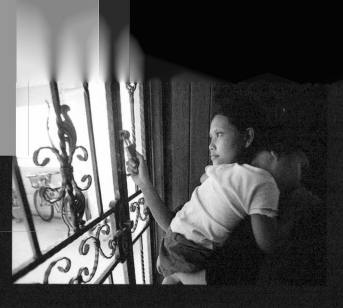

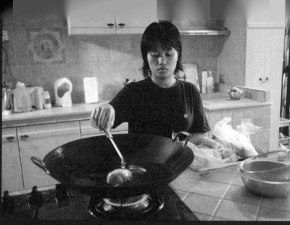

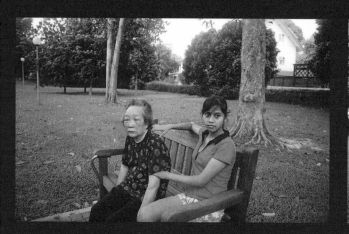

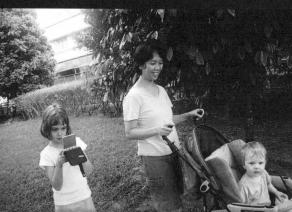

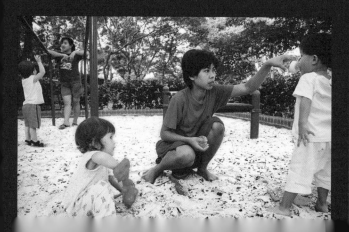

'Some of them get bad news from the campon of origin. That their husbands are not home anymore, that nobody is taking care of their children, or that their husbands get married.'

Maid to Order, Human Rights Watch, December 2005.

They would lock me inside for hours with the
baby. I was not allowed to make phone calls or
send letters to my family. I wasn't allowed to say
anything or talk to the neighbours. I had to just
keep quiet.'

ni Khadijah, age 34, Indonesian domestic worker.
Singapore, 19 February 2005.

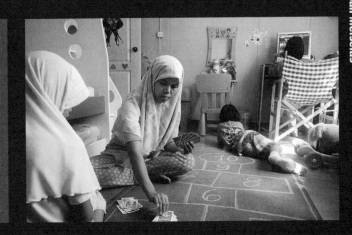

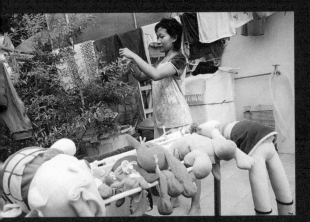

'To repay huge recruitment fees, Indonesian
workers in Singapore typically receive no
pay for the first ten months of their two-year
contracts.'

Maid to Order, Human Rights Watch, December 2005.

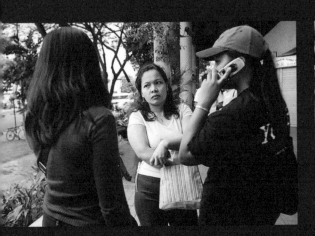

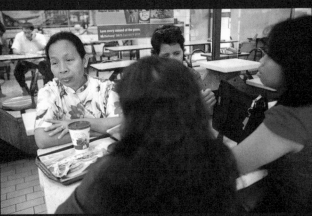

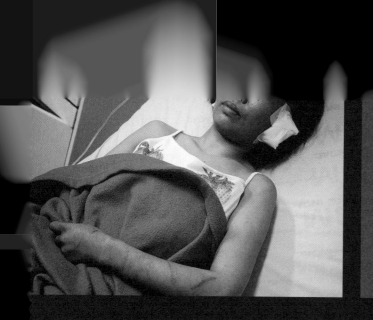

Eni is a 27-year-old woman from Central Java. She worked for eight months in Saudi Arabia without receiving a salary.

Her employer punched her and beat her repeatedly on the head, causing her to require surgery on her ears upon her return to Indonesia.

Eni's employer left multiple scars on her arms by scraping them with forks and spoons and also beat her with a cable leaving scars on her feet.

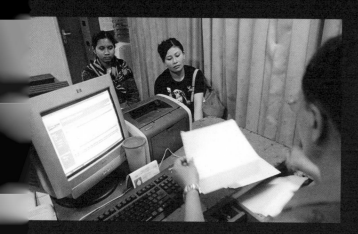

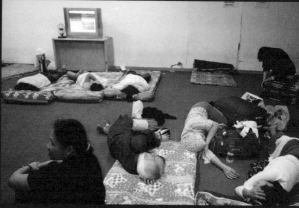

'Hopefully the money I have earned can buy me a piece of land. I hope that other migrant workers will be careful. Hopefully we will have better conditions in the future.'

Tina W., a 34-year-old woman from Central Java. Singapore, 28 February 2005.

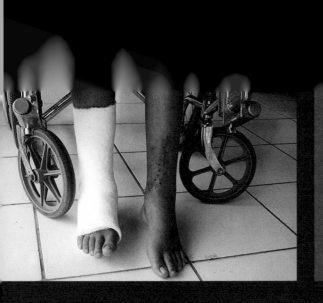

Fatima was 17 when she migrated to Saudi Arabia. When her male employer began sexually harassing her, she locked herself in the bathroom.

After a year and a half of this behaviour, the male employer approached her by surprise. He was completely naked and pushed open the door she had barricaded.

Terrified of being raped, she ran to the only escape in sight and jumped out of a third story window. Fatima required surgery for her broken leg and ankle.

'[I am so anxious that] I want to cry. What if I don't finish my contract, if I make a mistake, if I get in trouble? Then I would go back to Indonesia, and my parents, of course, would be angry with me.'

Awma R., age 23, Indonesian domestic worker en route to Singapore. Batam, 24 May 2006.

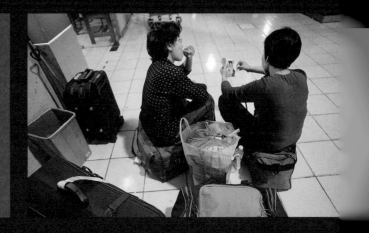

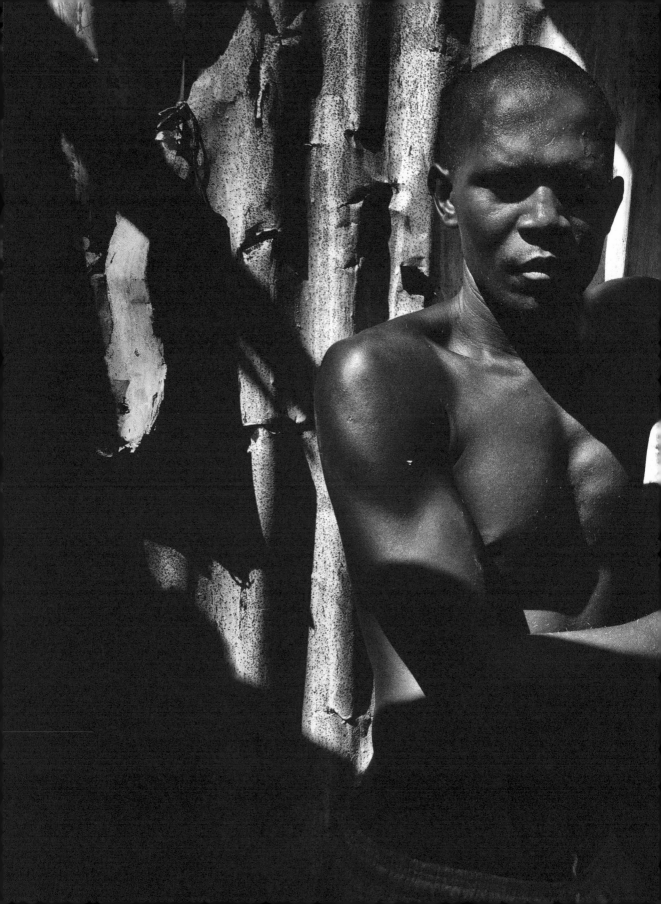

Restavek

Paolo Pellegrin

Restavek
Child Slaves in Haiti

Restavek is a Creole term ('*rester avec*', meaning 'to stay with') referring to a system of child domestic labour prevalent in Haiti, one of the most impoverished countries on earth, which is situated on the Caribbean island of Hispaniola. It is estimated that 300,000 children between four and eighteen, or one in ten of the child population, is forced into servitude in this way. These children (three-quarters of them girls) are sent by their parents, usually from rural areas, to live as domestic servants with families or adults who provide them with shelter, food and clothing in exchange for their domestic labour. Restavek children often work for 12 to 14 hours a day, washing and ironing clothes, preparing meals, fetching water, cleaning and looking after the family's children. They are rarely sent to school or allowed to play, and they are often abused, verbally, physically or sexually. In the view of the human rights organisation Anti-Slavery International, the practice of restavek 'constitutes one of the worst and most widespread manifestations of child domestic servitude to be found anywhere in the world.'

Paolo Pellegrin went to Haiti's capital, Port-au-Prince, to photograph restavek children in their everyday situations, with their masters/mistresses, carrying out typical domestic chores and showing him where they slept. He also met activists campaigning against the restavek system, attended demonstrations and made portraits of former restaveks-turned-campaigners.

Roger Malbert

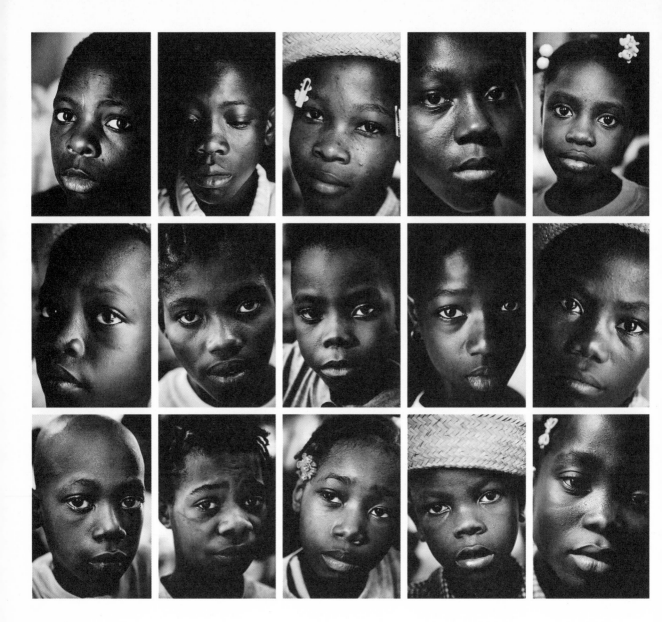

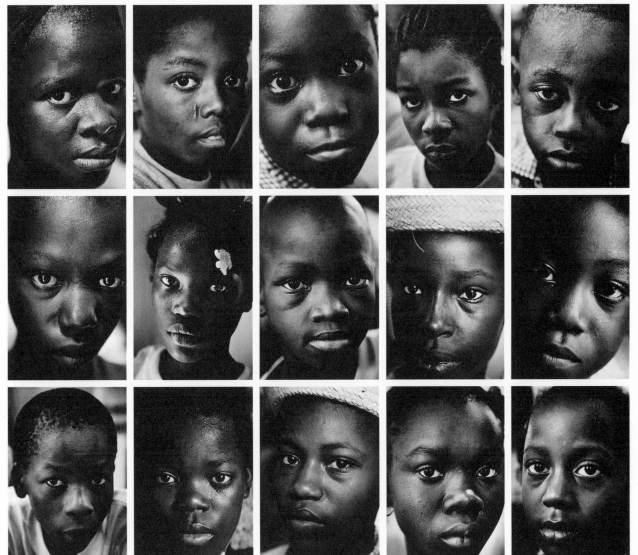

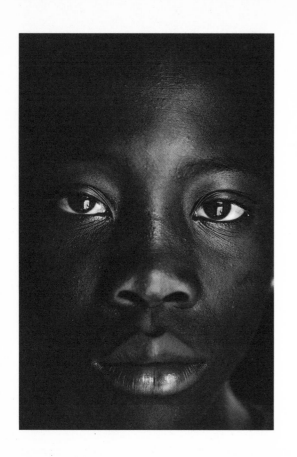
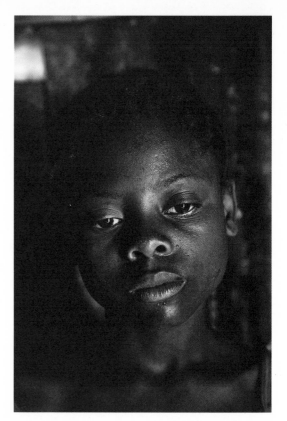
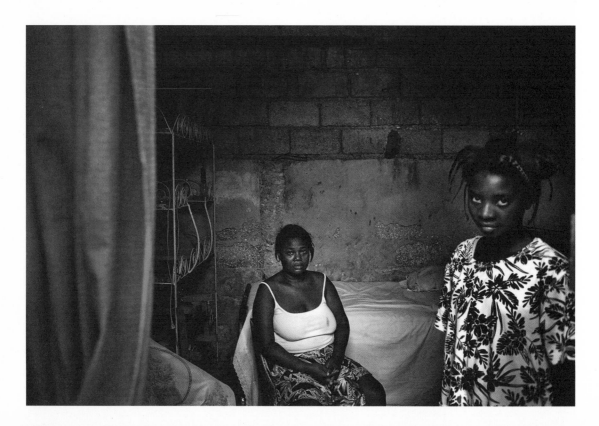

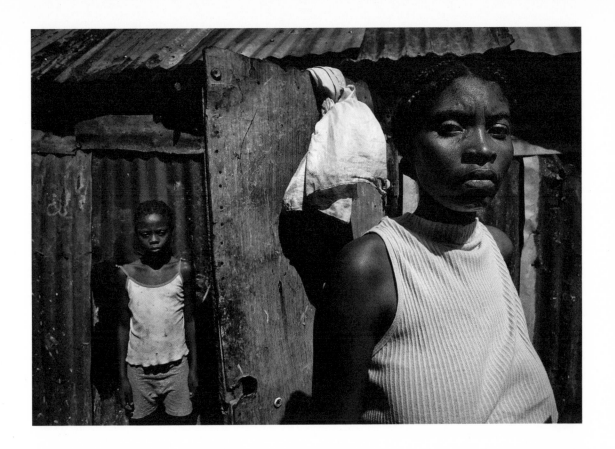

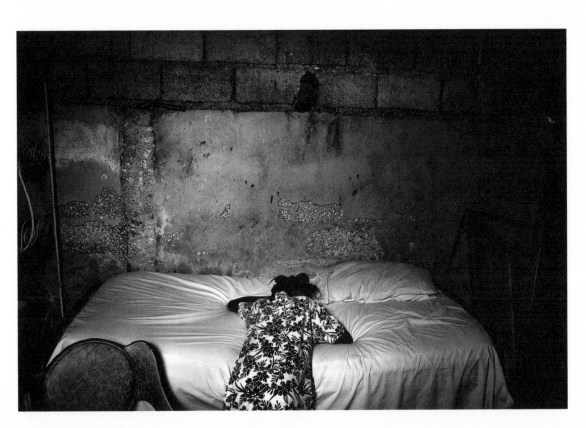

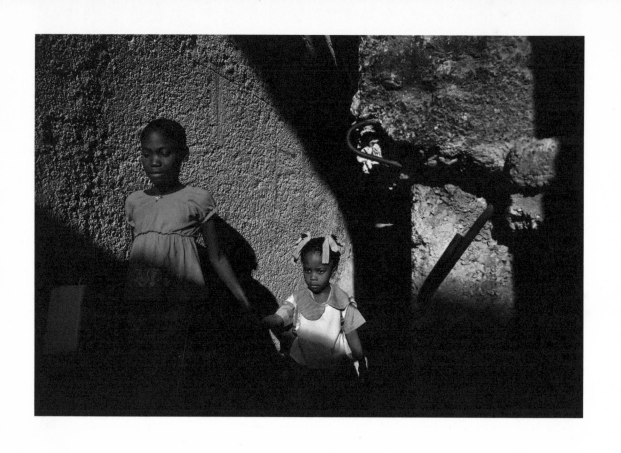

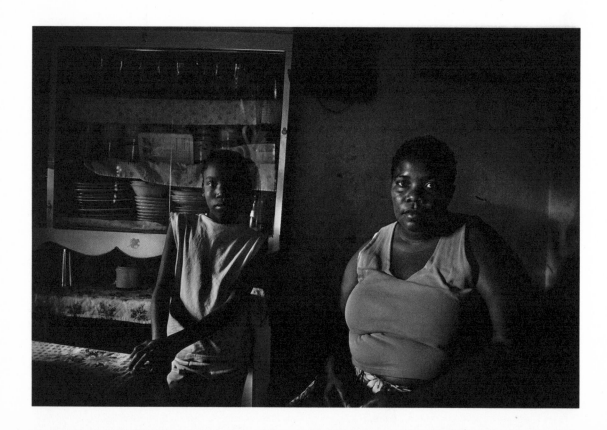

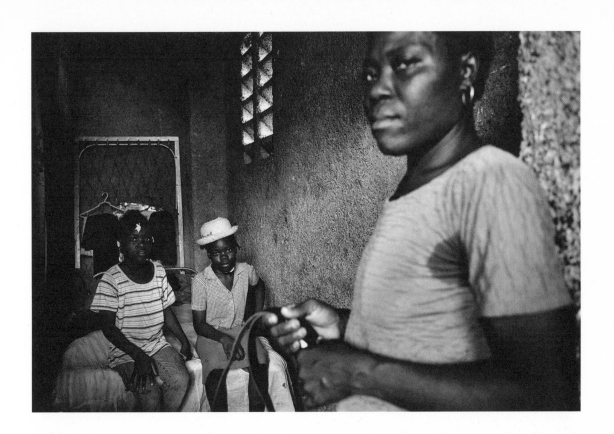

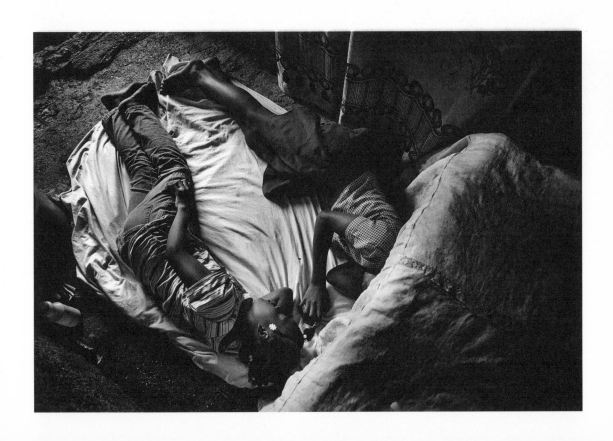

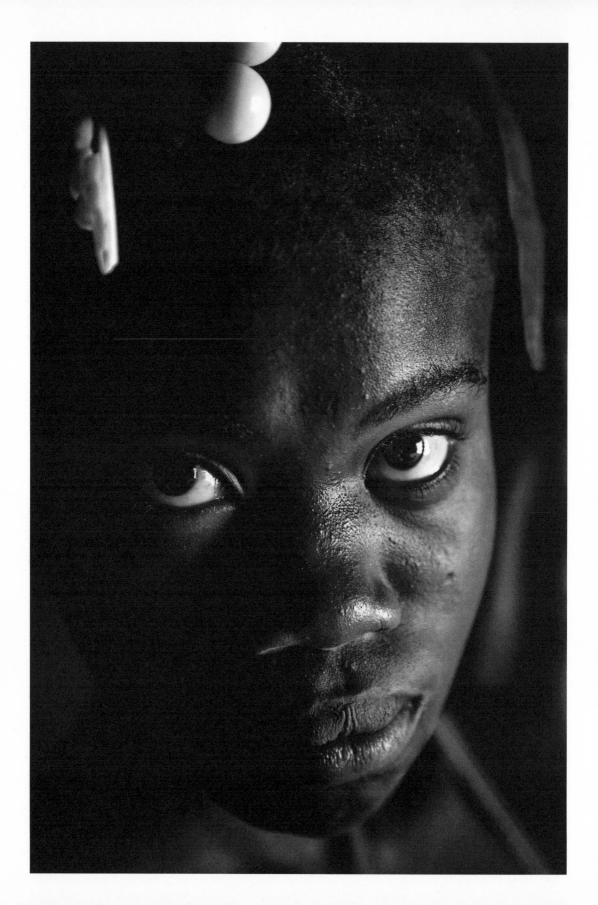

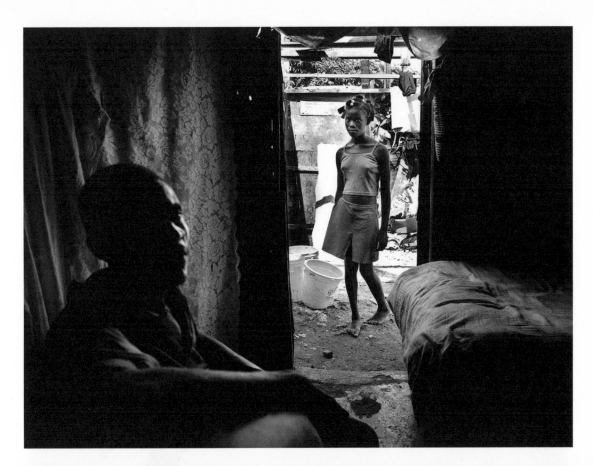

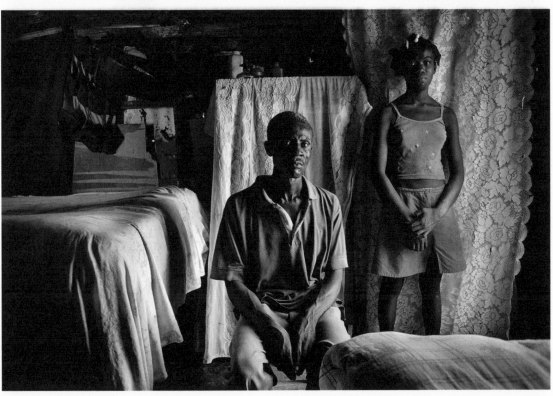

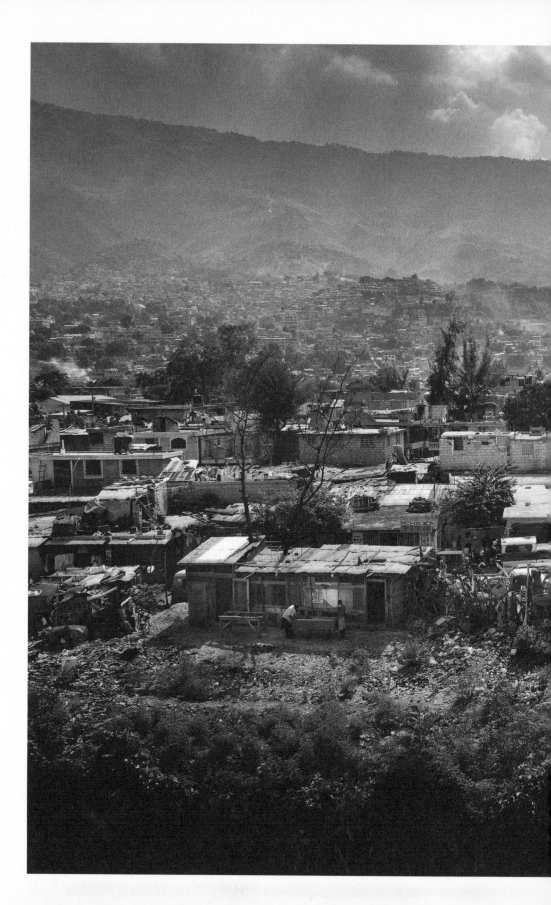

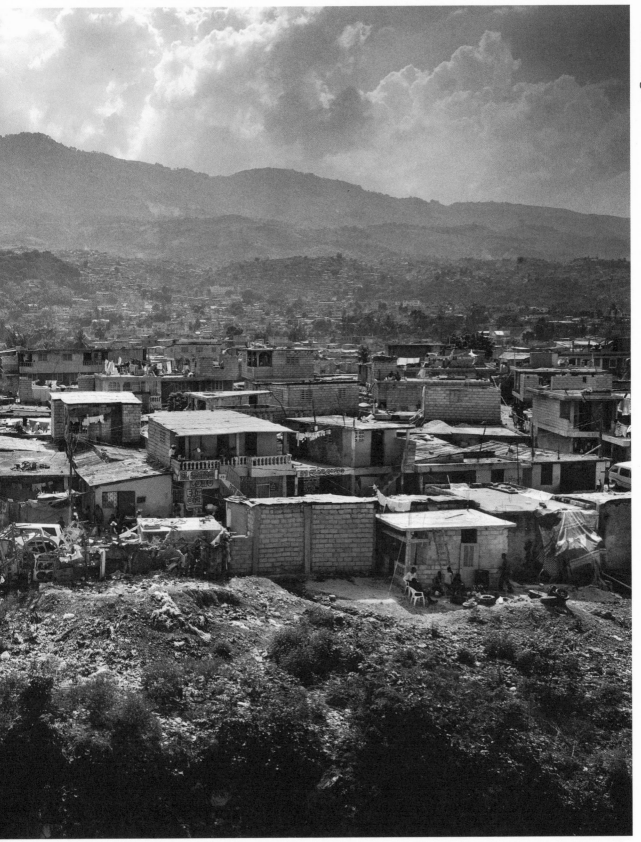

Korean 'Comfort Women'

Chris Steele-Perkins

Korean 'Comfort Women'
Japanese Wartime Sex Slaves

'Comfort Women' was the term used to disguise the use of
women as sex slaves to the Japanese military during the
Pacific (Second World) War. It happened throughout the South
Pacific region that Japan controlled, including Korea. Some
of the Korean women have been particularly courageous and
outspoken about what happened to them, and have formed a
group fighting for recognition of the crimes committed against
them and for compensation from the Japanese government. In
other countries there has not been this level of openness and
organisation. It was for this reason that I chose to work in
South Korea as I would be able to meet, photograph and talk
to some of these women as they had already stepped forward
to testify in court.

What a sacrifice that is: to stand up in public as an old
woman – having kept the traumas of your past hidden until this
time – and tell how, for years, you had been systematically
raped and abused by the troops of an invading army. Yet it
is a tribute to the support they have had in the new South
Korea that they are now generally considered with great
respect and sympathy.

We will never know how many 'Comfort Women' there were as
most are now dead, and only a few of those remaining have
been able to face publicly acknowledging what happened to
them over 50 years ago. These women are some of the oldest
surviving slaves. I wanted to include them in this project as

a reminder of slavery far removed from African history, but similar in that it was sponsored and condoned by a national government, not some criminal gang. I chose to make very simple portraits of these women and interview them, including their testimony alongside their images. This work needs no further embellishment.

Taking these photographs and conducting these interviews was an emotional experience as just about all of those who agreed to participate broke down into silent tears as they told me, through an interpreter, what had happened to them. I did not photograph this, as I wanted to photograph these women as I fundamentally saw them: strong women who had survived the most degrading atrocities unbroken and with dignity. Women I admired.

> And theirs' will ache a never-ending pain
> as rape on rape on rape remains;
> in some dark tumour of the human brain
> lies hurt again, again, again, again.
>
> What does it take to speak your deepest shame
> while all the bitter poisons of your past
> leak out in tears of rage and tears of pain
> and then speak out again, again, again?
>
> The crimes that others try to claim
> never took place; are by your strength exposed
> as lies. The rapist shall be justly blamed,
> but you still must bear that never ending pain.

Chris Steele-Perkins

Pak Okseon (b. 1924)

Pak Okseon comes from a poor family of eight children.
She was forced into sex slavery in Manchuria after
going to China with friends to try to find work in
a textile plant. She attempted suicide a number of
times, but finally escaped after four years of slavery
when the sex station was bombed. She is still
scared of Japanese people and has had no financial
compensation from the Japanese government.

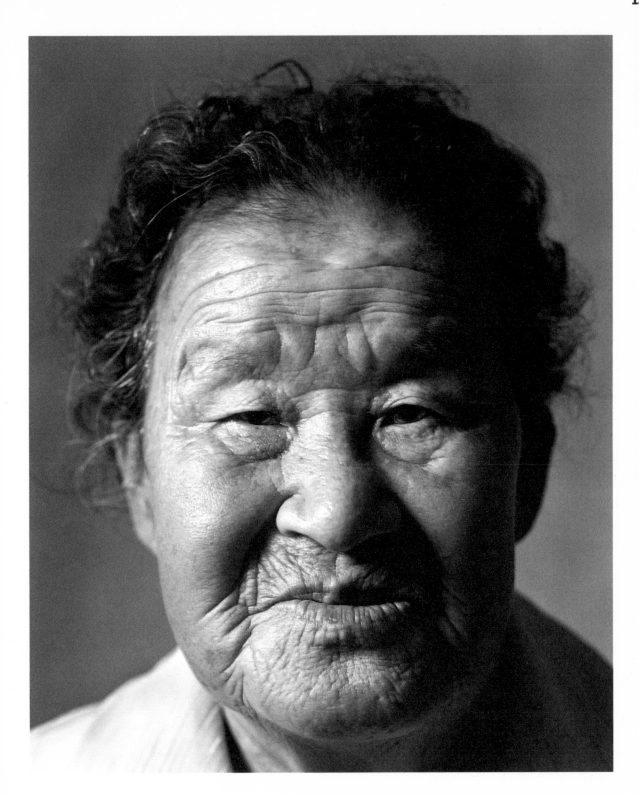

Yi Okseon (b. 1927)

Yi Okseon was abducted from a bar when she was
16 by two men and taken to work building a Japanese
airport. When she protested, she was taken to a sex
station and made to have sex 40 to 50 times a day.
When she complained, she was stabbed in the arm
and beaten so badly her eyesight and hearing were
permanently damaged. One girl at the same sex
station who objected was stabbed to death in front
of her and thrown into the street to be eaten by dogs.

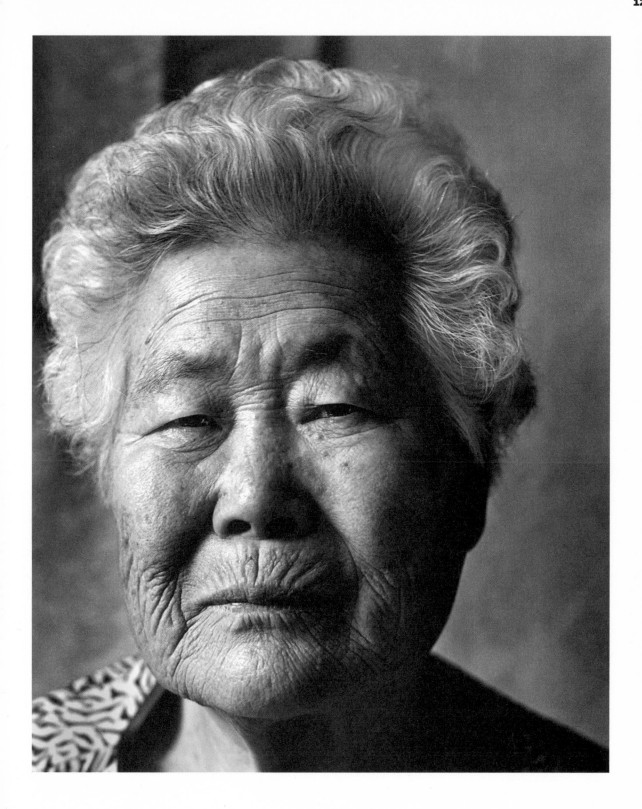

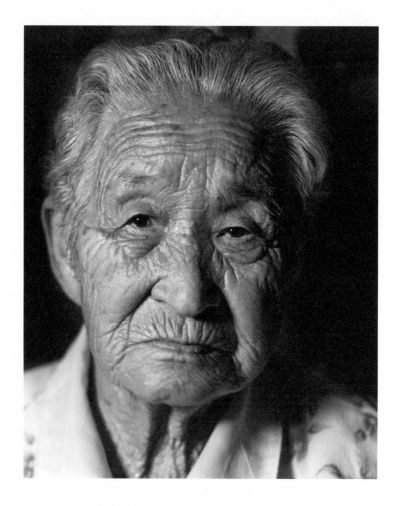

Pak Onglyeon (b. 1919)

When she was 20-years old, Pak Onglyeon's abusive
husband sold her to an employment agency, where she
was told she would be washing clothes and caring for
wounded soldiers. Instead, she was sent to Papua New
Guinea where she discovered she was to be a sex slave.

From 7am to 4pm she had to have sex with private
soldiers; from 4pm to 7pm, non-commissioned officers;
and from 7pm to 10pm, officers. In principle, the time
assigned to a soldier was one hour but there were too
many men to keep that schedule. She had to have sex
with 20 to 30 soldiers a day.

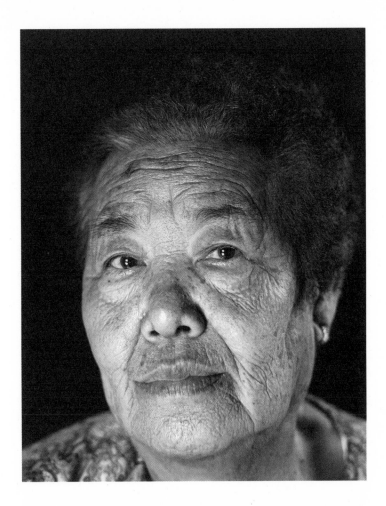

Kim Koon-Ja

The oldest of three daughters, Kim Koon-Ja's father died when she was 10 and her mother died when she was 14. She was adopted into her aunt's family. When she turned 17, she had to get a job and was taken by a Korean agent to a 'Comfort Station'.

Her first trade was with an officer who smashed her eardrum when she refused him sex. After that, she had to service officers on weekdays and ordinary soldiers on weekends. Every Friday, she had a medical check for sexually transmitted diseases. She was liberated when she was 20-years old.

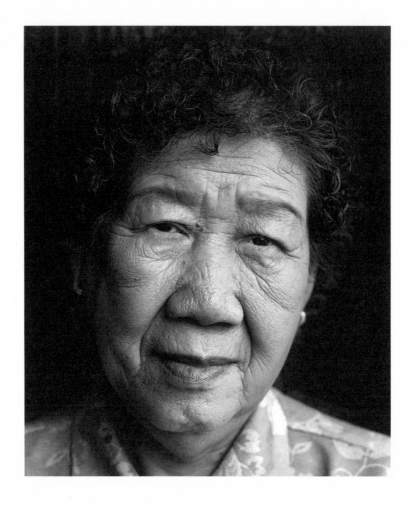

Kang Ilchul (b. 1928)

Kang Ilchul was abducted by a military police officer who told her she was being conscripted for the National Guard. Instead, she was taken to a sex station in China where she was raped until her vagina bled. Twice she attempted suicide. She is now not interested in financial compensation but wants public acknowledgement from the Japanese government.

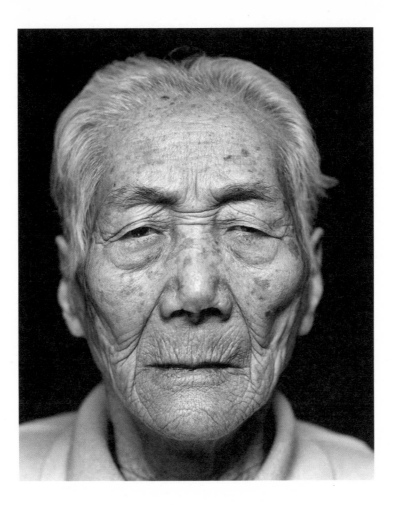

Lee Sun Duk

Lee Sun Duk was 17-years old and working on a farm when she was abducted by a Japanese soldier. She was put in a room with 15 other girls and then taken to Shanghai, where she was forced to work at a sex station. There, she was frequently beaten for resisting sex, the abuse damaging her eyesight. She had to have sex every day of the year, and when she finally got out and went back home, she discovered that both her parents had died.

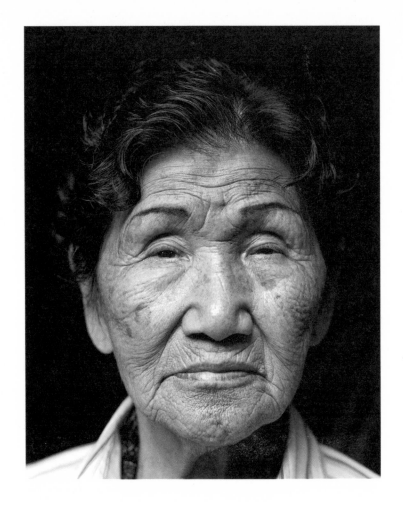

Jang Jum Dol

Jang Jum Dol was 14 and on the way to do laundry when she was abducted by a Japanese man and told she was being taken to a factory to earn money. Instead, she was tied up in a house with an 11-year old girl and then taken with some other girls to Manchuria. When she tried to escape, she was captured, beaten and imprisoned at a sex station with a wire fence around it. She had three children there – two of them died and the surviving girl had a weak heart – but had to continue as a sex slave. When she returned to Korea with her daughter after the war she was so poor she had to sleep in the streets.

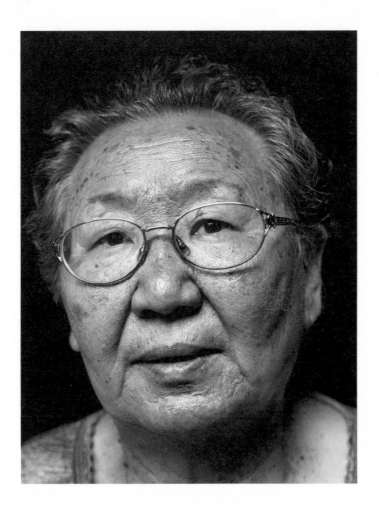

Kil Won Ok

Kil Won Ok was 13-years old when she was taken
to Beijing to help build a factory the Japanese
were constructing. A friend had told her that they
could make a lot of money there, and so they took
a train to this place, which ended-up being a sex
station. They were forced to be sex slaves, were
beaten frequently and had their feet stamped on
as punishment if they resisted. Kil Won Ok says
that the present is the happiest time in her life.

Kim Soon Ak (b. 1928)

Kim Soon Ak is the eldest child and only daughter of
poor farmers. She remembers she was wearing a white
top and black skirt when, aged 17, she was told that
she was being taken to work at a thread factory.
Instead, she was taken on a four-day journey to
Mongolia and made to work in a sex station.

On weekends, even when she had her period, she was
forced to have sex with 20 to 30 soldiers who stood
waiting in a line outside. When she eventually
returned home, she learned that her father had died
of grief over losing her.

Until the Comfort Women movement started she had
told no one of her past. She still wishes she could
have got married.

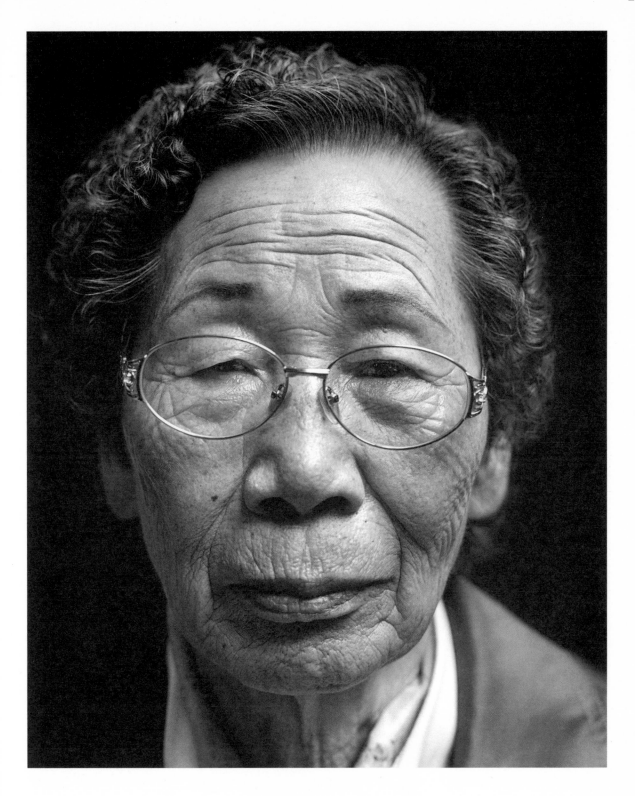

Yi Yong Soo (b. 1928)

Yi Yong Soo came from a poor family. Her mother worked as a nanny and her father delivered rice. She was 16 when a friend came by her house and invited her outside to meet a Japanese man. The man gave her a dress and leather shoes and promised her more if she came and worked for him. There were four other girls including her friend with the man and Yi Yong Soo was too excited to think about where they were going.

They traveled for several days to the north of Korea and were forced to work harvesting radishes. The man's behaviour changed and he beat them if they made mistakes or complained. After a month, they were put on a Japanese naval ship to Taiwan. The girls were repeatedly raped on the journey and Yi Yong Soo contracted a sexual disease.

In Taiwan, they were forced to work in a 'Comfort Station' where they had to have sex three or four times a day, even when they had their periods. They were beaten and electrocuted if they resisted. They mainly had to service Kamikaze pilots before suicide missions. Yi Yong Soo was not allowed to speak Korean and was given the name Doshiko. She was never paid.

One suicide pilot fell in love with Yi Yong Soo, and before his fatal mission he came and gave her his final possessions – a photo and his toiletries. He told her the sexually transmitted disease that she had infected him with was a gift from her, Doshiko, to him. He was gentle and he taught her a song:

> Take off bravely. Leaving Shin-jook
> Crossing over the clouds
> There is no one to see me off
> Only one crying for me. Doshiko.

After the war was over, Yi Yong Soo found her way home. When her mother first saw her, her mother was frightened and thought she was a ghost, as she had assumed her daughter was dead.

Yi Yong Soo feels relieved now she has revealed what happened to her as a sex slave. She has never married and lives alone.

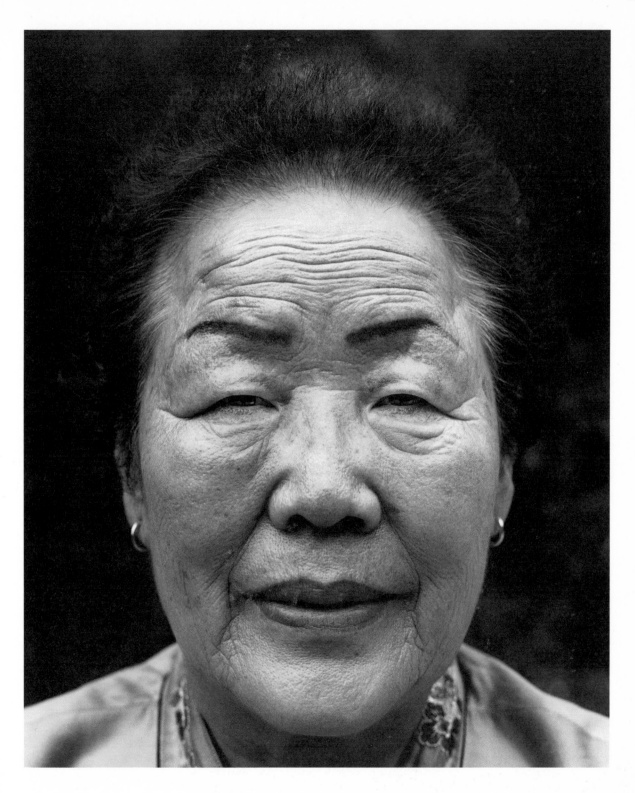

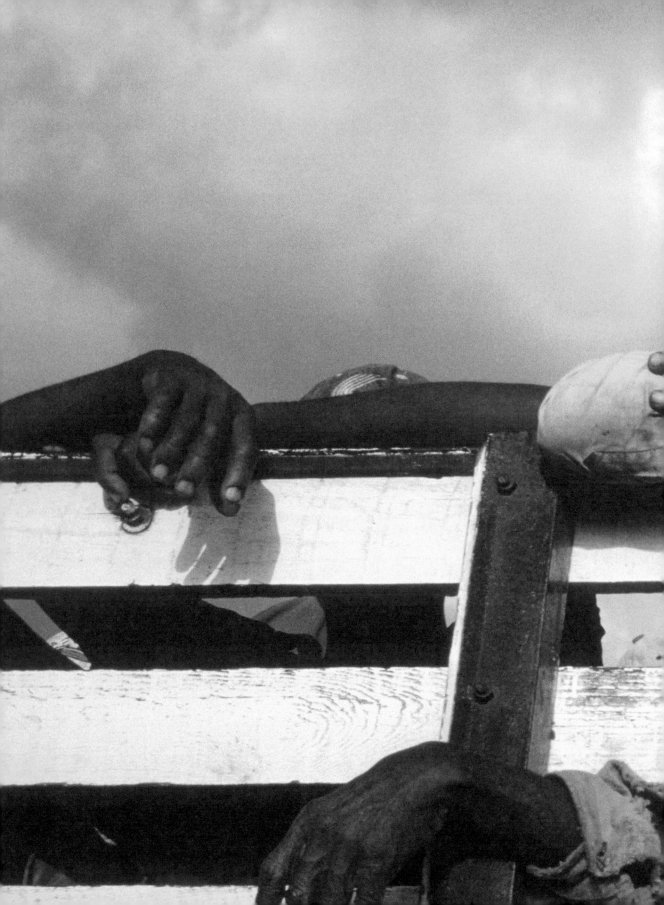

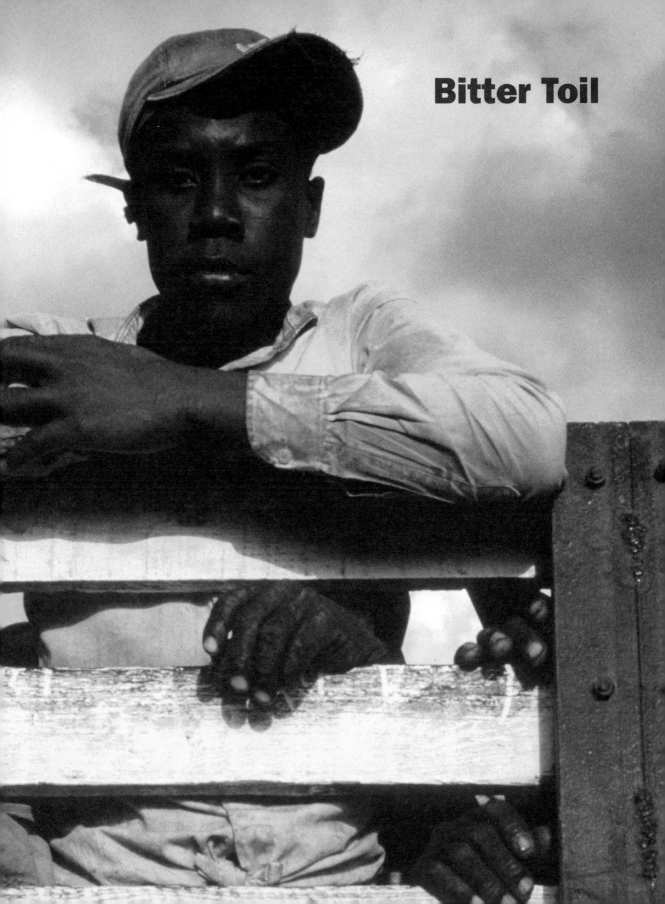

Bitter Toil

Alex Webb

Bitter Toil
Haitian Sugar Workers in the Dominican Republic

It's ironic that the world's first black republic, Haiti – born out of the slaves' revolt against the French some 200 years ago – is party to what can be seen as a modern form of slavery. Haiti shares the island of Hispaniola with the Dominican Republic. Both countries are poor, but Haiti is far poorer, easily the most impoverished country in the New World, ranking economically alongside parts of sub-Saharan Africa and Bangladesh. And while the Dominican Republic remains to a large extent a verdant Caribbean land, Haiti, thanks to a long history of drought, an ongoing charcoal industry, and slash and burn agricultural practices, is arid and deforested. Seen from the air, the border between the two countries offers a startling contrast: on one side, the forested slopes of the Dominican Republic; on the other, the barren, desiccated land of Haiti. Hence Haitians have often sought work across the border.

For years, the Dominican sugar industry has relied on thousands of Haitian workers to cut cane during harvest time. Traditionally, these workers are recruited on both sides of the border by contractors for the sugar estates, who then subcontract the undocumented workers to the plantations. During the sugar harvest these Haitians – who, because they are undocumented, cannot easily travel elsewhere in the Dominican Republic – live in small isolated villages (*bateys*) that dot the cane fields. These *bateys* usually lack running water, toilets, kitchens and medical facilities. Both the workers and their families face the prejudice of Dominican society against those of Haitian descent, prejudice that has at times erupted into violence. Haitian women in the *bateys* have reportedly been subject to rape from Dominican farmers and police or soldiers while their husbands labour in the cane fields. Children born out of such unions are potentially stateless, neither Dominicans nor Haitians, and may remain in the *bateys* in a kind of limbo for the rest of their lives.

For the cane workers, their job is brutally grueling and dangerous. Manual sugar cane cutting – hacking down cane with a machete that can easily rebound into a worker's limb – is one of the most

perilous jobs in the world, and these workers are not supplied with any kind of protective gear. Furthermore, workers are not always paid in currency. Instead, they may receive a kind of coupon, which can only be reimbursed at a company store. And, occasionally, at the end of the harvest, the Haitians are arrested by the Dominican police, who are often in cahoots with the companies, and the workers are forcibly returned to Haiti before they have received their final payments.

These photographs were taken in the *bateys* and sugar fields of the eastern Dominican Republic during the Spring 2007 harvest.

Alex Webb

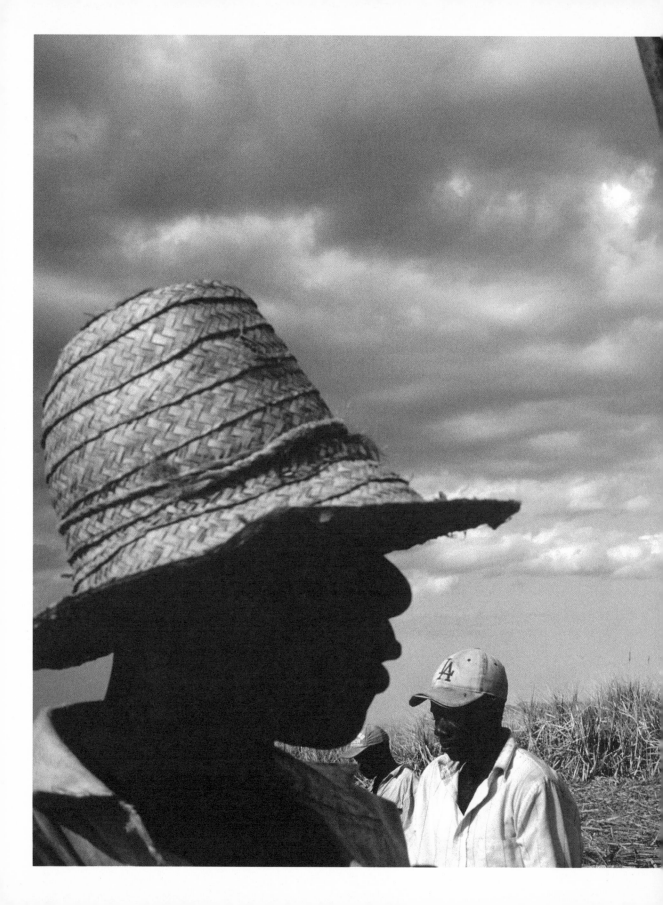

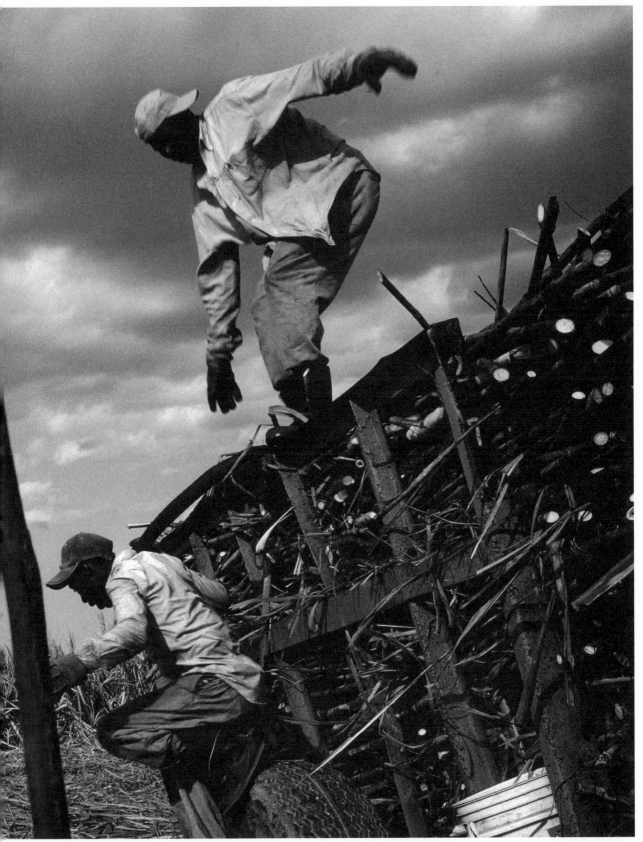

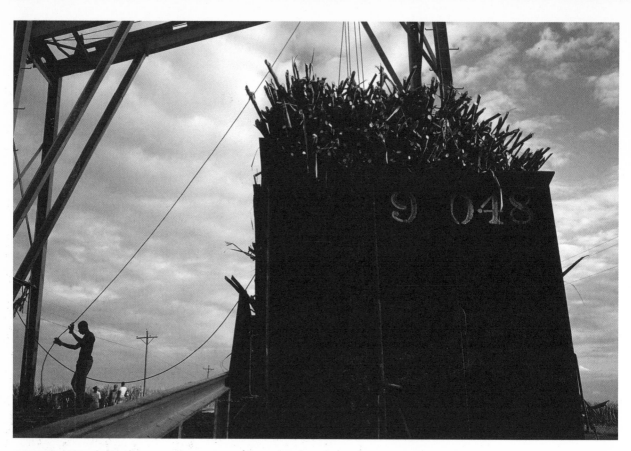

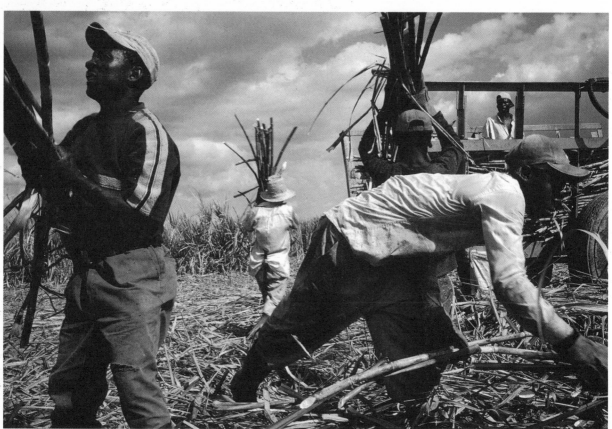

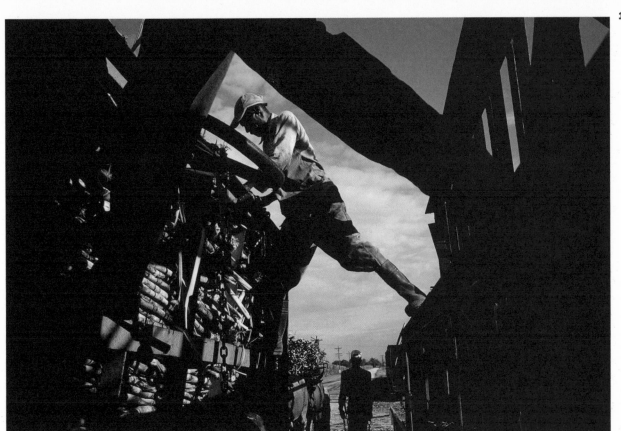

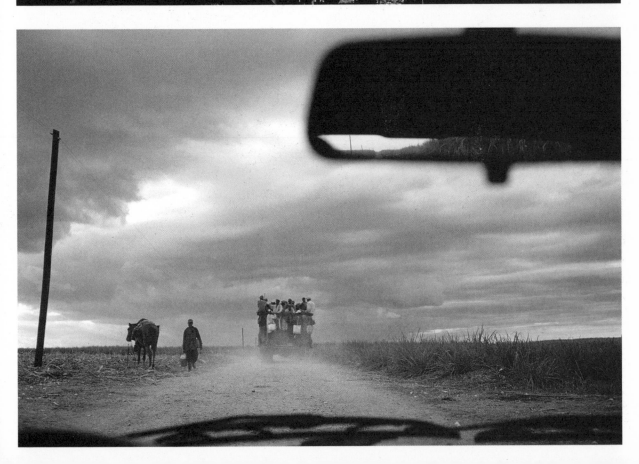

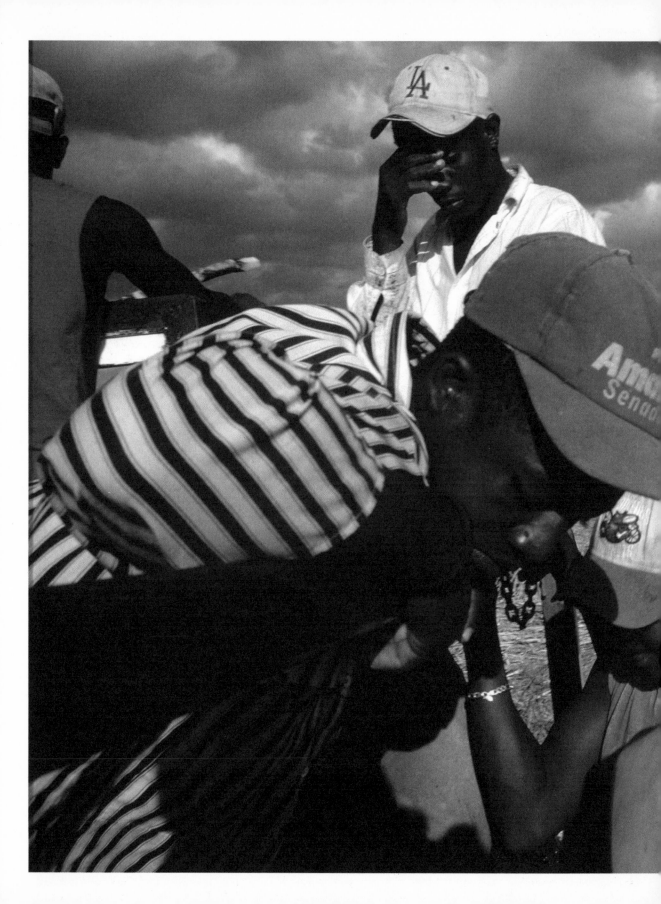

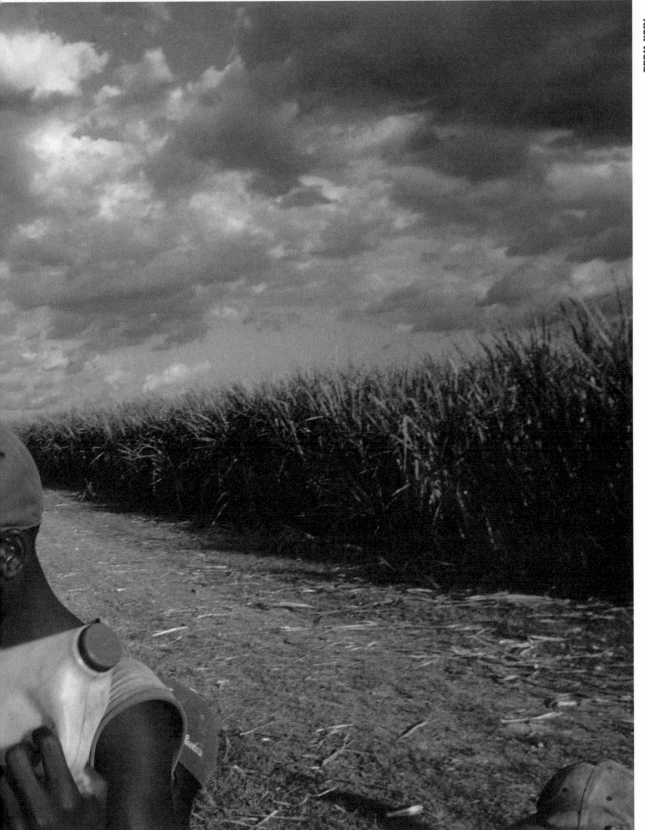

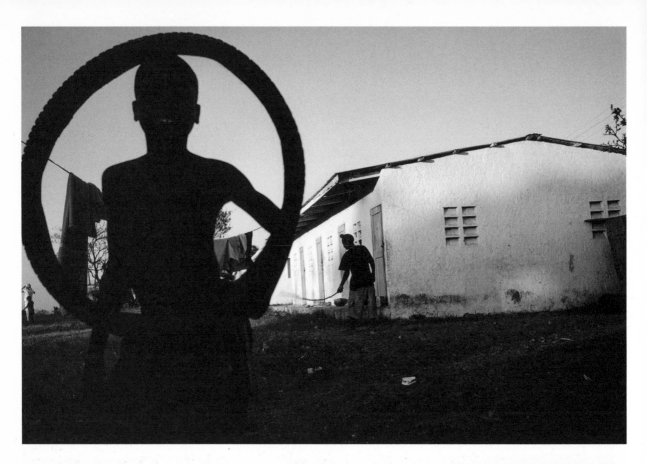
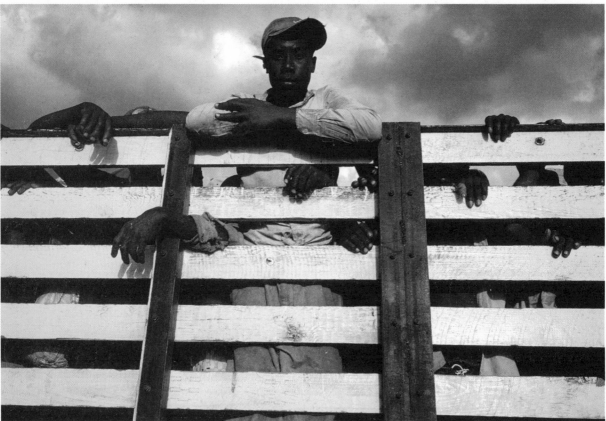

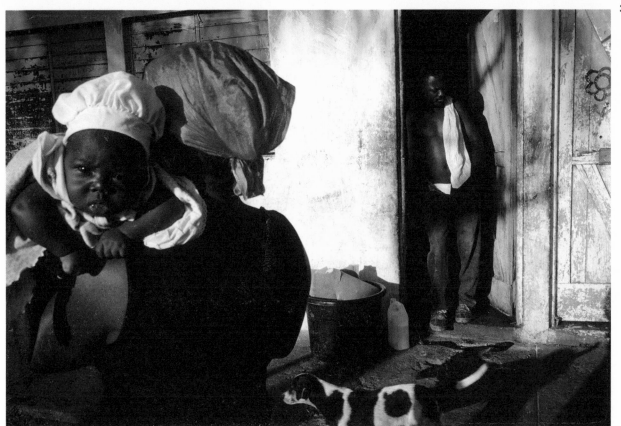

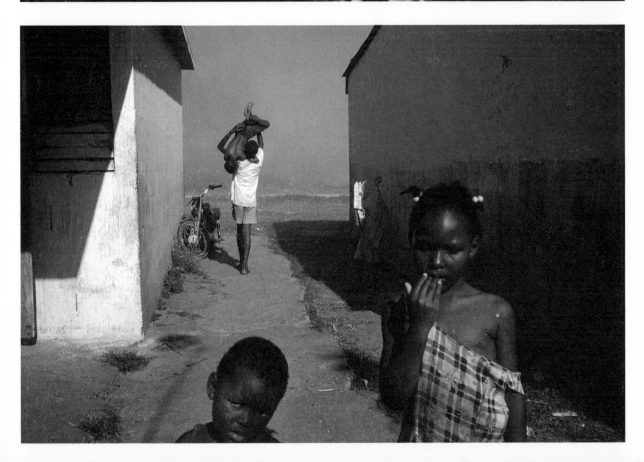

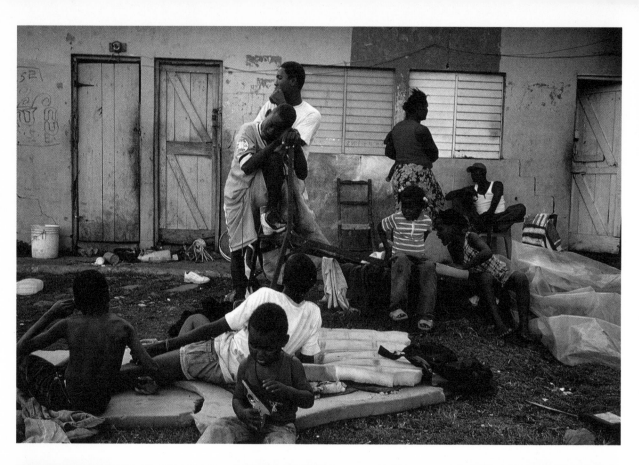
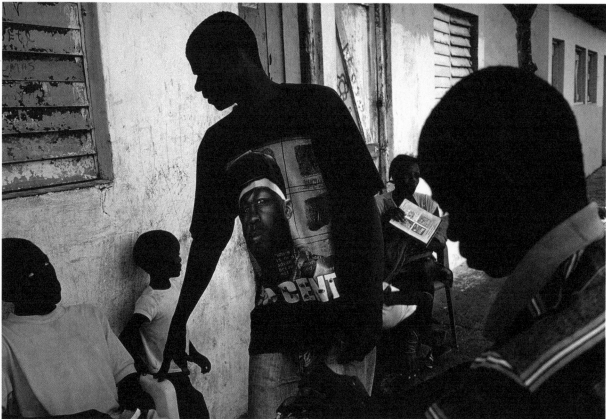

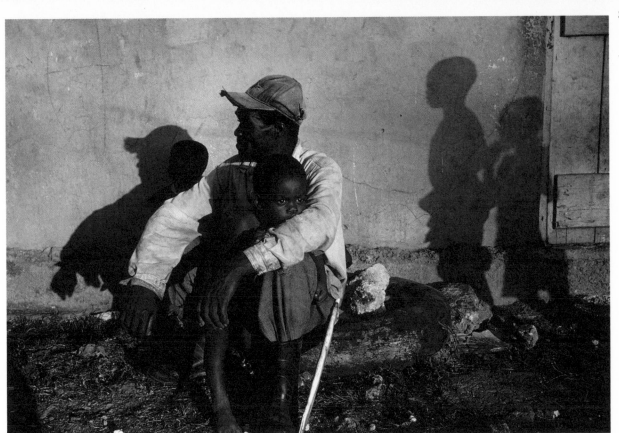

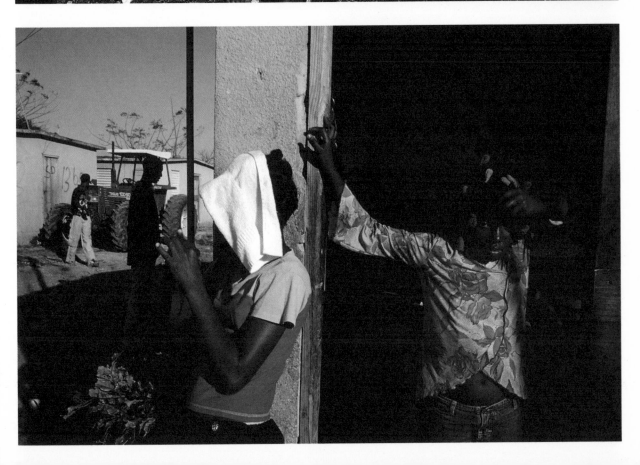

Biographies

Abbas

An Iranian transplanted to Paris, Abbas has dedicated himself to documenting the political and social life of societies in conflict. In his major work since 1970, he has covered wars and revolutions in Biafra, Bangladesh, Northern Ireland, Vietnam, the Middle East, Chile, Cuba and South Africa during apartheid.

From 1978 to 1980, Abbas photographed the revolution in Iran, to which he returned in 1997 after 17 years of voluntary exile. His book *Iran Diary 1971–2002* (2002), photographed and written as a private journal, is a critical interpretation of Iranian history.

Between 1983 and 1986, he journeyed through Mexico resulting in the exhibition and book, *Return to Mexico: Journeys Beyond the Mask* (1992). He has since undertaken a series of major photographic essays on Islam, Christianity and Paganism, published in his books *Allah O Akbar* (1994), a journey through militant Islam, *Faces of Christianity* (2000) and *Sur la Route des Esprits* (2005). His latest work, yet to be published, is a post 9/11 essay on how religion is perceived as replacing political ideologies as the driving force behind international conflicts.

More information at
www.magnumphotos.com

Ian Berry

Ian Berry moved to South Africa in his early twenties, where he witnessed a great deal of political violence and was the only photographer to record the Sharpeville massacre in March 1960. Returning to Europe, he was invited to join Magnum in 1962. He has documented Russia's invasion of Czechoslovakia; conflict in Israel, Ireland, Zaire, Vietnam and Congo; and famine in Ethiopia. His photographs of South Africa under apartheid were published in the book *Living Apart* (1996).

Berry has also reported on the political and social transformations in China and the former USSR. Recent projects include retracing the steps of the original Silk Road through Turkey, Iran and Southern Central Asia to Northern China, and photographing Greenland for a book on climate control. His work is included in the Arts Council Collection exhibition and book, *No Such Thing as Society: Photography in Britain 1967–87* (2007).

More information at
www.ianberrymagnum.com

Stuart Franklin

Stuart Franklin's coverage of the Sahel famine in 1984–85 was internationally acclaimed, but he is perhaps best known for his celebrated photograph of a man defying a tank in Tiananmen Square, China, in 1989, which won him a World Press Photo award.

Since 1990, Franklin has completed over 20 assignments for *National Geographic* magazine. His work has taken him to Central and South America, China, Southeast Asia and across Europe. Since 2004, he has focused primarily on projects concerned with man and the environment, in particular climate change and patterns of transformation in Europe's landscape.

More information at
www.stuartfranklin.com

Jim Goldberg

Over the past 20 years, Jim Goldberg's work with various social subcultures and his innovative use of image and text have distinguished him as a landmark photographer of our times. He began to explore experimental storytelling and the potentials of combining image and text with *Rich and Poor* (1977–85), in which he juxtaposed the residents of welfare hotel rooms with the upper class and their elegantly furnished home interiors to investigate the nature of American myths about class, power and happiness. In *Raised by Wolves* (1985–95) he worked closely with runaway teenagers in San Francisco and Los Angeles to create a book and exhibition that combined original photographs, text, home movie stills, snapshots, drawings and diary entries, as well as single- and multi-channel video, sculpture, found objects, light boxes and other 3-D elements. He is currently working on a book on migration in Europe to be published in 2009 by Steidl. He is represented by Pace/MacGill Gallery in New York and the Stephen Wirtz Gallery in San Francisco.

His work is in numerous private and public collections including NYMOMA, SFMOMA, Whitney Museum of American Art, Getty, LACMA, Corcoran, MFA Boston, Hallmark Collection, The High Museum, Library of Congress, MFA Houston, National Museum of American Art, and the Art Institute of Chicago. Jim Goldberg's fashion, editorial and advertising work has appeared in numerous publications including *W, Details, Flaunt, The New York Times Magazine, Esquire, Rebel, GQ* and *Dazed and Confused*.

More information at
www.magnumphotos.com

Susan Meiselas

Susan Meiselas' first major photographic essay focused on the lives of women doing striptease at New England country fairs. *Carnival Strippers* was published in 1976, and a selection of the images was shown at the Whitney Museum of American Art, New York, in June 2000. She is perhaps best known for her coverage of the insurrection in Nicaragua, which she published as her second monograph in 1981, and for her documentation of human rights issues in Latin America.

Meiselas edited and contributed to *El Salvador: The Work of 30 Photographers* and edited *Chile from Within*, which features work by photographers living under the regime of Augusto Pinochet. She has co-directed two films: *Living at Risk: The Story of a Nicaraguan Family* (1986) and *Pictures from a Revolution* (1991). In 1997, she completed a six-year project curating a 100-year visual history of Kurdistan. Her 2001 monograph, *Pandora's Box*, which explores a New York S&M club, was followed by *Encounters with the Dani*, an account of an indigenous people living in Indonesia's Papua highlands.

More information at
www.susanmeiselas.com

Paolo Pellegrin

Paolo Pellegrin became a Magnum Photos nominee in 2001 and a full member in 2005. He is a contract photographer for *Newsweek* magazine. Pellegrin is winner of many awards, including eight World Press Photo and numerous Photographer of the Year Awards, a Leica Medal of Excellence, an Olivier Rebbot Award, the Hansel-Meith Preis, and the Robert Capa Gold Medal Award. In 2006, he was assigned the W. Eugene Smith Grant in Humanistic Photography. He has published six books: *Bambini* (1997), *Cambogia* (1998), *L'au delà est là* (2001), *Kosovo 1999–2000: The Flight of Reason* (2002), *Double Blind* (2007) and *As I was Dying* (2007). He lives between Rome and New York.

More information at
www.magnumphotos.com

Chris Steele-Perkins

Chris Steele-Perkins' early work as a free-lance photographer was mainly concerned with urban poverty and subcultures in Britain. In 1979, he published his first solo book, *The Ted,* which documented the myth of the Teddy Boy. During this early period he also worked with EXIT, a collective dealing with social problems in British cities, which culminated in the book *Survival Programmes,* in 1982.

Steele-Perkins joined Magnum Photos in 1979 and soon began working in the developing world, particularly in Africa, Central America and Lebanon, as well as continuing to document Britain. In 1992, he published *Afghanistan,* the result of four trips over four years. After marrying his second wife, Miyako Yamada, he embarked on a long-term photographic exploration of Japan, publishing his first book of that work, *Fuji,* in 2000. A highly personal diary of 2001, *Echoes,* was published in 2003, and the second of his Japanese books, *Tokyo Love Hello,* in 2006. He has continued to work in Britain documenting rural life in Durham, culminating in the book *Northern Exposures* (2006). His work is included in the Arts Council Collection exhibition and book, *No Such Thing as Society: Photography in Britain 1967–87* (2007).

More information at
www.chrissteeleperkins.com

Alex Webb

Alex Webb began working as a professional photojournalist in 1974 and his photographs soon began to appear in publications such as *The New York Times Magazine, Life, Stern* and *National Geographic.*

Webb joined Magnum Photos as an associate member in 1976. During the mid-1970s, Webb photographed in the American south, documenting small-town life in black and white. He also began working in the Caribbean and Mexico. In 1978, he started to photograph in colour, as he has continued to do. Webb has published seven photography books, including *Hot Light/Half-Made Worlds: Photographs from the Tropics* (1986), *Under A Grudging Sun* (1989), documenting life in Haiti, *Crossings: Photographs from the US-Mexico Border* (2003), the limited edition artist book *Dislocations* (1998–99), and *Istanbul: City of a Hundred Names* (2007). He has also exhibited widely in the United States and Europe in museums including the Whitney Museum of American Art, the Metropolitan Museum of Art, the High Museum, and the Museum of Contemporary Art, San Diego.

More information at
www.magnumphotos.com

Published on the occasion of the exhibition
Disposable People: Contemporary Global Slavery
**A Hayward Touring exhibition in collaboration
with Autograph ABP and Magnum Photos**

Exhibition tour:

**26 September – 9 November 2008
Southbank Centre, London**

**10 January – 21 February 2009
The Gallery, Peninsula Arts, University of Plymouth**

**28 February – 9 April 2009
University of Northumbria, Newcastle-Upon-Tyne**

**23 May – 5 July 2009
Tullie House Museum and Art Gallery, Carlisle**

**1 August – 13 September 2009
New Art Exchange, Nottingham**

**7 November – 3 January 2010
Aberystwyth Arts Centre**

**Exhibition curated by Mark Sealy
Exhibition organised by Roger Malbert and Alice Lobb**

With support from:

MTV Europe Foundation

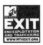

Christian Aid

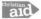

Concern Worldwide

**Art Publisher: Caroline Wetherilt
Publishing Co-ordinator: Giselle Osborne
Sales Manager: Deborah Power
Catalogue designed by Herman Lelie and
Stefania Bonelli
Produced in the UK by fandg.co.uk**

Cover: Alex Webb, *Bitter Toil: Haitian Sugar
Workers in the Dominican Republic* (detail)

Published by Hayward Publishing
Southbank Centre, Belvedere Road, London
SE1 8XX, UK. www.southbankcentre.co.uk
© The Hayward/Southbank Centre 2008
Texts © the authors 2008
Artworks/photographs © the photographer/Magnum
Photos, 2008 (unless otherwise stated)
Commissioned by Autograph ABP
Map (pp. 8–9): Courtesy *The Guardian* and
Free the Slaves

The publisher has made every effort to
contact all copyright holders. If proper
acknowledgement has not been made, we ask
copyright holders to contact the publisher.

ISBN 978 1 85332 264 8

Distributed in North America, Central America and
South America through D.A.P./Distributed Art
Publishers, 155 Sixth Avenue, 2nd Floor, New York,
N.Y. 10013, tel: +212 627 1999, fax: +212 627 9484
www.artbook.com

Distributed outside North and South America by
Cornerhouse Publications, 70 Oxford Street, Manchester
M1 5NH, tel. +44 (0)161 200 1503;
fax. +44 (0)161 200 1504, www.cornerhouse.org/books

Developing Employability for Business

Maryvonne Lumley

James Wilkinson

OXFORD
UNIVERSITY PRESS

OXFORD
UNIVERSITY PRESS

Great Clarendon Street, Oxford, OX2 6DP,
United Kingdom

Oxford University Press is a department of the University of Oxford.
It furthers the University's objective of excellence in research, scholarship,
and education by publishing worldwide. Oxford is a registered trade mark of
Oxford University Press in the UK and in certain other countries

Published in the United States of America by Oxford University Press
198 Madison Avenue, New York, NY 10016, United States of America

British Library Cataloguing in Publication Data
Data available

Library of Congress Control Number: 2013942198

ISBN 978-0-19-967245-5

Printed in Great Britain by
Ashford Colour Press Ltd, Gosport, Hampshire

Links to third party websites are provided by Oxford in good faith and
for information only. Oxford disclaims any responsibility for the materials
contained in any third party website referenced in this work.

Developing Employability for Business

Acknowledgements

We would like to pay special thanks to the following individuals who have given generously of their time in talking with us, to provide their insights and experience concerning employability.

Students and graduates

Nikhil
Anna Slowikowska
Grace McNulty-Brown
Andrew Sifuna Njenga
Ernestine Blake
Carlotta Olason
Ilona Motyer

Employers, Entrepreneurs, Management and Employer Organizations and Consultants

Petra Wilton, Director of Policy and Research, Chartered Management Institute
Tom Millar, Director of Learning2Work, Reed
Peter Cobbe, Independent Coach and Consultant
Lance and Tania Beecheno, SupportPlan Ltd
Pat Bensky, Managing Director at Tenthmatrix Information Systems Ltd
Balinder Walia, CTO (Founder) at Tenthmatrix Information Systems Ltd
Mervyn Caldwell, Corporate Creative Director and Founding Partner, Creative Leap
Dominique Bonnafoux, Head of Insight and Propositions, Creative Leap
Michelle Healy, Design Director, Corporate Brands, Creative Leap
Louise Morrissey, Director of Land and Planning, Peel Land & Property
Ronan Dunne, Chief Executive Officer, Telefónica UK Limited (O_2)
Ann Pickering, Director of Human Resources, Telefónica UK Limited (O_2)

... and also to people who spoke to us anonymously, to whom we are equally grateful.

Contents

How you can use this book

You can use this book in different ways, which we describe below. Whichever way you decide upon, we suggest that before you start you spend a short while just familiarizing yourself with the contents of the book so that if you need to check up on something specific you have an idea of where to find it. The learning outcomes at the beginning of each chapter should serve to help with this.

Sequentially

You can read it like any other book, from start to finish. The topics are presented in a logical sequence with each one building on the previous one. Case studies help to introduce chapters and illustrate important points. There are also activities for you to undertake, many of which encourage you to identify your learning needs, reflect on your performance, and consider possible actions for personal development.

By theme

You can also follow a particular theme as you need it, and so various themes are signposted throughout the book. This allows you to dip into the book, following the signposts to work on a theme of specific interest to you. For instance you may be particularly interested in issues relating to working globally in a cross-cultural environment, a topic which is raised several times.

In conjunction with a project

However, although we believe you will gain from reading the book in these ways, actually developing employability requires more than just acquiring information about it. Indeed, your success in the employment market depends on a lot more than just knowing things. It involves being able to present a set of 'employability assets' effectively to employers. These assets include knowledge, as demonstrated by your qualifications, and also skills and attitudes or 'mindset'. Looking for evidence of these skills and mindset, employers will want to see achievements which convince them that you are the kind of person who can set yourself goals, can work with others, can get things done and will keep trying even in the face of setbacks and difficulties.

Acquiring these skills and this mindset requires more than turning pages, just as reading a book about swimming will not enable you to swim. So to help you develop employability, this book provides not only information but is also designed to get you doing things, with a project and tasks for you to accomplish. Indeed, our recommended method for working through the book is to tackle the project tasks. Choosing to work through the book using this project-based approach will give you opportunities to apply and develop skills, to evaluate and reflect on your abilities and 'mindset', and to identify and address your learning needs.

The project will also help you explore and understand the relationship between the different elements in the book. Some of the project involves working with others; other parts involve individual effort. The project takes quite a long time to complete and, as well as managing time effectively, you will have to manage different tasks, taking personal responsibility for some, while relying on colleagues to complete others. In this way, it gives you opportunities for evaluating and reflecting on your own performance. How well did I work with others? Was it just somebody else's fault that things went wrong or could I have managed things better? Did I get my tasks done? Could I have done better? Did I keep trying even when things became difficult?

Working through the project and evaluating your own performance in this way will help you to develop realistic awareness of your capabilities. You will understand better where your strengths lie and how you can talk convincingly about these to employers. You will also understand where you need to improve and will learn to plan how to develop these areas.

The following is an overview of the project areas that will be introduced in the following chapters (although not in this specific order). They have been grouped for you to demonstrate the part they play in your journey towards successful employment.

We recommend that you present all your individual work, and where appropriate, your reflections on any group work, in a portfolio, preferably in an electronic, online format. If you are using this book on a taught module, this is something you can discuss with the tutor.

Working on your own	Where to find help
1. Learning about yourself	
1.1. Complete the CareerEDGE Employability Development Profile Questionnaire. Use this exercise to reflect on your strengths and weaknesses and identify key learning needs	Chapter 2 (EDP questionnaire)
1.2. Clarify your long- and short-term goals in relation to the kind of work you might eventually wish to do. Start by designing your own criteria for deciding between different career options, and completing Table 2.7 You will be able to revisit and revise your career aims during your university course, but having goals to aim for is important, not least for your motivation	Chapter 2 ('Selection from Options Criteria' exercise)
1.3. Draw up an action plan for the various avenues you can follow for building up your skills, attitude, and experience	Chapter 4
1.4. Identify stakeholders (people who have an interest in your success) and canvass support from them for your future endeavours. N.B. Networking and mentoring can be of great value, both in finding your first job and subsequent progression	Chapter 11
1.5. Reflect on and document your learning journey. Use learning logs and Personal Development Planning to record and document your experiences and draw up an action plan that identifies specific ways in which you can improve	Chapters 1 and 2
1.6. From the research you have done, and also from the experience of working with others, revisit your original aims and identify areas that you need to work on further. Identify at least three unique selling points (USPs). How will you make sure you stand out from the crowd?	Chapters 9 and 10

Working on your own	Where to find help
2. Tackling the job market (The following tasks may also be undertaken as group tasks, especially if you are working with people with similar career interests)	Many of these tasks involve research on the internet, e.g. looking at job adverts. See also the Prospects website (www.prospects.ac.uk)
2.1. Investigate employment trends in general and on your chosen area in particular, and record what you find out	
2.2. Gather from as many sources as you can what employers say they want but also try and determine what is implicit in their requirements	
2.3. Investigate how important your digital identity might be and reflect on the way you wish to appear to potential employers	Chapter 9
2.4. What mindset qualities have you developed and demonstrated? Write convincingly about these, providing examples of three different attitudes that you think will impress employers	Chapters 2, 9, and 10
2.5. Use your experience of teamworking (see below) to write convincingly about examples that provide evidence of your skills in that area	

Note: Items that are blank indicate areas that the reader is expected to research via the internet, papers etc.

Where relevant with the following group work activities, discuss these points with your team colleagues, as well as reflecting individually on them.

Working with others	Where to find help in the book
Record reflections on your learning about teamworking and project management techniques	
1. As you learn theory, compare this with your own past experience of team and project work	Chapters 5, 6, and 7
2. As you apply the theory on your group project (e.g. when researching employability and what employers want), record reflections on your experience of teamwork. How does your actual experience reflect theory that you have learnt?	Chapters 5, 6, and 7
3. Research prospective companies via business papers, professional journals, and websites. Your tutor will guide you through this	
4. Research employability and what employers want, producing guidance notes for yourself and other students and preparing a group presentation	
5. Identify how you and others in the team work best, your strengths and weaknesses and what you bring to the project	Chapters 1, 2, 4, 8, 9, and 10
6. Develop a responsibility matrix for teamworking	Chapters 6 and 7
7. Identify critical incidents throughout the teamwork	Chapters 6 and 7
8. Analyse how you interact with others, using experiences from school, university, part-time jobs, clubs, and your current group work	Chapters 6 and 7

(continued...)

Developing specific skills

1. Explore and implement time management techniques to support you in the rest of study and on into work Chapter 5

2. Customer service skills are very important to employers. Research these skills – what skills and techniques for dealing with customers do employers expect you to have? How do you measure up with these? Draw up an action plan for improvement

Whichever way you use the book, you will have plenty of opportunities for thinking, analysis, reflection, and discussion, which will help make the material an intrinsic part of your journey towards employment and beyond.

The following is a key to the various features we have used to guide you through the material.

 Learning outcomes

will help you to focus your learning and evaluate how well you have achieved what the chapter is covering

What do you think?

consider and record your starting position on certain topics. You will record these and keep them by you until the end of the chapter when you will revisit your original thoughts and see whether you have changed your mind

Case studies

are used throughout the book to give you an insight into both employer and student perspectives, and experiences relating to employability and employment. All such cases are real, based on interviews. Most people were happy to let us identify them and where relevant their companies. However, some preferred to remain anonymous and we have protected their identity and that of their company

 Signpost

points you to where the same theme is covered elsewhere in the book

 Activity

will give you an opportunity to explore a topic or concept further

 Discussion

will raise topics which may cover difficult or ambiguous issues. There may be no 'one-right-answer' to these discussions. Their purpose is to enable you to explore the issues and be aware of their existence

 Project activity

provides instructions for the next stage of the project. These will help you to manage and complete the project

 Reflection

suggestions are designed to help with your personal development planning, allowing you to identify learning needs and action plans, and to explain and provide evidence for your employability

Further reading

will point you towards relevant reading on areas that will deepen your understanding and will include reading activity relating to the project

Section 1

Identifying and Building Employability Assets

In this section you will develop awareness of what employers are looking for and at the same time learn to appreciate how closely you meet their requirements. This means that as well as identifying your own strengths, you will also become aware of areas that you need to improve. A key step in this process is developing the habit of reflecting on your performance and experience on a regular basis.

Employability involves a mix of skills, knowledge, experience, attitudes, and mindset, and we refer to these as your employability assets (also known as attributes). When employers recruit graduates, it is true that they do want to see how well they have performed academically. Indeed, academic success can show evidence of several important employability assets. These include important transferable skills relating to ability to research and analyse issues as well as organization and self-management skills, and also aspects of mindset such as tenacity, determination, and confidence. Achieving a good overall degree result is therefore very important.

The problem, however, is that at the end of your studies you will not be the only graduate with a 2:1 or even a First Class degree. Moreover, employers are not just looking for good academic results. To differentiate yourself from others with a similar degree, you must be able to provide powerful evidence that you possess not only excellent transferable skills, but also that you have a special kind of mindset. For many of the employers we spoke with, this mindset is a key factor and is made up of a number of different attitudes, which can often best be demonstrated through the range of extracurricular activities to which you give time and commitment.

Understanding employability and your development needs

 Learning outcomes

- Have a clear idea of what employers are looking for in their new recruits.
- Have made a start with personal development planning, identifying learning needs and other actions you will take to enhance your employability.

Note

Throughout the book, we use case studies to introduce and illustrate important points. All of these are real and are based on interviews or email correspondence we have conducted with employers, students, and recent graduates. To get you thinking about employability before reading the first case study, answer the following questions and discuss your answers with fellow students.

What do you think?

- What are the five most important things employers look for in recent graduates? Compare your answers with others.
- Do you think these are different to what employers would be looking for in more experienced jobseekers?
- When should you start developing and gathering evidence of the items on your list?

Our first case study describes the career path of Anna Slowikowska, who studied Business Studies on both Higher National Diploma (HND) and Bachelor of Arts (BA) programmes at the University of West London.

Case study

After studying full-time for her HND, Anna Slowikowska was able to transfer onto Level 6 (the final stage) of the BA in Business Studies. She is now studying part-time because in December 2011 she was offered a full-time job in the public sector, working as Business Support for Cafcass, the Children and Family Court Advisory and Support Service.

(continued...)

I was one of the first of my university friends to get a full-time job, in an area in which I am interested.

Anna believes there were a number of factors in her success.

Before going to university I attended many interviews but each one was a failure. That's because I didn't have real life examples to support my statements. It's easy to say that you are a team player, but it's more difficult to provide an example of that. Thanks to the University experience I am now able to provide many examples of teamwork, working together to achieve a common goal, prioritizing my work or dealing with conflicts.

I think that University is highly appreciated by employers. They know that it involves not only good time management, motivation, and determination, but also good teamworking skills, ability to research information on your own, and being able to present it to others. University enabled me to become familiar with different functions of the business and to become open for new opportunities. It built up my confidence and proved that I can achieve a lot if I only want to. It is very important to know that you are a worthwhile person.

I have also done lots of additional courses to learn other skills which might help with my career including Administration L2, the ECDL IT qualification, the AAT 2 Accounting qualification, as well as Spanish.

As well as being keen to make the most of these learning opportunities while at university, Anna also acquired useful experience by volunteering.

During the second year of HND I did volunteering at the Citizens Advice Bureau (CAB), where I received professional training on customer service and advice and got the chance to gain practical experience, to build up my CV and to put skills learned at University into practice.

From Anna's story it is possible to learn a lot about what it takes to enhance your employability. Crucially, her success was because of her ability to present evidence of a number of key employability assets, especially ones relating to knowledge and skills. Indeed, these are perhaps the two most obvious employability assets that are developed while you are at school and university.

 Activity

Under the following headings, draw up lists of the important skills that you think you will need in employment. Anna mentions a number of these, but you may be able to think of more.

Knowledge	Skills	
	Working on my own	Working with others

In addition to knowledge and skills, Anna mentions a number of other qualities that she believes are important. The words and phrases she uses are: 'motivation, determination, open for new opportunities, confidence', 'I can achieve a lot if I want to', and 'it is very important to know that you are a worthwhile person'. As you will see as we discuss the topic of employability more fully, these personal qualities and attitudes are now also believed to be crucial for employability.

See if you can add any more of these personal attributes and attitudes to the lists you already have for knowledge and skills.

Employability

The topic of employability has been researched and discussed by vocational education experts, careers advisers, and higher education academics for many years. At the risk of over-simplifying things, we will focus on just a few authors whose definitions and ideas we believe are especially helpful in explaining relevant ideas, and also the practical things people should do to enhance their employability.

The definition of employability proposed by Mantz Yorke suggests benefits not only for individuals but also for society more widely:

> a set of achievements – skills, understandings and personal attributes – that makes graduates more likely to gain employment and be successful in their chosen occupations, which benefits themselves, the workforce, the community and the economy.

(Yorke 2006, p. 8)

Included in the personal attributes that Yorke identifies, are attitudes that affect how effectively an individual is able to work at tasks, both on their own and with others. These include the concepts of emotional intelligence and of self-efficacy, a key element of the employability model that Yorke developed with Peter Knight (Knight and Yorke 2004). Alfred Bandura proposed the idea of self-efficacy in the 1970s, and has described it in many of his later works (e.g. Bandura 2012). The idea of self-efficacy involves a person's belief in their own abilities, and how their self-belief affects such things as their motivation and willingness to keep trying, even in the face of difficulties and setbacks. We will discuss this concept more fully in Chapter 2.

Question

Why do you think employers are keen to recruit individuals with strong self-efficacy?

To make it easier to talk about the above set of achievements, we refer to them throughout the book as 'assets', a term used by Hillage and Pollard (1998) who, besides identifying 'knowledge, skills and attitudes', emphasized the importance of being able to present these effectively to employers. Yorke's reference to 'achievements' is significant because it emphasizes the need to be able to give examples of our experience and things we have done. In other words, it is not enough to say that we possess employability assets: to be convincing (and employable), we need to show examples that demonstrate we possess them.

Talking about relevant experience, and showing how it demonstrates our employability, requires reflection. It is only by thinking about our experiences that we can fully appreciate their significance and can learn from them (Knight and Yorke 2004). Reflection can therefore help us identify what we are good at, and it can also show us where we have made mistakes or need to do better.

Reflection and evaluation are key elements of the 'CareerEDGE' model of employability proposed by Lorraine Dacre Pool and Peter Sewell (2007, cited in Sewell and Dacre Pool 2010) (Figure 1.1). This widely used and respected model emphasizes the importance of attributes relating to self-esteem, self-confidence, and self-efficacy. Self-confidence in this context refers to the ability to present oneself with assurance. In discussing their model, Dacre Pool and Sewell explain that as well as giving people confidence, self-esteem also helps them

Figure 1.1 The CareerEDGE model. (Sewell, P. and Dacre Pool, L. (2010) Moving from conceptual ambiguity to operational clarity. Employability, enterprise and entrepreneurship in higher education. *Education and Training*, 52 (1). Bingley: Emerald. pp. 89–94. <http://www.emeraldinsight.com/journals.htm?issn=0040-0912&volume=52&issue=1&articleid=1838995&show=abstract>)

to be realistic in their self-evaluations and willing to do what is necessary to make good any deficiencies.

 The CareerEDGE model also highlights the need for emotional intelligence, a concept made popular by Daniel Goleman in his book of the same title (1995), which we will revisit in Chapters 2, 6, 8, and 12. The model also includes the need for career development learning, which we discuss in Chapters 2, 9, 10, and 11.

We like the way that the model makes the different elements and processes for employability easy to understand and remember, and also its emphasis on self-efficacy, self-esteem, and self-confidence. However, although these are indeed helpful to have for employability and are also enhanced through the process of experience and reflection, it is important not to make these attributes – especially positive self-esteem – dependent on success in the employment market (or for that matter in other areas of life). Rather, we believe it is good to try to develop an intrinsic sense of personal self-worth. This means seeing value in the things that make you unique and special.

We will return to this model in Chapter 2, where the various CareerEDGE elements become clearer as you complete a questionnaire.

About employability and employment

During your time at university, a key focus is likely to be on achieving a good degree. Perhaps you have already thought about the final result that you are aiming towards, and are hoping to achieve an Upper Second (2:1) or even a First Class degree classification. There is no doubt that finding out what you need to do, aiming high and planning how to achieve such good results is a sensible way of approaching your studies, not least because for many jobs, having at least a 2:1 degree is necessary for you even to be considered.

This said, when it comes to developing your overall employability, success in your degree is only one part of the equation. Indeed, employers and graduates with whom we have spoken have all emphasized that to be successful in gaining graduate employment, you have to be able to show much more than just the paper qualifications that you have gained at school, college, and university. So the aim of this book is to help you understand the various assets that employers are looking for, and to give you the tools to develop them during your course.

You are likely to be aware that for the past few years, unemployment rates in general have been fairly high. In the three months leading to April 2012, the rate of employment in relation to those of working age was about 70% (IDS 2012). The implication for graduates looking for work is that there is significant competition in the graduate labour market. According to IDS, there were 46 applicants for each graduate vacancy in 2011. This may appear to present a depressing picture, but we believe that even in such difficult times, with the right mindset you can find and make the most of opportunities. Moreover, not all the news is gloomy. There is evidence that in the ten years leading to April 2011, graduates earned on average £12,000 more a year than people without degrees (Office for National Statistics 2011)

Your goal then should not just be to get a good degree, but also to learn how to demonstrate to employers that you are the employee they need. In order to do this it is important to understand what employers really want. To find this out for ourselves, we have talked to many employers, large and small, as well as to agencies, taking advice as to what employers are really looking for when they recruit graduates. We have also talked to present and ex-students about their experiences of developing their employability, and getting that important first job.

A useful starting point is to examine research findings conducted on behalf of the Chartered Management Institute (CMI) by Woodman and Hutchings (2011), whose survey findings are based on responses from more than 500 managers. In answer to the question 'What do managers look for when recruiting young people?', you may be surprised to see that 'personal presentation' has a bigger impact on recruitment decisions than 'academic achievements' (Figure 1.2).

As you read through this book you will begin to see that your academic achievements, however good, are just part of the package that employers are looking for. And, although a good degree outcome is evidence that you have the academic skills needed for the area of work for which you are aiming, employers are also looking for other, more generic skills (see Figure 1.3).

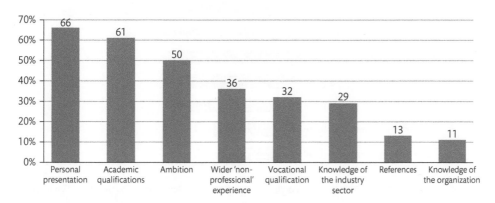

Figure 1.2 Factors with the biggest impact on recruitment decisions about young people. (*Tomorrow's Leaders*, Woodman and Hutchings, Chartered Management Institute, 2011.)

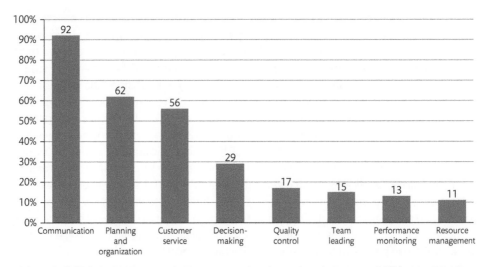

Figure 1.3 Skills that managers most want young people to have when they start work. (*Tomorrow's Leaders*, Woodman and Hutchings, Chartered Management Institute, 2012.)

You will note that the first two of these skills are actually the kind of skills that we need to succeed in life in general. Unlike IT skills, for example, they are 'timeless'. Developing these skills will not only assist you in getting your first job, they will ensure that you succeed in it. They are skills worth developing as soon as possible as they will also help you to succeed in your university career, and we will be covering these in more detail later in the book.

In the same survey, when asked to assess young people's skill levels across a range of different areas, managers were far from being impressed, awarding average scores of 'good' only to IT literacy skills, 'adequate' to one other skill, and below adequate to all the others (Figure 1.4).

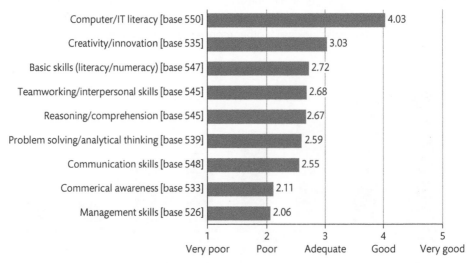

Figure 1.4 Assessment of young people's skills. (*Tomorrow's Leaders*, Woodman and Hutchings, Chartered Management Institute, 2013.)

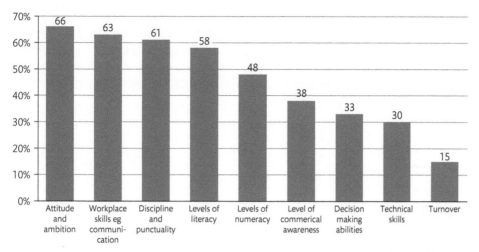

Figure 1.5 Problems faced when recruiting young people. (*Tomorrow's Leaders*, Woodman and Hutchings, Chartered Management Institute, 2014.)

With regard to weaknesses observed when recruiting young people, the same survey identified key problems relating to mindset ('attitude and ambition'), and workplace skills such as communication, including literacy (Figure 1.5).

Note also the high level of importance employers place on discipline and punctuality. It is perhaps an issue for 'Generation Y', and as lecturers we are often surprised at how many appear to feel that poor punctuality is acceptable. As our case study in Chapter 2 shows, it is important to realise that such behaviour is often perceived as a lack of self-discipline, courtesy, and motivation, and that employers regard this very negatively.

Perhaps this is one of the areas you could start developing now. Being punctual, and having a disciplined approach to assignments and other work will improve your study experience and be excellent practice for work. In fact, in addition to undertaking actions to improve your skills, we recommend that as you work through this book, you think about the various aspects of employability and how well you measure up to them. As we explained when discussing the topic of employability more generally, such reflection is important, as it can help you to identify what you need to do to improve. The following may give you an opportunity to think about something you may not have given much thought to previously.

 Reflection

Are punctuality and time keeping problems for you? Can you identify the reasons? What immediate steps could you take to improve them?

Jot down your thoughts on this and revisit them after reading how to keep a learning log in Chapter 2.

What will distinguish you from others may be some of the less clearly specified attributes that employers are seeking and it is important that you start developing and producing evidence for these, starting from now.

Reed and Stoltz (2011) conducted research into the attributes that employers really want from their employees, but do not always state in their job adverts and specifications. Their research revealed that top of the list for most employers is hiring people with the right 'mindset'. This means people who have a positive, 'can do' approach to work and life. We will cover this further in Chapter 2, but in order to give you a flavour, here are the top eight mindset qualities reported by Reed and Stoltz:

- Honesty
- Trustworthiness
- Commitment
- Adaptability
- Accountability
- Flexibility
- Determination
- Loyalty.

 Reflection

- Are you surprised by any of the mindset qualities desired by employers?
- How many of these qualities do you have?
- How would you be able to develop any in which you feel weak?
- How would you be able to prove to someone that you had these qualities?
- Keep your initial thoughts on these by you for use in Chapter 2.

You will see that the issue of trustworthiness features very highly in the interviews with at least one of our employers later on in this book.

Question

Do you see links between any of the above mindset qualities and the elements of self-efficacy, self-confidence, self-esteem, and emotional intelligence which feature in Dacre Pool and Sewell's CareerEDGE model?

You should now have a basic appreciation of the 'bundle' of qualities and skills you need to be able to demonstrate to employers. It will take time to build up convincing evidence and to undertake the necessary learning, so you need to consider the small steps that you will take on your way there. Each of the steps you take will also add to and build your confidence.

Leaving things to the last minute is not a good idea. As with revision or with assignments, this will only leave you in a panic and produce less than satisfactory results. Moreover, you might be surprised at how early in your academic career employers are interested in trying out students. Some use summer internships or even one-year placements as part of their long-term recruitment strategy.

Such work experience will give you some of the best opportunities for developing skills that employers are looking for, and give you examples to talk about in your future job applications

Case study

NOTE: The student we spoke to for this case study prefers to remain anonymous so we will refer to her as Kate.

Many employers visit universities to talk to students at the **start** of their first and second years at University, and to offer internships during the following summer holidays. Kate initially hesitated to apply for an internship in her first year, which was for three months in another country, the other side of the world. However, the company was so impressed with her eventual application that they covered the costs of flight and accommodation, and also paid a salary. The student had an excellent experience with the company and is in no doubt that the experience gained and the things learnt were key factors in a successful application for an internship with another prestigious company for the following summer. This company too gave excellent training and interesting projects to complete during the internship and also paid a substantial salary.

and interviews. It is therefore important to be alert to opportunities and to gather as much evidence of your employability as possible, right from the beginning of your course.

Working through this book

We have three important goals in writing this book. The first is to help you develop awareness of the assets you need to be successful in seeking and being effective in employment. Our second goal is that, using this awareness, you should learn how to present yourself effectively to employers, giving them persuasive examples of when you have demonstrated these assets. Our final goal is that you should come to understand how well you measure up to the expectations of employers, and to identify and undertake actions to help you improve.

It is important that you are honest with yourself about your strengths and weaknesses and that you take pride in what you do well. At the same time you should not miss opportunities for further improvement, and should treat your weaknesses as an opportunity for growth. Remember that overcoming weaknesses can provide evidence to employers that you have the right 'attitude' or 'mindset'. We would like you to be brave and take risks. Treat any failure as an opportunity for further learning. As Dewey noted (cited in Harris 2011, p. 15)

> Failure is instructive. The person who really thinks learns quite as much from his failures as from his successes.

Key areas we will be asking you to reflect on throughout the book are:

- Learning about yourself.
- Learning to work with others.
- The evidence you can provide of your graduate assets for employers.

What do you think now?

Having worked through this chapter, have you revised your opinion on any of the questions above? How about your classmates? Have any of them changed their opinions?

 Project

Your tutor will give you further guidance on how to work through the project tasks. The material we provide below summarizes the tasks and links them to other parts of this book.

Identify whether or not you have a clear career in mind

Research into employer requirements

(a) If you have a clear career in mind, focus on the requirements of that area.

(b) If you do not have a clear career in mind:

 - Check on areas of skills shortage.
 - Check what general requirements employers specify.
 - Do the 'selecting from options criteria' exercise (Table 2.7) towards the end of Chapter 2. This will help you to develop a clearer sense of what you do or do not want to do.
 - Visit your institution's Careers Service. They can give good advice and offer support in helping you choose a career which suits you.

Prepare for teamwork

Think about times you have worked in teams. What were you good at? What were you not so good at? Have a look at Belbin's team roles in Chapter 6.

(a) Try and identify the kind of team member you are.

(b) Try and identify what other kinds of team members you need to work with in order to be part of a broadly skilled team.

Keep a note of all your thoughts on the above.

Further reading

Harris, R. (2011) *The Confidence Gap. A Guide to Overcoming Fear and Self Doubt.* Boston: Trumpeter Books.

Reed, J. and Stoltz, P. G. (2011) *Put your Mindset to Work. The one asset you really need to win and keep the job you love.* London: Penguin Books Ltd.

Yorke, M. (2006) *Employability in higher education: what it is – what it is not.* York: The Higher Education Academy. <http://www.heacademy.ac.uk/assets/documents/tla/employability/id116_employability_in_higher_education_336.pdf> (accessed 26 April 2013).

2

Employability audit, learning logs and portfolio-building

Learning outcomes

By the end of this chapter you should:

- Understand the principles of Personal Development Planning (PDP).
- Have completed an employability development questionnaire, identifying your level of confidence regarding key employability assets.
- Have planned strategies and actions to address areas for development.
- Have begun to gather evidence of your employability assets for your portfolio.
- Have started the process of career planning.

What do you think?

- How early in your university career do you think employers might start considering you as a possible intern or employee?
- When is the right time to start seriously thinking about the specific employment you want to gain?
- When is a good time to start gathering evidence of your employability assets?
- How relevant is what you do on a weekly basis to your final employment?
- How important is it for you to be self-confident and believe in your own effectiveness?

The following case study is based on an interview with a real employer who wanted to remain anonymous, so we have changed his name.

Case study

Mark recruits a lot of graduates, so his views about their performance at interview are worth noting, even if they make for uncomfortable reading. Mark works for a company that offers interior design services for large-scale overseas projects involving, for example private villas, universities, airports, and hospitals. During recent years they have experienced significant growth and now employ about 250 employees. Their services include, in addition to interior design, procurement and installation of materials, for example fitting out airport counters or ordering and fitting the carpet and upholstery for villas. Roughly

(continued...)

60-70% of the company's employees are graduates, needed to fulfil a range of business functions such as administrators, various procurement roles, and project managers. Mark finds that many applicants for these positions are not well prepared for their interviews.

> With recent appointments we've struggled to fill the vacancies. I think the candidates seem to lack a way of portraying their skill sets and their qualifications and their ability to fulfil the role that we're trying to employ them for. We find that the people who come to interview are very poorly prepared, are very casual, have done very limited research, and don't portray themselves very well. One of the questions that we use in interviewing is: 'Give me five words that describe yourself'. Good candidates come up with words such as 'honest, hard working, fair', and easily answer (with) five good words about themselves. But you have people who say: 'Err, well I'm sociable. I quite like going down to the pub with my colleagues', and then they get stuck. All we want is five words and they can't grasp that concept, of being precise, and concise. And they just deviate and struggle to find even five.

Introduction

Perhaps Mark is being a little harsh. Faced with unexpected questions, it can be hard to express ideas with clarity and precision, and talking about ourselves can seem especially difficult. However, this is exactly what we have to do when we walk into an interview room, so knowing what to expect and having thought how to respond is a major part of performing well at interview. And it is not just at interview that you will need to be able to describe your employability assets convincingly: in online application forms, CVs, and cover letters, you will need to give a powerful account of yourself in writing.

Showing you how to present yourself effectively in this way is an important goal of this book, but it is not enough simply to know a few self-presentation tips. Developing your employability starts by being aware of what employers want and understanding how well you match their requirements. This means identifying your strengths and knowing how best to tell employers about them, and also being aware of your weaknesses and planning actions to improve them. This is what is meant by Personal Development Planning (PDP).

 In this chapter you will learn more about PDP and the assets that are important in employment. You will be able to assess your development needs by using a self-assessment tool developed by Lorraine Dacre Pool and Peter Sewell, which is based on their CareerEDGE model which we presented in Chapter 1.

You will also see how learning logs can be used to record experiences, thus helping you to develop a realistic awareness of your strengths and weaknesses. You can then develop a plan of action to address those areas that you find difficult. Finally, you will make a start on career development activity, using criteria to help you identify suitable potential career paths.

Many people find the process of PDP difficult. This is partly because reflecting on their own performance may not be something they have done before and would not usually choose to do. Another important reason is that thinking about weaknesses can be painful. For example, if I have to face up to the fact that I do not have good planning and organization skills, or that I have difficulty working in teams, I might worry about what this says about me as a person. Something that can help you overcome such feelings is understanding that everybody has areas in which they need to improve. Moreover, skills involving organization and teamwork – or indeed other generic employability skills – are harder than many people realize, so it is not

surprising if you find them difficult. By being honest in your self-assessment, you are more likely to seek out and make the most of opportunities to improve. Moreover, we believe this will lead to important feelings of confidence and self-esteem, as is evident in the following reflections by three students after they had completed a project designed to boost their employability.

- [D]uring this module my ability to work with others has developed massively, and I found that I actually liked working with others.
- I have been able to learn more about myself, about being flexible and able to work, study and do this project.
- I have been able to balance my home life, work obligations, university workload and social life successfully throughout the semester, which has been the most challenging skill I developed.

Personal Development Planning (PDP)

PDP is undertaken in several stages:

- First, you need to identify and record evidence of the knowledge, skills, and mindset qualities that make you employable (your employability assets).
- Second, reflect on those assets and recognize areas where you have strengths and where you need to improve.
- In the next stage you plan what you are going to do to improve areas of weakness and to build further your strengths.
- Because PDP is an ongoing, repeated process, having identified suitable actions you will then put these into practice and, in the light of new experience, reflect further and make new plans.

This process mirrors Kolb's (1984) learning cycle, where you start by having an experience, then reflect on it, work out what can be learnt from that experience and then apply it when engaging in new experiences. You may have met Kolb's model of learning already but we present a version of it in Figure 2.1 in case you are not familiar with it.

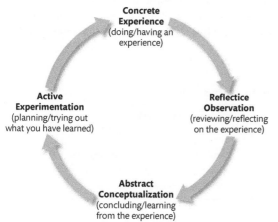

Figure 2.1 Learning cycle. (© 2005 The University of Leeds (Clara Davies & Tony Lowe).)

The importance of mindset

In Chapter 1, we explained that certain skills are important for your employability, but that having the right mindset and being able to provide evidence of this is also crucially important. It is no coincidence that the key words that Mark mentioned as his examples relate to mindset rather than to specific skills or knowledge.

In 2003, James Wilkinson (one of the authors of this book) conducted research into employers' views on graduate employability. Analysing their responses to open questions about the kind of things they looked for during the interview, James and his colleagues counted the number of words the employers used to describe various types of employability asset (Figure 2.2). They discovered that most of these words referred to what they interpreted as 'personal attributes', more even than for skills.

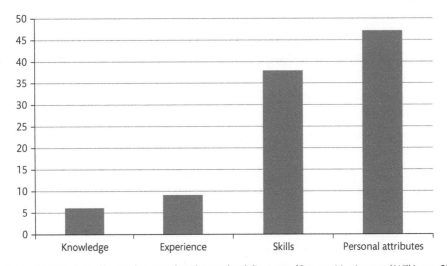

Figure 2.2 Words used by employers to describe employability assets. (Greaves, Mortimer and Wilkinson, 2004.)

Interestingly, the four most often mentioned words relating to 'personal attributes' are similar or even identical to the top eight words later identified as elements of 'mindset' by Reed and Stoltz (2011) in a much larger study (see Table 2.1), which we mentioned in Chapter 1.

Table 2.1 Personal attributes and mindset qualities.

Greaves et al. (2004)	Reed and Stoltz (2011)
motivation, self-confidence	determination
truthfulness	honesty, trustworthiness, accountability
adaptability/flexibility	adaptability, flexibility
	loyalty, commitment

Seeing these qualities as belonging to mindset is significant because whereas personal attributes may be difficult to change, aspects of mindset may be easier to do something about.

In particular, several of these mindset qualities have a profound effect on how well people perform the various skills.

Self-efficacy

In Chapter 1 we introduced the concept of self-efficacy, which we explained refers to the belief people have in their capabilities across different areas of activity (Bandura 2012). An individual's performance is significantly affected by how good they are at motivating themselves and this has been linked to their self-efficacy beliefs. Self-belief may vary across different areas, for example your self-belief may be different concerning your abilities in academic subjects, such as Maths or written English, or in other aspects of life such as driving a car, swimming, losing weight, or keeping fit. According to the theory, where individuals have strong self-belief, they appear better able to regulate their internal, emotional states and are not put off from trying again if they encounter setbacks. In fact they may see these as potential learning opportunities. This strong self-belief gives them strong reserves of persistence and tenacity and they refuse to give up, even in the face of difficulties or setbacks. For fairly obvious reasons, such qualities are highly sought after by employers, so self-efficacy is believed to be of crucial importance for graduate employability (Knight and Yorke 2004, Dacre Pool and Sewell 2007).

Bandura proposes that people's beliefs in their capabilities are developed in various ways. This includes their experience in mastering a particular skill. If success comes very easily, they may get used to getting quick results and become discouraged if they subsequently encounter failures and setbacks. He therefore argues that to develop 'resilient self-efficacy' (p. 13), individuals need to have experience in overcoming obstacles for which they have had to keep persevering. We believe that if you follow the project-based approach with this book, it should give you plenty of opportunities to experience achieving goals through hard work and persevering in the face of difficulties.

Another important way of developing self-efficacy is by seeing others succeeding as a result of trying hard over a prolonged period of time. This is why it is good to talk with people who have succeeded in this way.

 In Chapter 10 we introduce you to Grace, a graduate who talked with others who had been successful in getting onto one of the graduate schemes in which she was interested.

Because strong self-belief acts as a kind of self-fulfilling prophecy, persuading people to believe in themselves helps them to keep trying in spite of difficulties. This is why we are keen to persuade you to believe in yourself! If this sounds simplistic, you should remember that this principle features prominently in sports psychology and coaching.

Finally, self-efficacy beliefs are affected by physical and emotional states. Keeping oneself healthy in mind and body helps one to have stronger, more positive self-belief. This is why it is important also to be aware if you are depressed, stressed, or 'run-down' and to do things that will help address these issues.

'Fixed' and 'malleable' self-belief

It is important not to imagine that only certain individuals can ever have such positive self-beliefs: we can all develop them. In this respect, it is helpful to be aware of work by Carol Dweck (1999, cited by Knight and Yorke 2004) which provides evidence that some people have a 'fixed' self-belief, thinking that their abilities, such as IQ, are in some way predetermined and cannot be changed. Such individuals seem more likely to succumb to negative internal emotional states and to give up trying when the going gets tough. For them, setbacks merely confirm their fixed belief that they are simply no good, and cannot improve. In contrast, people with a 'malleable' self-belief think that they have the capacity to develop, so even if they lack certain skills, they believe that they can acquire these through learning and hard work. Reed and Stoltz (2011) likewise refer to Dweck's work, emphasizing how important it is to believe in the possibility of growth through personal effort.

Grit

Reed and Stoltz use the catchier word 'grit' to summarize the ideas concerning positive self-efficacy and malleable self-belief. For them, grit is one of three key elements of the mindset needed to secure and be successful in work.

Goodness and empathy

Reed and Stoltz also identify a mindset that allows us to work and get on well with other people. This time they use the adjective 'good' to convey qualities such as 'honest', 'moral', 'dependable', 'caring' and 'good' (in the sense of 'striving to be a good person with and for others') (p. 47). Being good in these ways also affects the esteem with which you are held by others, and this in turn builds your own self-esteem.

In fact, much of this behaviour relates to empathy, for if we understand and respect the feelings of others, we are more likely to exhibit the above qualities. Being aware of other people's feelings also requires attitudes of sensitivity, as well as communication skills, not only the ability to get our message across but also being alert to the spoken and unspoken signals that come from others.

Openness

The third key mindset quality is openness, which Reed and Stoltz refer to as having a 'global' outlook. This means being open to people, opportunities, and issues in the wider world, not simply limiting yourself to who and what is in your immediate vicinity. This includes having the ability to develop and draw on a network of people from many different contexts in your life. These people can help you with immediate, short-term goals as well as long-term goals. It also means being aware of ideas and issues that are relevant to the wider context in which you live and work. Keeping yourself well informed helps you to be receptive to valuable new ideas, to be alert to potential threats and to be aware of and make the most of opportunities.

Emotional intelligence

 In Chapter 1 we introduced you to the concept of emotional intelligence. Most if not all of the key mindset qualities discussed also contribute to our emotional intelligence.

In his book *Emotional Intelligence. Why it can matter more than IQ* (1995), Goleman shows how an understanding of the way our brains work can help us manage our feelings towards people and events. This in turn can also make us more empathic, better able to respond to and influence people who are important to us, in both personal and professional spheres. He cites research by Robert Kelley and Janet Caplan (1993) into the skills and qualities that make for 'star' performance. Their work suggests that the best performers at work excel in their abilities to communicate, build networks, and establish trust, and these contribute significantly to their skills in:

- effectively coordinating their efforts in teamwork;
- being leaders in building consensus;
- being able to see things from the perspective of others, such as customers or others on a work team;
- persuasiveness;
- and promoting cooperation while avoiding conflict.

(Goleman 1995, p. 163, citing Kelley and Caplan 1993)

As you begin to understand what employers are looking for, you may have already started to think about how you measure up to their expectations. In the next section, we introduce an employability development questionnaire that will help you to understand more fully the various employability assets that employers are looking for and will explain how to assess your own performance as part of your PDP.

Assessing your employability

Assessing your own level of competence in ways that make sense for employability is quite hard. It can be difficult to be objective about our own skills and aptitudes. Sometimes people are not aware how good they are, possibly because they are conscious of the difficulties involved in performing well and the desire to achieve 'perfection'. Alternatively, lacking an awareness of the issues involved can mean that others overestimate their abilities.

The following self-assessment exercises are reproduced by kind permission of Lorraine Dacre Pool and Peter Sewell and the University of Central Lancashire, and are based on their 'CareerEDGE' model of employability which we described in Chapter 1. They are designed to help you evaluate your employability assets, to identify development needs, and plan how you will address these. In the previous sections we have drawn attention to several of these, particularly mindset, that are significant. It is important that you reflect on how well your own employability assets reflect these mindset qualities and skills.

 ### The University of Central Lancashire: CareerEDGE Employability Development Profile Questionnaire

Please respond to the following statements. This is a personal development tool that should help you and your academic/careers adviser to identify possible areas for development over the next year. It is therefore important that you try to answer as honestly and accurately as possible.

		1 Strongly disagree	2 Disagree	3 Slightly disagree	4 Neither agree nor disagree	5 Slightly agree	6 Agree	7 Strongly agree
Career Development Learning								
1)	I know what kinds of work would suit my personality	1	2	3	4	5	6	7
2)	Apart from money, I know what I want from my working life	1	2	3	4	5	6	7
3)	I know where to find out information about jobs that interest me	1	2	3	4	5	6	7
4)	I know what I want to do when I finish my degree	1	2	3	4	5	6	7
5)	I know what is required for me to successfully secure the sort of work I want to do	1	2	3	4	5	6	7
Experience Work/Life								
6)	I have a lot of work-relevant experience	1	2	3	4	5	6	7
7)	I can explain the value of my experience to a potential employer	1	2	3	4	5	6	7
Degree Subject Knowledge								
8)	I am satisfied with my academic performance so far	1	2	3	4	5	6	7
9)	My academic performance so far is in line with my career aspirations	1	2	3	4	5	6	7
Generic Skills								
10)	I have good oral communication skills	1	2	3	4	5	6	7
11)	I am good at making presentations	1	2	3	4	5	6	7
12)	I am confident about my written communication skills for various audiences	1	2	3	4	5	6	7

		1 Strongly disagree	2 Disagree	3 Slightly disagree	4 Neither agree nor disagree	5 Slightly agree	6 Agree	7 Strongly agree
13)	I work well in a team	1	2	3	4	5	6	7
14)	I work well independently	1	2	3	4	5	6	7
15)	I am good at solving problems	1	2	3	4	5	6	7
16)	I have good planning and organization skills	1	2	3	4	5	6	7
17)	I manage my time effectively	1	2	3	4	5	6	7
18)	I am always open to new ideas	1	2	3	4	5	6	7
19)	I am prepared to accept responsibility for my decisions	1	2	3	4	5	6	7
20)	I have a good understanding of how businesses operate	1	2	3	4	5	6	7
21)	I am a confident user of information and communication technologies (ICT)	1	2	3	4	5	6	7
22)	I am satisfied with my level of numeracy	1	2	3	4	5	6	7
23)	I am good at coming up with new ideas	1	2	3	4	5	6	7
24)	I am able to adapt easily to new situations	1	2	3	4	5	6	7
25)	I can pay attention to detail when necessary	1	2	3	4	5	6	7
	Emotional Intelligence							
26)	I am good at working out what other people are feeling	1	2	3	4	5	6	7
27)	I am good at knowing how I am feeling at a given time	1	2	3	4	5	6	7
28)	I am able to manage my emotions effectively	1	2	3	4	5	6	7

	Items	Range	My Score
Career Development Learning	1–5	5–35	
Experience Work/Life	6–7	2–14	
Degree Subject Knowledge	8–9	2–14	
Generic Skills	10–25	16–112	
Emotional Intelligence	26–28	3–21	
Total Score	1–28	28–196	_____

(continued...)

Now take a look at the way you have scored the questionnaire. For the items you have scored with a 6 or a 7, would you be able to demonstrate your abilities in these areas and give some good examples of these? In the exercise provided online choose one of these highly rated areas and write how you would explain this to a potential employer.

Now take a look at the items you have scored with a 1, 2, 3, or 4. What action could you take to help you increase these scores to a 6 or 7? In the online exercise choose one of these items and write your action plan in the box provided.

Learning logs

The self-assessment exercise is an important first step in helping you to evaluate your performance across a range of important employability assets, and to plan how you will address development needs. Many of these needs will be addressed in various ways throughout your time at university, for example via a range of individual and group work assignments involving inquiry, teamwork, and presentation both on paper and in front of an audience. In fact if, as we recommend, you are using the project-based approach in studying this book, this will give you opportunities to practise and develop most of these employability assets.

As we explained earlier when discussing the way we learn through experience, it is important that you devote time to reflecting on your performance as you experience and develop these skills. A good way to do this is by keeping a learning log, and throughout this book we will refer to this often, asking you to record in it, reflect on it, learn from it. Such reflection requires good analysis of the behaviour that you experience, both of yourself and others, and of the change and growth that you make through this journey. Analysis requires asking lots of questions, and a helpful way of remembering what questions to ask is summarized in the well known poem *The Elephant's Child* by Rudyard Kipling (1865–1936):

I keep six honest serving-men
(They taught me all I knew);
Their names are What and Why and When
And How and Where and Who.

A learning log is essentially an informal way of recording your experience, not only describing it but analysing it by asking the important and difficult questions. It is very personal to you. Your log is not an 'academic' piece of work, so it will not be judged for grammar, spelling, or format. If you prefer, you can be the only person ever to look at it, although we would recommend that you consider sharing it with a mentor or other 'stakeholder' as this will give you different perspectives and deeper insights.

Examples of learning log formats

Students always ask for examples of learning log formats. A simple search would provide you with many different formats, or you could devise your own. For example, you could use Kipling's questions (Table 2.2):

Table 2.2 Learning log based on Kipling's 'Honest Serving-Men'.

What	Why	When	How	Where	Who

Table 2.3 Learning log based on Kolb's Learning Cycle (1984).

Date	Concrete experience	Reflective observation	Abstract conceptualization	Active experimentation
	What did I DO?	What did I OBSERVE?	What did I THINK? (So what?)	What is my PLAN for future action (What next?)

Or you could base your log on a learning cycle (see Table 2.3 and Chapter 3) that you find useful, for example Kolb's (1984).

But, do not let the format constrain you in any way. The important thing is that you make some form of record whenever you have had a new or significant learning experience. This may include, for example, problems you have had (solved or unsolved) or how you felt about tackling a new skill. Do not limit yourself to formal lecture or seminar situations. If you have experiences when doing part-time work, volunteering, or in a social setting they should be included too.

The kinds of things you are asking yourself are:

- What happened?
- How did I feel about it?
- What did I think?
- Did it go well, or badly?
- What did I learn?
- What will I do, or not do, in future?
- Who might help me to do better in future?
- What am I able to do now that I could do before?

Your attempt to answer these questions when you have encountered a difficulty (or a success) shows that you are critically reflecting on your learning experiences and these reflections will contribute significantly to your PDP.

One thing that might not immediately strike you is that you can reflect on any learning event. It does not necessarily have to be one you have directly experienced.

Learning would be exceedingly laborious, not to mention hazardous, if people had to rely solely on the effects of their own actions to inform them what to do. Fortunately, most human behavior is learned ... from observing others.

(Bandura 1977, p. 22 in Smith, M. K. 1999)

Table 2.4 Example of student reflective log.

Reflection point	Record
What happened	They arrived late. One member was missing
I felt	A bit annoyed as we all had to wait for them to start
I thought	They should have organized themselves more carefully. They'd had plenty of warning
Did it go well, or badly?	It was a bit disorganized, and they ran out of time. No one was ready to cover the material of the missing member
I learnt	That timing and punctuality is very important. It means you are calmer and more in control and your audience are more receptive
	Also it is very important not to let down the rest of your team. It's also vital to communicate effectively, including when there are problems
What I will, or will not, do	I will discuss the importance of these issues with my group. I will also make sure that if one of our members is missing we have their material so we can cover it
	Should I mention to the other group what I felt about their performance?

Therefore, for example, if you were invited to watch a presentation given by other students you may find you wish to reflect on how their performance went (Table 2.4).

One of the key values of a learning log is that you can revisit events that took place a few weeks ago. Progress on developing a skill or change in attitude very rarely happens all at once, so looking back can give you a longer-term perspective on where you are now. On doing this you may find that you are now 'on top of' something that was worrying you, which should encourage you for the future. You may on the other hand see that you have failed to follow up on something that you thought was important.

Try to make writing logs and asking yourself such questions part of your routine (perhaps set up a reminder on your computer or phone). Useful questions to ask yourself include:

- Is anything different since I wrote this?
- Have I made any progress?
- Do I need to do anything further to tackle this issue?
- Who might help me to do so?
- How can I use this as evidence for my PDP?

Making it a habit

You might be thinking this is a lot of effort and is it really for me? The answer to this is 'Yes, yes, yes'. We know that not everyone is organized enough to keep logs regularly. To start with you may find it difficult, or even 'artificial' to reflect on your learning, but as with anything practice makes perfect. It is not just the finished product that is useful but the process itself. This is beneficial because writing up reflections on your learning forces you to think about the things that are giving you problems and, as you do this, start thinking about the solutions. If

you persist with your log you should have a valuable tool for change available to you and, as already noted, change is an important part of learning.

Miller, Tomlinson, and Jones (1994) identify the changes associated with reflection as listed in Table 2.5.

Table 2.5 Changes achieved through reflection (Miller, Tomlinson and Jones 1994).

From	To
Accepting	Questioning
Intolerant	Tolerant
Doing	Thinking
Descriptive	Analytical
Impulsive	Diplomatic
Reserved	Being more open
Unassertive	Assertive
Unskilled communicators	Skilled communicators
Reactive	Reflective
Concrete thinking	Abstract thinking
Lacking self-awareness	Self-aware

If a learning log is to be a useful tool in your learning, then you must be strictly honest with yourself. As noted above your log – or sections of it – can be kept totally private, but we hope that as you develop confidence in your reflections, you may become more able to share them with others.

Starting to plan what career you want

As you completed the CareerEDGE Employability Development Profile questionnaire above, we guess that your scores in the 'Career Development Learning' section may have been quite low. If so, this may have alerted you to the need to start thinking seriously about your career plans, and perhaps also made you realize that you do not know how to go about this. One difficulty, as you will no doubt be well aware, is that there are many other pressing issues demanding your attention, a point made by Grace, one of the graduates we spoke to when researching this book and who we introduce properly in Chapter 10:

People are sort of focused on just getting used to being at university, ... figuring out what the best approach is to writing an essay and that kind of thing. ... I think for a lot of first year students, it seems like a long way away and they don't think that they need to think about it yet.

However, all the graduates we spoke with agree that it is helpful to develop a career focus from as early as possible. Andrew, another graduate we introduce later, is convinced that having a clearer idea of his eventual career focus would have helped him perform better as an undergraduate, and as he and Grace both found out after they graduated, getting ahead of the game is vitally important. They both admit that they could have done more to help themselves while in their first year, during which Grace believes that students should visit their Careers Department and make the most of its resources. These resources include electronic questionnaires that can help you match your skills and interests with a range of career options and explain what kind of work each one involves so that you can get a feel for whether it is right for you. There are also dedicated advisers on hand who in our experience are more than keen to help, though it is important to be aware that such human resources are probably stretched, and their help will be most effective if you yourself are proactive in doing your own research.

There are also numerous outside organizations that are very helpful. For example, Graduate Prospects provides information, advice, and opportunities to students and graduates in journals and directories as well as on its extensive website (<http://prospects.ac.uk>). This gives careers advice, including job hunting skills such as CV writing and interview tests and exercises, information about jobs and work experience, postgraduate study, different job sectors, and how to make the most of student life. We suggest several other sites at the end of this chapter, but we also recommend that you try searching for your own.

Our message, then, is that if you have not already done so, it is important to start thinking about your career as soon as possible. Developing a firm view about what you are going to do becomes increasingly important as you progress through your degree though as Grace found, her career intentions changed more than once during her time at university and afterwards, which is not at all unusual.

Alongside the formal assistance given by your university's Careers Service, your decisions can be based on observing the jobs of your extended family, family friends, and other acquaintances. Make the most of this opportunity to ask people what their jobs involve, how they got them, what assets they had which made them employable. At the very least this research might clarify for you what kind of job you definitely do not want.

 Activity

You can start entering notes into a table on the career planning activity that Grace and Andrew undertook during their time at university and also the advice that they offer. In Chapter 4 you will learn more about various employability-building activities and can add these to your notes. We suggest that you start by preparing a table as in Table 2.6 (we have included a suggested entry, inferring points from what Grace actually said so that it is more generally relevant).
Continue with new rows for each new activity.
For the 'What I will do' column, as well as seeing what Grace and Andrew have to say, try brainstorming ideas with fellow students and asking tutors, career advisers, or anybody else that you know who might have some valuable advice.

Table 2.6 Career planning activities.

Career planning activities mentioned	Benefits/points to note	What I will do
Thinking of pursuing a career in Law, have studied some modules in this	Worth considering, but I should also be flexible and prepared to rethink things	Consider careers linked to other modules studied on my course. Be flexible
Wonder if I can get something out of the part-time work I've been doing in retail	Should be at a higher level than I'm doing now or wasting my degree	

Grace's actions:

[O]nce I got to second and third year I started by looking at various schemes in retail and applied for a few in my third year of university, [but] I was also considering Law. I studied Family Law and thought I wouldn't mind pursuing a career in that, so then I did continue studying Law [on a postgraduate Law course] for another year and pursued Family Law further. I did work experience, gained quite a lot of work experience actually in lots of different areas of Law, and then I had another change of heart after I went through the whole recruitment process for Law. … [She applied for numerous legal traineeships but was unsuccessful.] Then I went back to thinking about Head Office Retail, so it's something I thought about, drifted away from a bit and now I've gone back to.

In fact Andrew argues that it is important to decide on your career much earlier than the second year, even going so far as to say that you should know before you go to university, because having a clear career focus helps you to engage better with your studies.

Personal Development Planning: identifying needs for further development and experience

In Chapter 1 we introduced Anna and mentioned the number of additional qualifications that she undertook alongside the main subjects she was studying, and how these helped to give her an edge over the competition. Being aware of the extra specialist knowledge and skills needed for a particular area means that you can research into where you can go to gain these skills and then start working on achieving them while at university. But in order to do this, you need to have started early to research career possibilities and undertake PDP.

When you reach the second and third years of your degree, and indeed after you graduate, the value of having started planning for your future as early as possible becomes clear. For instance, if you were to work in the field of accountancy, knowledge of Sage accounting software would be valuable. Or if you are interested in working for a company working in more than one country – and this includes many relatively small organizations as well as all of the larger ones – then you can make yourself much more attractive to a prospective employer if you have developed foreign language and intercultural skills while at university. This might include signing up for foreign language and intercultural

communication classes, but could also involve spending part of your studies at a partner university abroad or applying to do an internship or placement overseas. Your university's International and Placement Offices can tell you more about such opportunities, and give you information about European and other funding that you may be able to apply to for support while abroad.

Your PDP should also reveal a further major weakness relevant to most undergraduates, namely the lack of experience. Experience is so important because it is what provides evidence that you have the skills employers are looking for. And just in case you think that you can leave it until later to gain experience, it is worth reminding you about the competition: if when you graduate you do not have these additional qualifications and skills, as well as solid evidence of these in the form of experience, you must remember that somebody else will.

 As it is so important for your eventual employability, we devote much of Chapter 4 to discussing different ways for you to build up relevant experience.

Thinking through your career options

The need to build up experience is another reason why having a career focus is helpful, as if you know what you want to do after leaving university, you will also know what kind of experiences will be relevant. The good news is that there are many sources of help for identifying the most suitable career for you, notably your university's Careers Service and many websites, including Graduate Prospects which we have already mentioned. We strongly recommend that you make the most of these resources.

As a way of starting to think about possible career options, we also recommend that you use a method recommended to us by Peter Cobbe, a human resources coaching expert. This involves drawing up a table of criteria that are important to you.

 Activity

(1) Think about the possible career options open to you.

(2) Insert each one into a column heading, as illustrated in Table 2.7.

(3) Now identify all the things related to work that are important to you, as illustrated in Table 2.7.

(4) Think how likely it is that each of the job options identified under (1) will meet the criteria set under (3).

(5) Then, give each option a score on a scale of 1–10, where 10 has the highest likelihood of meeting your criteria and 1 has the lowest chance of meeting your needs.

Think about these options in the medium to long term.

Table 2.7 Reaching a balanced solution to inform your thinking.

CRITERIA that matter to me FOR EXAMPLE What does this option give me in terms of:	SCORING on a range between 1 and 10		
	Career Option 1 (e.g. HRM job)	Career Option 2 (e.g. train in PR)	Career Option 3 (e.g. Administrator)
Salary at entry			
Longer-term reward potential			
Interest and stimulation provided			
The security this option provides			
How effective it will be as a stepping stone			
Chances of further training			
Future impact on CV/career trajectory			
Working in a culture with nice colleagues			
etc.			
etc.			
etc.			
TOTAL SCORE			
TOP 6 scores			

Now total up the scores and consider what this tells you about your possible career choices.
Now highlight what you think are the Top 6 most important criteria on your list right now and check their scores. What does this tell you about what you should be aiming for?

Conclusion

In Chapter 1 we emphasized the importance not only of having practical skills, but also of having the personal attributes and mindset qualities which employers are looking for.

In this chapter we have discussed in more detail what these employability attributes are, and have given you the opportunity to score yourself on them as the first stage in your portfolio-building and PDP. We have also given some suggestions for how you can start identifying career options.

In the next chapter we will give you further guidance on how to reflect on your performance and record your learning on a regular basis.

What do you think now?

Having worked through this chapter, have you revised your opinion on any of the questions above? Why? How about your classmates? Have any of them changed their opinions?

 ## Project

Your tutor will give you further guidance on how to work through the project tasks. The material we provide below summarizes the tasks and links them to other parts of this book.

- Try and ensure the team you form meets the criteria covered under team roles in Chapter 6.
- Also consider having a team building game – read the relevant section in Chapter 6.
- Share with your team members your career aims.
- Share your research into employer requirements.
- You will over the course of the project be finding the answer to the question: what do employers want and how can you give it to them?
- Combine the research you have done individually so far and brainstorm further places you can look.
- Share out the different places to search.
- Allocate each member of the team to skim-read a couple of chapters in this book so that when you need specific information you will know where to find it.

Further reading

Bandura, A. (1997) *Self-efficacy: the exercise of control*. New York: W.H. Freeman.

Davies, C. and Lowe, A. (2005) *Kolb learning cycle tutorial – static version*. University of Leeds. <http://www.ldu.leeds.ac.uk/ldu/sddu_multimedia/kolb/static_version.php. (accessed 27 April 2013).

Goleman, D. (1995) *Emotional Intelligence*. London: Bloomsbury Publishing Plc.

3 Reflection and transferable skills

◉ Learning outcomes

At the end of this chapter you should:

- Understand different ways in which people prefer to learn (learning styles).
- Know your preferred learning style and be aware of how other styles may be more appropriate for some types of learning.
- Have learnt about techniques for researching and processing information, both at university and at work.
- Have started to write reflective logs in which you reflect on and identify learning needs for PDP.
- Know how to write up reports and minutes for meetings.

What do you think?

Does everyone learn in the same way?
Do you learn best by

- doing things;
- thinking about what you or others have done;
- following rules, principles, or theories; or
- adapting and applying theory to new experiences and circumstances?

Why do you think employers value volunteer work and contributions to social or sporting activities as well as work experience and placements?
What skills are you developing at university that will be valuable at work?

Case study

Nikhil is a first year student at one of the 'new' universities in the UK. Certain aspects of his childhood and upbringing have been significant in shaping his mindset and his drive to develop himself. First, his Hindu background has given him certain key values. These include respect for his elders and getting a good education. Second, he has been in a shop from a very young age and this has also motivated him to study hard and go on to university. Even if he does not get a different job afterwards, he believes the degree will help him by giving him expertise and skills to expand the family business.

(continued...)

Introduction

 In Chapter 2 we introduced Kolb's Learning Cycle, which implied that learning is a circular and repeated process.

Although you may associate learning with people telling you things, Kolb's theory strongly suggests that significant learning occurs when we have experiences, reflect on them, draw conclusions, and apply these next time we have a similar experience (Kolb 1984). The term 'lifelong learning' suggests that learning is not just confined to your school or student days, but that to be successful in your career (and life in general) you will need to continue to reflect on your experiences, evaluate your learning needs, and address them accordingly.

By way of example, the authors of this book have, between them, worked in a café, bank, gearbox factory, antiques business, recruitment agency, publishing house, medical research unit, library, and various colleges and universities. Moving from one stage in their careers to another has involved significant reflection on their various experiences along the way and led them to

- identifying employability assets;
- analysing strengths and weaknesses;
- recognizing development needs; and
- undertaking relevant training and qualifications.

While such chopping and changing might have seemed strange a generation or two ago, when 'jobs for life' were the norm in many countries, today being able to reinvent ourselves is not only an everyday reality but often a necessity.

 Activity

Ask your parents, other family members, and family friends about their employment history. How many of them are in the same job as when they left full-time study? How did they progress between jobs? How did they use what they had learnt in one job to improve their chances of getting another job?
Suggestion: Make a log of what you learn from their responses.

Understanding the process of learning: learning cycles and styles

There are several reasons why understanding the process of learning and learning styles is important for employability. Because you will need to keep on learning throughout your life, it makes sense to know how to do it effectively, whether or not you are in an academic

environment. Another important reason is that people learn in different ways, often referred to as 'learning styles' or as 'learning preferences', but they do not always learn in the way most suited to what it is they are trying to learn.

Understanding about the process of learning, and your own preferred style of learning can help you learn in the way that will be most effective for you, and which will suit the specific situation. An additional reason is that people's learning styles affect how they approach problem solving, carrying out tasks, and working on projects, so they can have a big impact on teamwork. Understanding about different learning styles can therefore help us understand differences in the way people behave in teams.

David Kolb's Learning Cycle, which we mentioned in the previous chapter, has been extremely influential as an explanation for how we learn through experience, and many authors have drawn on his theory. Graham Gibbs has adapted Kolb's ideas to produce his own cycle (Figure 3.1), which provides useful headings to guide our reflections on experience, our conclusions and the way we apply these, next time we have similar experiences.

Peter Honey and Alan Mumford have likewise drawn on Kolb's Learning Cycle when designing research and developing their own learning cycle and, linked to it, people's preferred learning styles (Table 3.1).

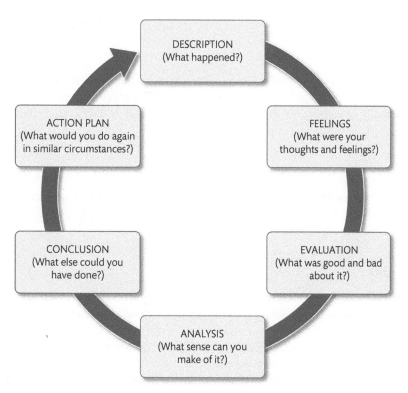

Figure 3.1 Gibbs' Reflective Cycle. (Gibbs, G., 1988. *Learning by Doing: A Guide to Teaching and Learning Methods*. Oxford: Further Educational Unit, Oxford Polytechnic.)

Table 3.1 Learning cycle stages and preferred learning styles (Kolb 1984, Mumford 1997 cited by Gallagher 2010).

Stages of Kolb's Learning Cycle (Kolb 1984)	Stages in Honey and Mumford's Learning Cycle	Honey and Mumford's Learning Styles
concrete experience	having an experience	'activist'
reflective observation	reviewing the experience	'reflector'
abstract conceptualization	concluding from the experience	'theorist'
active experimentation	planning the next step	'pragmatist'
(Kolb 1984)	(Honey and Mumford, cited by Gallagher 2010)	

To help you identify which of these styles you tend to use most in your learning, it is possible to download a questionnaire from the internet (http://peterhoney.com). However, we have provided you with a simple questionnaire, which should give you an indication of which category you fit into.

Activists

Activists like to learn by doing things, and love throwing themselves into new experiences. They get things moving but it can mean that they will take action before thinking through what might happen as a result.

Reflectors

Reflectors are more cautious than activists, preferring to observe and think about events and experience. They are thoughtful, keen to think through all aspects and consequences of problems and solutions before deciding how to act, but they might be slow to take action.

Theorists

As their name suggests, theorists want to grasp the theoretical relevance of actions. They like having theories, models, concepts, and facts, and they like to bring these together into a synthesis that provides a framework for their understanding. They dislike decisions and analysis based on subjective arguments.

Pragmatists

Pragmatists are practical in their approach and like to apply ideas to tasks and to the solution of problems. They can be impatient, preferring to proceed with the task in hand rather than have lengthy discussions.

Now look again at the version of Table 3.2 you completed and compare the numbers you circled with the learning styles that these predict in Table 3.3. In the right-hand column, give a score of 1 or −1 for each of the statements you circled (1 for the points you like, and −1 for the ones you do not like).

 ## Activity

In Table 3.2, circle the numbers to the left of the pairs of statements that correspond to the way you 'like' and 'don't like' learning. After completing the table, read the descriptions for Activists, Reflectors, Theorists, and Pragmatists, and check to see which learning style(s) you usually adopt.

Table 3.2 Learning style analysis.

	I like	I don't like
1	having space and time to think about what I have observed, before having to comment or act	having to take quick decisions
2	being able to see the relevance of any theory and how it can be applied	if there aren't obvious practical benefits and applications of what I'm doing
3	taking up opportunities and engaging in new experiences	having to read, write, and think things through on my own
4	tasks/learning activities with a clear structure and purpose	if there is ambiguity or a lack of structure
5	tackling problems head on	sitting in lectures
6	having opportunities to challenge and think critically	if subjective emotions and feelings are involved
7	being given opportunities to practise, with feedback from somebody with more knowledge and experience	if I'm not given clear guidelines
8	being given opportunities to evaluate events and experiences	having to provide leadership
9	making choices concerning activities, decisions or solutions according to concepts, theories, or principles	having to base actions, decisions, or solutions on intuitions rather than principles, theories, or concepts
10	learning through work or play with others	having to analyse and explain complex information
11	having plenty of time to do things	having to work to tight deadlines

Table 3.3 Key to learning style analysis.

Statement numbers	Learning style	How many I circled
3, 5, 10	Activist	
1, 8, 12	Reflector	
4, 6, 9	Theorist	
2, 7, 11	Pragmatist	

You may find that you use a balance of all or several of the styles, or that you usually adopt just one of the styles. Identifying your preferred learning style in this way can help you understand how you will learn most effectively. It should also alert you to possible gaps in your approach and encourage you to practise using other styles. For example, if you realize that you usually tend to reflect on things and hesitate to act decisively, maybe you need to practise taking more of an active or even a leadership role. Alternatively, if you are more of an active type, perhaps you need to be more reflective and to learn more by reading theory.

Other learning style models

You should be aware that there are many other learning style models. For example, you may learn things visually, remembering best what you have seen or read, or in a way that is more physical or 'kinesthetic'. If this is the case, you could look at the VARK model, whose initials stand for Visual, Aural, Read/write, and Kinesthetic (Fleming and Baume 2006). For more information about this and to access the questionnaire, the VARK website is at <http://www.varklearn.com/english/page.asp?p=questionnaire>.

Learning style or cultural programming?

Human behaviour and factors that may be causing it are complex. One problem with focusing on learning styles theory is that it may cause us to overlook other factors that could explain behaviour and learning preferences. For example, we suggested that theorists have difficulty learning in unstructured, ambiguous situations. In fact the same desire for structure has been noted among people from cultures high in 'uncertainty avoidance'. In research carried out in about 70 countries, Geert Hofstede analysed questionnaire responses from IBM employees and identified four (later more) so-called 'cultural dimensions', and one of these was uncertainty avoidance (Hofstede et al. 2010). We all face uncertainty and do things to reduce it but according to Hofstede's research, nationals from certain countries are likely to be especially concerned to avoid uncertainty.

 This topic is covered in more detail in Chapter 7.

 Reflection

Does it matter whether your need, for example, for structure is as a result of your learning style or cultural programming? Is it easy to alter either of them? If not, does an awareness of them help you to understand why others might find your style difficult to cope with? What can you and any team you are working in, do to make things easier?

Learning cycle or journey?

Although the various stages are repeated, we see learning as more of a journey (Figure 3.2) because we like the idea of progression.

How to Learn from your Experiences

RESULT
Was it positive/negative?

ANALYSE
What and Why and When
and How and Where and Who

EVENT
Any 'critical' incident
e.g. something
bad/good something
unusual something
interesting

REFLECT
What did I feel about it:
• Happy?
• Sad?
• Anxious?

DEVELOP STRATEGIES
Build up skills needed to
avoid future occurrences
Hone the skills which helped
a successful outcome
Discuss the situation with
mentor or others

Figure 3.2 A reflective journey.

Using key stages from the reflective journey (Figure 3.2) to guide your reflection

Table 3.4 provides a summary of the kind of things that you might write in your own learning log. In fact, you would probably give more space – perhaps half a side of A4 – to each of the entries and provide more detail. Our intention is to give a flavour of the sort of things that would be worth including. Recording issues like this not only helps you to reflect on the experience of teamwork but can also help you find solutions, as was commented by a student interviewed by James on the 'Combined Learning for Employability and Research' (CLEAR) project, identifying the benefits of keeping a learning log.

> [Y]ou looked at every difficulty, analysed it in different ways and then looked to find ways of improving on it which is also good 'cause it enables you to find solutions.
>
> (Student B, CLEAR project)

Locating, processing and communicating information

Your work so far should have led you to a deeper understanding of your approaches to learning and the skills and aptitudes you have. It is possible that you will have highlighted your communication skills as being either strong or weak, and you may have recognized that your written communication skill at university is one that can be transferred to the workplace.

 We noted in Chapter 1 that the ability to communicate is one of the key skills employers seek.

Table 3.4 Student A's log book.

Week	1	2	3	4	5
Event/diary entry/critical incident	Discussed project brief Analysed/broke down project into manageable elements	Discussed time plan for the project. Drew up a Gantt chart. C and D went off to the refectory together afterwards	C and D had not done anything. I told the tutor I did not want to work with them. Tutor said this was not possible: we must sort out differences and see it through. Team had big argument. Agreed everyone should identify ground rules for next time	Had a long discussion of ground rules. Ended by agreeing set of rules. C suggested we go to café together afterwards	We seem to be working better now
Result: positive/negative	Useful meeting Identified different tasks Allocated tasks	Another useful meeting	Really bad meeting. Tutor was no help – why won't he sort things out?	Still not making much progress but it's good to have ground rules	A has done X, B has done Y, C has made a good start on Z
Feelings: good or bad	Felt positive about the project, although a bit daunted by all that has to be done	I liked doing the Gantt chart but am worried by C and D's attitude. They say it will all work out ok and seem only to want to chat	Felt angry with group and with the tutor. Very anxious and uncertain about the project – worried we will not get all the work done in time	Am still worried we are not progressing fast enough, but I understand better the others' point of view	Am feeling more optimistic now but still quite anxious
Analyse. What does this mean for me and the group? What, when, where, who, why?	Need to make lists of all that needs to be done	1. The Gantt chart helps us know what has to be done by when 2. It's all very well socializing, but there's work to be done	Not everyone seems to be as focused on the task and on deadlines	Should have agreed ground rules at the start	
Compare (1): share own view/experience with others	B's log entries are similar. D is keen to get to know other team members	Again, B agrees with me but C complains we only ever seem to think about the work			
Compare (2): make links to theory		I think I have a 'Theorist' learning style (Honey and Mumford), strong uncertainty avoidance (Hofstede), and also strong deal focus while C and D are more relationship focused (Gesteland). PS. I added this after our meeting in Week 5		This seems to be an example of the 'Storming' (Tuckman) or 'Chaos' (Honey) stages that teams are said to go through	The need for team building activities (reference) and Rathje's suggestion that intercultural competence involves creating new culture and cohesion
Conclude: What else could I/we have done? How can we avoid ...? What should we repeat/do more?		Perhaps I need to make more effort to get to know the other team members better. I also need to explain better why having things clearly structured is important to me			
Generalizations/ principles for the future					

Your lecturers therefore are keen to help you develop the techniques needed to do so clearly. One way in which the skill is demonstrated, both at university and in your working life, is the ability to produce a coherent and well researched essay or report.

 Reflection

When you have had to research a topic for an essay in the past, how successfully did you do it? Did you feel that you used your time well?

If you have not already done so, it might be a good idea to do a SWOT analysis of your academic reading and writing skills? We have given you an example in Table 3.5, but you can tailor this to your specific situation.

Table 3.5 SWOT analysis of academic reading and writing skills.

Strengths	Weaknesses
Enjoy searching the literature	Weak on referencing and citations
Opportunities	Threats
Improving my writing skills will help me in my final year dissertation	Failure to produce well researched written work will bring down my degree classification

Academic skills

Academic skills, including critical skills, are concerned with locating, processing, and communicating information which has clarity and authority. These skills include the aspects shown in Figure 3.3.

You are likely to learn about these on other modules because of the importance for your academic success of these 'critical' and 'analytical' skills. We have observed that students who have developed good critical skills perform better in most of their modules. We also see a clear parallel with these academically valued skills and the skills employers ask for. These skills will certainly be needed if you are carrying out the project which is part of this book.

Clarify the topic

You will have been told at school that the first step, when you are set a topic for further research is to ensure that you have understood the question. This holds equally true for academic essays and reports. When you have decided what the question is asking for, consider how much you already know about the topic. Spending a little time jotting down your initial thoughts and the information you already have will give you a good platform from which to start.

Data searching and gathering

Next start to gather the additional data you need. Tackling this stage intelligently can be the make or break of the whole essay or report, and we offer two pieces of advice:

- Allow yourself sufficient time to research effectively – in other words do not leave your research until the last minute. The ideal would be to research and read round the topic

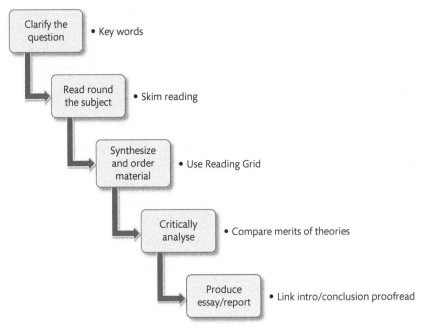

Figure 3.3 Academic skills.

then give yourself time to absorb what you have read. The time management techniques covered in Chapter 5 may be of value in making sure you allocate the appropriate period of time to this and each of the other stages.

- Start with the appropriate resources. Although the temptation is to go straight to Google, do be aware that this will expose you to many non-academic and perhaps non-valid sources. Begin your research with a library search (either physically or online, including your university's online databases which give access to academic journal articles) and do not forget that your university will have a subject librarian who will be happy to help.

Synthesize and organize material

Sometimes the amount of literature relating to a topic might appear daunting. Initially, therefore, you may simply skim through various sources to get a feel for what is relevant to the topic you are researching. Clanchy and Ballard (1992, cited in Gallagher 2010) suggest that it is possible to get the gist of a good piece of writing by reading the introduction and the first sentence of each paragraph. The idea is that the first sentence of the paragraph should present the 'idea' being covered in that paragraph. This is obviously a point you should bear in mind when structuring your own essay.

Reading 'intelligently' is important in this case. Gallagher (2010, p. 79) quotes Robson (1970) who stresses the value of what might be called 'active' reading and suggests the following SQ3R method of reading:

- Surveying
- Questioning

- Reading
- Recalling
- Reviewing.

If, as recommended, you have allowed yourself sufficient time to read round a subject, you should also find you will have the opportunity to make sense of the subject and develop a 'take' on the topic you are researching. You will at the end of this stage have evaluated what material is relevant to your topic.

Analyse material

It can be easy to become 'lost' in the material you have gathered. You may find that the Reading Log Grid Method will help you to keep an overview of your reading. The purpose of this method is to help you manage, critically analyse, and synthesize ideas from multiple perspectives. It can help you to plan how to challenge the main ideas by exploring controversy or discussing alternative views. These are all very important higher education skills.

Our Grid Method was inspired by qualitative data analysis techniques described by Crabtree and Miller (1999), which include entering key words or phrases into boxes on a grid, and then grouping related words together.

The Reading Log Grid Method

(1) **Storing the ideas:** as you read different literature sources, put the various ideas you find into boxes on a 4 × 4 table, as in Table 3.6 based on one of the themes for this book (*Working in culturally diverse teams*, see Chapter 7). (A 4 × 4 grid in landscape format usually works well but feel free to adapt the technique to suit yourself.)

Table 3.6 Reading Log Grid.

Leave this column blank so that later you can enter headings, and copy and paste relevant text into the row to the right	According to Hofstede et al. (2010), in 'individualist' cultures, value is attached to individuals pursuing their own goals and sorting out problems by themselves. In other, more 'collectivist' cultures, greater emphasis is placed on the group and doing things together	Gesteland (1999) proposes that in their interactions with others, some cultures are more 'deal focused' and think more about the task, project or deal. Conversely, in 'relationship focused' cultures, developing good relations with others comes first	Ting-Toomey (1999, p. 67) emphasizes the significance for identity, suggesting that collectivist cultures emphasize 'the importance of the "we" identity over the "I" identity, group rights over individual rights, and in-group ... needs over individual wants and desires'

(2) **Present the ideas in your own words** (paraphrase) as you read them (as has been done in Table 3.6). This might take a bit longer but it will save a lot of time later. In fact, if done well you will be able to simply copy and paste the text into the essay later.

- You *can* include quotations but do this sparingly, choosing short sentences. Only quote an author's actual words if they are especially well expressed, and you could not say it better yourself (see for example the quote by Stella Ting-Toomey above).

- Remember to include the in-text reference (citation) and the full record of all references used as you go along in accordance with your course guidelines. This will save you a lot of time later.

There is excellent software available that will make the job of keeping a record of your references much easier. If you are not aware of these it is likely that your college library, or IT services, will be able to point you in the right direction.

(3) **Organizing the ideas:** when you have finished recording your reading, you should have a good overview of the important ideas, on just one or a few pages.

(4) If your essay, or report topic, involves an evolution of ideas you might find it useful to produce a timeline showing the order in which they occur, for example see the timeline of management theorists (Figure 3.4).

Figure 3.4 Timeline of management theorists.

(5) However, be aware that a potential danger with a chronological approach is that it results in a descriptive presentation of ideas, with little sense of the significance of the different points of view, or of potential contradictions or controversy.

(6) An alternative is to present ideas thematically. In other words, you develop arguments relating to themes, drawing on related or contrasting ideas, regardless of when they were first proposed.

(7) To do this, it will help to create a new grid with the headings, as in Table 3.7. These headings will remind you to be critical and not simply accept one author's words as undisputed facts. It will also encourage you to develop a 'thesis' or argument based on your reading.

(8) Organize the ideas in the order that appears most logical and which allows you to develop the argument(s) well.

- Identify three or four key words or phrases that summarize the main themes and write these in bold in the boxes on the left of the grid, numbering them 1, 2, 3, and so on.

Table 3.7 Example of final stage in Grid.

Key words/headings	Main ideas/views	Criticism/controversy/ alternative views/ counterarguments	My take on this – how do I think this is relevant to the question?
1. 'individualism versus collectivism' (Here I have looked through the boxes and decided that 'individualism versus collectivism' makes a good heading It's likely that there will need to be more main headings, so you will have more such rows with further headings)	According to Hofstede et al. (2010), in 'individualist' cultures, value is attached to individuals pursuing their own goals and sorting out problems by themselves. In other, more 'collectivist' cultures, greater emphasis is placed on the group and doing things together Ting-Toomey (1999, p. 67) notes the significance for identity, suggesting that collectivist cultures emphasize 'the importance of the "we" identity over the "I" identity, group rights over individual rights, and in-group ... needs over individual wants and desires'	Gesteland (1999), suggests that in their interactions with others, some cultures are more 'deal focused' and think more about the task, project, or deal. Conversely, in 'relationship focused' cultures, developing good relations with others comes first	Understanding how different cultures tend to act more independently (individualists) or interdependently (collectivists) can help us to understand why there can be different expectations about how people should work together (Hofstede et al. 2010). Whereas some assume tasks will be undertaken by individuals, others expect such activity to be shared Gesteland's 'Deal versus Relationship Focus' theory may be related, in that the cultures that attach special value to building relationships appear to be the same as those that favour a collectivist approach

Produce the essay

Producing several such rows of key words and headings in this way, with referenced ideas presented alongside, will give you the basis of a plan for the main body of the essay, with a good deal actually written already. You will also need an introductory paragraph that introduces the reader to:

- your interpretation of the question;
- the various perspectives on the question that you find relevant.

A common weakness is the tendency to simply state what has been read without using the material to make a point or build an argument, for example see Table 3.8.

There are many good academic websites that give guidance on argument development, for example you should find <http://www.uefap.com/> (accessed January 2013) useful in giving you further phrases for developing arguments.

Table 3.8 Examples of argument development.

Literature source and fact	Simple statement	Improved usage	
		Citation used to make a strong argument	Citation used to make a counterargument
Taylor – Leadership is innate	Taylor (date) said that leadership is innate ...	Furthermore, Taylor's (date) research demonstrates that leadership is innate ...	On the other hand, if we accept Taylor's (date) assertion that leadership is innate ...
More examples can be added if necessary			

Summary

The YouTube clip devised by Greaves (2012), <http://www.youtube.com/watch?v= 0X3WE6orEdw>, is a useful tool for checking that all the elements for producing a well structured essay have been observed.

The method advocates using a colour coding system to indicate whether the various elements that make a good essay, or report, have been included. So you should always check, before finalizing your copy, that you have:

- a properly presented bibliography (in the Harvard style or whatever format your institution uses);
- sufficient, correct, citations in each paragraph to develop your argument;
- not only just summarized the position of others, but have weighed the relative merits of all the sources, resulting in a well founded conclusion.

Report writing

All of the research methods described previously will apply to writing a report for your lecturer or employer. Properly written reports are a valuable way of:

- communicating information to other people;
- persuading people to your point of view;
- bringing about change.

Reports differ from essays in that they:

- have a formal structure;
- are strongly based on research or evidence;
- offer suggestions for a course of action.

What especially distinguishes a report from an essay is the more formal structure and grammar that has to be observed. You will need to use the structure given in Table 3.9 if and when you are tackling the second part of the project.

In general a good report should:

- have a clear aim;
- have a clear structure – as above;
- be in reported speech and good English (for an explanation and activity, see below);
- be well presented and contain no typographical errors. Suggestion: if possible get someone else to read your report both for content and spelling/grammar. If this is not possible put the report aside for a day or two and read it again. You will then be able to look at it with a fresh eye;
- be written at an appropriate level for the target audience – the report is not designed to show your erudition but to impart information.

Table 3.9 Report writing Pro Forma.

Title page	Should give a title to the topic making it as clear and succinct as possible. Also includes
	The author's name
	The date when the report was finished
	The name of the organization (business or academic)
Contents	Especially important with long reports, to give busy people a quick overview of what the report will contain
	The content page will look something like the following:
	Contents
	1) Abstract (or Executive Summary) 1
	2) Introduction 2
	3) Methodology 3
	4) Findings
	• First finding 4
	• Second finding 4
	• Third finding 5
	5) Conclusions 6
	• First conclusion 6
	• Second conclusion 6
	6) Recommendations 7
	7) Appendices 8
	8) Bibliography 9
Abstract	A brief summary of why the report has been written, giving a clear picture of what the report contains, what has been found and what subsequent action has been suggested. This would not normally be longer than 300 words, but may need to be shorter
	It is usual to write this last
Introduction	Why the report is needed
	Who has asked for it
	Anything else that puts the report into 'context' and establishes the terms of reference
Methodology	A clear description of the research that was carried out in order to obtain facts on which to make a decision. Includes
	How the people doing the research were selected
	How you gained the information – literature search, surveys, questionnaires, reading other people's work, etc.
	How the data was analysed
	Should someone wish to research further, the methodology would guide them as to what has already been done
Findings	Numbered section headings
	The data gathered from Primary (which you have done) and Secondary (summarized from other people) research
	An explanation and analysis of the data gathered
	Graphs, charts, diagrams, or anything else that makes the findings easy to understand
	Note: actual data will be provided at the end in Appendices

(continued...)

Table 3.9 (*continued...*)

Conclusion	Summary of the most important findings
	What can be learnt from these findings
	No NEW information
Recommendations	Suggestions for any course of action suggested by the findings
	Should say why the recommended action should be taken ('It is recommended that ...')
Bibliography	A record of all the reading that has informed the above process
Appendices	These contain supporting materials, which are not essential to the main argument of the report. They might include:
	Data tables
	Questionnaires and responses
	Other data supporting, but not included in the findings section

Meetings

If you have been following the project path through this book you should have had a couple of meetings with your fellow group members. We have advised you to make notes of your meetings in order to record what has been agreed so that everyone will be clear and commit to group decisions. It should help you at this stage to be aware of the formalities that surround meetings so that you can become familiar with this form of communication. It is certainly one of the skills you will find useful in a work context.

Holding successful meetings

Meetings can be a useful tool for generating and exchanging ideas but they can also be big time wasters. Indeed, the economist John Kenneth Galbraith (1908–2006) is credited with saying 'Meetings are indispensable when you don't want to do anything'.

It is clearly important to ensure that your meetings have value and are a good use of time. Whether small and informal or large and formal, the following guidelines can help ensure the practical success of meetings.

- *Before the meeting:* one thing that people do not always do is to decide whether a meeting is really necessary, bearing in mind the time and resources a meeting can require. For instance:
 - Do you have a clear goal? In other words, what would you judge as a successful outcome? If you have no measure for success then you probably need to take time to clarify your objectives.
 Are you seeking consensus? Is it important that you get everyone at the meeting on board for some project? In other words, are you really seeking their input? If you are simply wishing to give out information, consider using email, the intranet, etc.
- *Is a face-to-face meeting necessary?* (Table 3.10)

Table 3.10 Criteria for holding a face-to-face meeting.

Reason for proposed meeting	Possible alternative
To gather or give out information	Could this be gathered via questionnaire or other survey? Could information be sent via email, intranet, or social media?
To exchange ideas, opinions, suggestions	Valid reason for a meeting, but if the numbers are small could this be done informally in a working group or brainstorming session?
To make plans and decisions	A meeting is a good forum, especially if a public demonstration of fairness and transparency is needed
To divulge plans for the future	A meeting could be a good forum, but how much feedback are you seeking? Would a published report work as well?

Whether your meeting is virtual or 'real' it is worth clarifying the following:

Figure 3.5

- *Planning and preparation:* when you have decided that you do need to hold a meeting, either face-to-face or via video/audio conferencing, then you can start making the practical arrangements. The practical organization of a meeting is a bit like organizing a party or other social event, where you need as many as possible of:

 - the right people;
 - in the right place;
 - at the same time.

However, unlike a party, there are often ground rules set out which govern the frequency of meetings, the notice needed, and the quorum required.

Question

The last time you worked in a group did you consider these things when deciding when and how you would communicate?

What could be the consequences of not considering all these steps?

For formal meetings, the decision as to who should be invited is made in liaison between the Secretary and the Chair. For your group meetings, you have probably tried to make sure you all meet, although occasionally you may allocate pairs of members to work on specific items (working groups) and then report back to the rest of you.

Documentation

For formal meetings, notification of the meeting is sent with an agenda which is a list of items to be discussed that ensures the meeting has a clear order and structure. The content will vary according to the topic, although certain items should always be included, such as minutes of the last meeting, apologies, and a date for the next meeting (see Table 3.11).

With formal meetings, guidelines are set for the period of notice given to attendees. This is so that everyone is given a fair chance to make arrangements to attend. In less formal

Table 3.11 Duties and responsibilities for meetings.

	Chair	Secretary	Attendees	Comments
Before	Work with the secretary to produce an agenda	Circulate the minutes of the last meeting	Read the minutes of the last meeting	See below
		Prepare the agenda and circulate it with the notice of meeting in sufficient time for people to make arrangements	Read the agenda and come prepared with any contribution	
			Be prepared to report on any action they were asked to carry out	
		Prepare any supporting documents		
During	Agree with attendees that minutes of previous meeting are a correct record	Take notes or minutes of meeting	Follow meeting conventions by sticking to the agenda and addressing all remarks 'through the chair'	See below
	Maintain order – all remarks are addressed 'through the chair'		Listen to other opinions respectfully	
	Ensures that voting is fair – uses his 'casting' vote to keep to the status quo		Contribute constructively to any discussion	
After	Agrees with secretary the minutes	Produce the minutes of the meeting and send to chair for comment	Carry out any action allocated to them	
	Takes chair's action where necessary			

situations you will have to make a judgement as to how much advance notice you should give.

Everyone who attends a meeting has a role to play before, during and after the meeting.

During the meeting

One key area where everyone needs to take responsibility is to ensure is that the environment in which the meeting takes place makes everyone feel that their contribution is valued. Ceserani and Greatwood (1995, p. 32) show that where people feel threatened they expend more energy on trying to 'survive' than they do focusing on the task (see Figure 3.6).

Figure 3.6 Meeting contributions (Jonne Ceserani, *Big ideas, putting the zest into creativity and innovation at work*, published by Power and Grace Ltd, 2011, www.powerandgrace.co.uk).

This accords with Maslow's (1943) motivation theory of needs, which suggests that people cannot be fully themselves in a situation where basic needs such as psychological safety and the need to be held in esteem are not present. According to Ceserani and Greatwood, in situations perceived as *'adversarial or threatening'*, the energy of individuals and teams is used for self-preservation rather than creative and productive work. Aggression does not have to be 'overt' but includes:

- failing to pay attention or listen to others;
- ignoring someone;
- discounting or putting down other people's opinions.

For teams to achieve a 'creative atmosphere', individuals need to act co-operatively and supportively as this *'removes the need for self-protection and team members are able to focus on task and success'* (Ceserani and Greatwood 1995, p. 33).

Recording the meeting

It is important to keep some kind of record of what has been covered in a meeting. If you are following the project path you will have kept informal notes of any meetings you held during the week. In a more formal situation a record is kept in the form of the minutes of the meeting.

In its simplest form this means recording what decisions were made, although often a record of the discussion leading up to the decision is also made.

Why take minutes?

- To record who was present.
- To create an accurate record of the meeting.
- To gain consensus from all participants for that record.
- To enable actions to be highlighted.

As was the case with a formal report, minutes are recorded in reported speech. This means they are written about the past, as if by an impartial observer. This is discussed further below.

The relationship between the minutes and the agenda is illustrated in Table 3.12.

Taking proper minutes takes practice. When you have finished the minutes check that you have:

- followed the order of the agenda;
- included all crucial information including decisions, statistics, figures, action points, dates/deadlines;
- kept your report neutral and unbiased;
- identified who has said something if necessary;
- ensured your minutes are clear and free from spelling/grammatical errors;
- used reported speech.

When things go wrong: despite the most careful planning and organization, meetings do not all run smoothly. Table 3.13 provides a list of some we have encountered and that you may already have experienced. We suggest you add any of your own negative experiences to the list and discuss ways in which they may be solved.

The next time you have a meeting, it would be worth your while to make a learning log entry if any of the above, or other problems occur.

Reported speech

In both reports and recording of minutes, an objective style is adopted and this means avoiding use of first person pronouns such as 'I', 'me', 'my', 'we', 'us', or 'our'. Instead, either third person pronouns ('he', 'she', 'they' etc.) are used, or the passive voice is used for verbs, so for minutes you would read something like:

- 'It was noted that ...';
- 'Jane offered to ...';
- 'The Chair asked the meeting to ...'.

Also, a more condensed and precise style is used as it is important to reduce the kind of repetition and ambiguous language that is often used when people are talking to each other.

Table 3.12 Relationship between agenda and minutes of a meeting.

NOTICE OF MEETING AND AGENDA	MINUTES OF A MEETING OF THE GROUP HELD ON DATE AND TIME AT WHATEVER VENUE	ACTION	
Notice of a meeting of the Group to be held on the date and the time at Whatever Venue			
	In Attendance:	Take names from the ATTENDANCE LIST circulated during the meeting	
AGENDA	Apologies:	As reported at the meeting	
(1) Introductory remarks (if appropriate)	1 Introductory remarks	The chair welcomed new members to the meeting and explained what should be achieved	
(2) Apologies for absence	2 Apologies for absence		
(3) Minutes of last meeting (insert date)	3 Minutes of last meeting (insert date)	These had been previously circulated and were taken as read	
(4) Matters arising	4 Matters arising	Will explained that he had been unable to xxx as requested as … Joyce reported that she had …	
(5) Other items arranged logically	5 Other items in logical order	5.1 The motion that ??? was discussed. Shiraz proposed that ??? and Mohammed seconded. Agreed unanimously 5.2 etc 5.3	
(6) Any other business (at the discretion of the chair)	6 Any other business	Luke raised the issue of … It was agreed that this would be added to the agenda for the next meeting in order to allow time for further data gathering.	Luke to gather data
(7) Date of next meeting	7 Date of next meeting	Will be held on …	
Name of Secretary Designation of Secretary Date of Notice			

Table 3.13 Suggested solutions to commonly encountered problems in meetings.

Problem	Our suggestion	Your suggestion
People not sticking to the point	Summarize in a way that brings the meeting back to the original subject. 'So do you agree that we should ... (i.e. restate motion)'	
People not sticking to the agenda	Have timed meetings. Draw attention to the time remaining Suggest if time remains at end topic is discussed under 'Any other business' (AOB) or goes on agenda for next meeting	
Some people not joining in	Invite them specifically to contribute 'What do you think ...?' 'Do you have anything to add?' Make a point of acknowledging their contribution 'Thank you, that was very helpful/ interesting ...'	
Lack of clarity	Ask clarifying questions. 'Do I understand you to mean ...?'	
People getting angry	Acknowledge the anger 'I can see this is an issue you feel strongly about. Shall we have some cool off time and discuss it further later?'	
People angry with one another	Arrange for each of them to be able to state their case without being interrupted (see problem solving in Chapter 5)	

For example, a dialogue with your line manager Seema Patel, Marketing Director, might go something like this:

SEEMA: I really can't understand why the SA4250 (a new product) is not selling. Have you got any ideas why sales are so disappointing? Can you look into it and come up with some suggestions for what we should do about it?

For the subsequent report that you write, rather than repeating every word that Seema said, it would be better to use the minimum number of words to accurately convey the meaning. In the suggested version below, notice also how the items are numbered, so that they can be referred to neatly at a later point.

1. Introduction

The author was asked by the Marketing Director to:

1.1 investigate reasons for poor sales of the SA4250; and

1.2 suggest suitable strategic responses.

Similarly, for the rest of the report, it will be important to express ideas concisely and precisely, and to avoid writing in the same way that you speak and think.

Conclusion

In this chapter we have explored how awareness of different learning styles can help you learn in the way you like best but also to identify potential weaknesses in the learning strategies you usually adopt. An awareness of learning styles can help you to choose the most appropriate approach for what you need to learn. Understanding about learning styles can also help explain why team colleagues might approach tasks in a different way from you.

We have also discussed reflection on experience and how this can help you identify principles for future action, personal development needs, and ways of addressing these. For example, if you did not do this as you were reading the final section of the chapter, you should certainly now think carefully about your own skills in essay and report writing, including the ability to analyse critically and produce a coherent and well argued analysis and synthesis of ideas. These skills are key intended learning outcomes for the whole of your higher education experience and a major reason why employers want to recruit graduates. It therefore makes sense to practise using and applying the techniques we have suggested, and to seek out further sources of support and guidance.

What do you think now?

Having worked through this chapter, have you revised your opinion on any of the questions above? How about your classmates? Have any of them changed their opinions?

Project

Your tutor will give you further guidance on how to work through the project tasks. The material we provide below summarizes the tasks and links them to other parts of this book.
Work on your individual development:

- Make sure you have identified your learning style.

- Reflect on your first experience of teamwork. If it did not go as well as you hoped, what are you going to do to ensure more success in the coming weeks?

- Learn as much as you can about procedures for meetings so that you can provide leadership on this if necessary.

- Make sure you know how to write up minutes of future meetings in case that task falls to you.

Further reading

Fleming, N. and Baume, D. (2006) Learning Styles Again: VARKing up the right tree!, *Educational Developments*, SEDA, 7.4, 4–7. <http://www.vark-learn.com/documents/educational%20 developments.pdf> (accessed 23 April 2013).

Gallagher, K. (2010) *Skills Development for Business and Management Students*. Oxford: Oxford University Press.

Honey, P. and Mumford, A. (1992) *A Manual of Learning Styles,* 3rd edn. Peter Honey.

4 Enhancing your profile: standing out from the crowd

 Learning outcomes

By the end of this chapter you should:

- Have recognized the importance of and initiated some of the following extracurricular activities in order to build up your experience:
 - participating in societies;
 - volunteering;
 - part-time work/Saturday jobs;
 - work experience;
 - holiday internships;
 - twelve-month placements;
 - activities that demonstrate global connectedness.
- Understand the importance of achieving significant personal goals.
- Have reflected on the value of having a positive mindset and of visualizing success.

What do you think?

- What sort of things do you do outside of your university course that might impress employers?
- How much do you think employers value such extracurricular activities?
- How important is a positive attitude towards your employment prospects?

Case study

Telefónica UK Limited

Telefónica UK – also known in the UK and Europe as O2 – is the kind of organization that many university students imagine themselves working for once they graduate. Worldwide, Telefónica is a major presence in the mobile telecommunications industry and employs more than a quarter of a million people. In the UK, the company has more than 10,000 employees and sponsors the O2 Arena, the O2 Academies, and the English rugby team.

According to Telefónica UK's Chief Executive Officer Ronan Dunne, with whom we spoke early in 2013 together with HR Director Ann Pickering, being *'born mobile'* makes today's graduates useful for the

(continued...)

organization, not so much because they are needed to work in specific, digital and IT roles, but because *'they have digital skills, they understand mobility'.*

Besides having an annual graduate intake, the company also offers paid, three-month summer internships and one-year placements. So if you are aspiring to work for such an organization, Telefónica UK would undoubtedly offer an excellent career start, no matter what your degree subject. Indeed, Ronan is keen to stress that the company is looking to bring in not so much subject specialists as people with a special kind of attitude.

> What we're looking for is people who bring a broader dimension which is: a thirst for knowledge, a desire for change, who are looking for a career that will give them opportunities to maybe travel, but also to do different things. And therefore in our structured programme for our new graduate intakes, they move between different areas of the business in order to get different experience. And overarching everything, what we're looking for is attitude. We want bright people and we're lucky enough to get a lot of bright people but it is that kind of 'get up and go', self-motivated attitude to want to make a difference, a sense of purpose.

Ann explains why attitude is so important in today's fast changing environment.

> Our firm belief is: you recruit for attitude – you can train for skills, because in our world, we don't know what skills we'll need in two years' time.

Introduction

When thinking about their future careers, many students do indeed tend to think about the big-name companies, and there is no doubt that getting onto a graduate traineeship with a well known, multinational company would be an excellent stepping stone in your career. On many graduate training schemes such as at Telefónica, you would have the chance to explore different areas of work, on a structured programme, with excellent support and guidance. You would gain valuable skills, and simply having such experience on your CV would open up all sorts of future opportunities, whether with the company you started with or moving on to work in others. For all of these reasons, graduate schemes of this kind are certainly worth aiming for, and you should also look out for work experience opportunities during your studies. Organizations sometimes see these as extended interviews: if they like you while you are with them on a three-month internship or a twelve-month placement, maybe there will be a job waiting for you when you complete your studies and even if not, it will be great to have on your CV.

This said, it is vital that you understand the extremely high expectations and standards set by companies like Telefónica UK and the huge competition you will be up against. As Ann explains:

> When we had our first round of recruitment earlier this year (in early 2013) we didn't fill our quota because what we said is: 'That's where we're setting the bar, and we're not just going for quantity, we're going for quality'.

When you learn that in the graduate recruitment round to which she is referring, there were more than 12,500 applicants for 60 roles, and they still did not fill all the positions, you should start to get the picture. Such statistics are daunting. Indeed, they should help to convince you

of the importance of also researching smaller, less well known companies and organizations that can also offer good opportunities. However, just because they are less high profile, it does not mean that these smaller organizations do not also have high expectations or that there will be little competition for the jobs they are offering. Applying for a job where there are 'only' 30 or 40 other applicants, you will still need to stand out if you are to be successful.

This chapter aims to help you do just that, by showing you the kind of things you can and should be doing, besides studying hard, to build up evidence that you have the set of employability assets employers want. These extracurricular activities can include: participation in university societies, hobbies, sport, and voluntary work; engaging with both local and global communities; part-time work; work experience such as holiday internships and twelve-month placements; and achieving significant personal goals. Hopefully you are already doing some of these things.

 As we explain in Chapters 9 and 10, these activities are important because they will give you noteworthy things to write and talk about when you are applying for jobs and they will give employers evidence of the kind of special mindset and attributes that they are looking for.

Undertaking and being successful in these kinds of activities is not only good for your future employability but it is also satisfying, and contributes to positive feelings of self-worth and self-belief. Because these are such important employability assets, we conclude the chapter by emphasizing the importance of maintaining a positive mindset and of visualizing success.

The importance of extracurricular activities

As Ronan makes clear, companies want bright people but they also want more than that. So while academic success is important, you really have to do more than simply focus on your studies and achieve a good degree in order to make employers take notice of what you have to offer. As we explained in Chapters 1 and 2, to be successful, you need to convince employers that you possess a set of employability 'assets', which includes skills, knowledge, and that special ingredient that Ronan and Ann both emphasized, which they refer to as 'attitude' and which Reed and Stoltz (2011) call 'mindset'. And for all of these you need to provide evidence.

This is not to say that working hard at your academic studies is not important. Indeed, for evidence of knowledge and – perhaps more importantly – the skills and mindset needed for acquiring and processing knowledge and for achieving success academically, employers look at your academic profile. In addition to the qualifications you gained before studying at university, these will include the degree classification that you eventually achieve. So applying yourself purposefully and rigorously in your academic studies is vitally important.

However, the problem is that for every job you apply for, you will be up against many others whose degrees are as good as or better than yours. This means that to stand out, there have to be other things about you which show that you possess the assets that employers are looking for. This is why extracurricular activities are so important, as Ann emphasizes.

What makes us choose A over B? The thing that really stands out for me is the extracurricular stuff. If we've got two CVs that are identical, we'll go for the one that looks like a more interesting person because of the stuff they do outside of their university course. The extracurricular activities that they do personally are often a key differentiator.

Another employer that we spoke with, Louise Morrissey – who we introduce in Chapter 10 – is also keen to get an idea of the kind of person you are, and likewise looks for this in extra-curricular activities.

> One of the things I particularly look for is: what is this person like, what is this person going to bring, and is this person going to fit in with my team. When writing their CVs and cover letters and their personal statements, people rush at the hobby side, or rush at what experiences they've had. I would spend a bit more time making it clear that there's more to you than the academic achievement.

Mentioning your extracurricular activities is indeed important in the written elements of your job applications, and it is also very significant at interview. Grace, the graduate we introduce in Chapter 9 who has had interviews for various graduate schemes, explained to us that in most of the interviews she attended, the majority of questions were 'competency-based', where you are asked questions like 'Give me an example of where you have demonstrated ...' and the sentence finishes with a different competency statement relating, for example, to teamwork, achieving difficult tasks, meeting deadlines, etc. We give more examples of these in Chapters 8 and 9, but the point for now is to understand that your extracurricular activities allow you to give good examples of where you have applied the kind of competencies that employers are looking for and which give them a glimpse of the sort of person you are. Grace describes how this works and why academic grades are not enough on their own.

> I'd say that it's essential to take part in extracurricular activities because every job I've applied for involves the same sort of application process, and you need to have these examples for competency-based questions, so even if you get the best degree mark possible, you're still not going to have anything to talk about on your applications, and your grades are only one part of the process now. Lots of people come out now with a 2:1 or a First, so you need to stand out in other ways, particularly as for all the jobs I've applied for you have to have a 2:1 to apply in the first place. So if you think about that you start to realize how important extra-curricular activities and other things that you do ... how important they are, because they are what make you stand out.

Indeed, university performance alone is not enough to demonstrate many of the qualities employers look for in new graduate recruits. Employers are looking for evidence of wide-ranging abilities and attitude, which include strong team playing ability and willingness to contribute and show commitment. Ronan puts it like this:

> What we're looking for is 'rounded', it's 'breadth', it's evidence of that kind of 'engagement mindset' – people who want to be involved, people who want to make a difference, a combination of intellect and attitude.

Participating in societies, hobbies and sport

When writing and talking about yourself in job applications and interviews, the kinds of things you do in your free time can therefore provide evidence of exactly this 'engagement mindset'. Important examples of this can be drawn from experiences relating to societies to

which you belong, your hobbies and also sporting activities, whether as a competitor or in some official, organizing or adjudicating capacity. Besides giving you important experience of teamwork and perhaps leadership, these activities can also provide evidence of what makes you tick, in particular they give an insight into the values that drive you. For Ronan, this is significant.

> A lot of graduates will be coming to us because of what they see as our values and how they line up with their values – values in the broad sense of 'this is important to me and therefore this is what is likely to motivate me, whether it be in a work environment or in my personal environment' – that 'fit' is really important to us.

Giving concrete examples of these values and of you applying them in real situations, such as in your spare time activity, is therefore very important. Our conversations with graduates give a sense of how these examples can be drawn from your extracurricular activity and how this is beneficial. Here is Grace talking about how belonging to a society while at university can be helpful in the application process.

> If you've been involved in societies – I suppose by that I don't mean just being involved but actually being on committees, running for a committee position for example – that's really relevant to a lot of application questions. Firstly, you're always going to have a good example of teamwork, having worked with different people. They're usually quite small teams, so around a maximum of ten people on the committee, so it's a good example to use for teamwork. And also: you're likely to have faced differences of opinion. I tend to use it a lot for that, because that tends to happen quite a lot when you're trying to agree on things at meetings.

Using skills of persuasion and also achieving consensus in a group situation are indeed important skills, and common questions about this might include:

- 'Describe a time you've had to persuade someone about something' or
- 'Describe a time where you've had a difference of opinion with someone and you've had to convince them, or come to an agreement'.

Grace shows how her involvement on a university society gave her relevant examples to talk about:

> [W]e had an example where we had a disagreement as to which supplier to use. I wanted to go with one particular supplier but the president of the society was keen on another one so in that situation, it's about negotiating. So instead of trying to insist on my idea, I suggested we try both of them, get a few samples from each supplier and then test them and see which style everyone prefers. So it's all to do with negotiation really, and just trying to come up with a solution. ... Sometimes you can waste a lot of time just arguing back and forth, so it's better to come up with a more creative solution just so you don't waste time.

And if you enjoy sports, you will be pleased to learn that Ann mentioned two team sports, as well as refereeing, as examples of the kind of activity where you can demonstrate that you

are a team player, and also that you have the kind of engaged, committed attitude that Ronan said was so important.

Voluntary activities: getting involved

Both Ann and Louise also cited voluntary activities, which can likewise convey powerfully your commitment and desire to get involved, perhaps at the level of your local community, or in a more globally connected way. If you watched the London Olympics, whether live at the actual events or on television, you are likely to be aware of the huge part played by the 'Games Makers' – volunteers who helped to manage the events. In fact, since the Olympics there has been a significant increase in the interest shown by people wanting to get involved in a whole range of volunteering activities, with many different organizations.

Andrew (who we introduce in Chapter 9) and Grace – as well as Anna, who we met in Chapters 1 and 2 – all found it useful to undertake volunteering. Both Grace and Anna worked for some time with the Citizens Advice Bureau. Andrew was keen to do something relevant to his career focus in public health, and although they were not advertising at the time, he sent a speculative email to the Sickle Cell Society and was invited to an interview. He has been working there for more than a year and has developed many important administrative and networking skills. He has also been able to apply and extend his writing skills, which have been employed in preparing publicity and educational material for the society. Indeed, many skills can be gained by doing voluntary work and you might receive training in return for giving up your time.

Remember also that doing activities such as volunteering is not just valuable because of skills that you gain. Bearing in mind Ronan and Ann's emphasis on attitude and values, volunteering can show evidence of significant personal qualities and these include showing your caring attitude, commitment, and willingness to do that 'little bit extra'. Many universities run a dedicated service which can show you opportunities in your local neighbourhood, as well as activities that could involve you with communities the other side of the world.

Having a global outlook

After attitude and leadership, foreign language skills were the third element that Ann mentioned when we asked about the knowledge, mindset, and skills that Telefónica looks for in its graduate applicants.

> Obviously because we're a global organization, we wanted to take a tranche of people who were at the very least bilingual. So most of our graduates to date have got at least one other language.

This makes it clear how important it is not to be limited to only one language in today's competitive and global employment market. Regrettably there has been a perception in various quarters in the UK, including government and a number of schools and universities, that learning foreign languages is not really important if you happen to come from a country that speaks English, because everyone else supposedly speaks the language. It

is unfortunate, because it gives an impression of arrogance if we effectively say to people from other countries:

> When we have dealings with you, whether for business or other reasons, we don't need to speak your language, you'll have to speak ours.

The fact that so many organizations have to act globally now also highlights the importance of the attitude we described as 'Openness' in Chapter 2: being open to people, opportunities, and issues in the wider world, and possessing cultural sensitivity and awareness. In fact there are all sorts of ways in which you can broaden your horizons in this way while at university, and we list just a few of them here.

Study and work placements abroad

Spending time in a foreign country is an excellent way of developing your intercultural awareness and skills, and may also be a great opportunity for developing foreign language skills to a high level. Your university's International Office will be able to give you guidance and support relating to such opportunities including information about grants that may be available from the EU and other international charities and organizations. Support may also be available from your university's Placements Office. If you do study abroad, make special efforts to get to know students from the host country and try to avoid spending all your time with people from your home country.

Foreign language classes

These may be available at your university. Alternatively, you can join an evening class close to where you live. There are also online options available, although you may find it harder to develop confidence in the spoken language than if you were interacting with others in a classroom situation.

International projects

Students and academics at your university may be undertaking these. They can come in many shapes and sizes and might include engineering, humanitarian, or knowledge sharing projects, to mention just a few. Look out for such projects on your university and student union websites.

You could also join a nationally – or internationally – based charitable organization and get involved in all sorts of activity, from fund-raising to marathon running and even taking part in charitable work in a part of the world in which the organization operates.

Mozilla Open Badges

At the time of writing, the Mozilla organization are promoting a system of virtual 'badges' which can be used to verify your learning outside of the classroom. This system has been set up because they recognize the fact that much learning takes place in places other than educational settings. Badges can be collected and used to provide evidence to employers of the breadth of your engagement in non-university related projects <http://openbadges.org/> (accessed March 2013).

 Activity

If you are not already involved in any clubs, societies, or voluntary activities (either local or global), do some research into things that you could possibly get enthusiastic about and involved in. Make a point within the next month of finding something you are happy to commit to, and get involved. Don't forget when you do so to keep a learning log and add your activity to your personal development plan. You might also explore the Open Badges link and keep a watching brief for badges that you can collect.

Building work experience

The most common way that university students gain experience is through part-time work and this can be very valuable. There are further important ways that students can increase and enhance their experience, and these include holiday internships and year-long or six-month placements. We explore each of these in the sections that follow.

Part-time

Not so very long ago, students had more tutorial contact than at most universities today, attending timetabled classes five days a week. The most common form of work they did was temporary jobs in the university holidays and perhaps a Saturday job. During the week and in term time they were expected, and able to, concentrate almost entirely on their studies.

However, it is not unusual now for students to have part-time jobs which they do on week-days, some even on each day of the week, before or after their attendance at university. It has to be said that good planning is needed to make sure that neither their academic work nor their job suffer as a result of these dual responsibilities.

In many ways those earlier students were fortunate to have the luxury of concentrating on one thing at a time. However, in successfully combining work, personal, and academic life, the benefits to today's students are manifold in terms of providing evidence of the kind of skills their future employers will seek. Having to be somewhere on time regularly shows that you are reliable and responsible. It also shows that you carried out your duties to the satisfaction of the person or organization that employs you, and being able to show that you have been successful in your degree while maintaining a good work/life balance demonstrates good self- and time management.

As an aside, it is worth also noting that because of working regularly, current students are better able to see some of the things they are being taught in context. Moreover, in addition to what holding down a part-time job shows to an employer, it also builds confidence.

Unfortunately, from an employability point of view, people often play down the things they do, and it is not unusual to hear them say: 'It's only a ... job'. For example, 'It's only a bar job'. We hope that as you become more aware of the things that employers value, you will find it easier to talk confidently about the transferable skills and the evidence of attitude and other personal qualities that your job demonstrates.

 Activity

In Table 4.1, we have provided you with examples of the skills we think are needed to work in a bar. Those of you who work in bars will probably be able to add to these. We have also suggested a few other typical student part-time jobs. Discuss with your fellow students the part-time jobs they do. Add them to the list and discuss with them the experience, knowledge, and skills they feel they have gained from doing their jobs. You may be surprised at their variety.

Table 4.1 Transferable skills gained from part-time work.

Job	Skills needed
Bar work	Communication skills – listening to people. Being appropriately sociable
	Dealing with difficult people – placating people who have perhaps drunk too much.
	Working under pressure – in a busy bar, making sure people are served, tables are cleared, food orders are delivered, etc.
	Legal knowledge – rights and responsibilities of part-time workers, health and safety legislation
Shop assistant	
Charity fund fundraiser (Chugger)	

If your attitude to your part-time job is to learn as much as possible from it, then it ceases to be 'Only a … job'. We know of several students who have been offered excellent training opportunities, such as customer service training, through their part-time jobs, training that provided valuable extra material for their CVs.

One final benefit of doing a part-time job well is that it can lead to a full-time job. One of our students who worked regularly in a fast food outlet eventually obtained a permanent management job.

Internships

Grace had this to say about internships:

> And also, if you know what kind of area you're thinking of going into, the earlier you can decide that the better. It just makes it easier – you can apply for that summer internship. Lots of people do that in their second year and if I had known that that was a good thing to do, I would have definitely done that. Applying for an internship in the summer can then lead to having a job offered to you when you leave university – you can walk straight into a job. I would definitely recommend applying for an internship, gaining as much work experience as you can.

To give yourself the best chance of getting an internship, having a longer-term career focus is helpful, especially if this enables you to get relevant part-time experience and decide if it is the right area for you to aim for. Grace suggests that:

> There are lots of internships online, for example on 'Milk Round' and websites like that. ... They tend to be for second year. First year students I would say, just try to gain some sort of experience ... in the first year, so if you know what sort of area you're interested in, or actually even if you're kind of interested in something but you're not entirely sure, get some experience in it as soon as possible so then you can either rule it out or establish whether you really are interested in it in the long term.

Many internships are indeed for second year students, the assumption being that at that stage they have more experience and maturity to handle the job. However, this does not mean that a first year student cannot prove to an employer that they could handle an internship. We have heard of students getting great internships in the summer holidays after their first year at university (e.g. Kate who we mentioned in Chapter 1), then being in an excellent position to apply for another one for the following year.

In fact, successfully securing an internship in your second year is by no means a foregone conclusion, but the earlier you can learn and practise the skills needed for the application process, the better.

We are not suggesting that it is easy to decide on the path you want to follow, and, unfortunately, as employers highly value enthusiasm it can be that you are in a Catch 22 situation while you make up your mind. It can seem that the whole of your life depends on the next decision you make. However, as we pointed out in Chapter 2, many people's working careers go through twists and turns so there might not be just one right job for you but many possibilities. Grace gives good advice on this:

> Just try things, if work experience is offered to you, or ... just have a look online. If something even mildly interests you, I would say apply for it as work experience, because you're not going to be able to really evaluate what you want to do until you've tried something ... I would recommend at least going to the Careers Department, having a look – they have online questionnaires and things like that which try and match you.

You need to be aware that companies offering internships generally start the application process in the autumn. At Telefónica, for example, the application stage starts in September but you can register your interest before this online.

Placement year

Andrew likewise emphasizes the importance of building good quality experience while at university as he has found that a lot of the kind of 'entry level' training positions of the kind applied for by Grace are 'not being offered any more'. This is in large part because of the state of the economy, which impacts the graduate labour market as follows: firstly, tight financial control makes organizations reluctant to invest in graduate traineeships, and, secondly, when companies *are* recruiting, they want people who already have the experience and so can '*hit the ground running and make an impact quickly*' (Yorke and Harvey 2005, p. 41). As well as internships undertaken during the holidays, it is possible to do a one-year 'thick' placement after the second year of your studies, or in some cases two 'thin' placements of six months spread over the course of your programme. These are a mandatory element of so-called sandwich courses, although if you are not on such a programme, it may be possible to defer your studies by a year in order to take up a placement.

N.B. If you are considering doing a placement, it will be crucial to start applying early in your second year at university. As with internships, the companies that offer such opportunities usually advertise them during the autumn.

Andrew is convinced that undertaking an industrial placement in this way helps to 'give (people) an edge' and also improves their motivation and focus on their studies:

> I know people that did sandwich courses, did very well during their placement, and once they finished their undergrad' they had a job waiting for them.

Evidence of achieving significant personal goals

In discussing with us the things that impress them, two of the employers we spoke with – Ronan and Louise – both mentioned examples of people achieving personal goals which are remarkable in some way, even if their direct relevance to the world of work may not be immediately apparent. As we mentioned earlier Louise, suggested that people should not underplay their hobbies and experiences, and she gave examples.

> Perhaps you've canoed down the Zambezi or you've done a sponsored walk for the blind dogs or maybe you've decorated an old person's home.

Such projects will doubtless have developed important planning abilities and there are likely to have been other skills that you can mention in connection with such achievements. They also give a positive impression of your values and your mindset, as no doubt they will have involved a good deal of motivation, determination, and tenacity, as is the case in the example that Ronan gives:

> [I]t might be that 'I went and walked for three months in the Andes, and the reason I did that was X,Y and Z' might be interesting for us as regards: that sort of individual has demonstrated that they're self-motivated, they're able to organize themselves, they're able to deliver on personal objectives, so there could be as much out of the 'Andes for three months' as there was for 'three months with Linklaters' (a global law firm).

As you will no doubt appreciate, an internship with a leading international company will *not* necessarily be less valuable than undertaking some exciting personal adventure. The important point to realize is that the two are different, but both have value, and with all such experiences it is crucial to highlight for employers the skills, values, personal, and mindset qualities of which these achievements provide evidence.

Having a positive mindset and visualizing success

Most of this chapter has been devoted to practical things that you can do to help you build up your profile and stand out in the graduate employment market. We turn now to the more intangible aspect of mindset and how important it is to remain positive during the job application process, not least because of the huge competition for graduate positions, as we indicated in the introduction to this chapter.

Our intention is not to put you off trying for the big-name organizations like Telefónica. For a start just because there are, as Ann mentioned, 12,500 or more applicants applying to get onto these graduate schemes, it does not mean that 12,499 of them are all better than you. Instead of worrying about the chances of succeeding against seemingly impossible odds, we suggest that you start by considering how many candidates are in with a serious chance. For every position that Telefónica is offering on its graduate scheme, roughly six candidates are shortlisted for the final interview, so a different, more positive approach is to think:

What do I need to do to put myself up there with the very best of applicants so that my chances of success are one in six?

Put like this, the challenge appears much more realizable. In fact, this way of thinking is in line with the kind of provocative, 'brain jolter' questioning that Reed and Stoltz (2011, p. 187) say is needed when you face difficult obstacles, where they suggest that you ask the following questions:

Clearly, this is impossible. But if it were possible, how would I/you/we do it?
Clearly, this can't be done. But if it could, how would I/you/we do it?

 Reflection

Can you think of something at the moment that you feel daunted by? Try the above technique. If this isn't applicable at the moment try this procedure next time you come across what you think of as an 'insurmountable' obstacle. Keep a log of the outcome.

Unfortunately such thinking does not always come easily. In Chapter 2 we discussed theory relating to self-efficacy (Bandura 1994), and also to fixed and malleable self-belief (Knight and Yorke 2004, citing Dweck 1999). Such theory suggests that for people with a fixed self-belief, experience of failure in the jobs market might appear to them as yet further evidence of their own personal shortcomings. Such a view can really only lead downwards into a very negative and unhelpful spiral. Nevertheless, it is worth being aware that such feelings – or similarly negative ways of thinking – are common, and also very natural, in lots of people who have invested huge amounts of time and energy in the applications process, only to find themselves continually being rejected.

The situation can be further clouded by perceptions, either of oneself or within one's own community, which suggest that the employment market may not be a level playing field, and that people with certain backgrounds, or of certain ability, age, or gender are perhaps privileged over others. Our discussions with Andrew, Ernestine, and Carlotta – volunteers at the Sickle Cell Society, all three of whom are black – highlighted the emotive and demoralizing nature of discrimination, whether real or perceived, and the added importance of nevertheless maintaining a positive mindset. Perhaps as a non-British black person, Andrew is able to discuss such issues with a certain detachment:

Being a black person but being born and raised in Africa, I kind of have a different perspective to people I have met and become friends from here. I do think that a lot of young black people from the UK do perceive themselves to be discriminated ... the perception is definitely

there and I do think that for some black people, it will discourage them. It discourages them from education and work, because they think 'I'm being discriminated anyway. I'm never going to get this. I might as well do something else.' So I think the perception of discrimination does exist but it's not across the board.

Ernestine believes that it is very important to remain positive, and also to maintain a good support network:

It's for the individual to know that 'I'm better than this. I can do this …' and to be able to say: 'OK, this is what I want to do, or this is what I want to be, regardless of what the situation is. It's going to be difficult, it's going to be hard, but I'm going to pursue that and try to achieve what I want.' It's not easy. There are various challenges you may encounter as you go along, but as long as you have got a goal, you've got something in your head, you know, at the end of the tunnel, you're going to win, you're going to get the star, or whatever it is, you will, you will! You should be determined in yourself, and also at the same time, get the support, so that when you need to cry, or when you're emotionally down, you've got that support around you, and the right sort of support, people who can help you through it, who you can speak to in confidence.

We will revisit the issue of remaining positive in Chapter 11 when we talk about career management.

Maintaining optimism

There is a tendency for people to think that being an optimist or a pessimist is something we are 'born' with and which cannot be changed. However, it has been suggested that optimism is something that can be learnt (Seligman 1998). You may wonder why, apart from the fact that it is quite pleasant to view the world optimistically, we should be suggesting that it is worth your while learning to be optimistic if it is not your natural tendency. The reason is that there is research providing strong evidence that optimists are more successful in their job searches. Kaniel et al. (2010, Abstract) conducted research on the job search performance of MBA students in which they found:

[T]hat dispositional optimists experience significantly better job search outcomes than pessimists with similar skills. During the job search process, they spend less effort searching and are offered jobs more quickly. They are choosier and are more likely to be promoted than others.

In fact the news gets even better. Research suggests that optimists and people who think positively tend to experience positive health benefits (Goode 2003, Segerstrom and Sephton 2010), which can only be beneficial in relation to work performance.

Visualizing success and maintaining a positive outlook in the face of adversity are not things that come easily and without practice. There is a lot of literature on the topic of personal power, visualization, remaining positive, positive mental attitude, and being optimistic. Spend some time researching these topics and try one or two methods that seem feasible to you. We have offered you a starter reading list.

 Activity

As a starting point, you could try any of the following to increase your optimism.

Think about the possibility that with any situation, you can choose how you look at it, or interpret it. This means that you can choose to focus on the negative aspects, or you can choose to focus on the more positive aspects. Practise focusing on the possibilities in any situation rather than the obstacles. Accept that things change. That means that even if things are bad now they could be better in a month or year from now. To convince yourself of the above, think back to bad things in the past that now seem insignificant.

As an alternative to this, think back on successful times. Remember how you managed to overcome obstacles, and how good that made you feel.

Remember the saying 'When the going gets tough, the tough get going'.

Conclusion

In case you had not been well aware of this already, you should by now realize the scale of the competition you will face in the graduate employment market. That competition means that because so many other graduates – including people with considerable experience – will all be applying for the same jobs as you, employers can now pick and choose. For employers to select you, you have to stand out and to do this you have to be able to show convincing evidence not only of skills acquired through education and employment, but also of having a committed, engaged, and resilient mindset, and values that fit with theirs.

This chapter has aimed to show you the importance of building this evidence and how this can be done through your extracurricular activities. It is never too early to start building this evidence. In any case, we believe that engaging in such activities alongside your studies is both enjoyable and enriching, and we know that it will count for a lot when the time comes for you to apply for work, whether during or after your studies. In fact, it will probably make all the difference.

What do you think now?

Having worked through this chapter, have you revised your opinion on any of the questions above? How about your classmates? Have any of them changed their opinions?

 Project

Your tutor will give you further guidance on how to work through the project tasks. The material we provide below summarizes the tasks and links them to other parts of this book.

Your team should now have gathered information on the first part of the question: What do employers want and how can you give it to them?

Make sure this is in a format that you could present to others if necessary, in accordance with any assessment your tutor might have given you. *(continued...)*

You should now be able to move on to the second part of the question which is to do with building up graduate assets and gathering evidence of these assets.

Your team should spend time identifying your current team formation stage.

This might also be a good time to have an honest evaluation of how you think you are performing and address any issues that are developing. Chapters 6 and 7 should help with this, as should any further research you do into the topic

Further reading

<http://connection.ebscohost.com/c/articles/55509036/personal-power-6-rules-how-harness-yours>.

Goleman, D. (1987) Research affirms power of positive thinking. *The New York Times*. <http://www.nytimes.com/1987/02/03/science/research-affirms-power-of-positive-thinking.html?pagewanted=all&src=pm>.

Goode, E. (2003) Power of Positive Thinking May Have a Health Benefit, Study Says. *The New York Times*. <http://psyphz.psych.wisc.edu/web/News/Positive_thinking_NYT_9-03.html>.

Keller, H. (1903) *Optimism, An Essay*. D. B. Updike, The Merrymount Press: Boston <http://www.gutenberg.org/files/31622/31622-h/31622-h.htm>.

Kaniel, R., Massey., C., and Robinson, D. T. (2010) *The Importance of Being an Optimist: Evidence from Labor Markets*. NBER Working Paper No 1638 <http://www.nber.org/papers/w16328>.

Rogers, C. R. (1978) *On Personal Power: Inner Strength and its Revolutionary Impact*. Philadelphia: Trans-Atlantic Publications.

Segerstrom, S. and Sephton, S. (2010) Optimistic expectancies and cell-mediated immunity: The role of positive affect. *Psychological Science*, 21(3), 448–55.

Seligman, M. E. P. PhD (1998) *Learned Optimism: How to Change your Mind and your Life*. New York: Pocket Books.

Section 2

Developing Essential Employability Assets

In this section you will be learning the importance of skills and attitudes needed to manage yourself and others effectively on projects and in teams, and also of having customer focus. The competencies involved in these areas are complex and are needed in almost every organization and situation, which is why they are often referred to as 'transferable' or 'generic' skills, and also why employers are so keen to see evidence of your competence in applying them. These need to be practised regularly so that you develop confidence and can provide convincing evidence.

In the following chapters you will learn about the graduate attributes needed to work successfully on projects, and to manage yourself, other team members, and customers. If, as we recommend, you are following the project route through this book, you will learn to apply these key employability assets by working on tasks in your teams.

It will also look especially impressive to employers if you can apply this learning in the activities you take part in outside of university, as recommended in Chapter 4.

5

Managing projects, managing yourself

 Learning outcomes

At the end of this chapter you should:

- Know the stages which a project goes through.
- Be aware of some of the threats to the successful completion of a project.
- Have adopted a technique for keeping your own projects on track.
- Appreciate the skills and techniques needed by leaders.
- Have identified a time management technique that works for you.

What do you think?

- What are the key features of a project?
- What are the main things you need to control in a successful project?
- Is there one time management technique that works for everyone?

Case study

On their website, G4S describe themselves as 'the world's leading international security solutions group' with 'operations in more than 125 countries and 657,000 employees' (G4S n.d.). No doubt they seemed a reasonable choice to provide security for the London 2012 Olympics. However, barely a fortnight before the Olympics, the company had to admit they had failed to recruit the required complement of 10,400 security staff and the government had to step in with military personnel to cover the shortfall (Sengupta 2012, Wearden 2012)

What had gone wrong? In its review of the problems, the company admits that

> the monitoring and tracking of the security workforce, management information and the project management framework and practices were ineffective to address the scale, complexities and dependencies of the Olympic contract. Together this caused the failure of the company to deliver the contract requirements in full and resulted in the identification of the key problems at a very late stage.

> (G4S 2012)

It has been suggested that the problems also may have been a result of the management style of one of the executives involved and of his 'unwillingness to listen to the views of others and surround himself with yes men' (Sengupta 2012).

Introduction

Projects are an important and regular feature of work in business. They ensure that companies, whatever their size, grow and change as required. It would be unusual therefore if you were not involved in working on a project even quite early in your employment.

 Furthermore, if you were thinking of becoming an entrepreneur and running your own business (as discussed in Chapters 4, 9, and 11), then you will certainly need to understand some of the techniques and procedures discussed in this chapter.

Finally, the assignments and tasks set for you while at university would also fall under the definition of a project as given in this chapter. Therefore, applying techniques outlined in this chapter will assist you in working successfully on your university assignments.

The difficulty in ensuring that projects are successful arises from the combination of skills and techniques required to implement them. As well as having a knowledge of the stages a project must go through, a wide range of other skills and attributes are needed including good time management, problem solving, openness to change, tenacity, and vision. You might now recognize these as some of the specific transferable skills and mindset qualities valued by employers. Where the project involves a group of people, the above list can be extended to include teamworking (see Chapters 6 and 7), leadership skills, and the ability to delegate or be delegated to.

With such a complex subject, this chapter can serve only as an introduction. However, as the knowledge and skills relating to project management are so valuable whenever you undertake projects, you should be taking note of the important employability assets involved, including not only knowledge and skills but also attitudes and mindset qualities. You should also find ways of providing evidence of having these when job hunting.

If you do intend to run your own business or are planning other projects on your course or at work, we refer you to the further reading at the end of this chapter.

What is a project?

The Association for Project Management (n.d) defines a project at its simplest level as: 'A unique, transient endeavour undertaken to achieve planned objectives'.

This emphasizes the specific and finite nature of projects, and that they are different from everyday tasks.

Projects usually come about because some specific event or anticipated future event makes them necessary. In other words, they usually start from the realization that there is a need for change. This may happen in any type of organization and for all sorts of reasons. For example, the 2012 London Olympics necessitated the recruitment of a large number of security staff, a project that was awarded to G4S. On the other hand, a smaller project might consist of carrying out installation of computer equipment and systems at a client's site.

Because projects are 'finite', project life cycles are used to describe, diagrammatically, the journey through the 'life' of a project. These vary depending on the complexity of the project and the size of the organization. For a very simple project, such as an assignment you

 Activity

Using the above definition, identify which of the following could truly be called a project. Explain the reason for your answer.

- Organizing a conference.
- Your personal development plan.
- Planning a wedding.
- Arranging a holiday.
- Writing an essay.
- Your reflections on your learning.

were tackling or a small event you wished to organize, the life cycle may consist of defining the goals, setting interim and final deadlines, and allocating someone to be responsible for meeting the targets.

Figure 5.1 is a simple representation of a project life cycle, although it is possible to find in the literature more complex versions, with additional stages.

The main thing to note is that all projects have a beginning and an end, although it is not at all unusual to have to go back to a previous stage. Also, although they can be carried out by one person, they normally require the selection of a team who between them have the specific skills needed to ensure a successful outcome (Chapter 6).

Figure 5.3 provides a summary of some the stages and decisions that have to be made when designing a project. You may find it useful to have a look at that before you start reading the next section.

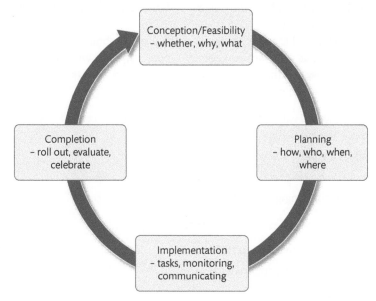

Figure 5.1 A project life cycle.

Conception and initiation

It is important by the end of the 'Conception' and 'Planning' stages that it is clear whether the project will yield any 'beneficial gains'. In other words, will the person or organization see an improvement as a result of the project. It is also important at this stage to be clear WHAT the project is and how a successful outcome is defined.

Whatever the size of the project (including group projects you work on), most or all of the following are needed at this stage:

- A clear definition of what is required – what will be different as a result of the project.
- A reason why it is required – what is lacking or not working now and what benefits will result from the change.
- Decisions on the practicalities of when and how the project needs to be delivered, what resources are available and the level of quality needed.

Feasibility study

However desirable a project might seem, it is important to be sure that it is possible within the resources available (whether these be time, people, money, or anything else). For a big project a special group of people may be allocated the task because the feasibility study will determine whether the project is possible or practicable. In the end, the success of a project should not be judged on how smoothly it runs, but on how much better things are when it is implemented. One of the ways to do this is to involve as many stakeholders as possible to ensure that as many perspectives as possible are understood. This means asking, among others, colleagues, senior managers, customers, and perhaps also members of the local community questions about the current system, how they use it, what benefits they want, and any risks they foresee.

A technique useful for this and other stages of the project is brainstorming. Osborn (1953) described this technique as a means whereby groups come up with creative solutions to problems, and you may find this useful in the various groups you work in during your degree course. Osborn set out four basic rules for effective brainstorming:

- All ideas are accepted without criticism so that everyone feels comfortable offering suggestions – no censorship.
- Unusual ideas are particularly welcome.
- There should be no limit set on how many ideas are generated.
- Suggestions for combining and improving ideas are also welcome.

Here are some basic guidelines to help you brainstorm:

- Include as many stakeholders as possible.
- Give the group a brief description of the problem.
- Encourage everyone to join in.
- Try and make the session fun.

One technique for brainstorming which encourages everyone to contribute, devised in the 1920s by Dr C. C. Crawford, Professor of Education at the University of Southern California (in Dettmer 2003), involves gathering ideas from people on sticky notes or slips of paper.

- Distribute equal sized strips of paper and get everyone to write down one, succinct, idea on each.
- Lay the completed strips out on a table and, as a group, identify main headings.
- Write these main headings on a flip chart or white board and stick the pieces of paper under each heading.
- Ensure that everyone's ideas are presented.
- Make clear that all views are valued and tactfully expressed; disagreement is also welcome.
- Discuss the ideas and reach consensus about the best and most practicable ideas. This may mean discarding some ideas and developing others.
- When all possible avenues have been explored the solutions can be presented in a table form, and people given the opportunity to vote on it.

 Activity

Next time you have a team or group meeting and have to think of ways of tackling an issue, try the above strategy.
Produce a learning log of your reflections on how it worked.

Allocating resources to the project

As noted above decisions need to be taken as to what resources will be allocated to the project. The sensible allocation of resources ensures that the gains of the project outweigh the cost. It is tempting to think of resources just as money and facilities, but actually time and the people who will deliver the project are important too.

Who will work on the project?

 Reflection

When you have worked in groups (perhaps on the project associated with this book), have you found that one person is particularly good at searching through the literature and finding useful information? Perhaps you have noticed that when you are stuck, there is someone who somehow or other moves you on? Have you worked with someone who is good at calming the situation down when a couple of team members are finding it difficult to agree?
Try and identify any other useful contributions team members (including yourself) have made. Make a log of this and refer to it when you read the next chapter.
From your reflection you should have realized how important it is to get the right balance of individual skills if you are to ensure your group is a success. This delicate balance is why selecting a project team is such a tough task. We will discuss the make up of teams in more detail in Chapter 6.
In a business setting, the question of 'who' is made more difficult because if the right people are working on one task, they may not be free to work on others. This is why it is important to clarify this at the feasibility stage.

Figure 5.2 The time-cost-quality balance.

Time, cost, and quality

Three key criteria (Figure 5.2) that will have to be decided are how much time is going to be allowed for the project, how much of a budget will be allocated to it, and what level of quality or functionality will be required. This is similar to your work at university where you may find yourself with multiple deadlines occuring at once and have to decide how much time and effort you can allocate to each subject and even whether you have to cut down on some part-time work.

Most projects would be successful if infinite time and money were available. As this is unlikely, decisions have to be made concerning the quality to be achieved with the resources available. In the case of your university deadlines it may be a decision about which subjects you aim to do thoroughly to get a good grade and which ones you just aim to pass.

Where safety is involved, the quality issue will be especially important and arguments may be put forward for extra resources and time.

 Activity

In the scenarios given in Table 5.1, which of the three criteria will have greatest importance?

Table 5.1 Time-cost-quality exercise.

	Quality	Cost	Time
A project to develop a new, larger, more comfortable passenger airplane			
A project to provide a 24 hour, unstaffed, library service			
A project to enhance the learning experience at your university			
An assignment you are tackling on your university course			
Your search for a job (which we are sure will come under the definition of a project if you follow our suggestions)			

You may be able to provide further examples from your own knowledge.

Planning

Various successful people including Churchill, Franklin, and Harvey Mackay (<http://www.harveymackay.com>) have observed that failing to plan is equivalent to planning to fail. For this reason, when you are working on any project at university you need to clearly outline:

- what you are going to do;
- who is going to do it if you are working in a group;
- when it needs to be done by.

Next, a detailed plan needs to be produced for the whole project (in business this task is often given to a dedicated project group). The plan should be communicated widely to all stakeholders to ensure maximum understanding of the project's objectives. If stakeholders are fully involved it is likely that they will be more committed in the long run.

The working group set up to establish the original feasibility of the project may be joined or replaced by a planning team. Under the guidance of the project manager they will identify the project milestones and the best people for each job.

Implementation

This stage involves carrying out the project as specified in the plan. Once again, new team members may need to be drafted in because of having particular expertise. If so, it is essential they are fully briefed and made to feel 'included' as part of the team.

 In Chapter 6 we talk about threats to teams, one of them being the unsettling nature of team members leaving or new ones joining. In Chapter 7 you will find a section on team maintenance which addresses this issue.

Scheduling and tracking progress

In the implementation stage it is crucial to keep control of time and meet the targets set for each part of the project. The Gantt chart is one example of the many scheduling techniques and systems available for planning and monitoring project progress. Henry Lawrence Gantt (1861–1919) originally designed his charts for planning major construction works (Gantt 1919). However, they have since successfully been used in business to allocate time to the various project tasks, to decide on the order in which tasks should be completed, and to assist with staying on schedule so that deadlines are not missed.

Gantt charts can be applied successfully to tasks involving various, sequential stages. When building a house, for example, certain tasks have to be tackled before others.

Before designing a Gantt chart it is necessary to:

- identify all the tasks which need to be carried out;
- make an estimate of how long each task will take;
- put the tasks in order, taking particular care to identify which tasks are dependent on another task having been completed. Note also tasks that can be done at the same time.

Table 5.2 Gantt chart – house building example.

Building a house									
Week	1	2	3	4	5	6	7	8	9
Deliver materials for external structure	▓								
Dig trenches for foundations	▓								
Fill trenches with concrete	▓								
Build walls: external		▓	▓						
Roof: timber work				▓					
Roof: tiles					▓				
Walls: internal						▓			
Deliver materials for stairs					▓				
Erect stairs						▓			
Deliver plumbing/electrical materials						▓			
Plumbing							▓		
Electricity								▓	
Delivery of decorating materials							▓		
Decorating									▓

Our Gantt chart for building a house is given as Table 5.2. If you have been using a Gantt chart for your group project already, you may be able to improve on our version.

 Activity

In groups, think of an end of module event in which you might all like to participate. Follow the guidelines provided and draw up a draft Gantt chart to schedule all the activities that would need to take place and in what order these should occur.

Completion

It is tempting to think that when all the work has been done and the goals have been achieved that the work of the project team is over. However, in a large formal project there are various stages to go through which include:

- Identifying the project completion criteria.
- Listing any outstanding activities or deliverables.
- Creating a plan for passing deliverables to your customer.

- Planning the handover of project documentation.
- Closing supplier contracts and agreements.
- Releasing project resources to the business.
- Communicating closure of the project.

Even in your smaller group projects some of these stages are still necessary. For instance, you do need to check whether all the objectives you set have been met and explain why any have not been met.

 One final step is to evaluate team performance, and acknowledge the effort the team has put in, even if the project is not one hundred per cent successful. This is covered further under Teamworking in Chapter 7.

And finally, as people have worked closely together on this project it is good practice to organize some way of marking the end of the project, whether it be a party, an outing, or simply a cup of coffee together.

As you will have realized, organizing a project can be complex and even the simplest may go through several stages. We hope Figure 5.3 will help to clarify the process for you and serve as a checklist when you next have to undertake a project.

Having explained the stages of a project, we will now consider some of the things that will help that process to be successful.

Communications

Communication is vital for ensuring that a project runs smoothly and that all team members know what they need to know.

 You may wish to refer back to Chapter 4, in which we covered some of the most common forms of practical communication methods. Also, in Chapter 7 we have a further discussion on communication in teams.

In some companies communication is ad hoc and very informal. 'Open door' policies mean that people can have quick face-to-face chats and solve issues quickly. However, not everyone is conveniently geographically located for such informal communication and, furthermore, some issues need more formal treatment. Together with emails and telephone calls, meetings are one of the key ways of sharing knowledge.

Managing the project

Any project has to be managed and the role of the Project Manager is an important one, particularly in the implementation stage. They may be responsible for some or all of the following.

- Clarifying the goals for the team.
- Planning the work.

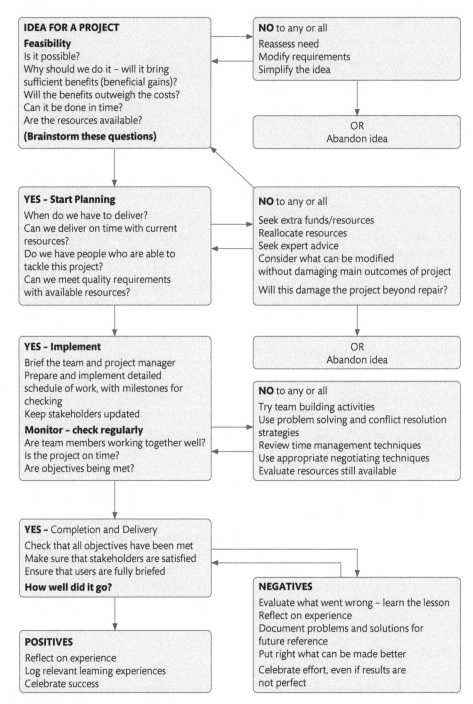

IDEA FOR A PROJECT
Feasibility
Is it possible?
Why should we do it – will it bring sufficient benefits (beneficial gains)?
Will the benefits outweigh the costs?
Can it be done in time?
Are the resources available?
(Brainstorm these questions)

NO to any or all
Reassess need
Modify requirements
Simplify the idea

OR
Abandon idea

YES – Start Planning
When do we have to deliver?
Can we deliver on time with current resources?
Do we have people who are able to tackle this project?
Can we meet quality requirements with available resources?

NO to any or all
Seek extra funds/resources
Reallocate resources
Seek expert advice
Consider what can be modified without damaging main outcomes of project

Will this damage the project beyond repair?

OR
Abandon idea

YES – Implement
Brief the team and project manager
Prepare and implement detailed schedule of work, with milestones for checking
Keep stakeholders updated
Monitor – check regularly
Are team members working together well?
Is the project on time?
Are objectives being met?

NO to any or all
Try team building activities
Use problem solving and conflict resolution strategies
Review time management techniques
Use appropriate negotiating techniques
Evaluate resources still available

YES – Completion and Delivery
Check that all objectives have been met
Make sure that stakeholders are satisfied
Ensure that users are fully briefed
How well did it go?

NEGATIVES
Evaluate what went wrong – learn the lesson
Reflect on experience
Document problems and solutions for future reference
Put right what can be made better
Celebrate effort, even if results are not perfect

POSITIVES
Reflect on experience
Log relevant learning experiences
Celebrate success

Figure 5.3 Checklist for undertaking a project.

- Delegating tasks.
- Guiding the team through problems.
- Monitoring the work.
- Ensuring that deadlines are met.
- Reporting on progress.
- Reviewing and closing down.

A detailed discussion of the role of a Project Manager is outside the remit of this book, although we will be discussing leadership later in this chapter. If you are interested in pursuing a career as a Project Manager, we suggest you visit the Association for Project Management website (<http://www.apm.org.uk>), or one of the other organizations devoted to this area of work.

In the meantime, in your group projects you might adopt the practice of rotating the role of project leader as this would give each of you experience of the challenges and difficulties of running a project and allow responsibility to be shared. This method is covered in more detail when we introduce Kazemek (1991) in Chapter 6.

Resistance

Because projects by their very nature are finite, all team members are dealing with the unknown. Obviously this results in team members being uncertain about what is going to happen next. For some people this is exciting and challenging, for others it is very uncomfortable. In Chapter 7 we deal with how different people and cultures relate to these things, but the following are guidelines on how resistance might be dealt with.

Honey (2004), proposes four ways of tackling resistance (Table 5.3).

Table 5.3 Tackling resistance – based on Honey (2004).

Negotiate	Or bargain. You can offer something else of importance or value in return for getting someone on board
Educate	Give all the reasons why it will be better when the change happens. Try and point out the benefits to the individual and the team and the company
Participate	Get the resistors to help. Getting people actively involved leads to deeper understanding and consequent commitment
Force and support	Ignore the resistance and implement the change. This is often a strategy used by governments where they feel the cause justifies it (e.g. Equality Legislation in the UK)

As noted above, projects need leaders in order to motivate and direct their teams towards achieving the goals they have set. In discussing leadership here we have two aims in mind.

- To help you achieve group cohesion and implement decisions: as a student working in a group you may well have been involved in electing or have been appointed to the role of a group or team leader. Hopefully your group has been harmonious and team members have worked well together, but at some point you may find that you are working with less co-operative people. In this case, trying to hold the group together and implement

any decisions can seem very difficult because in reality you may see yourself as having no 'power' to persuade anyone to do anything. The following material may give you a deeper understanding of the options leaders have and the way they can tackle the task of keeping the team working together towards their common goal.

- To encourage empathy for the team leader: at work, the person to whom you are answerable has a certain amount of power and authority. This is not really the case on a university group assignment, so the ability to understand and empathize with the person who is leading your team will make for a more productive and harmonious situation.

The quest to define the qualities of a good leader goes back hundreds, even thousands of years. Some 2500 years ago the Chinese philosopher Lao-tzu (quoted by Grinnell 2012), wrote:

> With the greatest leader above them
> people barely know one exists
> The great leader speaks little
> He never speaks carelessly.
> He works without self-interest
> and leaves no trace.
> When all is finished, the people say,
> 'We did it ourselves.'

We would all probably count ourselves lucky to work under such a leader. But how would we define one?

 Activity

In your groups:

- List the qualities you think are needed for a good leader.
- Think of examples of good leaders.
- Think of examples of poor leaders – what is it they do not do?
- Are leaders born that way, or can we learn to be good leaders?

One of the reasons people find it difficult to define leadership is that often 'great', charismatic, people come to mind, so it is difficult to think of the day-to-day skills 'ordinary' but effective leaders might have.

Another difficulty is the extensive range of literature, on the topic defining different leadership styles, qualities, behaviours, and competencies.

Are good leaders born or made?

When we asked you to think of examples of 'good' leaders, you may have thought of 'charismatic' leaders such as Ghandi, Mandela, Aung san Suu Kyi, and Martin Luther King. There is a tendency to think of these people as being 'born' leaders. In fact, Taylor (1911; credited with being the Father of Scientific Management) believed that leadership qualities were innate and

could not be learnt. If this were the case, then unless you were one of those 'born to greatness' there would be no point in your trying to develop leadership skills.

Fortunately many modern management theorists (e.g. Bass 1990, Grinnell 2012) believe that although some leadership qualities may indeed be genetically inherited, many aspects of leadership can be learnt. Riggio (2010) states that 'Recent research has provided a good answer: about one third consists of inborn qualities (e.g. temperament, personality), with two-thirds being "made" – developed over time through parenting, schooling, and experience'.

In terms of your PDP, the key here is 'developed over time ...'. If you acknowledge that leadership skills will be of value to you, then you need to start working on them now. Consider also whether 'fixed' and 'malleable' self-belief, which we discussed in relation to self-efficacy in Chapter 2, may also be relevant here.

The way that thinking about leadership has developed over the past hundred or so years reflects two different emphases by management theorists. These relate to the need to complete the task on one hand, and on the other, having an awareness of the needs of the people carrying out the task.

Task versus individual in team leadership

Taylor's management theory was developed in an industrial and mechanized environment, and therefore focused attention on streamlining mechanical tasks. When adopted by business, the general idea was that workers should carry out their tasks according to precise rules, as handed down from above. Although this method undoubtedly worked (the Ford car company achieved its success by applying it), the increasing movement towards a Knowledge Economy resulted in a realization that it was necessary to develop workers in a more holistic way.

The balance between the need to focus on either the task or the people carrying it out may vary according to a particular task. It has also been noted that some leaders have a tendency to focus on one or the other of these. In fact, Fiedler (1967) identified two major personality traits in people concerning whether they gained satisfaction from relating with others or preferred focusing on the task.

Leadership focus

Adair (2011) built on the dichotomy between concentrating on the task or the individual and identified a third area of concern to leaders, namely how people work together in teams. His theory is usually pictured as three overlapping circles: individual, team, and task.

In order to deal with each of these areas the leader must address the issues listed in Table 5.4.

While Figure 5.4 shows these three areas overlapping more or less equally, different situations call for different leadership styles that emphasize one or other of the circles more strongly.

Basic leadership styles

Current management practice regards the workforce as a valuable business resource, after all a significant part of their outgoings are in the form of wages. There is recognition that without

Figure 5.4 John Adair's Action-Centred Leadership Model. (© Adair, J. (1973) *Action-Centred Leadership*, London: McGraw Hill.)

Table 5.4 Leadership focus based on Adair (2011).

Task	Team	Individual
Set clear objectives	Ensure there is a suitable group structure	Be aware of individual goals
Set realistic time limits for goals and sub-goals	Use praise, recognition, and rewards to motivate and keep focus	Reward and motivate people appropriately
Make sure that work is shared out (delegated) fairly	Encourage team to sacrifice own goals for the team	Ensure job satisfaction
Give credit to team for success	Lead by example	Use appropriate sanctions for lack of performance
Take blame for failure	Deal appropriately with lack of performance	

people, there would be no business, so good, appropriate leadership is seen as vital, and the topic has generated a large volume of literature.

As early as 1939, Lewin et al. identified three main styles of leadership: Autocratic, Democratic, and Laissez-faire. The style of leadership generally attributed to Taylor is Autocratic. This is a top-down form of leadership where management set the goals and the workforce simply need to achieve them. In contrast, Democratic styles are far more participative. As its name suggests, Laissez-faire (which in French means 'let do') is very hands-off, with teams allowed to get on with tasks in the way they think best.

 Discussion

Try and identify, from your experience, which kind of leadership might be appropriate in different situations; for instance, if a team had a very tight deadline or needed to come up with a creative idea for a new product.

Table 5.5 Comparison of leadership styles based on Bass (1990).

Transformational leader	Transactional leader
Is charismatic	Uses rewards to produce results
Provides vision and sense of mission, instils pride, gains respect and trust	Contracts exchange of rewards for effort, promises rewards for good performance, recognizes accomplishments
Inspires workers	Management by Exception (active)
Communicates high expectations, uses symbols to focus efforts, expresses important purposes in simple ways	Watches and searches for deviations from rules and standards, takes corrective action
Stimulates the intelligence of workers	Management by Exception (passive)
Promotes intelligence, rationality, and careful problem solving	Intervenes only if standards are not met
Treats workers as individuals	Laissez-faire
Gives personal attention, treats each employee individually, coaches, advises	Abdicates responsibilities, avoids making decisions

Styles of leadership may vary across different cultures. For instance, paternalistic leadership (in which, as its name implies the leader acts like a parent who knows best but also has high concern for the welfare of the workforce) is less prevalent in the UK than it was in previous centuries. However, in other parts of the world such as Taiwan and mainland China, it is still very much in evidence. In our global environment this could mean that if you were working for a company operating from a country other than your own, you might experience a leadership style with which you were less familiar.

The above section should serve to give you a flavour of the historic development of leadership theory in business, but research continues in the area. If you find yourself in a supervisory role, as a result of long-standing experience in a part-time job (as have some of our students), you may wish to delve deeper into the topic of leadership, or you may do so simply because the topic interests you. Alternatively, you may be having difficulties understanding the behaviour of someone who is leading you and wish to understand why. We suggest in these cases that you use some of the search skills discussed in Chapter 3 to learn more about the subject. As a starting point you may find the work of Bass (1990) interesting. He introduces the idea of leaders who are either transactional or transformational. Table 5.5 gives a flavour of the difference between them. You will be able to form your own ideas of the pros and cons of each of these styles as you read further round the topic, and also reflect on your own experience of leadership.

If you are interested in learning more about your own leadership style, you will find a multi-choice question, self-scoring profile on Adair's website (<http://www.johnadair.co.uk/profiles.html>).

Delegation and taking direction

It is apparent that the main reason for having a team is that tasks can be shared between all of its members and that, as discussed in the next chapter, different people contribute in different ways. One of the things that some leaders find difficult, for various reasons, is delegating work to others. If a team is to work well it is important that work is shared out appropriately and according to people's capabilities, so delegation is a skill required by all leaders.

Delegating tasks to other people is a key skill that all managers, team leaders, and supervisors need to develop. It is one that you should try to develop if you are nominated as leader of a group for a task on your course.

Two former US presidents had interesting things to say about delegation:

> I not only use all the brains I have, but all that I can borrow.
>
> (Woodrow Wilson)

> The best executive is the one who has sense enough to pick good (people) to do what he wants done, and self-restraint enough to keep from meddling with them while they do it.
>
> (Theodore Roosevelt; quoted by M2 Communications n.d.)

Whether team leadership is an individual or as recommended by Kazemek (1991) a *shared* responsibility (see Chapter 6), it is important to 'borrow' the right brains. This means there must be a clear understanding of what skills and aptitudes are needed to complete the sub-tasks, and to identify who is best suited to tackle them.

Advantages of delegating properly

Delegation is necessary to ensure that large tasks can be carried out to a deadline. It can also act as a valuable development tool, giving a trainee the opportunity to try out something new under supervision and helping prepare them for the next step up the work ladder. Delegation also ensures a fairer workload distribution, lessening the likelihood of conflict and preventing bottlenecks from occurring because one person has too much to do.

Ground rules for delegation

Delegation is not simply a matter of giving someone a list of instructions. The following ground rules should ensure a successful outcome.

- Choose the right person for the job.
- Describe the task in its wider context.
- Clearly identify the specific required outcomes.
- Set final and interim deadlines.
- Allow individual initiative and creativity to give a sense of ownership of the task (micro-management is demoralizing and defeats the object of delegation).

Giving people freedom over how to tackle tasks should be combined with regular, pre-arranged, monitoring sessions. This progress check should avoid them going seriously adrift and also serve as an assurance to them that they are on the right track.

It is also important to make sure that the delegatee has the necessary authority to ask for and be provided with any resources needed to achieve the specified goals.

Reviewing performance

Your role as a delegator is not finished when the task is completed. Prompt feedback is very important. Giving thanks and praise for a job well done can be very motivating for anyone

(as long as it is not done in a way that appears patronizing). Pointing out areas for improvement can be more difficult. It is not easy to tell someone that they have failed, especially if they have worked hard, but it is very important that lessons are learnt from any mistakes. This does not mean that the delegator apportions blame. In fact, a golden rule in delegation is that, although authority is delegated to the subordinate, final responsibility remains with the delegator.

Nevertheless both parties should analyse their performance and share their views on how problems can be avoided in future. This may involve improved communication, better training (for both parties) or clearer specification of boundaries. In this way even a less than successful project can have a positive outcome.

 Discussion

How would you tackle the problem of telling people where their performance has fallen short? Try role playing this within your group. Add your observations to your PDP and revisit this when you have read the teamworking chapters 6 and 7

Making the most of being a subordinate

How you respond to being given work can make a big difference to your career progression, and this often relates to how well you can follow instructions. Unfortunately, people do not always find this easy, as is illustrated by Lance – an employer who we introduce in Chapter 6 – describing one of his new starters:

> There have been times when he's given a clear instruction on how to solve a technical problem but he goes off spec and chooses his own method of working and as often as not he will spend hours coming back to the same conclusion as he was told within 10 minutes by the experienced colleague.

It is important in terms of establishing trust that you try to do a task as well as you can within the guidelines and deadlines set. However, there may be occasions when this is difficult.

 Discussion

What do you think you should do if you find the task difficult, do not understand it, or feel that you cannot complete it on time?

In terms of your working life, simply being given instructions to follow is unlikely to give you long-term job satisfaction. That is why you would eventually hope to have more autonomy to carry out tasks.

Despite the obvious advantages of delegation, some supervisors and managers do not delegate. There are a variety of possible reasons for this. They may feel that only *they* can do the task properly, or they may not have experience of delegation and be unaware of its value.

The problem may also stem from a failure to stop and think what the different tasks are. In other words, it is important to analyse carefully the work to be done, breaking it down into separate tasks and sub-tasks, which can then be delegated.

 Discussion

What do you think you can do to encourage your supervisor or manager to delegate work to you?

Coping with change

Jamie Oliver puts it neatly: 'People hate change until the pain of not changing is worse than change itself' (BBC News 2012).

 Reflection

If you look back over the last year or two, you will probably realize that you have had to cope with many changes. Just spend a few minutes jotting down all the changes you have had to cope with.

We guess that your list will include leaving a school with which you were familiar, and starting at university. You may have had to leave home. You will have left behind old friends, and, hopefully, have made new ones. Change can be exciting. It can also be scary.

One of the many challenges that businesses face is that they have to change to survive, and this means they often have to implement new projects within tight time constraints. It also means that they need to motivate their workforce as they will be the ones who are carrying out the change. One of the reasons employers are asking for people who are 'adaptable' and 'flexible' in their job adverts is that they want people who are open to, and able to cope with, change. It is up to you to convince them, preferably with evidence, that you understand what change is and are prepared for it.

Unfortunately, as Jamie Oliver points out, many people do not like change. There is a tendency to carry on doing things that have worked in the past, and behaving in a way that is comfortable. Usually it takes something external to happen that makes us think that perhaps things could be, or should be different. Then, it seems that the more we think about it, the more dissatisfied we become with the present situation. This starts us wondering about what else we could do, how else we could act. And finally, hopefully, we make the change. In other words the alternative to change becomes so uncomfortable that we finally move on.

 Activity

The next time you are faced with some uncomfortable change, remember to keep a learning log of how you felt and consider how you can make yourself more open to change in the future.

Managing time and personal effectiveness

Implementing a project means completing tasks to required standards, within set resources and on time. Successful implementation is a key task for the Project Manager. The quality of standard required should be specified according to measurable success criteria. With your group project, for example, such criteria include thoroughness of research, application of academic standards including proper referencing, and excellence of presentation. Producing work on time is also a key criterion and is a skill both for your course and future career.

It is often tempting to blame any failure in performance on lack of time. However, as Jackson Brown Jr is reported as saying, 'Don't say you don't have enough time. You have exactly the same number of hours per day that were given to Helen Keller, Pasteur, Michael Angelo, Mother Teresa, Leonardo da Vinci, Thomas Jefferson, and Albert Einstein' (goodreads n.d.).

Indeed, our ability to manage time well is closely related to our 'personal effectiveness', which can be demonstrated by our ability to:

- Make the best use of the resources we have at our disposal.
- Do more in the time we have available.
- Ensure that we are putting our energies into what is important.
- Achieve more without increasing our stress levels.

There are many different time management techniques. The secret is to find one that suits your style of working best and then to use it regularly.

Quadrant method

This method appears in various guises, but it is said that it was used by former US President Dwight D. Eisenhower, who is often quoted as saying that: 'What is important is seldom urgent and what is urgent is seldom important'.

What do you think he meant by this?

Covey (1992) brought it to public attention when he described the method in his *Seven Habits of Highly Effective People* under the title of 'The Urgent/Important Matrix'.

The process used for the quadrant method is to evaluate a task as either important or unimportant, and urgent or non-urgent (Table 5.6):

Table 5.6 'Urgent/Important Matrix' based on Covey (1992).

	Urgent (deadline near)	Not urgent (no immediate deadline)
Important (consequences of not doing it severe)	Process this task immediately	Schedule to do them so that they do not become 'urgent'
Not important (nothing would really change if not done)	Could be 'delegated' to someone else	Can be left

 Activity

From your own life at present, can you identify what tasks would go into each quadrant with the examples in Table 5.7?

Table 5.7 Example of Urgent/Important Matrix.

	Urgent	Not urgent
Important	Assignment due tomorrow	Revision for end of module examination
Not important	Running out of note paper. Look out for special offers	Texting a friend

How the various items are interpreted is subjective, particularly in the 'non-urgent, not important' categories, so the tool is designed to be tailored to your own requirements.

Pareto Principle

The Pareto Principle (named after Vilfredo Pareto, 1848–1923), also known as the 80:20 rule, suggests that 80% of effectiveness comes from 20% of effort. In a sales situation the Pareto Principle would describe a situation where a company earns 80% of its income from 20% of its customers. Therefore, these customers are the ones to concentrate on. Losing one of these customers would be more serious than losing one of the other 80%.

Although the Pareto Principle was not originally designed to be applied to efficiency situations, it does apply remarkably well and helps identify where time and resources should be allocated.

Table 5.8 imagines the most significant problems you are having with assessment areas, helping you to identify on which areas to focus in future.

Table 5.8 Pareto Analysis of poor marks for assessment.

	%
Poor writing skills	5
Lack of research	35
Proofreading errors	5
Poor bibliography	15
Unclear introduction	10
Vague conclusion	10
No citations in main body	20

Conclusion

In this chapter we have taken you through the stages of a project required to reach a successful conclusion, and we have given you a brief introduction to the many transferable skills required in order to work successfully on a project. As well as giving you an insight into what

working on a project at work might entail, we have tried to highlight for you how these skills and techniques can be of use to you now in your university work. If you consciously apply this knowledge to your work, you should be on your way to providing evidence to employers that you are able to offer them the assets they require in a graduate.

> ### What do you think now?
>
> Having worked through this chapter, have you revised your opinion on any of the questions above? How about your classmates? Have any of them changed their opinions.

> ### Project
>
> Your tutor will give you further guidance on how to work through the project tasks. The material we provide below summarizes the tasks and links them to other parts of this book.
> Spend time reflecting on how well organized you are, and how good your time management techniques are.
>
> - Identify, using the Pareto Principle described above, what key tasks you need to carry out in the next few weeks.
> - Use a scheduling technique to ensure you have planned your time well.
>
> Do some research into time management techniques, and try one or two out. Try and find one that works for you and that you will use regularly.
> Remember to log all of the above, and add anything you have achieved to your PDP.

Further reading

Avolio, B. J. (2005) *Leadership Development in Balance: Made/Born*. NJ: Lawrence Erlbaum Publishers.

Goleman, D. (2000) 'Leadership that Gets Results', *Harvard Business Review*. March–April.

Honey, P. (2004) *Improve your People Skills* (2nd edition). London: CIPD.

Maylor, H. (2003) *Project Management* (3rd edition). Harlow: Pearson Education Ltd.

Riggio, R. E. (1988) *The Charisma Quotient: What it is, How to get it, How to Use it*. NY: Dod Mead.

6 Teamwork 1: Getting started

Learning outcomes

By the end of this chapter you should be able to:

- Define different types of team.
- Identify the different roles people may take in a team.
- Identify your own preferred team role.
- Understand the stages in team formation and their facilitation.
- Understand the role your own and other people's emotions play.
- Understand principles of good communication in teams.
- When working with new people, understand your own feelings and how to manage them.

What do you think?

- What do you understand a team to be?
- How quickly would you expect a team to be performing optimally?
- What kind of interpersonal skills are involved in teamwork?
- Is there any difference between working with a virtual team and face-to-face with team members?
- Can cultural differences have any serious effect on teamworking?
- Why do teams sometimes not get on?

Case study

In the course of this and other chapters, we will be presenting extracts from our interviews with Lance and Tania Beecheno of SupportPlan, an SME based in Vauxhall, London. Its core business is providing first class Mac computer support for a variety of deadline driven companies. SupportPlan has solved problems for a variety of clients, including major banks, design and media companies, and a singer-songwriter.

Lance Beecheno is the owner and Managing Director of the company, having worked his way up from being a sales consultant, and he works with his wife Tania Beecheno who is responsible for the company's marketing and HRM functions.

Other members of staff include fully qualified Mac technicians, some of whom also work in sales roles, analysing customer needs and providing tailored solutions for each business. Office staff keep track of the progress of all support calls.

SupportPlan has long had a policy of providing work experience and offering apprenticeships, so the company has good experience of the skills and aptitudes of typical school leavers and graduates.

(continued...)

Therefore, the Beechenos are well placed to comment on the areas in which undergraduates need to develop if they are to become useful members of teams such as theirs.

In particular, Lance describes the ability to get along with people as *crucially important*, as SupportPlan's technical staff, advisers, and office staff need to work effectively together to provide the best possible service and solutions for the company's clients.

You can visit the SupportPlan website at <http://www.supportplan.com>.

Introduction

So far, we have been focusing mainly on the things that you need to do as an individual to improve and demonstrate your employability. As we explained in the introduction at the start of the book, employers also want to see proof of your ability to work with others. A quick glance at any current job vacancies will show phrases such as 'You must be able to work as part of a busy team' and 'must be a proven team player', so in your job applications, CVs, and interviews you will need to provide persuasive evidence of this.

The reason for this is that many projects and tasks at work are just too big to be carried out by only one person, therefore people have to work together to get the job done. Furthermore, many businesses are deadline driven and need to be assured that when you join them, you already have the skills needed to work with others to get the job done on time.

This is why most universities will require you to work in groups as part of your studies and to reflect on the experience as part of your personal development planning. Working in a team can also give you valuable evidence of some of the mindset qualities we have identified as being important. For instance, have you proved yourself trustworthy when working in a group? What examples of this can you give?

This chapter identifies issues related to working in teams and provides some of the tools you need to address them. Understanding the process of working in a team, and mastering some basic skills should ensure that your performance both at university and work is successful.

An important, recurring theme in the chapter is that for teams to function well, there needs to be a sense of familiarity and trust, where people feel that they and their contribution are valued.

Defining what is meant by the word 'team' can appear straightforward enough. If you were to ask a cross-section of people for their definition, it is likely they would come up with something like the following definition: 'Two or more people working together … to achieve a common goal' (Oxford Dictionaries n.d.).

Given that this seems so straightforward, it is interesting that when people talk about teamwork, they often describe situations that do not sound very much like 'working together'. The following comments, from second year undergraduates interviewed about their experience of teamwork, are not untypical.

> Working with x was really difficult. I have never come across a person that was just not willing to put in the effort and just wanted you to do all the work.
>
> Most of the group work was really messy and people did not turn up and no one really said how they felt or what issue they had, … (so) no problems were solved.

Apparently, applying the definition in real life is not so simple.

Types and characteristics of teams

Please note: if you have already taken an Organizational Behaviour (OB) module you will probably be familiar with the following, and in that case you may prefer simply to skim through the content. However, it will still be useful to undertake the discussions, reflections, and activities suggested.

Teams can vary in size, duration, purpose, and in many other ways.

Team size

As already noted, even two people can be a team. However, teams can be much larger and some companies regard themselves as one big team. Meredith Belbin (n.d.) argues that having too many people in a team causes problems because of overlapping roles, and a tendency towards conformism and passivity. With smaller teams, it is easier for each individual's opinions and contributions to be heeded and valued.

 Discussion

Do you agree with Belbin? What do you think would be the difference between being in a team of 3 or a team of 30? How would managing these different teams vary? If you are using the project approach with this book, what would be your preferred team size for this?

Team duration

Both at work and at university, teams may be set up for a particular purpose and may only work together for a limited time. Team members may be selected simply because they are available or for their particular competencies, and they may not have worked together before. 'Time is money' and missing deadlines can mean losing contracts or failing coursework assignments. These pressures of time mean that the group must learn quickly to work together in order to maximize their performance.

Team location

In an increasingly global and hi-tech environment, keeping in touch with team colleagues can pose a challenge. However, even where team members work or study in the same building, the need to juggle different commitments often makes it difficult to meet face-to-face.

All of this means that keeping in touch via appropriate communication channels is an essential skill when working in teams, as will be discussed in the later section on 'Communication'.

Team stages

Just as with the teams you join at university, people at work have to get to know one another and find a way of quickly working successfully with people they may not otherwise have chosen to work with.

However, even if all involved are determined to do their best, this does not ensure that teams work at an optimum level immediately. Research suggests that groups go through various stages, and theory can help us to understand how teams follow a fairly clearly defined growth cycle within which they mature and develop. Bruce Tuckman and Peter Honey offer two such theoretical models.

Tuckman (1965) originally described group development as going through four stages:

- **Forming:** where colleagues are wary of each other and may be excessively polite, avoiding confrontation but not making very much progress.
- **Storming:** where personalities and deadlines create pressures, and team members challenge each others' views on how to proceed, what needs to be done, how, who should do what, etc.
- **Norming:** where the group has agreed how they want to tackle the task and ground rules for the group to follow.
- **Performing:** where the group is performing productively and well.

Tuckman identified three issues that can affect how quickly and how well a team navigates these stages.

- **Content:** what the team actually have to achieve.
- **Process:** how the team works towards achieving its goals.
- **Feelings:** how the members relate to one another.

He also observed that most teams tend to concentrate totally on content and ignore the other two dimensions (the implications of this will become clear later in the chapter). How quickly teams progress through the stages will therefore vary, and on occasions they might even regress to a previous stage. In any case it is highly unlikely that any team will move from the initial stages to efficient performance without some intervening steps.

Although Tuckman's model was developed some time ago, it is still recognized as a good basis for analysis, and many other researchers have built on it. For example, Honey (1994) also identifies different stages through which groups move before working 'skilfully' together.

- **Chaotic:** where people talk over each other, a leader may be appointed but has no clear role or is overly autocratic, and planning is minimal or non-existent.
- **Formal:** where, as a reaction to the previous stage, a perceived need for strong leadership results in overly rigid, step by step procedures being laid down and strictly enforced, and everyone is given a very specific role.
- **Skilful:** where procedures are more flexible, the role of strong leadership is less needed or is shared, team members openly share responsibility for success – or failures – and become more trusting and accepting of one another.

If this progression occurs too quickly, or too strongly, a return to the chaotic stage is possible. However, if the breakthrough takes place at the right time, the team can slide smoothly into the skilful stage and the team becomes more successful. Honey argues that the formal stage is necessary and that the sooner the group moves on through each stage, the sooner it can progress to operating skilfully.

Knowing about stages in teamwork can help you understand the stage you and your team are at, and this can help reduce frustration, anxiety, and conflict as the team moves on to the skilful/performing stage.

 Reflection

From now on, when you are working in your project, or any other group, reflect on which aspects of the above two models are relevant to your situation. If you feel you are in the 'Chaos' or 'Storming' stages, how can you move on quickly to the 'skilful' or 'performing' stages?

Do not forget to keep learning logs of your reflections and consider how the way you deal with the situation demonstrates your team role skills, and your mindset. Have these examples ready to use when you are applying for a job, or being interviewed.

Table 6.1 is an example of a learning log kept by a student after the second meeting of her group.

Table 6.1 Example of learning log following a team meeting.

Date	Concrete experience What did I DO?	Reflective observation What did I OBSERVE?	Abstract hypothesis What do I THINK?	Active testing What is my PLAN for future action
Friday 13 July	We had our second meeting which lasted about an hour. We discussed what reading each of us would do before our next meeting.	Group members X and Y were keen to take on lots of reading. Group member Z said that because of work commitments he would not be able to do any reading next week.	I am worried about both situations. I think X and Y are offering more than they will deliver. I am worried that Z is not motivated and will let the team down.	

 Discussion

What future action would you suggest this student could take?

 You may find some of the material in Chapter 7 relevant to your answers.

Team members and roles

When you are allocated a group task at university you might find you are in a group of people who work well together, but you may not always be so lucky. The dynamics of team membership is an ongoing area of research because of the importance of understanding the combination of skills and attributes team members need in order to cover all the areas required for successful completion of a project.

 As mentioned in Chapter 5, early research by Fiedler (1967) identified that some people are better at 'people' skills and others are more 'task' oriented.

Teams therefore benefit from having both of these team types, for without people focusing on the task, the job would not get done, but without team members with people skills, the team might experience conflict or misunderstandings. (Note also that differences regarding task and people focus can also be linked to cultural differences, which we discuss in Chapter 7.)

 Reflection

The next time you are in a group, see if you can identify the two modes of behaviour, people skills and task focus, in yourself and others.

Although this distinction serves well, subsequent research fine-tuned the team personality types and categories of people needed for a team. Based on working practices observed in over 200 teams, Meredith Belbin identified nine categories or roles that help to ensure good team performance (Belbin, n.d., citing his earlier work).

It is unlikely you will ever find yourself in a group of nine people having the skills, qualities and preferences to cover each of the roles in Table 6.2. Belbin's point is that these roles need

Table 6.2 Belbin's team roles (Belbin, n.d.).

Team role	Contribution	Allowable weaknesses
Plant	Creative, imaginative, free-thinking. Generates ideas and solves difficult problems	Ignores incidentals. Too preoccupied to communicate effectively
Resource investigator	Outgoing, enthusiastic, communicative. Explores opportunities and develops contacts	Over-optimistic. Loses interest once initial enthusiasm has passed
Co-ordinator	Mature, confident, identifies talent. Clarifies goals, delegates effectively	Can be seen as manipulative. Offloads own share of work
Shaper	Challenging, dynamic, thrives on pressure. Has the drive and courage to overcome obstacles	Prone to provocation. Offends people's feelings
Monitor Evaluator	Sober, strategic, and discerning. Sees all options and judges accurately	Lacks drive and ability to inspire others. Can be overly critical
Teamworker	Co-operative, perceptive, and diplomatic. Listens and averts friction	Indecisive in crunch situations. Avoids confrontation
Implementer	Practical, reliable, and efficient. Turns ideas into actions and organizes work that needs to be done	Somewhat inflexible. Slow to respond to new possibilities
Completer Finisher	Painstaking, conscientious, anxious. Searches out errors. Polishes and perfects	Inclined to worry unduly. Reluctant to delegate
Specialist	Single-minded, self-starting, dedicated. Provides knowledge and skills in rare supply	Contributes only on a narrow front. Dwells on technicalities

Reproduced with kind permission of Belbin <http://www.belbin.com>.

to be performed if the team is to function well. Therefore, an early awareness of any gaps in the group can ensure that someone takes responsibility for that role. It is also likely that the relative importance of each of these roles may vary depending on the type of project (or 'content', as identified by Tuckman).

 Discussion

How would you allocate the relative importance of the different Belbin team roles in the following project scenarios?

- A team has been asked to find out as much as possible about a particular country with which their company wishes to trade. A presentation on this is needed in seven days' time.
- A company wishes to bring out a completely new smartphone that will appeal to the 18–25 year range. Initial designs and target market potential are to be available within two months.

The issue of what might appear to be unbalanced contributions resulting from these different scenarios will be discussed in Chapter 8.

A simpler model by Honey (2001) proposes that teams need the following people:

- **Co-ordinator:** makes sure that objectives are clear and that everyone is involved and committed.
- **Challenger:** questions ineffectiveness and takes the lead in pressing for improvements/results.
- **Doer:** urges the team to get on with the task in hand.
- **Thinker:** produces carefully considered ideas and weighs up and improves ideas from other people.
- **Supporter:** eases tensions and maintains harmonious working relationships.

Why teams fail

If you have encountered difficulties working in teams, you are no different from many other teams in the working environment. The key thing is to learn from these problems so that you have strategies for dealing with them when you are at work. Being aware of the reasons why teams fail can help you avoid problems in the future.

Knowing about team stages may have already helped you identify why problems occurred. Other key questions to consider are:

- Has the team clarified its goals sufficiently?
- Are all the team members convinced by and committed to the goals (or have one or two forceful members pushed something through without carrying the others with them)?

- Has the way the goals are to be achieved been made clear?

- Has effective team building taken place (see below)? Failure to team build effectively could mean that team members do not trust one another, or are so fearful of being criticized for making a mistake that they avoid showing initiative or trying anything new.

- Is there conflict between members? This can be very destructive and needs to be dealt with early and openly. This will be discussed further under conflict resolution.

Slightly less obvious problems can be caused because of geographical location. Just as with personal friendships, it is easier to maintain good working relationships when you are in regular contact. With geographically dispersed teams, adjustments certainly have to be made to team building methods, monitoring, and evaluating. In the 'Communi-cation' section of this chapter, possible ways of overcoming geographical distances are discussed.

Belbin (2010) observed another surprising problem area. You might think that if you put together a team of very capable and intelligent people you would have the best chance of success. In fact, Belbin found that teams made up of such people (so-called Apollo teams) had poorer results than more balanced teams.

The problems appeared to be that:

- The team spent too much time arguing and debating, with team members trying to get others to accept their point of view and finding fault with other people's argument.

- Attention to detail was missing, resulting in some important tasks being overlooked.

- People would be deeply engaged in what they were doing, thus paying little or no attention to what other people were doing.

Our interview with Lance Beecheno illustrates several of these issues.

> I tend to find that the quicker, high functioning individuals ... tend to be more temperamental and get bored more quickly, so in that sense, if they're bored, they may well lose the plot, and lose their attention to detail. On the other hand, the people who ... plod away and are reliable ... they're not stupid, they're not necessarily slow, it's more to do with what they want from the role that they're doing. ... The people with the slower approach tend to take that little bit more care ... and they're better at the emotional side. ... They're less easily bored.

In your teamwork at university, you might find that choosing to work with people you believe to be the 'brightest' or most capable puts you into an 'Apollo' team. Be encouraged by the fact that these teams can succeed but if you find yourself in one, make sure that objectives and goals are clearly specified.

 Strong leadership also helps to focus attention (see Chapter 8). However, making an effort to join with people who can fulfil more of the roles identified above could improve your experience of teamworking.

Communication

'You must have excellent communication skills' and 'you must have effective communication skills'. In these extracts from typical recent job adverts, what do the employers mean by communication skills?

Communicating effectively in teams calls for several skills that we may feel we are already quite good at. These include listening, questioning, using body language as well as various forms of modern communication technology.

Active listening

It is tempting to think that communication is all about 'output', but processing 'input' is equally important. Listening attentively is something most of us find difficult, but as social psychologist and communication expert Hugh Mackay has written: '[L]istening is an important part of the contract we make with other people in any personal relationship. After all, why should anyone listen to us if we have not first listened to them?' (Mackay 1994, p. 154).

To appreciate this importance, just think of any conversation you have had with someone whose eyes are not on you, or who is trying to listen to another conversation at the same time, or even texting. How does this make you feel? And how does it make you feel when people interrupt because they cannot wait to let you finish the point you are making?

As Mackay suggests, if you want to establish good relationships with people you must develop 'active listening' skills. He explains that active listening is more than just not interrupting, although of course that is important. It is about giving the speaker your undivided attention, processing and fully understanding what they have to say. Active listeners take note of the speaker's body language, and even adjust theirs to show they are paying attention. By doing this they take in all the facts and are then in a better position to agree or disagree properly. Active listening helps you avoid time wasting through people having to repeat themselves.

Active listening also helps you know other team members' views and feelings and gives others the feeling of being understood and valued. To see why this is important, think how you feel when other people only seem interested in saying what *they* think, and ignore anything you have to say. Valuing other people's opinions will earn you respect and people will enjoy working with you. Listening attentively can also help you avoid conflict, or if it does occur, respecting and listening to each other is more likely to help resolve issues than if you start blaming each other, or making accusations.

For most of us, active listening does not come easily. Our minds race and we want to say what we are thinking before we forget it. However, it is an essential skill to practise.

Questioning and reflecting

Another important skill, especially if something complex has been said, is to reflect back what you think was said, for example 'So what you're saying is ...?'

This is also a useful technique if you feel you are getting overemotional. The act of phrasing the idea in a 'neutral' way may help you process it in a less emotional manner.

Watch your tone and body language

It is not always what you say that causes problems. The tone of your voice and your body language and posture can be even more powerful than the words you use. Have you ever felt uncomfortable in other people's presence, even though what they are saying is perfectly reasonable? It could be that you are picking up on their body language, which may be expressing more than they can bring themselves to say. It is good if you have picked up on it: it shows you have emotional intelligence. However, you should try to avoid giving these mixed signals yourself.

 Activity

Practise active listening at least once a day over the next week or so. Log your experiences in your PDP. Note whether it makes any difference to your relationship with the people you communicate with.

Using the technology

As already noted, not all communication is face-to-face. In an increasingly global and hi-tech environment, team members may be separated by considerable distances and scattered across regions, countries, and even continents. Keeping in regular touch with these colleagues is essential. Fortunately, modern communication technologies make it easy to do this nowadays, but we need to use them effectively. Lance emphasizes the value and importance of discussing and clarifying things orally before setting them down in writing.

> So you discuss what you are trying to achieve, you agree it, you then write it down. To write somebody a medium to lengthy document, being careful with your wording, the weighting of your words, the order of events etc., is extremely time consuming and is likely to lead to them writing back for clarification, and you replying with further clarification and them writing back a few more questions and then you answer their questions and eventually you come to where you could have come to with a conversation. So people tend to overuse email and underuse talking and listening.

Geographical distance often means it is not possible to talk face-to-face, and even where team members work or study in the same building, the need to juggle different commitments often makes it difficult to meet up. However, a phone call or videoconference may still be most appropriate when there are issues that need discussing. All of this means that keeping in touch via appropriate communication channels, some of which are identified below, is essential.

Table 6.3 summarizes different forms of communication and their various features.

 Discussion

Either with your project group or in informal groups, can you add any further means of communication to the list given in Table 6.3? Consider for each example how it might be most effectively used in your group work to help you communicate effectively in all circumstances.

Table 6.3 Communication methods.

More direct	
Face-to-face	Most direct and informative
	High cost for distant teams
Video conferencing	Next best thing to real-life meetings
	Relatively cheap and simple to set up
	Certain etiquettes need to be observed
Electronic discussion groups	Cheap and simple
	Allows exchange of information
	Lacks visual and oral cues
Telephone/audio conferencing	Affordable
	Simple and direct
	Lacks visual cues
Email	Quick
SMS	Does not 'impose' on recipient
	No visual or oral cues
Twitter	Good for keeping a personal circle informed
Facebook	Not 'secure' or 'private' (see later when we refer to digital identity)
Blogs	
Webpages	Good for broadcasting information to lots of people
Intranet	Open to 'general public'
Internet	
Letters	Allow careful drafting of information and facts
	Slow in production and delivery
	No verbal or visual cues
Less direct	

Team building

From the description of team building stages, and your own experiences of working in teams at university, you will appreciate that good working teams do not happen by chance.

From his work with many teams, Kazemek (1991) identified ten criteria he believed essential for building effective teams.

1. Goals and objectives. Successful teams understand and agree on these.
2. Trust and conflict. On effective teams, conflict may not be absent or avoided but is dealt with openly and worked out in a constructive manner.

3. Leadership. Effective teams share leadership roles among members. All members feel responsible for team leadership. Ineffective teams often have one person dominating.

4. Use of resources. Team members' resources are recognized and used fully on effective teams. Underuse of some members can be one of the greatest sources of frustration for people stuck in ineffective work groups. For some people, not being used to full potential is worse than being overworked.

5. Interpersonal communication. Effective teams pride themselves on open, participatory communication among members. Members generally know what is going on. Ineffective teams often are marked by guarded communication.

6. Control and procedures. Effective teams have procedures to guide team functioning and the members support these procedures and regulate themselves.

7. Problem solving and decision-making. Approaches to problem solving and decision-making are well established for effective teams.

8. Experimentation and creativity. Well functioning teams often experiment with different ways of doing things and encourage creativity. Ineffective teams often are bureaucratic and rigid.

9. Self-evaluation. Effective teams regularly evaluate their functions and processes. A regular retreat dedicated to team development issues and processes is a popular tactic used by strong teams.

10. Roles, responsibility, and authority. Members of an effective team clearly understand their roles, responsibilities, and degree of authority.

Kazemek acknowledges that not many teams will achieve all of these, but striving towards them should lead to success.

 Activity

Draw up your own checklist from Kazemek's\ points. In your next group work, try and get commitment from the group to apply them while you are working on your project.

You may be lucky enough during your course to continue working with a group of people you really get on with. However, team building strategies are needed for established teams as well as for new ones. A successful 'permanent' team can be unbalanced by changes in team membership, or they can simply become complacent and resistant to change (see 'Change management'). Monitoring the team's progress regularly will help to spot when things are going wrong, and problems can be tackled immediately.

Kazemek (1991) identifies the following requirements for successful team building relevant for established groups.

- The group must recognize the need to improve and admit that they could be more efficient.
- There has to be a desire to improve.
- Some objective measure of effectiveness is needed.

- A SWOT analysis could be used to identify strengths and weaknesses, a plan can be drawn up to build on strengths and minimize weaknesses.
- All team members need to commit to the plan.

Team building activities

At SupportPlan, Tania organizes a number of activities to promote good teamwork.

> We have a coffee morning once a month. Before the meeting everyone has to think about who they think has been the most helpful, kind, hardworking, innovative, (anything positive) person over the past month.
>
> At the beginning of the meeting we always start with the staff reading out their choice and explaining why they have chosen that person.
>
> The person with the most votes gets £30 vouchers from a shop of their choice and gets nominated as Employee of the Month.
>
> At the end of the meeting we close by stating something positive about the other employees. That way you get to say something positive about another person and close on a good note. No prizes for this one, just the 'feel good factor'.
>
> We deal with the negatives in the middle of the meeting.
>
> We find these sessions very useful because they create a good team spirit. A lot of people get recognition and a public pat on the back, and those who do not are encouraged to try harder.
>
> NB. We take a note of who has won each month and at the end of the year we have another vote to choose the employee of the year.

Good team building brings many benefits. Among others, it helps to engender trust between members, improve communication and problem solving skills, and encourage members to be open to change. The aim is that group members should have fun at the same time as they are learning.

If you find yourself organizing a team game, either when you are at work or in your university environment, here are some points to bear in mind:

- Good team building has a purpose, whether it is to get a new team up and running quickly, or to re-energize a 'permanent team'. Make sure you are clear what you and the participants will get out of the session.

- Organize yourself fully, but be flexible and willing to deal with the unexpected. People can constantly surprise.

- Be prepared for some resistance and do not take this personally. As mentioned in the section on change, some people find dealing with new situations uncomfortable.

- Try and provide an environment of 'psychological safety' so that people feel able to take chances without feeling they are going to be judged.

- It is not necessary to have any special venue, but wherever you are should be interruption-free so that members can give the game their complete attention.

- Make sure everyone is involved, even the people who usually try to stay in the background.

- Bear in mind that people are not able to concentrate on one thing for a long time (you may have noticed this in your lectures!), so vary the environment, the presentation style, their seating positions, anything and everything to keep the session dynamic. Provide breaks so that people can reflect and take a breather.
- Allow time for proper debriefing, otherwise the session will have no clear outcome.
 - Allow the group to raise issues and questions.
 - If they do not do so, ask participants open-ended questions about what they learnt and how they will use what they have learnt.
 - Listen very carefully to what is being said. Paraphrase it for the rest of the group if it is not clear.
 - Thank everyone for their contributions, if possible by name, with specifics.

Team building activities do not have to be expensive or take up a lot of time. With a clear sense of purpose and a bit of imagination, suitable activities can be devised.

 Activity

In pairs or a small group, think of a few team-building activities to promote good teamworking in your university group assignments.

Interpersonal skills

 Activity

Before reading this section, think what kinds of skills might be included under the heading 'interpersonal skills'. How important are these skills? What sorts of situations or tasks are they needed for? What problems occur when team members lack interpersonal skills? Draw on your own experience to answer these questions and discuss your answers with a few people around you.

You only need to look at the person specification on a few job adverts to know that phrases like 'interpersonal skills', 'people skills' or something similar feature on most, if not all of them. Likewise, interpersonal skills appear prominently in lists of 'transferable' or 'generic skills' and 'attributes' produced by people who have researched employability (e.g. Becket and Kemp 2006, Dacre Pool and Sewell 2007, Graves and Maher 2008).

In his interview with us, Lance Beecheno put it bluntly:

> If you gained 13 GCSE 'A' stars and straight 'A's at A Level, but could not create and maintain relationships with other colleagues or family members or partners, you would not be really a very useful human being, and you would not be very happy. So the ability to get along with people is crucially important.

Lance makes clear that when recruiting new staff, he is looking for more than just conventional intelligence, of the kind demonstrated by qualifications or IQ tests. At a later

point in our interview, he drew attention to two very important skills: 'People who are intelligent are not necessarily great at communicating, do not necessarily like each other or trust each other.'

Emotional intelligence

Indeed, during our interview with him, Lance was keen to emphasize how these abilities to communicate effectively and build up trust with others are crucially important in a range of contexts, both in customer facing situations and in teamwork. For him they are ingredients of another kind of intelligence that he believes are vital for his business: 'I'm looking for somebody with common sense, with emotional intelligence, who's able to empathize.'

His use of the phrase 'emotional intelligence' and reference to empathy are significant.

 In Chapter 4 we discussed how emotional intelligence is important in managing yourself in ways that are helpful when working on your own.

Rebecca Abraham (2004) explains how the added ingredient of empathy allows people to understand or anticipate how others are feeling, and in teamwork this is helpful when thinking about ideas and solutions to problems together. This is because empathy requires the ability to listen attentively to others, without always rushing to make your own point first, or reading emotional signals that reveal how people are feeling.

Lance is not alone in having faith in the power of emotional intelligence. Daniel Goleman, who made the idea popular in the 1990s, argues that strong emotional intelligence is a stronger predictor of 'star performance' than cognitive intelligence (IQ). Indeed, research by Kelley and Caplan (1993, cited by Goleman 1995), suggested that having strong emotional intelligence allows individuals to maximize the benefits of working with others while minimizing possible difficulties, in particular, by allowing people to:

- build positive relationships in the team;
- co-ordinate the efforts of team members effectively;
- get the team to agree on important issues;
- see things from other people's point of view;
- be persuasive;
- build networks of people who can help solve problems;
- encourage others to co-operate rather than fight.

Successful teamwork therefore requires the above emotional competences, but Abraham argues that these only flourish in the right 'organizational climate'.

In her 'Dimensions of Organizational Climate' table, Abraham (2004) summarizes 'climate factors' identified by different authors. In Figure 6.1, we present some of the factors that may have special relevance to teamwork.

Figure 6.1 Factors affecting organizational climate (adapted from Abraham 2004, p.125; authors in the diagram are cited by Abraham).

 Discussion

What do you think is meant by key words and phrases such as 'role stress' and 'role ambiguity'? Are they relevant in teamwork? If so, how?

Identify examples where you believe your own or other people's performance in teamwork has been affected by any of the factors included in Figure 6.1, either their presence or absence, at work, school, or university.

Discuss what you can do to influence organizational climate positively in your project team.

Discuss issues that can influence organizational climate negatively.

So far we have been discussing emotional and organizational factors that affect individuals' contribution to team efforts. We turn now to some of the issues that may make it harder for you or other team members to get along.

Working with new people and with diversity

Whether at work or during university group assignments, you are likely to find yourself having to work with people you have never met before or do not know very well. However, working with people we do not know can make us feel uneasy, and our discomfort can be even more pronounced if we perceive the other team members to be in some way different to ourselves, such as when they are from a different culture to our own.

Anxiety/uncertainty management

William Gudykunst (Gudykunst et al. 2005) argues that 'unfamiliar others' can make us feel uncertainty and anxiety, and he cites work by Stephan and Stephan (1985) which suggests that compared with people we already know well, new people can be harder to under-stand in terms of their behaviour, intentions, or the way they feel about us. We may also fear being judged negatively, either by the new people or perhaps even by members of our own in-groups.

Gudykunst suggests that both high *and* low levels of anxiety or uncertainty can prevent us from acting or communicating effectively with people who are unfamiliar. If our anxiety is too high we tend to stop interacting with them as quickly as possible, or even avoid doing so altogether. However, some uncertainty and anxiety is seen as a good thing, because if people are overconfident, they can appear insensitive or arrogant, and may also fail to pick up signals or information that would allow them to respond appropriately.

Identity management

Stella Ting-Toomey (1999) proposes that interacting with unfamiliar people can involve a threat to our sense of who we are. This is because of the way we develop our identities, both as individuals and as members of cultural groups (our 'in-groups'). Ting-Toomey argues that we do this by communicating with people in familiar cultural environments, and that our identities are linked to our needs to feel inclusion, trust, and connectedness. With strangers we feel no such connection, and we fear that becoming familiar enough with them to interact effectively will involve effort and risk to our personal or social identities.

Mindfulness

A further difficulty relates to the way we often act in automatic ways, using habits of thought and behaviour that were probably learnt as we were growing up. This automatic behaviour has been described as 'mindless', in the sense that in many situations we fail to pay very much attention to details that would allow us to respond to events and people 'mindfully' (Langer 1989). Part of this is our tendency to use categories or labels when assessing the behaviour and motives of people around us. (Langer et al. 1985).

A lesson that Gudykunst and Ting-Toomey draw from such 'mindless' behaviour is that it is important when meeting and working with people from unfamiliar cultural backgrounds to be mindful of our own possible preconceptions and to avoid judging others according to sim-plistic stereotypes. Rather, they suggest we should make special efforts to listen 'mindfully', taking care to listen to the person who is actually in front of us rather than some stereotype in our minds.

Such 'mindfulness' can help us see that even if there are things about new people that are different, such as the way they act and talk, the colour of their skin, or their abilities, they may also have a lot in common with us, not least of which is their need to feel respected and valued. At the same time, being mindfully attentive also allows us to discern more accurately where there are real differences, and to be honest and open about these.

Teamwork and job hunting

Interview questions employers ask about teamworking

 We will cover tackling interviews in Chapter 10 but you might like to consider specifically the questions relating to teamworking at this stage.

The following are typical of the types of question you might be asked.

- Give an example of a successful team project you have been part of.
- What factors in your experience help ensure that a team works successfully?
- Have you ever been a part of a team that had difficulties achieving its goal? What did you learn from that experience?

'Danger' questions

Not all employers are trained in interviewing, so you may occasionally be asked a question that could lead you to giving a very short answer which does not demonstrate your knowledge and application of all the areas you have covered above and in your project work. For instance if you were asked: 'Are you a good team player?', the answer could be 'Yes, I am' but obviously this would be inadequate. How should you respond in this situation?

 Discussion

Practise in your group answering this question in a way that will tell the employer what you can do for them and that could include any of the following assets you have to offer:

- positive attitude (back to mindset);
- communication skills;
- listening skills;
- awareness of the needs of others;
- willingness to help out colleagues;
- respect for others;
- empathy or emotional intelligence.

You will, we are sure, be able to add to this list other items you feel are important, having read the above material.

 In Chapter 9 you will learn about the STAR technique, which helps ensure that you cover all relevant aspects and that your answers are well structured. You may like to look at this quickly now.

Assessment centre interviews

 In Chapter 10 you will learn about preparing for an interview in an assessment centre.

Assessment centre interviews vary considerably, but, generally speaking, they are longer than a standard interview, sometimes lasting more than a day. They are designed to see how you behave and interact with others, rather than just what you know and they cover employability assets such as:

- communication;
- leadership;
- time management;
- initiative;
- decision-making;
- motivation;
- teamworking.

It is therefore worthwhile at this stage thinking about how you would demonstrate your teamworking strengths in such a situation. Remember that you will be working with others applying for the job. If you are in a successful team it will enhance your chances of being selected for the job.

 Discussion

Discuss in your group how, in an assessment centre situation, the team stages may be tackled and how you can demonstrate all the personal attributes identified above.

Conclusion

There is a lot to get right when it comes to teamwork, as was summed up by Anna Slowikowska when she was a second year business undergraduate, reflecting on her experience of teamwork.

> I learnt that planning, control, team management, communication and integration are crucial. Starting work without planning is not a good strategy. Setting clear aims and objectives is crucial for success of a project. In addition, communication between team members is very important and lack of good communication can lead to misunderstandings, conflicts or delay in work.

An idea that may help you bring all of this together is the suggestion that when we form new teams, we need to create an appropriate new cultural climate. Stefanie Rathje (2007) proposes that this process develops cohesion and synergy, allowing the team to achieve more than the sum of its individuals' efforts. Rathje believes that such cohesion grows out of people becoming familiar with each other, and that greater synergy is achieved when teams allow differences in the way individuals do things rather than by imposing rigid values and procedures that not all feel comfortable with. Whether the resulting culture is supportive or threatening also depends on a climate of familiarity, trust, and a sense of connection among team members.

 Activity

Read the following account of a child's first day at school. Although it is about a young child, can you make links between the story and ideas that have been presented in this chapter? How might you apply lessons from the story to your own teamwork?

> It was 50 years ago but I can still remember vividly feeling terrified the first time I arrived at primary school and entered a classroom full of unfamiliar faces. Luckily for me, one of the older boys got me to join in with a game they were all playing and within seconds I was happily crawling about the floor on my stomach, snapping at all the other 'crocodiles'. It might seem a trivial story, but I believe that experience was important and I'm sure it helped me settle in quickly and get the most out of school.

Read again through the sections on interpersonal skills and working with diversity, and produce your own bullet points under the headings of 'Dos' and 'Don'ts'.
Identify some creative and practical ways that can help to build familiarity and trust in teams.

What do you think now?

Go back to the questions at the beginning of this chapter. What do you think now? What for you are the important learning points of the chapter?

 Project

Your tutor will give you further guidance on how to work through the project tasks. The material we provide below summarizes the tasks and links them to other parts of this book.
Time to reflect on your team performance and how well you are progressing with any assessment you may have been given:

- Once again reflect on what team stage you have reached.
- Have clear team roles been defined?
- Are people communicating openly (including listening properly) and respecting the position of others?
- Are there any unresolved conflicts?
- Make sure you use the material in this book to address any issues now.

Is it time to introduce another team building/maintenance game? Can you invent a team maintenance activity similar to the one described by Tania in Chapter 7?
Ensure that the time management and scheduling activities you identified for yourself are being used by the team and you are on track to meet any deadlines.

Further reading

Belbin, M. (1993) *Team Roles at Work*. Oxford: Butterworth-Heinemann.

Honey, P. (n.d.) *Teams*. Peter Honey Publications. <http://oxfordlearninginstitute.peterhoney.com/resources.aspx?id=56> (accessed 8 April 2012).

Kazemek, E. (1991) *Ten Criteria For Effective Team Building*. Healthcare Financial Management, 45(9), 15.

7 Teamwork 2: Maintenance

 Learning outcomes

By the end of this chapter you should:

- Have an understanding of group dynamics.
- Have strategies for problem solving.
- Have examined ways of negotiating with others.
- Be aware of the impact of cultural difference.
- Be developing strategies for managing diversity issues, including stereotyping and prejudice.
- Understand about conflict, including dealing with difficult situations, processes and outcomes, saving face.

What do you think?

- Why might a successful team start having problems?
- Are culturally diverse teams likely to have different problems to other teams?
- Some people argue that meetings are a waste of time. Why do you think they may think this?
- Should conflict always be avoided in a team?

Case study

As we discussed in Chapter 6, good teamwork is needed when tasks and projects are too complex for individuals to complete on their own. In its work with major companies – many of them household names – Creative Leap, an SME branding consultancy, relies on excellent teamwork as it undertakes research and identifies the right strategy and designs needed to bring to life and reinvigorate new and existing brands. For example, at the time we spoke with them, they had recently been working with a PLC that had broken away from its parent company but still retained part of the old name. The company had made a number of acquisitions leading to a portfolio of seven different brands, but these were quite disparate and it was not clear how they fitted together or how they could be presented both to the general public and to the City. Creative Leap helped by undertaking numerous interviews across the business, including its customers, and produced proposals for the new PLC's identity and how this could be communicated.

This work involves complex processes in which effective teamwork plays a crucial part, and where colleagues need to contribute ideas and undertake different roles in each project. In this chapter we will be presenting extracts from our conversations with Creative Leap's Corporate Creative Director and Founding Partner, Mervyn Caldwell, Head of Insight and Propositions, Dominique Bonnafoux, and the company's Design Director, Corporate Brands, Michelle Healy.

In our conversation with them, communication, culture, and responsiveness to feedback were some of the key issues.

For more information about Creative Leap, you can view its website at <http://www.creativeleap.com>.

Introduction

In Chapter 4 we introduced the theory behind building a successful team. If you are using the project approach with this book, you will now have been working in your teams for several weeks and may have already encountered some of the issues described by Tuckman and Honey. We hope that you have overcome any 'storming' or 'chaos' issues and have identified your preferred team role(s), and that your team is working well together.

In order to ensure that a team continues working at its optimal level there are certain maintenance issues that need to be addressed. You cannot take for granted that a team will continue to function well without any effort. This chapter covers some of the areas it is important to get right in order to ensure the team continues to perform as well as possible (Figure 7.1).

Figure 7.1 A successful team.

Evaluating team performance

Later in this chapter we will discuss some of the reasons why not all team members may feel as comfortable with voicing disquiet about the way a team is working as others, so even a frank and open discussion might not give an insight into how individual members are feeling. You might therefore find it useful to find some 'objective' way of allowing members to give feedback for the group. A grading tool such as that shown in Table 7.1 can be useful.

Table 7.1 Grading tool. Circle the appropriate number – the lower the number, the less satisfied the respondent.

1	I am not sure what we are trying to do	1 2 3 4 5	I am clear about what we are aiming for
2	My contribution to the team isn't valued	1 2 3 4 5	I feel that I am a productive part of the team
3	There is not enough communication to keep me involved	1 2 3 4 5	I feel very well informed
4	I don't feel the other team members are on my side	1 2 3 4 5	I think there is a high level of support for individual team members
5	We don't seem to talk about difficult issues	1 2 3 4 5	We have open and frank discussions about our problems
6	Some members are not doing their share of the work	1 2 3 4 5	We are all contributing equally
7	I don't feel we have made any effort to build a good team	1 2 3 4 5	We have had some good team building events
8	One person is taking all the leadership decisions	1 2 3 4 5	We are all involved in making decisions

Table 7.2 Key to Table 7.1.

1 = Goal clarity	5 = Dealing with conflict
2 = Feeling of belonging	6 = All contributing
3 = Effective communication	7 = Team building
4 = Supportive culture	8 = Shared leadership

Our questionnaire tackles issues such as those detailed in Table 7.2.

You may wish, in your group, to add or amend Table 7.1 to address issues which are important to your group.

Acknowledging effort

We mentioned in Chapter 6 a team building activity which Tania of SupportPlan organized for the purpose of promoting good team work and acknowledging effort. However acknowledging effort can be even simpler (though perhaps not as social) as Tania's activity. Simply saying 'Thank You' in the right way can be enough to motivate people to keep doing their best.

You may be surprised that we say there is a right way to say thank you, but unless you praise people at the right time, ie when they have just completed the task, then it will not seem as if it was truly valued. Also it is useful to make it clear why what they did was so specifically appreciated. McClelland (1961) also points out that people often have different aims within a work context so how they are 'thanked' and rewarded should fit in with their needs.

Finally, there is even a cultural dimension to the way in which people respond to praise. Whereas in some countries praise is an important element of building a good working environment, in others excessive praise can make people feel uncomfortable. If these cultural differences are of relevance to you, we refer you to the back to the further reading for Chapter 6.

 Activity

In Chapter 6 we gave guidelines for team building activities and suggested that you tried to develop some team building activities to unite your group. You might wish at this point to discuss how successful these activities were. Now that you are an established group, you may wish to develop a maintenance activity similar to those run by Tania. Or you may wish to develop an activity that addresses any specific issues your group is experiencing. For example, a simple game that tests how well you now know your fellow team members, and gives you an opportunity to learn more, is Two Truths and a Lie. Each member of your group should tell the rest of you three things about themselves, two of which must be true and the other a lie. The rest of you should then decide between you which of the statements is a lie. This can be fun, and is a measure of how well you are getting to know one another.

Communication within teams

In many respects, having good communication systems within teams is key to success. Keeping people sufficiently informed of what is going on has many benefits, including making them feel part of what is going on and avoiding misunderstandings. However, it is also important not to overwhelm people with unnecessary information. Some of the side effects of this are highlighted in Figure 7.2.

Figure 7.2 Communication problems.

As you might imagine, it can be a difficult balancing act to get things just right. However, if you do use a team evaluation tool as suggested above, you can check that everyone in the team is happy with the amount of information they are receiving.

 As mentioned in Chapter 6 the method of communication used can also aid or hinder communication between teams.

Both Lance of SupportPlan and Louise of the Peel Group pointed out that using email is no guarantee for getting things done. Here is Louise commenting on her experience with recent graduates:

> Young adults – they think that email is the be-all and the end-all and certainly email is one way of covering yourself, so I get a lot of 'Yes, I sent an email. I've not had a reply yet', but they've achieved absolutely nothing! They have to learn to pick up the phone, make an appointment or go and see someone face-to-face: that is the way you'll get the job done.

This is not to say that email does not have its place, but that you need to ensure that the medium you use matches the purpose of the actual communication. Table 6.3 should help you decide. When communicating with people in different geographical locations, deciding on the best method becomes even more important.

Communicating globally

Most people today accept that they do not need to be in the same place at the same time to keep in touch with friends and relatives. However, this never used to be the case.

 Activity

Talk to some of your older relatives and their friends, particularly those who had to communicate pre-Internet and ask them how they kept in touch with people who were distant. Use the active listening skills discussed in Chapter 6. Discuss this with other group members. Consider things such as:

- What were the problems of communicating with people who they were not in face-to-face contact with?
- How did they deal with this?
- What do they think is better now?
- What do they think is worse?

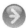 Bear the answers to the Activity in mind when you come to read about customer focus in Chapter 8, and remember that some of your customers may still have preferences for certain kinds of communication.

 Table 6.3 highlighted the main features of different forms of communication. We are raising this issue again because there is a general assumption that there are no difficulties for teams working at a distance. It is assumed that even though people may be on different continents, the technology is there so that they can still work together as effectively as if they shared an office. However, if you have been trying out some of the communicating methods we mentioned in Chapter 6, you may have found some of them more convenient and successful than others.

 Activity

Discuss with your group which communication methods you have found more or less successful and how you might overcome the disadvantages you have encountered. Enter these in Table 7.3, which we have started for you.

Table 7.3 Analysis of your team's communication problems.

Method	Problems	Possible solutions
Audioconferencing	No facial expressions or body language to help communication	
	People interrupting one another	
Skype		

There are advantages to using technology for communicating with people at a distance, and these include:

- It saves time and money on travelling.
- You may have access to people who you would not normally be able to have in a meeting – specialists and experts on a topic, for example.
- Less time is spent on things such as tea/coffee breaks.

Nevertheless, experts such as Hackman (2011) believe that teams that work remotely are disadvantaged and it is worthwhile for organizations with such teams to intersperse distance meetings with face-to-face meetings at the start, midpoint, and end of a project.

Negotiating with others

Later on in this chapter we suggest ways of dealing with conflict. However, good communication can help to ensure that conflict situations do not arise, and this includes good negotiating techniques. To some extent the techniques used for resolving conflict are important for good negotiations too. Such skills as asking the right question and listening are useful tools for many areas of life, negotiating included. Other guidelines for successful negotiation are:

- Be clear about what you want.
- Try and understand what the other person wants.
- Establish a friendly, co-operative climate.
- Do not let this develop into a battle of egos.
- Think about ways you can both get what you want.
- Finish on good terms – you may need to negotiate again in the future.

One final piece of advice is to watch how good sales people operate. The best of them are masters of negotiation. The really successful ones leave you feeling that you have got a good deal and that you will go back to them again in future.

 Activity

Before we go on to discuss culture and its impact on teamwork, here are some questions for you. In Table 7.4, circle answer A or B according to which is most like the way you would approach each of these issues. N.B. There is not a 'right' or 'wrong' answer, so just answer according to your instinct and do not confer with others at this stage.

Table 7.4 Teamworking preferences questionnaire.

		A	B
1	When starting to work in a new group my main priority is to get to know everyone so that we can establish a good working relationship	... to clearly identify the task so that we all know what we are doing
2	If I disagreed strongly with a team member, I would discuss the issue with them in private	... bring the issue up in the group to clear the air and give everyone a chance to have their say
3	When discussing issues with others in a group, I would assume that if someone remained silent, they were presumably in agreement	... if someone remained silent, they may be unhappy with what has been proposed
4	When I have several tasks to complete I like to make a start on several of the tasks at once	... I usually like to complete each one before starting another
5	In emotional situations, I don't mind showing my emotions in front of others	... I usually prefer to keep my emotions to myself
6	When I am working in a team, I think the leader should	... give me clear instructions that I can follow	... discuss possible courses of action with me and the team
7	When working on a project with others I believe that we should control what we can at the start, and the rest will sort itself out as we go along	... we should make sure everything is decided and clear before starting

Now compare your responses with others. Did everyone give the same answers? If not, discuss.

Towards the end of this chapter we have provided a key to this exercise that will allow you to interpret your responses according to theory, which we explain next.

Working in culturally diverse teams

People's experience of cultural diversity can be very different. Their attitudes and feelings about living, studying, or working among people unlike themselves are likely to be different, depending on whether they grew up in a largely multicultural setting or one in which most other people were of the same culture.

Our focus here is to give you an overview of theory relating to how culture, through its impact on behaviour and communication, can affect interpersonal and team effectiveness. An awareness of how relevant issues can help you and your team experience benefits rather than problems from having diverse group members can also help you.

In Chapter 5 we suggested that 'Theorists' dislike uncertainty, and in Chapter 6 we mentioned that some individuals were more 'people' or 'task' oriented. In fact, these 'personal' qualities can also be linked to cultural traits such as uncertainty avoidance (Hofstede et al. 2010) or 'Deal versus Relationship Focus' (Gesteland 1999). We discuss these more fully below, but the point here is that to understand human behaviour, we should also be aware of cultural factors.

Understanding about the impact of culture on behaviour and communication is not only important for international students or people likely to work abroad. In today's richly diverse society and globalized economy, this is relevant for everyone.

Defining culture

Culture is a multifaceted term linked to ideas relating to community and variously defined social groups. It has been defined as: '... the particular way of life of a group of people, comprising the deposit of knowledge, experience, beliefs, values, traditions, religion, notions of time, roles, spatial relations, worldviews, material objects, and geographic territory' (Liu et al. 2011, p. 57).

Culture relates to the way groups and their members make sense of the world, and to the values that guide their behaviour (Martin and Nakayama 2008) and produces 'guidelines for human conduct' (Gudykunst et al. 2005, p. 11). Typically, these guidelines are not written or spoken about. They are learnt indirectly via the process of socialization through which every child, in all cultures, learns how questions, problems, and events in life are to be addressed and communicated, and how they and others 'should' behave. This does not mean that culture is fixed. Together with other authors, Liu and colleagues agree that it is actually dynamic and changing (e.g. Rathje 2007, Rimmington and Alagic 2008), and that it is 'learnt' rather than naturally inherited.

Because culture has such an important impact on the way people think and behave, it has been described as a kind of 'software of the mind' (Hofstede et al. 2010). This 'mental programming' (p. 4) has important implications for the expectations people have of the way they and others 'should' behave and communicate.

The implications for group work are that if team members are from different cultural backgrounds, they will have different ways of behaving and of communicating. Moreover, if their expectations of how others should behave and communicate are in some way violated, this can lead to a range of negative emotional reactions, and conflict (Burgoon and Hubbard 2005).

 Discussion

Have you ever encountered 'culture shock', when the behaviour of those around you appeared strange or even shocking to you?

- Describe what happened and how this made you feel.

- Did your feelings change as you became more familiar in the new environment?

This exercise may appear especially relevant if you are an international student, but it is also likely that for most people the experience of coming to somewhere new, such as university, may have created similar experiences.

To put these unspoken cultural 'guidelines' into words, some researchers have identified 'cultural dimensions'. These describe spectrums of behaviour and communication lying between opposing extremes, which seem to distinguish different cultures. For example, whereas in some cultures the pursuit of individual goals is seen as normal, for others the needs of the community are prioritized. This 'individualism versus collectivism' dimension was one of several identified by Hofstede after analysing survey scores collected from IBM employees in more than 70 countries (Hofstede et al. 2010, referring to earlier work conducted by Hofstede).

Before saying more about them, it is important to point out that there are some issues that one should be aware of concerning cultural dimensions. Some have been criticized for being produced using flawed research methods. It is argued that they present human cultures as if they were uniform and fixed, when they are actually highly differentiated and dynamic, and that to make distinctions between peoples based on national differences is questionable (McSweeney 2002). There is also a concern that cultural dimensions actually encourage attitudes based on stereotypes, and these may obscure issues that could be revealed by a more subtle approach (Rimmington and Alagic 2008). These criticisms should be remembered when you are using cultural dimensions in your reflections on people's behaviour and communication, including your own.

However, it is worth remembering that 'cultural dimensions' are theoretical constructs. They are simply a way of representing ideas and phenomena that can be inferred from observations. As well as helping you understand the behaviour and thinking of people from cultures different to your own, they can also assist you, just as importantly, to develop self-awareness. In particular, they can help you understand how your cultural background influences your own behaviour, values, and attitudes. This can help you become more tolerant of others having different ways of doing, seeing, and communicating things. Learning about cultural dimensions can help you realize there is not always simply one way to approach tasks and problems, or how to interact with others.

For the sake of simplicity, we present them under three main headings relevant for teamwork:

- Relationships.
- Power.
- Uncertainty.

Relationships

Individualism versus Collectivism (Hofstede et al. 2010)

A key dimension affecting the way people interact and form relationships in groups is referred to as 'Individualism versus Collectivism'. According to this theory, in some cultures people tend to see themselves as independent entities, believing that their personal interests are best served by striving after individual goals. In others, people's sense of identity is defined more by their belonging to a group and they see themselves as more interdependent.

Figure 7.3 summarizes key issues relating to this dimension which affect teamwork.

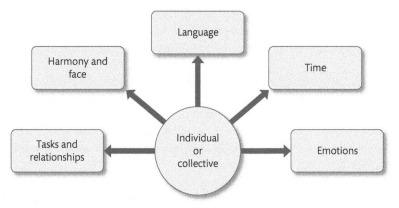

Figure 7.3 Key issues affecting teamwork.

 Discussion

How important is it to know other team members well when working together?
Think of your own answer first before discussing this with others.

Tasks and relationships

When some of James's students were asked the same question, two responses stood out. One student insisted that it was not necessary to get to know colleagues at a personal level. What *was* important was that people got on with the task in hand. The other student saw things differently: only if the various team members got to know each other could they hope to perform well in the task. If we tell you that one of these students was female and the other male, which do you think was so keen to build relationships in the team?

You might be surprised that it was in fact the man who felt you must get to know the people you work with. If so, you might consider whether male and female stereotypes led to your getting the answer wrong. As it happens, the male student was Chinese and she was English. According to Gesteland, these differences reflect a 'pattern of cross-cultural behaviour' which he calls 'Deal-Focus (DF) versus Relationship Focus (RF)'. People from RF cultures need to have developed a relationship with people before they feel comfortable working and interacting with them. Conversely, although building trust, harmony, and rapport is universally important, DF people's prime concern is with the deal, project, or task on which they are working. In fact, they may feel only able to develop a relationship once they know they can trust the other person to do the work. Here is Michelle Healy of Creative Leap:

> I'll build a relationship with someone once I know that they can do the work, and they've earned that respect, and you know that they're good, and that what they say is true.

Drawing on the above theory, a possible analysis of the above case is that for the Chinese student, feelings of trust and loyalty in the group were especially important but he believed

these would only develop if team members got to know each other. For the English student, in work or study contexts, attention to tasks was what mattered, and she felt no need to engage closely with colleagues considered to be outside her immediate circle of family or friends.

From a single case involving one English and one Chinese student we should not generalize. However, it is striking that Gesteland (1999, p. 5) categorizes Great Britain as 'moderately Deal Focused', and all of Asia except for Hong Kong and Singapore, as 'Relationship Focused'. Moreover, the individualism (IDV) score for Great Britain is very high (89) compared with China (20) (Hofstede et al. 2010), suggesting a link between deal focus and individualism, and between relationship focus and collectivism.

In Table 7.5, we have presented the cultures which Gesteland describes as 'Deal-Focused', 'Moderately Deal-Focused' and 'Relationship-Focused' alongside Hofstede's IDV scores for some of the countries. Correlations in the various sets of data are by no means perfect; however, countries identified as having a Deal Focus have significantly higher average IDV scores (77) than those with greater Relationship Focus (25).

Harmony and face

Emphasis on the group rather than the individual means that in collectivist, relationship-focused cultures, harmony is an especially important value which takes priority over the needs of the individual and of the task. In their desire for harmony with other people, members of such cultures take great care not to cause offence so are careful in how they behave in front of others, and in what and how they say things so that nobody loses face. 'Losing face' means experiencing damage to one's reputation. Preventing others losing face can mean being indirect when communicating.

Language

Such indirect communication might include being ambiguous, talking around the subject, not saying 'no', using euphemisms or even silence (Ting-Toomey 1999, citing Barnlund 1989). Dominique Bonnafoux of Creative Leap found this indirect use of language baffling when she first came to Britain:

> I really struggled when I went to the UK, because no one ever says 'No'. It's just not a word that anybody uses in the English language, at least not in business, so you're talking to a client, you're talking to a provider ... they will never say 'No', like the French will do, like: 'No, I can't do it by this time but I can do it by then'. They would find some really twisted kind of way of saying 'no'. I just wasn't getting it. It took me about six months to understand that.

During a group work assignment another of James's students, from Thailand, kept silent when he found himself disagreeing with other team members and felt frustrated that colleagues did not pick up that he was unhappy with a proposed course of action. Reflecting in class on the incident afterwards, he commented that: 'Silence does not necessarily mean "Yes"'.

That his silence might actually be communicating disagreement simply did not occur to most of those present, except for one student who was Japanese. In Asian culture, she explained, his silence would have been noted and it is likely that he would have been asked

Table 7.5 Deal-Focus and Relationship-Focus Cultures (Gesteland 1999) and individualism (IDV) scores.

'Deal-Focused' Cultures (Gesteland 1999)	IDV scores (Hofstede et al. 2010)	'Moderately Deal-Focused' Cultures (Gesteland 1999)	IDV scores (Hofstede et al. 2010)	'Relationship-Focused' Cultures (Gesteland 1999)	IDV scores (Hofstede et al. 2010)
Nordic and Germanic Europe	Denmark 74	Latin Europe	France 71	The Arab World	Arab Countries 38
	Germany 67		Italy 76	Most of Africa	Africa East 27
	Norway 69		Spain 51		Africa West 20
	Sweden 71	Central and Eastern Europe	Czech Republic 58	Latin America	Argentina 46
North America	Canada 80		Poland 60		Chile 23
	Canada French 73		Russia 39		Columbia 13
	USA 91		Slovenia 52		Costa Rica 15
Australia	90	Chile	23		Bangladesh 20
New Zealand	79	Southern Brazil	Brazil 38		China 20
		Northern Mexico	Mexico 30	Asia	India 48
		Great Britain	89		Indonesia 14
		South Africa	65		Malaysia 26
		Hong Kong	25		Pakistan 14
		Singapore	20		Thailand 20
Average IDV Scores	77		50		25

Geert Hofstede, Gert Jan Hofstede, Michael Minkov, *Cultures and Organizations, Software of the Mind*, Third Revised Edition, McGraw-Hill 2010, ISBN 0-07-166418-1. ©Geert Hofstede B.V. quoted with permission.

about it later, in private, by the project leader. She understood his difficulty in expressing disagreement in front of the group, because this would have threatened group harmony and involved loss of face for the colleague with whom he disagreed, and possibly for himself.

The use of silence and the Japanese student's ability to read between the lines are examples of what Edward Hall (1976) called 'high-context communication', where people's meaning is conveyed less by what they make explicit through words and detailed information and more by the context and via non-verbal means such as pauses, tone of voice, and silence. Important aspects of context include cultural beliefs, norms, values, and communication styles, all of which are understood by the in-group and do not need to be mentioned. Because so much can be conveyed with few words, high-context communication can be economical and fast but it relies on in-group members already having a lot of contextual knowledge. This is per-haps why it is so important for high-context, relationship-focused individuals to spend time getting to know other team members.

By contrast, in 'low-context' communication, information needs to be made verbally explicit because few assumptions are made about what the other person already knows. Gesteland (p. 10–11) links such communication to deal-focused countries, where language is often 'direct, frank, straight-forward' and even 'blunt'.

 Discussion

In a project group, some individuals are keen to get to know one another but others seem interested only in getting the work done.

- How might each of these behave during the project?
- How might they feel about the behaviour of the others?
- How might these differences cause tensions?

Your answers may be similar to the way Gesteland (p. 4) describes how RF and DF people see each other. Because they use direct language and prioritize tasks over people, DF indi-viduals can be seen as 'pushy, aggressive, and offensively blunt' by people more focused on relationships. On the other hand, building relationships takes time and DF people can feel that RF individuals take too long over things and that their indirect communication style makes them 'vague and inscrutable'.

Time

The importance attached to relationships and tasks has significant implications for peo-ple's attitude to time and the way that they structure activities. Hall (1976, p. 17) distin-guishes between 'monochronic time (M-time) and polychronic time (P-time)'. In cultures where M-time is the norm, people tend to do and complete things sequentially, one at a time, whereas in P-time, they may be doing several things all at once. Again, the thinking behind these different approaches can be linked to the 'relationship versus task' dimension. If we are mainly concerned about our individual schedule and about completing tasks, then we

do things in M-time. By contrast, where relationships have a higher priority, communicating with other people – face-to-face or via different media – is more important than sticking to a rigid schedule, so we are prepared to interrupt what we are doing if we see somebody or if they call us.

These differences are significant and can be the cause of much misunderstanding and even conflict.

 Discussion

You are in the middle of an important meeting with other project team members when a friend calls you on your phone. Your friend is going through a difficult time right now and you know that they have been anxious to talk with you.

On your own, think through what you would do in this situation. (Try to think what you have actually done in similar circumstances rather than what you think you 'should' do.)

Now compare your response with a few others before discussing with the wider group.

Expressing emotions

The way we show emotions communicates a lot to other people. Moreover, we perceive and interpret people's displays of emotion differently according to how much emotion we are used to expressing ourselves, and seeing in others. Analysing cross-cultural differences in emotional display, Trompenaars and Hampden-Turner (1997) refer to the 'neutral-affective' dimension. This relates to whether people from a culture appear neutral, showing little emotion, or affective, meaning that they show a lot of emotion. Expressing emotions non-verbally may be done through tone and loudness of voice, facial expressions, and various forms of body language such as gesticulations using hands and arms.

If you are from a 'neutral' culture, you may feel that a person expressing a lot of emotion is behaving inappropriately. You might even think they are being childish, irrational, insensitive, or simply too loud! Conversely, if you are used to showing strong emotions with your face, arms, and hands, whether by anger or joy, you may feel that someone who shows little emotion is cold and unapproachable.

There is likely to be more than one underlying cultural factor influencing such differences in how we show emotions. Ting-Toomey (1999) suggests there is a link with the individualism-collectivism dimension. Whereas individualists tend to feel entitled to express personal feelings freely, collectivists are more concerned with the opinions and reactions of others, and so are more cautious in showing their emotions. As in the case of verbal directness and indirectness, showing emotions too strongly could, in collectivist cultures, be a threat to harmony and face.

The important point to remember is that when meeting and interacting with people from cultural backgrounds different to our own, it is important not to judge them from the way they are expressing emotions.

As we have seen, differences in the way that people act – independently or interdependently – and the way they attach value to tasks and relationships have important implications

for the way people behave and communicate in teams. We believe also that where groups are drawn from more than one culture, it is especially helpful if team members take the time to get to know each other, as is emphasized by Dominique Bonnafoux, from Creative Leap:

> When you've got a collection of individuals, then you take your baggage with you, whatever that is: personality, your relationships and your attitudes to others. For me, trust is about time. It's about getting to know people ... understanding how they work, what makes them tick, what they respond to better ... you need to find out how you get the best from that person.

Power

There is another way in which people relate differently to each other. You may have noticed some university students only ever using tutors' titles and surnames, or addressing them as 'Sir' or 'Madam', and you might have found this rather formal. Alternatively, you may use this more formal approach yourself, in which case when you first heard other students using a tutor's first name this may have seemed disrespectful. These different levels of formality may relate to what Hofstede et al. (2010) term 'Power Distance'.

This dimension concerns the extent to which unequal power distribution is accepted by less powerful members of a society. In cultures where there is 'high' power distance, hierarchy and individuals' place within it is accepted unquestioningly. Subordinates are expected to be deferential to their bosses and not challenge their authority; teachers and lecturers are accorded high status and respect, and their opinions are not questioned. In low power distance cultures, where power inequalities *are* challenged, there is an expectation that students should be treated by teachers as equals. Students should ask questions and are encouraged to think independently, and even to challenge points made by the teacher.

In passing, it is worth noting that, for these reasons, it may be difficult for international students from high power distance cultures to express the critical mindset expected at higher education institutions in countries with low power distance, because they feel uncomfortable challenging ideas presented by tutors or by 'experts' in books (Doleschal and Mertens 2008).

As regards teamwork, cultures with high power distance tend to prefer decisive, authoritarian leaders. Likewise, leaders in such cultures expect to be able to tell people what to do, rather than acting in a more democratic fashion, as would be expected in low power distance cultures (Hofstede et al. 2010). These differences have important implications for leadership styles in teams.

Uncertainty

Different cultures appear to place different emphasis on structuring activities, and this is illustrated by Anna Slowikowska's experiences of study and work in her home country and in England:

> In Poland there is much more structure both in learning and at work. We are used to much more pressure, higher expectations and tighter deadlines.
>
> ... I find English students much more laid back, they do not seem to worry much about the time. ...
>
> How did it make me feel at Uni? I felt unsupported by other students in our teamwork, disappointed, stressed, I was worried we are not going to make it on time and that the standard of our work together will be low.

Uncertainty avoidance (Hofstede et al. 2010)

Anna's desire for structure and deadlines may relate to the 'Uncertainty Avoidance Index' (UAI). This refers to the degree to which people seek to avoid uncertainty and ambiguity. Indeed, the UAI score for Poland is very high (93) compared with Great Britain (35) (Hofstede et al. 2010). In cultures with strong uncertainty avoidance, people like to have things very clear, because they are uncomfortable if arrangements are ambiguous or not precisely structured. Cultures with weaker uncertainty avoidance are more relaxed about ambiguity and have a dislike for too many rules. 'Things will work themselves out' seems to be their motto.

These differences also affect people's emotional behaviour and the way they come across to others. Because of their higher anxiety levels in the face of uncertainty, people from cultures with high UAI scores can appear, to those with weak uncertainty avoidance, as busy, emotional, and aggressive (Hofstede et al. 2010).

This anxiety and their need for certainty drive them to want detailed, clear, and unambiguous plans. Such people may feel uncomfortable when working among weak uncertainty avoidance individuals who they may perceive as too easy-going or even lazy. The issue is compounded when groups containing a mix of individuals with 'weak' and 'strong' uncertainty avoidance face tackling complex tasks for which there is no clear structure. The project described in this book is a good example, as are many university assignments where structuring the task is an important element.

Having studied and worked in Britain for several years, Anna has developed strategies for coping: 'I think that the main lessons for me from the teamwork is that in future I'll have to stay calm, try to encourage greater communication and the commitment of others in a team by dividing tasks into specific roles'.

 Discussion

Anna achieved excellent grades in her studies and was among the first on her course to find graduate employment. How do you think that uncertainty avoidance might have contributed to this success?

The previous sections on managing cultural diversity have presented a necessarily simplified overview of a complex topic. We hope we have done enough to whet your appetite for learning more about cross-cultural issues and their impact on interpersonal interactions, behaviour, and communication, and to consider studying this fascinating subject in greater depth.

We have mentioned a few of the countries where the various theories appear to apply, but have deliberately refrained from telling you where all countries fit along the various theoretical spectrums. If you wish to find scores for a particular dimension, such as for your own country, you should be able to find these fairly easily on the Internet.

Doing this is interesting, but certain points must be remembered. Remember that the various dimensions are generalizations. They should not be used to predict, for example, that because someone comes from a certain country, he or she must be like this or like that. Knowing that Great Britain has a low score for uncertainty avoidance compared with Poland, for example, does not mean that all British people are so laid back that they never plan things properly, nor that all Poles are so uncomfortable with uncertainty that they are unable to be spontaneous. The issues of stereotyping and prejudice raised in Chapter 6 are very important in this respect

 Discussion

Towards the start of a project you have been appointed to lead, various incidents occur that seem to be affecting progress.

One of the team seems very impatient and wants to get started straight away, even though not everything has been worked out. She is rather irritated by one of the other team members who has suggested working in the canteen where they will be able to chat more easily, and by team members who spontaneously start chatting during meetings and do not seem so interested in getting on with the work. Another member of the team insists that every aspect of the project must first be planned carefully, down to the last detail. As project leader, you have been trying to impose your authority but two of the team members have complained that you are not allowing them to voice their opinions. At a meeting there is considerable tension because of these differences.

- Can you identify theories that may help to explain these different behaviours?
- As project leader, what specific actions might you take to diffuse the tension and manage the different points of view?

In Table 7.1, we asked you to circle responses A or B with questions relating to the above cross-cultural issues. Now circle the answers again in Table 7.6.

Table 7.6 Key to Table 7.4: Teamworking preferences/cultural tendencies.

Focus	Task (deal)	Relationship
	B1	A1
Tendency	Individualism	Collectivism
	B2	A2
Communication preference	Direct	Indirect Saving face Striving for harmony
	A3	B3
Number of tasks	Single task at a time (monochronic)	Multiple tasks at a time (polychronic)
	B4	A4
Emotional expression	Expressive/affective	Low expression/neutral
	A5	B5
Power	High	Low
	A6	B6
Dealing with uncertainty	High uncertainty avoidance	Low uncertainty avoidance
	B7	A7

Compare your answers with others in your class. Does any pattern emerge? Do your responses and those of your colleagues appear to be in line with the intercultural communication theory that we have discussed?

and it is worth reading them again, as well as ideas on uncertainty and anxiety management and identity management. Remember above all the point we made about not rushing to make assumptions too quickly about others and to react mindfully rather than mindlessly.

Conflict resolution

Remember that you do not have to like everyone you work with, but you do need to be able to maintain an appropriate level of communication so that you can work effectively on whatever you are undertaking. If handled properly, conflict situations can help to bring issues out in the open, which can be beneficial. However, if ignored, problems can become worse and harder to deal with as people's positions become more entrenched. Indeed, Mervyn Caldwell of Creative Leap believes it is important in teams for people to feel able to raise concerns without fear: 'People have to feel that they need not be scared or frightened to come up and say "Can I have a word because something's not making me feel happy?"'

People often say that an argument 'clears the air' and if all parties deal frankly and openly with the issues that are causing a problem, the result can be a great improvement on what has gone before.

Because each person, and each situation is different, there is no single right answer to how to manage conflict. The 'problem analysis' tree in Figure 7.4 may help you to make sensible choices when you meet with someone you consider problematic.

Communicating in problem situations

1. Both of you should state the problem as you see it.

 Try and stick to the point.

 Focus on the main issue – do not start bringing in a whole load of 'niggles'.

 Try not to use this as an opportunity to apportion blame.

 State the problem in neutral terms.

 Use 'I' statements to explain feelings rather than 'you' statements (e.g. 'I feel ... when ...' rather than 'You keep doing xxx,' or 'Why do you keep ...?').

2. Remember that you will learn more from listening than talking.

 If necessary, set a time limit in which each of you state your case without interruption.

 Look back at the 'active listening' section in Chapter 6.

 Show with body language that you are listening.

3. Summarize what you have understood. This has a double benefit:

 The other person will know that you have understood their point.

 Having to put it in your own words could make you understand their view point better.

 The other person may also be annoyed by something you are doing. Do not be too proud to apologize. A simple apology can diffuse a situation very quickly.

4. If you are still not clear about the issues, try and clarify them by means of questions such as 'Why is this ...?', 'How can we ...?', but do not try and pass the blame on to the other person. No accusations.

Is this person really a problem?

Reflection:

Am I over-reacting?

Am I expecting people to do things in exactly the same way as I would rather than judging by final results?

Am I being intolerant?

Can I still work with them, perhaps by making some adjustment?

Remember the only behaviour you have real control over is your own.

Remember even if you cannot change the situation you can change how you view and react to it.

Yes. This person really is causing the team/me problems. Can I tackle the issue myself?

No, I can cope by making an appropriate adjustment to my behaviour or attitude.
This is within my control and does not need to involve the other person. I am sure that in doing this I am not just running away from the problem or storing it up for later.

No, I do not feel confident enough to do so.

Do you want to take the issue to a superior now?

Yes

Reflection: If someone had a problem with me, how would I like him/her to deal with it?

Would I prefer them to talk to me about it initially or take it to a higher authority? We guess you would prefer to have them talk to you. It is a measure of your self-confidence and self-efficacy (see Chapters 1 and 2) if you can discuss your issues directly with the person. See the list of guidelines for 'problem solving' communication with someone else for further information.

Yes

Then at this point it is your prerogative to do so. If you are going to raise a complaint it is important that you have clearly and fairly documented the issues you have encountered.

Reflection: What effect do you think this will have on your working relationship and on the team you are part of?

Would it be worthwhile to try a bit harder with some of the suggestions above before you take this step?

No

Perhaps you could try to find a Mediator (see below).

Also, consider making it a long-term objective to build up your confidence to confront people and problems.

Figure 7.4 The problem analysis tree.

5. When you feel that you have understood one another's points of view, try and find some areas of agreement. Start with simple things first so that you get a sense of achievement.

> Example. Someone you are working with is producing their share of the work late, which means your team is missing its deadlines. After your discussion you realize that they feel they are being given an unfair amount of work, which they cannot cope with in the time available. You feel that their share of the work *is* fair. Your initial agreement might be that in future they will flag up earlier when they are having a problem. From there, seek agreement on what workload is fair for them to fulfil in the time available.

The following link gives an interesting perspective: <http://www.psychologytoday.com/articles/200609/dealing-difficult-people> (accessed January 2013).

Points to remember

- Body language affects how people respond, so keep yours relaxed and neutral.
- See the meeting as a joint effort to solve a problem, not an exchange of criticism.
- Cultures respond differently to criticism or other threats to reputation or 'face' (see earlier points made about conflict and face).
- If one of you is beginning to lose their temper, suggest adjourning the meeting but arrange to meet as soon as possible, ideally within the next 24 hours.
- Accept that just as you have a right to feel as you do, so does the other person. You cannot expect other people to change simply because you want them to. Work together towards a solution you can both live with.
- Talk about what you want and expect, rather than what you do not want.
- Go into your discussion feeling hopeful, not pessimistic.

Mediation

The above points should help you reach agreement but if this proves difficult, having a mediator might be helpful. This can be another colleague or fellow student who both parties respect and who is willing to help. Mediation is a tool that businesses sometimes have to use and the ACAS website (ACAS n.d.) is worth visiting as it contains guidelines on mediation.

A mediator should:

- Ensure that the aforementioned 'rules' are followed.
- If tensions are high, start by speaking to each party separately and then paraphrase the points of view to the other.
- Encourage direct communication between both parties as soon as possible.
- Try and instil optimism for a good outcome.
- Set time limits for a solution.
- Help both parties to find as many points of agreement as possible.

Final point: with or without mediation, pay attention to process and not just outcomes, remembering that it is important for both parties to emerge with reputations intact or even enhanced. In other words you are looking for a 'Win-Win' outcome.

 Activity

A colleague consistently fails to produce their allocated work, so your team is missing deadlines, with serious consequences.

In your groups, allocate roles, work through the decision tree in Figure 7.4 and see which strategies appear to be most effective. Draw on your own experience of group work to make it as realistic as possible.

Conclusion

Maintaining teams effectively involves many complex issues and we have attempted to offer you some insights and guidelines on how to behave in difficult situations. While communication is crucial to managing many of the issues successfully, it is important to understand that interpreting what people say, or do not say, is not always easy, because people communicate and behave in different ways. Mervyn Caldwell, of Creative Leap, emphasizes the importance of being alert to unspoken messages and the need also to deal sensitively with colleagues:

> [Y]ou sometimes pick up that somebody's not up to par at the moment. It might be for all sorts of reasons that that person's not performing, so keeping your 'radar' open, I think, is really important: ... picking up on the signs you get from people, you know, it could be that there's a problem at home or it could be, there's been a death in the family, you never know and you can't just always blame and jump on people and say, you know: 'This just isn't good enough!'

The work of Carl Rogers (1902–1987) offers a helpful way of simplifying and dealing with issues. Rogers, who worked as a therapist, suggested three things were necessary to establish a good and trusting relationship (Raskin and Rogers 1989). These are:

- Unconditional positive regard – treating people with dignity.
- Empathy – trying to understand the situation from their point of view.
- Congruence – being what you appear.

It is possible that these simple guidelines will cross all cultures and all situations to make for good relationships with other team members.

What do you think now?

Having worked through this chapter, have you revised your opinion on any of the questions above? How about your classmates? Have any of them changed their opinions.

 Project

Your tutor will give you further guidance on how to work through the project tasks. The material we provide below summarizes the tasks and links them to other parts of this book.
Time to reflect individually on various aspects.

- What has working in teams taught you about yourself?
- Have you encountered any difficulties with any other team member?
- Have you done extra research on negotiating skills and conflict resolution?

If you have a mixed culture team, check through the various issues discussed in this chapter concerning 'working in culturally diverse teams'. Discuss these with each other and identify any issues there may be for the team, which could be related to cultural differences.
Make sure all your reflections on the above are logged. Do not miss the opportunity of adding any evidence to your PDP.

Further reading

Caildini, R. (1991) *Influence: The Psychology of Persuasion.* New York, William Morrow and Company.

Gesteland, R. (1999) *Patterns of Cross-Cultural Business Behavior. Marketing, Negotiating and Managing Across Cultures.* Copenhagen Business School Press <http://cim.dcg.ibs.iscte.pt/Gesteland.pdf> (accessed 30 September 2012).

Gudykunst, W., Lee, C., Nishida, T. and Ogawa, N. (2005) Theorizing about Intercultural Communication. An Introduction. In Gudykunst, W. (Ed.) *Theorizing about Intercultural Communication.* London: Sage Publications Ltd.

Hall, E. (1989) *Beyond culture.* New York: Anchor Books/Random House Inc.

Hofstede, G., Hofstede, G.J. and Minkov, M. (2010) *Cultures and Organisations, Software of the Mind*, 3rd Edition, USA: McGraw-Hill.

McClelland, D.C. 1961. *The Achieving Society.* Princeton, NJ: Van Nostrand.

Ting-Toomey, S. (1999) *Communicating across cultures.* New York: The Guildford Press.

Customer facing skills

 Learning outcomes

Be aware of the importance of the following in relation to dealing with customers:

- Acknowledging.
- Listening.
- Building rapport.
- Maintaining trust.
- Keeping the customer informed of progress.
- Taking ownership of problems.
- Cultural issues.

What do you think?

- What are the key elements of a successful relationship with customers?
- Does it make any difference to your relationship if you do not ever meet customers face-to-face?
- If what you are offering the customer is good enough, does that mean they would accept it regardless of who is offering it?
- Do you see there being a difference between a customer and a client?

Case study

In Chapter 6 we introduced you to SupportPlan, a company that provides information technology support. Although the company's core business involves providing technical expertise, it is also crucial that SupportPlan's engineers know how to deal with people and demonstrate good customer service skills. In many cases, the work done by the company is also highly sensitive, as it involves systems which process, among other information, material of a very confidential nature.

Lance Beecheno understands very well the importance of these customer facing skills, not only because he is owner and Managing Director of the company, but also because of having worked his way up from being a sales representative. For our interview on customer related issues, we were joined by Lance's wife Tania Beecheno, who is responsible for the company's marketing and HRM functions. Tania does much of the interviewing of candidates, so it is worth noting her views on potential employees and their customer facing skills and attitudes.

Introduction

> There is only one boss. The customer. And he can fire everybody in the company from the chairman on down, simply by spending his money somewhere else.
>
> (Sam Walton – Walmart founder in Walton and Huey 1993)

If you are not planning on going into a sales position you may question the relevance of this chapter to your future career. However, in one way or another most businesses have customers or clients with whom maintaining good relationships is crucially important. The aim is not to 'hard sell' but to help customers make the right decisions for them, and to get the best from the organization. Indeed, if customers feel 'cared for', they will want to come back to you in the future. Moreover, in most medium to large sized organisations, the different departments provide services for each other, so whether you are working in accounts or marketing, in human resources or IT, a significant part of your role will involve offering services to colleagues working in other departments. Therefore, even if you are not involved with *external* customers, you will almost certainly need to interact with internal ones.

 Activity

In groups, can you think of businesses, trades, departments, or professions that require a high level of interaction with customers even though they might not be traditional 'sales' organizations? What would be the consequences of poor customer facing skills for these organisations? Do you have examples of having received poor customer service?

 As we mentioned in Chapter 1, customer service/facing skills are high on the list of those skills valued by employers. Indeed, in their survey carried out for the CMI, Woodman and Hutchings (2011) found that 56% of employers reported that these skills were among those they most wanted to see in new recruits. It is therefore important to recognize the components that make up good customer service so that you can develop and provide evidence of these assets ready for when you are applying for a job. Many of these skills and attitudes are also important for good teamworking.

Getting it right from the start

It has been said, especially in relation to interviews, that 'you don't get a second chance to make a good first impression', and this is particularly relevant when dealing with clients for the first time. In situations where you are the first point of contact with customers, it is very important to acknowledge them politely so that they know you are available to help. Grace, one of our graduate interviewees who we introduce in Chapter 9, has five years' experience of giving customer service:

> I think it's all to do with acknowledging people as soon as possible when they come in. We're told we have to acknowledge people within the first minute of them coming into

the store. And then it's important then to give them a bit of space so they can have a look around, and approach them again when you feel the right amount of time's passed. ... Yeah ... acknowledging people is the most important thing to make them feel welcome.

For SupportPlan, the issue of trust is especially important because of the confidential nature of their work, and so being trustworthy and having the ability to establish a good relationship with clients is essential, as Lance explains:

Number one, it's integrity and rapport. Everything we do is about trust. Trust is the number one thing in our business. I expect to trust my staff and clients should be able to trust them, because a lot of what we do, we do remotely. We may see sensitive information about their business – financial information, confidential information – it's about trust, so we need people who 'shine' with integrity. So that's the number one thing.

It is worth noting that Lance's strong emphasis on trust and integrity is in line with the high value given by Reed and Stoltz (2011) to 'Good', one of their '3G mindset' ('Good', 'Grit', and 'Global'), which they say is so important to be able to provide evidence of to employers. Indeed, Goleman (2012) makes a similar point. He suggests that although a salesperson might use skills of persuasion to achieve a sale, trust can be lost if the customer perceives this as manipulation. Goleman (n.d., *The emotionally intelligent salesman*) points out that the best sales people:

[A]pply a different approach: empathic concern, where you sense and care about the person's needs. Rather than persuade someone to buy the wrong thing, these sales stars make sure they match the customer's needs to what they offer – and may even send them elsewhere if need be. This builds a lasting relationship of trust – and a customer who returns again and again.

Lance's statement about 'shining with integrity' means providing evidence for something that is actually intangible, but it is clearly something that you need to be able to do in order to convince employers that you are the kind of person clients will trust.

 Reflection

Pause for a moment to reflect on how, right now, you can provide evidence of your trustworthiness. If you cannot do so, what are you going to do in the next few months to build up that evidence so that when you apply for any kind of employment you will be able to give examples in your written application or at interview?

Emotional intelligence

Building rapport with clients involves a significant level of sensitivity. It requires the ability to empathize with them and to show that you understand their concerns. When properly established, rapport with a client will mean that they will feel comfortable approaching you with whatever issues they have, and even if things do not go smoothly they will trust that you have their best interests at heart (see also Chapters 2, 6 and 7).

We will be suggesting various things that may influence the kind of relationship you build up with your customers. However, in many ways, being able to deal with people effectively and build up the rapport Lance talks about, draws on the faculty of emotional intelligence we first mentioned in Chapter 1. Goleman (2012) makes the point that the people who are most successful at dealing with customers are:

> [A]dept at emotional intelligence competencies like emotional self-management (curbing negative feelings and encouraging motivation and engagement), empathy (which allows them to sense how others feel, and so be more effective communicators), and collaboration (so they work seamlessly as team members).

In other words, there is no point in having a set way of behaviour that you apply to all customers in all situations. As Grace explained when asked about responding sensitively to a customer's needs:

> You've got to read their mood. Sometimes people are coming in and they're stressed, and they've come out to just be on their own and they don't really want to talk to you, so you've just got to sense that. And if someone comes in and they're very dismissive then you know to keep out of their way.

 You will note here the key word 'empathy' crops up again. In Chapter 7, we referred to the work of Carl Rogers (1978), in which he suggests that empathy is one of the key elements for building up trusting relationships.

 Reflection/Discussion

If someone were to ask you about how empathic you were, how would you reply? Can you think of situations where you have been able to empathize (as opposed to sympathize) with someone else's situation?
Discuss with other members of your class whether you think empathy is a quality that can be developed, and if so how.
How would you be able to provide evidence for your ability to empathize?

Appearance

As we have already mentioned, first impressions are really important and if you are meeting a client face-to-face then it is inevitable that you will initially be judged by how you look. We discuss the issue of appearance again in Chapter 10 when we discuss interviewing. However, just to give you a flavour of how important appearance is to people, in the CMI survey, 66% of employers reported that the biggest impact on their recruitment decisions was personal appearance.

When we asked Lance and Tania about what they wanted in their employees, Tania suggested 'polite, dressed smartly, look the part, you know, it's a package', to which Lance added 'absolutely. It's about integrity and trust, and that is about how somebody dresses, how they handle themselves.'

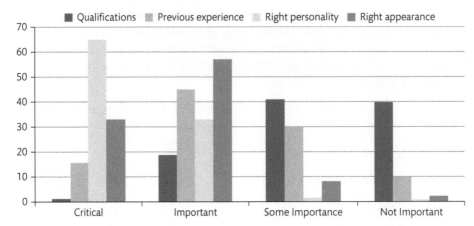

Figure 8.1 The attributes and capacities employers are seeking at the point of entry to employment (Warhurst et al. 2004).

The importance Lance and Tania attach to people taking care with their appearance is echoed in a study carried out by Strathclyde University for the Scottish Centre for Employment Research (Warhurst et al. 2004). Reporting British and American research into the key points that employers look for in retail and hospitality front-line staff, they highlight the following: 'Pride in appearance and good attitude. We equate the first with aesthetic or self-presentation skills of employees and the second with their social or interpersonal skills' (p. 5).

In fact your likelihood of getting a job where you are dealing with clients face-to-face may depend on your appearance in the first place. Figure 8.1, taken from the Strathclyde University survey (p. 16), shows how important the right appearance is to employers.

Although having the right personality was of overwhelming importance, 90% of employers felt that appearance was either critical or important.

Not surprisingly, when the same employers were asked what 'skills' were important for their customer facing staff (Figure 8.2), once again they placed great emphasis on self-presentation with 98% judging this to be critical or important.

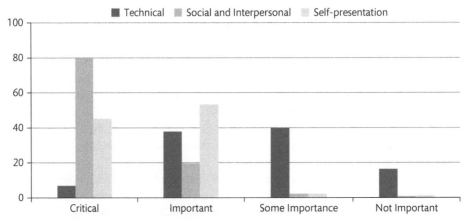

Figure 8.2 The skills that are important in customer facing staff.

All this may leave you wondering just how smart you need to be. As a rule of thumb, Lance suggests to his customer facing staff that they should be just a little bit smarter than their clients in order to show that they have the right attitude towards their relationship with them.

Although we have been stressing the importance of appearance, the above graphs do emphasize the value that employers place on what Warhurst et al. call 'soft' skills, which we discuss in 'Social and interpersonal skills'. You might be surprised that employers are not putting more emphasis on the technical aspects, but our interviews with various employers made clear their belief that the most important thing is to recruit people with the right attitude, or mindset. If they do that, they can give training in the technical areas and indeed, in a fast moving world they would expect to have to do so relatively frequently.

Social and interpersonal skills

As you can see, the highest scoring category in the Strathclyde University survey was social and interpersonal skills. Although the survey in question focused on customer facing roles, the ability to interact and communicate successfully with others is fundamental to any area of business. The umbrella terms 'social' and 'interpersonal' skills encompass many areas, including the ability to communicate, listen, and empathize with people, and to be able to do so in a variety of situations that require confidence and self-belief. These skills involve a strong element of the emotional intelligence we have mentioned above. They require you to be able to build a genuine rapport with someone, to convince them of your trustworthiness and to be able to empathize with them.

Communication skills

The importance of communication skills, in any work situation, can be gauged from the CMI survey referred to in Chapter 1 where it was reported that 92% of the employers interviewed regarded communication skills to be of prime importance when people start work. Moreover, customer service is one of a number of key areas in which these skills are paramount. However, the same survey found that employers generally considered young people's communication skills to be barely adequate, if not actually poor (see fig 1.4).

Asked whether he thought that people's communication skills can be improved, it is striking that the key words Lance mentioned related to mindset: 'We can turn them around if they have a desire to learn and understand. If they have no interest, then it's almost impossible. (Some) really don't care ... and don't get it that people are important.'

In agreeing with Lance, Tania was also keen to emphasize the ability to form relationships, and also to listen to customers: 'It's crucial. ... if you can't relate to customers, or listen to customers, it's just pointless.'

There are many ways in which you might communicate with your company's clients, whether speaking or in writing, via a number of different media. As we have discussed elsewhere, this means that you need to be able to cope with interactions through audio/videoconferencing, the telephone, email, social media, and probably other forms of communication still under development. Whatever channels you are using, effective communication requires a balance between specific skills and your attitude towards the other person.

 Activity

Table 6.3 listed the various forms of communication available. Discuss in your groups which of these might be used appropriately in customer facing situations, and what techniques you would adopt to ensure that you build rapport in those situations.

We have provided you with a starting point by indicating skills that are needed. What key words would you include to convey the right kind of attitude? (If this seems difficult to visualize, just think what attitudes you have found to be appropriate or inappropriate in the people who provide a service for you.)

TELEPHONE	Introduce yourself clearly
	Smile while you are talking, as the listener can tell
	Listen carefully to what the client has to say
	Give appropriate verbal and non-verbal responses to show you are listening and responding
	Etc.

Part of choosing a method of communication is recognizing the way in which people prefer to be contacted. When dealing with an urgent problem, for instance, there is more of a sense of urgency from using the telephone than perhaps sending an email. In our previous interview with Lance he stressed the importance, where possible, of communicating with clients face-to-face or at least over the phone in preference to emailing. You may recall how in Chapter 7, Louise Morrissey also insisted that picking up the phone or actually going to see a person is often a much better way of getting things done.

Whichever method of communication you use, *how* you use it will indicate how much you care about the client. For instance, people are generally aware of the importance of using clear language, correct grammar and spelling in letters but these requirements are no less important in business emails. A sloppy, incoherent email will be interpreted as an indication that you do not care, or of an unprofessional attitude. One of your authors rejected at least one candidate on the basis of a badly written speculative email.

Showing these attitudes over the telephone is especially important, as Tania explains: 'It's clear to the customer, on the phone, if you care. If you don't care – you're just doing your job and you're out the door at 5.30 – it really comes across.'

What is apparent here is the need to have the right, caring attitude, as well as the ability to show this and communicate it to the customer. In order to do this, we believe that if you put yourself in the shoes of the customer and really care whether they and their needs are satisfied, then you are likely to do all the other things right such as communicating, following through on commitments made, and doing your best to solve problems if they occur. This is why employers like Lance and Tania – and also Ronan Dunne and Ann Pickering, Chief Executive Officer and HR Director of O2, whom we introduced in Chapter 4 – are so emphatic about attitudes being more important than skills.

 Reflection

Go back to the above group activity and evaluate which forms of communication you are good at and those you are not so good at. Do you tend to use one rather than another simply to avoid situations in which you feel less confident? For example, do you email people to avoid having to explain yourself clearly on the telephone? Draw up an action plan on how you are going to tackle this issue in the next few weeks or months.

Alongside how you communicate, another important aspect is what and when you communicate and this is discussed in 'Problem solving' and 'Ensuring continuing satisfaction'.

Active listening

There is often a misconception that communicating is all about talking, but, in fact, as we stressed in Chapter 6, listening is arguably an even more important skill. When dealing with customers, listening is everything. The only way you can tailor your offering to your customer's requirements is to take the time to understand what they do require. By asking the right questions and listening carefully to the answers, you can not only ensure you are dealing with their real issues, but can also convince them that you really understand what they need, as Grace explains:

> You've got to be a good listener, so it's important to give the customer your full attention. So if you're talking when someone approaches you, it's really important that you stop what you're doing immediately. It's important to drop what you're doing instantly, giving your full attention. Make sure you understand what they are saying, so if you listen carefully there's no danger of misunderstanding what they've said and wasting their time.

As Grace also emphasizes, making assumptions about what your clients want without listening properly can waste time, cause the customer to become frustrated and possibly lose the company business:

> Sometimes people will only be half listening and then hear a particular word and assume the customer is asking a question, and go off into the stock room and see if we have a product, and actually they weren't asking that, they just wanted to see a photo or something.

Spending time learning about customer requirements and listening carefully, without interruptions, to what they are asking will show that you are giving them your full attention, as well as making sure you are getting the right message. This gives customers confidence in you, and is an important part of giving good customer service. Describing the process of communication involved in sorting out a client's problems with computer equipment, Lance makes clear that dealing with people in the right way is as important as finding solutions for them.

> We have to listen, show that we're listening, ... show that we care and that we understand, and fix it, calmly. ... It's about how we handle it and make them feel. So what we do is about handling people and their problems, not just fixing IT.

Note how Lance stresses that not only do you have to listen, you also have to *show* that you are listening. This raises the issue of non-verbal communication, which we will cover later in this chapter.

 Activity

- Work in groups of three.
- Select one member of the group to talk about a problem they have encountered recently, preferably in a customer service context. The other two group members should listen carefully without interrupting.
- Get one member of the group to use positive body language and non-lexical conversation sounds (these are sounds such as uh, uh, mmm, which have no specific meaning, but are used to indicate listening, agreement, etc.).
- The other group member should listen equally attentively but remain as inert as possible.
- When the speaker has finished, each of the listeners should paraphrase what they heard and even more so, what they felt the speaker wanted done. Then the speaker should reveal which of the listeners their attention was drawn to, and which responses helped with the flow of thought and conversation.

When asked whether there was a visual aspect to active listening, such as being aware of body language, Grace explained:

> Yes, it's a sort of natural process ... it's important to give good eye contact. Read the person. You can often tell if someone's in a hurry or if they have a lot of time. It's about reading each individual customer.

When Grace says it is a 'natural process', she is probably underestimating how much skill she has built up in this area over the years. In the activity above, how easy did the listeners find it to concentrate and try and interpret what the speaker wanted?

Giving full attention may sound straightforward enough, but there are times when this is not easy, and can be stressful. For instance, if you have just finished one demanding encounter on the phone, you may find it difficult to switch your full attention to the next person. Each client expects and deserves your best performance, but if you are stressed your performance may be below par. It is worth mastering some techniques that can help you relax quickly. Try some of the following. If one or two of them work for you, then keep practising them so that whenever you need to regain focus you can use them.

- Tense one hand, then release it. Note the difference in the way you feel when tense or relaxed. You could do this with your shoulders as people often hold tension there.
- Close your eyes for a few seconds and imagine yourself floating near the ceiling and looking down on yourself and what is around you.
- Smile broadly, relax, smile again.
- Breathe deeply, and concentrate on the feeling of the breath entering and leaving your lungs.
- Stretch your arms above your head.
- Use a stress ball.

When you feel ready to give your undivided attention to the next customer, make that call.

Body language

When we talk about communications it is tempting to think just in terms of what we say, and how we say it. However, much of the way we interact with others also involves us 'reading' clues from people's facial expressions, from their body language and other non-verbal messages that are conveyed, for example by the other person's tone of voice. It is as well to be aware that not only do such things influence our perception of and behaviour towards others, but they also influence the impression *we* make on others.

The importance of these non-verbal signals becomes clear when we remember that, when meeting people for the first time, we often trust our instincts as much as the words people actually say. In fact, such instinctive assessments are usually based on actual signals that we take in and respond to at an intuitive level. This is even true when we cannot see the other person, such as when speaking on the telephone. If you think of times, for example, when you have received an unsolicited call from somebody trying to sell you something, the words they say are often very persuasive, but their tone of voice is perhaps just too forceful, or they sound a little bit too friendly for you to be able to fully trust that they are genuine and sincere. Moreover, the words that a person uses tend to convey a message containing thoughts and ideas – its 'cognitive' content – whereas the non-verbal signals often communicate a person's true feelings. If, therefore, there is a contradiction between what a person is saying and the non-verbal signals that they are making (which would be lack of congruence in Roger's (1978) words), we tend to believe the latter 'because nonverbal messages are less conscious and more truthful' (Liu et al. 2011, p. 141).

Many training companies offer courses designed to help people understand the significance of such things as gaze, posture, personal space, and gestures, among other things. However, it is important to be aware also that in many cases these things are culturally determined, and that simply following a set of rules devised for one culture will not necessarily help, and in fact may hinder, your 'rapport' with people from a different culture.

Cultural issues

In any customer facing situation – whether customers are external or internal to the organization you work for – there are added reasons why it is important to make a good impression on the people you are serving. However, cultural differences both in behaviour and in the way that this is interpreted may explain why people form different impressions of others on account of their non-verbal communication. For example, for reasons linked to differences in the way that emotions are expressed, which we discussed in Chapter 7, maintaining a neutral impression in some cultural contexts might make a better impression than lots of smiling, whereas the opposite may be the case in others. Indeed, there is evidence to suggest that in some Asian cultures, greater restraint in terms of facial communication and body language is associated with people who are good at influencing others, whereas in the USA, having such credibility is more commonly linked to people with relaxed facial and physical posture (Ting-Toomey 1999, citing Burgoon et al. 1996).

As we also mentioned in Chapter 7, these issues relate to the way that individuals from different cultures have different expectations about the way that people 'should' or 'should not' behave and communicate, and this includes both verbal and non-verbal communication. Moreover, if these expectations are violated in some way – for example if somebody says

something or makes a gesture that the other person interprets as being offensive in some way – this can lead to misunderstandings and even conflict. Also, a person may have expectations about other people based on cultural stereotypes. If these expectations appear to be borne out by the other person's behaviour, this might confirm the stereotype and have a possibly negative impact on the relationship. Conversely, where, for example, their expectation is violated in a way that is pleasantly surprising, this can have a positive effect on the relationship (Burgoon and Hubbard 2005). The importance of non-verbal language on the creation of good rapport is therefore not to be underestimated.

All of this means that when interacting in customer facing situations with people who are from different cultures, it is important to act *mindfully*, in the sense we discussed in Chapter 7. This means being aware that people's non-verbal forms of communication are not necessarily the same as our own, and that we should therefore not rush to make judgements about them. It also means being alert to the stereotypical views we may have of others, and not to allow them to affect and possibly distort the way we interpret other people's behaviour.

 Discussion

Think about people from different cultures that you have actually met or observed in real life.

- Are there any differences that you have observed in their non-verbal communication?
- What effect did this have on how you related to them? For example, did it make your feelings positive, negative, or indifferent?
- How might these issues affect outcomes in customer facing situations?

If you are in a class containing people from different cultures, discuss the above questions in groups of about six people who are as culturally diverse as possible, and if possible with a balance of male and female students.

Selling your company, your product, yourself

Even though the survey by Warhurst et al. showed that, in terms of customer facing skills, other factors outweighed technical knowledge, most people would agree that once in post you would be expected to build up your expert knowledge of the product you are selling or the service your company provides. Indeed your company would no doubt expect to provide training to ensure your competence. However, it is also important to widen your knowledge of the industry you are working in, and, if appropriate, what your competitors are offering.

However important it is to know about your company's products or services, Lance insists that making a good impression on other people, and in particular being able to relate to potential customers in a way that makes them trust you is also crucial: 'Ultimately, people buy people, not qualifications, not experience, but people buy people, so being able to build rapport is what we're looking for in our staff.'

In other words, if you have a rapport with the person, and trust them, you are more likely to have confidence in their product or service because you feel that they are trying to do their best for you.

 Reflection

Think of the last time you bought anything of significant value (this does not have to be a physical thing, it could be insurance, a holiday, etc.). Did you feel comfortable with the person you bought the product from? How likely are you to buy something from someone you do not like or trust? Would you therefore agree with Lance's statement or would you buy from someone you did not like if they offered you a good deal?

It seems then that the reasons why we feel comfortable, or why we do not buy from someone starts with their appearance. If we feel they look the part we will be predisposed to listen to what they have to say. At that point their interpersonal skills will be important if they are to build rapport with us. But after this there is a level at which we need to believe that they know what they are talking about, and this is the stage where product, company, and industry knowledge come into play.

One thing that may not be obvious is that customers are not always aware of what they do and do not know. You will only find out their level of knowledge by listening. Only when you have done this, will you be able to give them a clear idea of how your product can satisfy their needs, perhaps even in comparison with a competitor's product. All this requires you to make sure you get up to speed about the company's offering as quickly as possible.

When you first start work you will be on a steep learning curve in this respect. The following guidelines should help you in the first instance.

- Keep notes of what you have been told and make sure you check your facts to ensure that you give out accurate information. Giving out wrong information can destroy a customer's trust in you, and we have already stressed the importance of trust.

- Do not make any promises to customers that you are not sure you and the company can keep. Part of keeping a client's trust is being clear on what your company is or is not able to provide. As Tania points out: 'It's very important for service, because there's no product, so if you make a promise and then the staff don't deliver, it's a big issue. It's a very big issue.'

- In relation to promises, Lance has a saying that you should 'under-promise and over-deliver'. In other words, it is better to be sure that you can deliver what you promise. That way you avoid disappointing the customer, and getting more than they expected can do nothing but good.

- Because customers' level of knowledge varies, it is important to appreciate that the level of detail to include when talking about products and services needs likewise to vary, as Lance explains: 'The skill is in knowing who they're talking to, picking the right level of detail so that it doesn't come across as being condescending.'

For Lance and Tania, leaving their customers with the right kind of feeling is almost as important as finding good solutions to their problems. In Tania's experience, not everyone finds this easy:

It's difficult to get all that mix of skills. There are some who are brilliant at knowing the technical stuff, but they're just not good at leaving the client happy. They might go there and say: 'This is the right solution', but they won't communicate it with the client and the client ends up being unhappy.

Problem solving

Much of the customer facing role involves sorting out problems for clients. However, in the CMI survey employers awarded low scores not only for young people's communication but also their problem solving skills. If you feel that your problem solving skills are less than adequate, then now is the time to take advantage of any exercises you are given at university to develop them and to start bringing them up to standard.

The first stage in this process is when a customer contacts you with a problem. The customer may be angry or frustrated or anxious. A simple apology or acknowledgement of their frustration at this stage can help defuse the situation. You then need to decide if you are the person best suited to solve the problem. As a customer yourself, you may have been in a situation where you have been passed from person to person and had to repeat your problem endlessly, and then not been offered a solution. If you feel it is necessary to pass a problem on, you should not consider your role in the procedure complete until you are sure that someone else has understood the problem and taken ownership. Until they have confirmed that they have done so, the problem is yours and you continue to deal with the customer and keep them informed.

When we asked Lance and Tania about the problem solving skills they thought were vital, Lance had this to say:

> Listen. Show that you're listening. So – communicate that you are listening. The client needs to know, so: empathy. So number one: listen and empathize. You know ... understand the importance of this problem to the client.

For Lance it is as much about handling the people as dealing with the problem: '... It's about how we handle it and make them feel. So what we do is about handling people and their problems.'

The important point therefore is that you cannot persuade a client that you can solve their problem unless you convince them first that you have understood it, and the only way you can do that is to show you are hearing what they are saying.

Having understood the problem, the next step is to come up with a strategy for solving it and discuss that with the client. At this stage it is tempting to concentrate on simply solving the problem, but ,as Lance points out, it is crucial that you keep the client informed of your progress

> During the process of solving and taking this action plan through, communicate with the client, as frequently as possible, or more frequently, to the point of irritation that you are – every other minute you're on the phone – telling them where you are ... it's all about showing and demonstrating unequivocally that you're doing everything a person could reasonably do. ..., if you could do such a thing, almost over-communicate with the client because clients' biggest irritation isn't usually the problem, it's the fact that you don't communicate with them.

The point Lance is making is that while you are trying to solve the problem, wishing to get back to them with good news, the client may be stressing about what is going on. Keeping them informed on a regular basis means that they know you are working on it. It also

means that they do not need to keep phoning you for a progress report. Lance explains it this way:

> If you just call them and say 'I've got your problem, I'm looking into it now. I'll be back on the phone within the next hour', they'll say 'Oh thanks so much!', you can hear the relief in their voice, and they feel that they've handed you the problem and they can go and worry about something else. Until then it's like waiting for a bus, not knowing. ... If someone tells you you're going to wait nine minutes for a bus, or fifteen minutes, then it's no problem.

Good and frequent communications are therefore an essential aspect of problem solving, and this involves not only thinking about what and how to communicate, but also when and how often.

Ensuring continuing satisfaction

Making sure your clients are satisfied is crucial. Estimates vary, but it is generally suggested that it costs seven to ten times as much to win a new customer as it does to keep your existing ones. Furthermore, social media means that bad word of mouth publicity from a dissatisfied ex-customer can have widespread negative impact for a business. However good your service to your customer is, you are only as good as the last solution you have provided. This means that constant vigilance and monitoring is necessary.

Once again Grace notes the role that emotional intelligence and empathy play in the process of making sure that the customer leaves with good feelings about the transaction they have with you:

> [Y]ou can sense when they're not completely satisfied, you haven't done enough, so then you've got to try to think of something else you can say to them, or ... just try to relate to them, so make them understand that if *you* were in the same situation you would feel the same as them. It's trying to build up that relationship.

Part of ensuring satisfaction is about monitoring a customer's perception of the service they have been given. Tania suggests that: 'Once you've solved the problem, get on the phone and say you've done XYZ – "Are you happy?" Don't just do it and leave it.'

Lance explains how at SupportPlan they make doubly sure that they have solved the problem to the customer's satisfaction:

> [W]hen we've solved the problem we say to the client: 'Here's the problem we logged. Here's what we did about it. We think we've solved it, please get back to us if not.' Then we call up or email within one to three days to say 'We logged this problem. We worked on it. We believe we've solved it. Are you happy as a result of what we did for you?'

Although this applies to the service industry SupportPlan are in, to a greater or lesser degree this process is valuable following dealings with any customer complaint.

However, simply making sure that a specific problem is solved is not sufficient for long-term purposes. For a client to feel that you are really concerned about them, it is necessary to keep in contact with them. If you are responsible for particular clients, then you should have some system of monitoring their satisfaction levels. In fact, your employer should probably

have some formal monitoring process in place involving questionnaires, focus groups, or some other system. The results of these are important in informing you of areas on which you need to focus. In addition to these formal monitoring procedures, you should also have a follow-up system in place which ensures that you regularly check with clients for which you are responsible, to see whether they are satisfied with your offering. How frequently you make such checks will be determined by the likelihood of them needing general help and advice.

Another aspect of ensuring success is through exceeding the customer's expectations. This could take the form of helping a customer, or potential customer, even if there is not any apparent, or immediate, return on investment. Being polite and helpful with a non-customer might bring another customer on board, if not the person you have helped, but perhaps the people to whom they have recommended you.

It is worth noting that at job interviews, it is quite common for employers to ask, for example, 'How have you exceeded people's expectations?' Grace finds it is good to use customer service examples for this and often these involve talking about some kind of problem that you have helped to solve:

> You tend to exceed expectations when people have a problem, and when you've shown that you're really understanding and that you're really going to try and drop everything and figure this out for the customer, and making sure you show you really understand through listening, making a note in front of them so they can see you're writing it down and that you're definitely going to take care of it. And then actually doing it of course!

Another way of exceeding expectations might involve providing a client with something over and above what they are paying for. This can be a valuable tool for tying the customer in with your company. However, it should be used with care. As Lance points out there is no point in

> [D]oing someone a favour in business if they don't know it. Forget the moral point of all this work. In business, there is no point. There's a cost to everything that you do and if you don't tell the client, you're just wasting time and money, but they'll expect you to do it every time if you don't tell them it's an unusual thing you are doing.

Conclusion

The list of customer facing skills we could address is probably endless. We could add to those discussed above, being friendly, tactful, dependable, enthusiastic, professional, tenacious, flexible. However, Lance actually summed up the essence of good customer focus when he said 'Customer service is about caring, and demonstrating that you care.' This, together with having emotional intelligence and being trustworthy, encompasses almost any other customer facing skill which could be listed.

In Chapter 4 we suggested that you analyse the assets you are gaining through your part-time work. If one of those is that your work involves customer facing skills, then you should now be aware of how highly valued this experience will be to an employer. Bearing in mind what Lance has said about demonstrating your caring attitude, make sure that you are logging interesting and relevant experiences and reflecting on what you have learnt from them. This way you will have good evidence for your CV, letter of application, and interviews.

What do you think now?

Having worked through this chapter, have you revised your opinion on any of the questions above? How about your classmates? Have any of them changed their opinions.

 ### Project

Your tutor will give you further guidance on how to work through the project tasks. The material we provide below summarizes the tasks and links them to other parts of this book.

- Make sure your team are clear on any joint assessment you may be required to carry out.
- Have you continued to communicate openly and respectfully with one another?

This week you can consider how you can gather evidence of having good customer facing skills in order to address the second part of the assessment question:

- What do employers want and how can you give it to them?
- Share your experiences of either dealing with customers or being a customer. You could draw up a table of experiences, good and bad, from each perspective.
- You might like to try role playing in your group.
- Identify what would be appropriate evidence and work out between you how you might be able to gather and present that evidence.

Further reading

Burley-Allen, M. (1995) *Listening: The Forgotten Skill: A Self-Teaching Guide*, 2nd Edition. Chichester: Wiley.

Sanders, A. (1994) *Customers for Life*. San Diego: Pfeiffer & Company.

Woodman, P. and Hutchings, P. (2011) *Tomorrow's Leaders*. London: CMI.

Section 3

..

Into Work

..

This section may be what you thought employability was all about. Indeed, people often think that CVs, cover letters, and job interviews are where the process starts. However, as Tom Millar of Reed (the company we mentioned in our earlier chapters) suggests, employability is a process which encompasses the categories of being employable, getting employed and most importantly, sustaining employment.

Hopefully you will understand by now that work on becoming employable has to start long before you are applying for your first job, internship, or placement. This is because to get work, you have to demonstrate convincingly that you possess the employability assets that employers want, and this means providing solid evidence built up over a period of time. In Chapters 9 and 10, you will learn about applying for jobs, first in writing and then at interview. In Chapter 11, you will explore different ways of increasing opportunities, including the idea of having your own business. Finally, in Chapter 12, you will get an insight into what it is like to start work. This is just the start of your journey. By carrying on with the process of reflecting on your performance at work you should ensure that not only is your first job a success, but that it will lead to bigger and better things.

Preparing the evidence

 Learning outcomes

By the end of this chapter you should have:

- Developed an understanding of issues relating to application documentation, including:
 - CVs;
 - letters of application;
 - online application forms.
- Identified ways of standing out from the crowd, including:
 - using action words;
 - drawing on extracurricular activity such as:
 - work experience;
 - voluntary activity;
 - interests/leisure pursuits;
 - personal achievements;
 - using PDP to identify key strengths and demonstrate suitability.
- Understand benefits and issues relating to digital identity, including:
 - e-portfolios;
 - issues relating to social media.

What do you think?

- Is there such a thing as an all purpose perfect CV?
- Is a cover letter as important as a CV?
- Is work experience worth mentioning if it is not related to the job for which you are applying?
- Are there any particular words you can use in your CV to make it stand out?

Case studies

Andrew

Andrew, an international student from Kenya, graduated in 2009 with a third class degree. He then embarked on an MSc in Public Health. Unlike his first degree, this was a field in which he wanted to make his career and he did well, achieving 'Commendation' overall. At the time of our interview with him, it had been a little more than a year since he completed his Masters. Both his degrees were completed in the UK.

(continued...)

In seeking graduate work, he faced the difficulty that as a foreign national, recent legislation had made applying for jobs especially difficult because organizations were unwilling to sponsor him. And there were two further major challenges that he believes face all graduates. The first of these is the competition: despite making 60 or so job applications per month and getting as far as the interview stage on several occasions, he had yet to be successful. The other big challenge was his limited experience. It was a 'catch-22' situation (a seemingly impossible predicament) because without a job, he could not gain experience, but without experience, he could not get a job. The problem is also related to the issue of competition: because of the economic situation, for every job on offer, he was finding himself in competition with many candidates who had more experience.

Nevertheless, Andrew's positive outlook and his resourcefulness allowed him to 'think outside the box', enabling him to enhance his employability and also to earn money in a number of ways. As soon as he completed his Masters, he investigated possibilities for volunteering in a field related to his own career focus in public health. He found that he was able to develop useful skills and also draw on his talent for writing. The same writing skills have also allowed him to earn money, such as preparing web content for friends starting up their own businesses.

Grace

At the time of writing, in January 2013, it had been more than 18 months since Grace had completed her bachelor's degree and graduated from university. Like many of her former university friends, she had yet to secure graduate employment despite having achieved a good 2:1 Honours degree.

She was working as a sales adviser for a high street shop in her home town, and she also worked at the store's warehouse a few miles away. She had had the job for five and a half years, since before going to university. For much of that time she had worked relatively limited hours but since graduating, although still on a casual contract, she was working more or less full time.

Grace's story is typical of many university graduates' experience after leaving university. Her work in the shop and warehouse was not exactly the return on her investment in higher education that she had imagined when signing up to a three-year degree course. Nevertheless, she saw it as a temporary situation and an opportunity to build experience, skills, and knowledge relevant for her main career aim, which was eventually to work in head office retail. She had been applying for graduate schemes in the sector but had received many rejections, often after proceeding successfully through several of the early stages and getting interviews. When we spoke with her in January, she had been applying to such schemes for many months but a few days earlier she had attended an assessment centre and been interviewed for a buying and merchandising graduate traineeship. As with many such schemes, the application process had been a lengthy and fairly arduous process. It had started the previous September when she completed an online application form. This was followed by online tests, an online interview, and finally – after successfully getting through the earlier stages – the assessment centre which included a second, face-to-face interview. Getting to the final interview stage for this one scheme had taken nearly four months.

Happily, her efforts were rewarded and within a few days of her interview she was offered a place on the scheme. It is, in fact, a permanent position and she now has the prospect of being fast-tracked into a more senior role.

Introduction

In the first section of this book we explained what employers are looking for when they recruit graduates. We included research undertaken on behalf of the Chartered Management Institute, which emphasized the importance of self-presentation and communication, and these are crucially important at all stages of the application process: in the CV, cover letters,

and application forms (which we cover in this chapter), and at assessment centres and interviews (Chapter 10).

We also guided you through an analysis of your abilities and employability assets. We are now going to examine how you will put this awareness into practice.

As Andrew's and Grace's examples show, being successful in job hunting is difficult and requires a lot of self-awareness, persistence, and determination, as well as the ability to pick yourself up and keep trying after the disappointment of rejections. An important lesson is to realize that the earlier you think about what you want to do and start developing the skills needed for job hunting, the better placed you will be to identify and take up opportunities.

All of the steps taken by Grace and Andrew after leaving university are relevant for anyone seeking graduate employment, whether they are aiming for graduate traineeships with a big organization or working their way up inside a small or medium-sized one.

 In Chapters 4 and 8, we present their experience and views both before and since graduating, and believe you will find these both interesting and useful in helping you to plan your career and set about applying for graduate employment.

Application documentation

There are a number of points to remember for the various documents you have to produce as part of the application process.

- You will need to use your very best skills of communication and self-presentation.
- You need to stand out from the competition.
- You have to convince an employer that you possess the skills and mindset they are looking for. It is not enough to say: 'I have excellent communication skills'. To be convincing, you will need to provide evidence in the form of examples from your experience using the STAR approach, which we describe below, and this is needed also as you prepare for the interview (Chapter 10).

The STAR method helps you to make the best use of examples that provide evidence of your competence. STAR stands for:

- **Situation** – Describe the task you were trying to accomplish, or the situation you found yourself in. Be succinct but make sure you have given enough of a description for the context and its significance to be clear.
- **Task** – What were you trying to achieve at the time?
- **Action** – What did you do to ensure you met your goals in the situation you found yourself in?
- **Result** – Explain what happened as a result of your actions. This is not a time to be modest so do take credit for your successes.

 Activity

Based on your experiences of working in your groups, use the STAR technique to answer the
question 'Give an example of how you dealt with a difficult situation when working in your groups'.
(This is a typical question that you might be asked on an online application form.)
It is easy to underestimate the difficulties involved with the above points and how long it can take to
write really convincingly about yourself.

In the following sections on the CV, cover letter, and application forms, we explain the basic
principles and also tell you how you can make yourself stand out.

CVs

How long do you think employers will typically spend reading your CV? If we tell you that
many will take as little as 30 seconds, you should begin to realise how crucial it is for it to
stand out. This may not seem fair after all the hours you have spent making sure that your CV
is attractively presented, with all necessary information stated as concisely as possible. How-
ever, you must remember that employers receive many CVs and reject any that are not of the
highest standard, as is explained by Louise Morrissey, director in a large north-west England
company (see Case study in Chapter 10):

> [T]his may seem an unfair process, but you have to be quite ruthless. If the presentation of
> the CV is not sharp, not easy to read, full of errors in terms of grammar and spelling, then it's
> a reject.

Typically, Louise receives 40–50 CVs for one graduate position, so she and a colleague skim
read them very quickly and look to see if anyone really stands out, because they will usually
only interview six candidates, or ten at most. As she says, this means 'you are in a totally com-
petitive situation.'

Before exploring how to make your CV stand out, we explain some of the basics. An easy
way of getting started with writing a CV is to do what Grace did and go online: 'I had a look
at a few CV templates online and then decided which one looked the best to me, and then
followed that format'.

If we presented CVs here, they would probably look out-of-date by the time you read
them, added to which if you copied them they would lack individuality, so we recommend
that you visit Prospects and other websites, where you can look at examples of different
styles of CV, including 'Skills-based' and 'Chronological'. The two approaches have different
strengths. Skills-based CVs are effective in giving an overview of the key skills and mindset
qualities that you can offer and are effective at giving a strong initial impact on page one.
With employers spending very little time on each application, first impressions are vital. The
chronological CV is good if you wish to emphasize consistent progression you have made in
relevant employment, which is presented in reverse chronological order (most recent first).
There are no right or wrong formats for CVs, so we recommend that you work out for yourself
which format will be most effective for what you wish to highlight to employers. You should
also visit your university careers service who can give advice on this.

Whichever format you use, CVs usually contain most of the following, although not always in this order:

- personal details (name, address, telephone, email);
- personal profile;
- education, i.e. qualifications;
- all employment both paid and unpaid (when ... where ... what?);
- additional skills and achievements (e.g. IT, languages, awards, training, volunteering);
- interests/hobbies;
- references, usually just the name, address and contact details of two people who can produce a written statement (the 'reference') about your employable qualities.

It used to be customary to include a date of birth as part of personal details but the Employment Equality (Age) Regulations 2006 have made it illegal to discriminate on the grounds of age in the recruitment process so you may include yours if you feel it is to your advantage, but it is no longer necessary.

Not everyone includes a 'personal profile' and, as we see below, some research suggests that including it does not make any difference to whether or not you are invited to interview. It provides, in about two or three lines, a very brief overview of your key employability features and is often written in the third person. It should be revised for each new job applied for, so that you appear to match key requirements specified in the job advert.

Using 'action words' and adjectives

Many sources of guidance on the application process advise using certain 'key words', 'buzz words', 'active verbs', 'action words', or 'power words'. Typically, these are verbs that allow you to state things that you have done positively and concisely, or they might be adjectives describing the quality of something you did. In the sample CVs you find online, see how people have used these words. We list a few examples here, but you should be able to find more online.

Verbs: achieved, analysed, communicated, co-ordinated, created, developed, directed, established, expanded, experienced, guided, implemented, improved, initiated, led, managed, monitored, negotiated, organized, processed, sold, specialized, supervised, trained.

Adjectives: effective, efficient, expert, experienced, productive, proficient, profitable, successful.

Source: Careers and Employment Service, University of West London

As well as helping you to communicate your achievements effectively, several larger organizations use computer software to routinely search for these key words. Your CV may therefore not even progress beyond this scanning stage if you do not include enough of them.

However, it should be noted that computer search techniques change and become more sophisticated with time. Because key word searches can yield lots of redundant information, both for the applicant and the recruiter, semantic searches are becoming more popular. The way these differ from key words searches is that they interpret what

is actually meant so that searches can be conducted in natural language. Salpeter (2012) gives the following example:

> [I]nstead of typing ('sales' OR 'business development' OR 'field sales') AND ('enterprise software' OR 'erp' OR 'e.r.p.' OR 'oracle' OR 'peoplesoft' OR 'sap' OR 'Siebel' OR 'salesforce.com' OR 'WorkDay'), a job seeker could simply type: 'director of business development enterprise applications' and expect relevant results.

Because this is a game-changer for both employers and job seekers, you will need to keep this in mind when designing your CV. Salpeter points out that it is advisable to keep CV structures quite simple because search engines might have problems with columns and sophisticated formatting. In other ways the advice Salpeter gives is in line with the advice in this book. Using key words is still valuable but it is particularly important to:

> Make sure to articulate your value and reinforce your skills over time. The search engine will evaluate how recently you used relevant skills and how many years of experience you have in each targeted area.

Digital identity

Just as you might use the internet to learn more about a potential employer, employers are increasingly using the internet to find potential employees and to learn more about people who have applied to them for jobs.

According to an online survey of over 2,300 hiring managers in the USA in 2012, over 37% of managers were using online searches to learn more about the people who had applied to them and another 11% were planning on doing so (Careerbuilder n.d.). Of those who were searching, 65% looked at Facebook which may surprise you as you may feel that Facebook is somewhere quite personal to you, your friends, and family.

Although an important reason is to see if candidates present themselves professionally online, it is important to understand that employers are also looking for reasons why they should *not* hire you. The list of what they do not wish to see is too long to include here, but important ones to be aware of are: candidates making discriminatory remarks; candidates disparaging previous employers; and those who lie about their qualifications.

We suggest now that you carry out the following Activity (Table 9.1) to clarify for yourself the amount and type of information an employer might find out about you.

It is important that you repeat the process of checking on your digital identity regularly as it does not remain static. For instance, employers are now also looking at Twitter and no doubt as new social media become available, they will be also be used as a source of information.

Employers are not only trying to find negative information about candidates. Other reasons cited were to find if the candidate would fit in with the company culture (53%), to find out more about qualifications (45%), and to see whether the candidate was well rounded. There was also a strong emphasis on communication skills, with 49% of job offers being based on the candidates' communication skills online. This shows the importance of having a well expressed blog.

Many employers (63%) also look at LinkedIn. This shows the importance of making sure that your profile there is up-to-date and gives a good flavour of the graduate assets you have to offer. Many of the managers surveyed had given job offers because good references had

Activity

Enter your responses in Table 9.1.

Table 9.1 How aware are you of your digital identity?

Places where I know I have posted information about myself (e.g. Facebook, LinkedIn)	
Google yourself – does anything unexpected appear? (You may have taken care with your privacy settings, but has someone else posted pictures and stories about you without your knowing?)	
Analyse: Does what you read put you in a good light? How would you feel about an employer seeing it? Would it enhance your job prospects?	
Discuss with your group what responsibility you have towards protecting and respecting other people's digital identity. In what ways might you damage them unwittingly?	
Research how you can improve or hide what you do not want employers to see. Check your privacy settings. Bury things you cannot hide with things that are advantageous to you.	

been posted online, so do not be embarrassed to ask someone you have done something for, to give you a recommendation or reference.

Making your CV stand out

There is a serious but common fallacy relating to CVs and that is that all you need is one basic, perfect CV. In fact, what you should aim for is a good CV that is specifically tailored to the information prospective employers have spelled out in the job descriptions and person specification. This tailoring of the CV is vital:

> You have to tailor your CV to every job that you apply to ... because it helps you to stand out if you've shown that you've thought about how your work experience relates to a company. ... Employers will be able to tell whether you've altered your CV ... to match their criteria, so ... if an employer sees it's just a general CV and not much thought has gone into it, they might not even read it. (Grace)
>
> To get to the interview, to stand out, you have to tailor your CV to that particular job. You may think you haven't got time ... but believe me: someone will have done that and if you are to be in with a chance you have to do the same. The interest, the learning, the knowledge has got to be geared to the post ...you've got to be an appropriate candidate. It's no good sitting at home saying 'I can't get a job, I've got a hundred CVs out there' – everybody's doing that. What you've got to do is to put appropriate CVs out and apply for appropriate jobs. (Louise)

If a successful graduate and an employer who regularly recruits graduates are both saying much the same thing, we hope you will have taken the point. Indeed, we suggest that rather than sending off dozens of CVs left, right, and centre, you are more likely to be successful if you are selective about the jobs you apply for, making sure not only that you are a good match for what the employer is looking for, but also that they are offering what *you* want. Again, this comes back to having a career focus, knowing what you really want and are suited for. With the right jobs to apply for, it is much easier to tailor your CV and so convince the employer that you are an ideal candidate.

Where possible, try to convey something of yourself as a person. CVs have a tendency to appear rather 'wooden', or as Louise puts it:

> [W]e don't want somebody who's like an android, somebody who's mass-produced. What we want is somebody that we can get a glimmer of what they are like. If we like what we read then you might stand more of a chance.

However, be careful not to overdo things in this respect. Louise also says: 'I don't want fancy fonts, and it's no point sending it in bright red.'

Another key point to make about making the CV stand out relates to how you describe achievements, as for example in the 'Employment' section or where you are providing evidence of possessing relevant skills. You can achieve much greater impact by putting the achievement in context, explaining its purpose, saying what you did and indicating the result. In other words, this means using the 'STAR' method, which we described earlier.

The same technique should be used as you complete application forms, write cover letters and notes in preparation for interview. For the CV, the sentences you write have to be exceptionally concise and to the point.

 Activity

First look at the following extracts from two different CVs (Prospects n.d.) and identify the phrases which represent the four STAR words. Then discuss which of the two is stronger, and why.

1. Excellent team player with strong communication skills.
2. Demonstrated excellent teamwork skills in a busy financial environment, such as an ability to listen to clients and managers, perform my role to a high level and support colleagues, resulting in an early promotion.

What is most important?

As you proceed through university, you should be developing a critical mindset, not accepting everything that you read in one source but being open to alternative views, looking for evidence to support the arguments you make and being aware of potential flaws in authors' reasoning. With this in mind, you may be interested to learn that Reed and Stoltz (2011) report findings from research based on analysis of 30,000 CVs which appears to contradict some of our earlier points. For example, they suggest that the inclusion of active verbs makes no difference to whether an applicant's CV persuades an employer to interview them. They

also say the same thing about the inclusion of 'personal profiles' or 'personal statements', and 'hobbies and interests'. So what should we believe?

The large sample size that they report is certainly impressive, but it is worth noting that several of the employers we spoke to said they were keen to read about candidates' hobbies and interests, as this gives a 'glimmer' of what the applicant is like as a person, and about their extracurricular achievements. Perhaps the significant point to remember is not simply to name the interest with one or two words but to give an example of something you have done which can be presented as an achievement.

Likewise, active verbs may not be especially significant if evaluated in isolation. However, we believe that they *are* indeed valuable, and that their importance lies in their use in concise statements which describe achievements, where you use the STAR technique to explain context and purpose, show what you did and highlight the result. They then become part of statements which Reed and Stoltz claim can triple your chances of being selected for interview.

 For them, these statements must emphasize your possession of their '3G mindset' ('Grit', 'Good', and 'Global' – see Chapter 2).

As you prepare or revise your CV, you should therefore check to make sure that it contains good examples where you have demonstrated not only key skills, but also this 3G mindset.

Cover letters

Often, having spent a lot of time on an application form or CV there is a feeling that time is running out and the cover letter is then rushed. This is a mistake as the cover letter can be 'make or break' in terms of gaining an interview.

In many ways the guidelines relating to cover letters are quite simple as you will see from the example below. However, the application of these guidelines is quite challenging as you have little space (one page only) to catch the potential employer's attention.

The simplest part of writing a cover letter (whether you are posting or emailing it) is the mechanics of laying it out properly. There are many examples of how to write cover letters on job-seeking websites, as Grace explains: 'It's got to have the right layout ... there are templates everywhere if you just type into Google, you can find a few good examples.'

The other part, which should be simple, is to make sure it is properly proofread and error-free. One spelling mistake in a cover letter could mean that all the work in the rest of your application is wasted as you will be put directly on the discarded pile. What Louise said about CVs is equally applicable to cover letters, as unless your cover letter is 'nicely presented, clean, crisp, without spelling mistakes and nicely set out so that it's easy to read ...', you may as well save yourself the postage. On the subject of postage, it is worth noting that you need to take just as much care when sending a cover letter by email. Although email is generally considered an informal medium, when being used to apply for a job you must treat it as you would a paper copy. We have heard of at least one case where a well qualified applicant was not called to interview because of the casual nature of the email application submitted.

So apart from the mechanics of writing your cover letter, what should it contain? Grace suggests:

You have an opening paragraph where you introduce yourself, let the employer know where you're up to, so if you've graduated, let them know that, and what you graduated in. Then you tell them why you want to work for them in the next paragraph, so why the job stands out to you, and then in the next paragraph why they (should) want you, so highlight a few skills or qualities that you feel make you stand out. You haven't got very much space, really, so just a few sentences, and then a concluding paragraph or just a concluding sentence where you might say 'Thank you for reading my cover letter. I look forward to hearing from you shortly.' And then make sure you sign it.

The following example summarizes the key features of a cover letter.

Your address

and other contact details

Date

Potential employer's name (wherever possible addressed to a specific person)

Address

Dear (name again where possible, Sir or Madam if not)

Subject heading – Containing details of the position applied for, with a reference number if available.

Paragraph One – Details of the job for which you are applying, where you saw it advertised, and reference to any contact you have already made with the company.

Paragraph Two – This is where you succinctly highlight the main points in your favour. Show that you know what the position requires. Tell the employer what you have to offer. Back this up with references to qualifications, skills, and experience evidenced in your CV or application form. Keep your sentences short and simple so that every point stands out. Use lists if you want to highlight several assets.

Final Paragraph – Thank the employer for considering your application and point the way ahead by suggesting that you are free for interview at a time to suit them.

Yours sincerely (if addressed to a named person)

Yours faithfully (if addressed to Dear Sir or Madam)

Your signature if a paper copy

Your full name

Enc – to indicate the inclusion of a CV or application form

The importance of cover letters was further highlighted by Louise:

> Cover letters are often more interesting reading than the CVs to be honest. Very important to get that right. Normally the content will be: I'd just like to draw your attention within my CV to this experience, or this desire or this research that I've done, which makes me appropriate.

and

> I know you are very busy. Can I draw out these particular things in case it's missed, I want you to know that I've done this, this, this, and this, or have researched this, this, this, and this.

You will see that the examples Louse has given are similar to what Grace suggested and we have illustrated in Paragraph Two of our letter. Louise points out that if the applicant does this she knows what they have to offer. She goes on to give the following example which shows how Paragraph Three can be tackled: 'would dearly like to come and have an interview to show you my potential and what I can do for your company'.

In other words, Louise is asking applicants to identify their key strengths and make sure their letter is really tailored to the specific job she is offering and point the way ahead.

Really, the only way to become competent at using a cover letter as a way of selling yourself is to practise it. You need to practise finding ways of showing how your particular skills and strengths could be useful to the employer.

 Activity

Drawing on your PDP and learning logs, how would you sell your skills if asked for the following as some of the key skills employers require? We have completed the first one for you, but you should still think of a way to personalize it.

Table 9.2 Selling your skills.

The employer wants	You have	How you sell it in the cover letter
Good communication skills	Lots of experience in customer service from your part-time job while at university	I appreciate the importance of good communication skills in your organization and would like to draw your attention to my customer service experience. Here, I have used excellent communication skills in making customers feel welcome, listening carefully to their requirements and responding to complaints and helping to address problems
Ability to work in a team		
Problem solving skills		
Customer facing skills		
Decision-making skills		

Swap your work with someone else and discuss how well you have achieved your aim. Have you remembered to use the STAR technique? Add this work to your PDP, and continue adding to it as you come across more employer requirements.

Online application forms

With CVs, cover letters, and personal statements, you have substantial control over the content. True, as we have emphasized, it is vital that you tailor each of these to the requirements specified by the employer if you are to stand much chance of being selected for interview. Nevertheless, what you choose to include and how you present it is, to a significant extent, down to you.

However, many larger organizations prefer to devise application forms where it is they who have control over what you tell them about, and often their standard application form is all that they will accept. They may even state specifically that they will not consider CVs. (In this respect, it is worth mentioning that Louise – who recruits graduates to a large-sized company – is impressed if candidates follow up their online applications by sending in a CV and cover letter, as long as it is 'pristine' and conforms to the above advice. As she herself stresses, however, candidates must follow the instructions given by employers about this.)

It is a good idea to read through all sections of the application first so that you know all that is required, although this is not always possible as with some you can only see one section at a time, and cannot proceed to the next one until the current screen has been completed. There are different parts to application forms which can be thought of under two headings: 1. Standard/Personal; 2. Selection critical.

The sub-headings which we suggest may not be obvious in the actual online application form, as you may simply be directed to the next untitled page or 'screen' having completed the previous one.

'Standard/Personal' sections

These ask for personal information needed as part of the standard application process. They may appear under slightly different guises, but the following headings are typical:

- Personal Details – name, contact details, national insurance number, etc.
- Equal Opportunities Data – which allows organizations to monitor and account for whether they are operating fair recruitment practices and not discriminating.
- 'Ability/Disability' – details any disability and support needed to help perform the role.
- 'Right to Work in the UK' – records your status in this respect.
- 'Criminal Record' – where anyone who has a criminal conviction (spent or unspent) is asked to provide details.

Most of these elements are fairly straightforward and, although we do not call them 'critical', it is still important to take care in completing them. You should also be aware that, although not difficult to complete, they can be surprisingly time-consuming.

The software used with online application forms often allows you to complete the various sections one at a time, save them, and return later to complete further sections. It is therefore a good idea to start filling these sections in straight away and it is certainly a bad idea to leave everything until the deadline, as you are unlikely to do justice to yourself in the more critical sections.

'Selection critical' sections

We call these sections 'critical' because the answers you enter into the spaces provided will decide whether or not you get through to the next stage in the application process. It is advisable to prepare and save your entries for these sections offline in separate Word documents. This is partly to allow you to ensure that you can later retrieve your answers and remind yourself what you have written and, also, many companies ask similar questions in these sections, so you may be able to tailor them to other jobs.

Employment history

This may be asked directly or posed in the form of a question such as 'Tell us about your experience in the workplace'. The amount of space varies, some allowing just enough space for name of the employer, address, and job title, whereas others allow you to provide brief information about each job. Make your answers concise but provide as much information as the section will allow, using the STAR technique and tailoring your entries to the needs of the employer. Within the available space sell yourself by highlighting relevant achievements and skills.

General and competency-based questions

There might be a section called something like 'About you', or 'Your suitability for the role'. This is the most crucial section, as employers will judge your answers according to whether they show sufficient evidence that you fulfil their needs. Before completing it, it is therefore vital to find out as much as you can about the nature of the role and to read very carefully the requirements spelled out in the job and person specification.

Before giving examples of questions and points to remember when answering them, here are some general issues. Application forms seek evidence for the following:

- Your suitability for the position, based on evidence drawn from your education, work, voluntary activity, or other extracurricular activity.
- Your motivation in applying for the position and evidence for this.
- Answering application form questions involves not only making claims about your skills and competences, but also presenting convincing evidence.
- Analyse carefully the question so that you understand what particular details it is important to emphasize in your answer.
- Many answers involve telling powerful stories about yourself. Doing this can be difficult, often not because there are no powerful stories to tell but because many people are not used to boasting, or often take for granted good things that they have done.
- Space is very limited, usually to a set number of words or characters. Writing concisely and bringing out key issues effectively is tricky and time-consuming. Try first writing it all down, then edit it and reduce the number of words used.
- Be selective. Your narrative should be truthful but as with any good story, there are points and themes that need developing and highlighting, and others which can be played down, or left out altogether.
- Start by considering the employer's needs, not necessarily the story as you remember it.
- Linked to the previous point, include key words from the job and person description.

The wording of these questions will differ, but they tend to recur on many forms. We recommend that for many of these you use the STAR technique to explain context (10%) and purpose or goal (10%), what you did (70%) and the result, where you highlight positive outcomes (10%). The percentages in brackets indicate approximately how much of your answer should be devoted to this element.

Tell us about an achievement that makes you proud.

Remember the point about starting from the employer's point of view. A common mistake is to think of an example that is especially significant to you, and to recount details that are memorable to you but not necessarily meaningful to the employer. If you start by thinking of the employer's needs, you will know what sort of achievement and which elements to include and emphasize.

Make clear why the achievement is noteworthy, so explaining the context is especially important.

Tell us about an occasion when you had to work in a team to achieve a common goal.

Explain what the team was trying to achieve and your contribution. Highlight specific details of what you did, in particular focusing on issues to do with teamwork such as negotiating with, listening to, supporting, and encouraging others.

Tell us about a challenging problem that you had to solve.

Be careful not to have too much overlap with your teamwork answer. Choose a problem which in overcoming, you demonstrated the following: good analytical skills, creativity and decisiveness. Make clear what each of these steps involved, and explain enough of the result to show how effective you were.

Tell us why you want to work for us.

This is partly an opportunity to demonstrate good research and communication skills but, equally importantly, to appear enthusiastic about the organization. Remember: if you cannot communicate enthusiastically what is good about the organization, why should it have confidence in your ability to present it positively to others?

Read the organization's website thoroughly. As Grace suggests, look to see what makes the organization stand out to you. It might be that you are a keen fan already of the company's products or user of its services, or you might like the philosophy they present in their mission statement.

Tell us why you want to work in this position/to join this training scheme.

You will need to show that you understand the nature of the job and how your skills, knowledge and mindset match the role requirements. Again, it is an opportunity to demonstrate your research and communication skills. When applying for graduate schemes, as well as reading up all she could about them online, Grace also found it very useful to attend graduate fairs where she was able to speak to recent graduates who were already on such schemes. Explain your motivation and how the position matches your interests.

We conclude this section with a list of further potential questions in the following activity.

 Activity

Discuss each of the following application form questions in a small group and produce bullet points of the important points to include or remember in your answers.

- Tell us about a situation where you had to meet a difficult deadline.
- Describe a time when you had a difference of opinion with someone and you had to persuade/convince them of your point of view, and/or come to an agreement.
- Describe an extracurricular activity or hobby and explain how you have engaged with it and how you have benefited.
- Describe a task you undertook which demonstrated your ability to communicate complex information.

Conclusion

As you read this and the next chapter, you will be starting to appreciate how much there is to do to be successful in the graduate employment market. The importance of clarifying your employment objectives becomes evident when you realize how much preparation is needed to provide employers with evidence that you have the skills and aptitudes they need. To have such evidence, it should also be clear by now that you will need to undertake activity besides just your studies, whether this be part-time work, joining and playing an active part in societies, undertaking voluntary work, getting organized early so that you will be in with a chance of being selected for an internship, or a combination of all of these. You should also understand that if by the end of your studies you are unable to present such evidence, there will be plenty of other job applicants who can.

The application process is time-consuming and needs stamina and imagination, but the guidelines and practice we provide in this chapter should help you on your way to success.

What do you think now?

Having worked through this chapter, have you revised your opinion on any of the questions above? How about your classmates? Have any of them changed their opinions?

 Project

Your tutor will give you further guidance on how to work through the project tasks. The material we provide below summarizes the tasks and links them to other parts of this book.
Make sure that your PDP is up to date.

- Examine the quality of evidence you are gathering.
- Do you have evidence that you think makes you stand out from other people in your class? If not, what are your plans for getting it?
- At the moment, how impressive are your leisure and other extracurricular activities to potential employers?
- Have you checked your digital identity recently? Does it give a good impression of you or do you need to follow some of the advice in this chapter to improve it?

Further reading

Careerbuilder (n.d.) <http://www.careerbuilder.com/JobPoster/Resources/page.aspx?pagever=
2012SocialMedia&template=none&sc_cmp2=JP_Infographic_2012SocialMedia>.

Prospects (n.d.) *CVs and Covering Letters. Example CVs.* <http://prospects.ac.uk/example_cvs.
htm> (accessed 25 January 2013).

Whitehead, H. (2011) *Managing your Digital Identity.* Nottingham University <http://www.
youtube.com/watch?v=Y3OXdhq68CU> (accessed April 2013).

Helpful websites

<http://123people.com>
<http://www.gradhacker.org/2013/03/20/manage-your-digital-identity/>
<http://www.sec.gov/spotlight/katrina/protectyourselfonline.htm>
<http://www.guardian.co.uk/technology/2013/mar/11/facebook-users-reveal-intimate-secrets>

10

Finding a job

Learning outcomes

By the end of this chapter you should:

- Have an awareness of the wide range of places where jobs can be found.
- Understand the importance of preparation for interviews, whether face-to-face or any other means.
- Feel confident in your ability to use the material you have gathered in order to impress at interview.

What do you think?

- If you were called for interview in the next week or two, how prepared do you think you are?
- Will your interviewers always be experienced and trained in interviewing?
- What happens at assessment centres?
- If you were prepared to relocate to improve your employment opportunities, how difficult might it be to get to the interview?

Case study

Louise Morissey is Director of Land and Planning for Peel Holdings, a large property investment company based mostly in the North West of the UK. Peel Holdings are estimated to be worth £5 billion, owning and managing such prestigious properties as the Manchester ship canal, port of Liverpool, and John Lennon airport. They have recently completed Media City in Salford Quays.

Louise's role is to look after the land, maximize usage, and bring properties forward. She is responsible for three teams and works with recent undergraduates.

As well as the above areas of work, she also sits on various boards, the main one being the board of the Cheshire and Warrington Local Enterprise Partnership (LEP). The main aim of LEPs is to facilitate growth and economic development in their area. Leaders in private industry work with the local authority to ensure that young people get the best start by means of interventions such as young apprenticeship programmes. They also work to retain graduates and prevent a 'brain drain' away from their area.

In this chapter, as well as in Chapters 4, 7, and 8, we present Louise's insights and forthright advice on CVs, interviews, and the early days at work.

Louise ended her interview with us by saying 'Good luck to all these graduates coming forward: must say very impressive most of the time.'

You can read more about the Peel Group at <http://www.peel.co.uk/> and the Cheshire and Warrington Local Enterprise Partnership at <http://www.candwlep.co.uk/>.

Introduction

In this chapter we present guidance on the actual job hunting process, which culminates in the interview stage. What we have presented so far in this book are the skills and attitudes employers value, and suggested ways in which you should gather evidence so that you will be ready to convince employers that you are the person they want. If you are using the project-based approach with this book, you and your group will have already done research on what employers are looking for, so we turn now to the task of finding employers who are looking for a person like you.

Table 10.1 Where employers advertise jobs.

Local and national newspapers	Local newspapers are useful if you are looking for a job in your area. Advertisements in national newspapers tend to focus on fairly high powered jobs
Professional journals	If you are clear about the area you wish to work in, then this will help you target jobs in that specific area
Online (job boards)	Can be a good way of searching through a lot of jobs quickly. Registering with an online job board should mean that you are regularly updated about jobs that match your criteria. However, do make sure that you are using a 'proper' job board. Some job boards are in fact agencies, and others do very little for you
Recruitment (employment) agencies	A good agency will work hard to match your abilities with the requirements of employers on your list
Word of mouth/ networking	Never underestimate the value of using personal contacts. Ask family and friends who are in work to let you know of any vacancies coming up in their organization. Don't think: 'But I don't know anyone'. Remember how Grace, in Chapter 8, sought out people who could give her valuable information, such as at graduate fairs (see below)
Graduate fairs	These give you an opportunity to meet employers who are offering everything from internships to postgraduate study opportunities, as well as actual jobs
	At a typical large graduate fair you can question employers and get advice on your CV, interview, and presentation performance. Employers often bring recent graduate recruits who can also give you lots of relevant information
Careers service	See section 'Careers service'

Finding vacancies

There have never been more ways in which employers advertise their positions. In theory this should make things easier for the job seeker, but of course covering all these possibilities does require effort and takes time. In Table 10.1, we list some of the main methods.

One thing you might have added to the list in Table 10.1 is getting employers to find you rather than you just looking for them. We are not talking about the way that employers use specialist 'head hunters' to find suitable candidates for (usually) senior roles, but about making sure that you are giving yourself as many opportunities as possible to be found.

 Reflection

Do not look at the next section until you have thought about this question.
Can you add anything to the list in Table 10.1?
Which of the above methods might be most suitable for the type of job you are seeking?

One simple way in which you can make yourself known is to post your CV on a job site designed for this purpose. Many university careers services allow you to do so, even after you have graduated, but there are other sites that offer this service. It is important to make sure the site you post to is genuine.

Another, perhaps even more efficient method of making yourself known is to post your profile on LinkedIn. Try and make sure you join any group relevant to the area you want to break into. For instance, Balinder Walia who is our case study in Chapter 11 uses his LinkedIn profile to describe his education, his experience, describes his company, and has recommendations and endorsements from people he has worked with. Your profile might not be so detailed yet, but it is never too early to start building it and getting people for whom you have done voluntary or part-time work to endorse you.

This may be more important than you realize because, increasingly, as part of their vetting procedures, employers routinely look for job applicants' Internet profiles. Not having an online presence may raise question marks in their mind about you, and they may see this as a weakness. Equally, if you have a highly visible online presence, there may be text or photographs that you really should not be letting employers see, so make sure that what they do see about you will make them interested in employing you rather than being put off. And if you use Facebook, make sure the public section of it puts you in a good light.

 See also points made about digital identity in Chapter 9.

 Activity

If you have not already done so, set up a LinkedIn account for yourself.

Careers service

It is always worth keeping in touch with your university careers service. Not only can they advise you on the assets the employers in your chosen field are seeking, but many now allow employers to upload their current vacancies directly onto the University Careers Website (in fact this is how Ilona, who we feature in Chapter 12 found her job). The careers service may also be aware of good jobs with smaller local companies, and these can offer you excellent opportunities.

Big or small

Graduates often think in terms of obtaining jobs with large organizations or multinationals, but the jobs and promotion opportunities with small companies may in fact be better suited to your skills and needs. In short, the decision is whether you wish to be a big fish in a small pond or vice versa. Certainly there are great advantages in starting your career with a small company as you can be exposed to a wider range of experiences, which will stand you in good stead when you wish to move on. This is not to say you should not try for the graduate training schemes with the bigger organizations, where you will usually be given excellent training, typically in a specialized area. The point is that you should think flexibly, be open to different possibilities, and thoroughly research the different options and job opportunities that are available to you. The self-awareness that you develop through your PDP will also help you to understand what kind of organization is likely to be best suited to you.

Learning about a specific industry

As we will discuss below, one of the questions you will probably be asked at interview is 'Do you have any more questions?' At this point you may simply breathe a sigh of relief or, more profitably, use this question to really show you have done your homework.

You may well be applying for a junior managerial or administrative role for which you are suited but in an industry you do not know very much about. If this is the case, it is essential that you do your research into that industry.

 We discussed research skills in Chapter 3 and some of those will be useful here.

Also, the relationship you have built up with the librarian, and your university's careers service will be invaluable. If there is a dedicated 'placements office', get to know the staff there, too. In our experience, they offer extremely helpful advice and information.

There are various places you can search to find out about an industry. First of all you may find out whether they are represented by a professional body or trade organization. If so, there will very likely be a journal or periodical which discusses what is going on in their area.

Keeping abreast of the business news generally can also ensure that you are aware of general current business events and how they impact on different businesses. The business sections of serious newspapers, Reuters, the BBC, and others will cover anything significant happening in the business world.

 Activity

Find out who represents the trade or profession you wish to work in, and what publications there are detailing their activities. If you have not yet decided, explore where you can find up-to-date information on one of the following:

- Marketing.
- Accountancy.
- Another area you may have already considered.

In the end, how much effort you are prepared to put into this research will depend on just how much you wish to work in that specific industry or profession. However, this kind of research will be necessary for learning about any specific company you apply for.

Learning about a specific company

In our interview with Louise Morissey, she points out:

> [Y]ou'd be amazed at how many people selected for interview haven't researched who it is that they are being interviewed with. They sit there and haven't researched the company, haven't been on the website, don't know which part of the company it is that they're being interviewed with. Do the research properly! It's not hard to get literature and to be serious about it, you can download it, read it, making sure you get that right.

So, as Louise suggests, the first step is to look at the company website. This is their public face and is how they want people to perceive them. We cannot over-emphasize the importance of this research into the company, as employers like Louise make clear. Indeed, they will almost certainly look for evidence that you have done your homework on the company beforehand, with questions such as 'Why do you want to work for us?' This can seem a deceptively simple question, but if you cannot give good reasons, the employer may conclude that you have little motivation, have made little effort, and are not really bothered. Would you employ someone who gave you that impression?

Look for the organization's mission statement, which will describe what is important to them, their ethical policies, and so forth. Being able to show how your own personal philosophy is in line with the organization's core values may well be a way of saying why you want to work for it. Some companies present this information without describing it as a mission statement, but somewhere on their company website you should find their stated aims.

Grace found that in almost all of her interviews, this question appeared in one guise or another, so she found it was crucial to be as well prepared as possible. Her research included looking online, picking out features of the job, the scheme or the company which stood out, making them particularly attractive to her, and this included looking at the company's mission statement and thinking about 'why the company has a better philosophy than another company'.

When doing your research, conducting a 'PEST' analysis (Table 10.2) of the company may help you focus on areas of current interest or importance to the company.

Table 10.2 PEST analysis of a potential employer.

Political	Economic
E.g. How does current tax legislation affect the company?	E.g. How has the economic downturn in the West, and rise in the East, affected the company/sector?
Social	Technological
E.g. What impact has the high unemployment rate among young people had on the company?	E.g. How has the rise in internet shopping affected the high street? (particularly relevant for the retail industry)

 Activity

Spend a little time looking at the websites for some major companies. Get an idea as to where they provide information about their aims and objectives. You will possibly also find financial information and details about where they trade. Put your findings into a PEST grid as above. All of this type of information could be useful to you when preparing your CV and at interview.

Preparing for the day

In some ways preparing for an interview is similar to preparing for an exam. It is about having everything in place to get you to where you need to be on time and looking good. Some of the advice in Table 10.3 may seem like a statement of the obvious, but employers we have talked to have said these were things some interviewees fail to do.

Table 10.3 Some things interviewees fail to do.

Be on time	If you cannot be on time for something as important as an interview then the implication is that you will not be punctual if given the job, and employers value punctuality highly. After all, they are paying you for your time. So, at least a day before, make sure you know where you are going, what transport you need, how long it will take, and allow yourself much more time than you need. It is better to be early than late. We know of at least one candidate who got a job on the strength of having been spotted testing out the route the day before to ensure they would be on time
Look smart	As Louise Morissey points out 'First impressions are absolutely everything. Clean, neat, tidy ... And you have got to have obviously made an effort. ... we're not talking top-end suits here. (Absolutely not) trainers, jeans, you know: sloppy stuff'
	However unfair it seems, people will judge you on your appearance within the first few seconds. Having done so much work to get to this stage, it would be a shame to lose to a candidate who has just dressed more smartly than you
Appear confident	However nervous you are, try to look at home in the interview room. Louise suggests: 'Walk tall. Shoulders back'

Practising interview skills

Having worked so hard to get to the interview stage, it is a shame to fall down at this last hurdle. However, people obviously do. Lance and Tania of SupportPlan gave us the example of an applicant who had sent them a brilliant CV but who interviewed very badly. He showed no enthusiasm for the job being offered and had to be probed to provide information.

If you have attended a few job interviews you may have noticed a difference in how they are conducted. What people do not always realize is that some interviewers may be almost as nervous as themselves, having had no real training in interviewing. Louise's advice is relevant for all interviews, but it may be particularly important to remember when applying for a position in a small company.

Try and be friendly, try to be approachable, make eye contact. Realize these are human be-ings on the other side of the panel that are interviewing you. Try and make it enjoyable for the panel as well.

For this reason, the more confident you are the more positive atmosphere will be created. While you should not 'take over' the interview, it is worth making sure that if you are not asked the questions you feel will put you in the best light, you have a plan for making your point.

It is unreasonable to expect, if you have not been for many interviews, that you will find an interview easy so it makes sense to practise beforehand. Louise gives the following advice on this to avoid other candidates 'outsmarting' you.

Don't say three days before: 'I'm nervous, I hate it, I don't like being interviewed.' For good-ness sake do some practising! And one of the hardest things you can do is to actually practise at home, being interviewed by people that you know. That's actually excruciating but you'd be amazed at what good it does you when, you know, mum or dad or brothers or sisters or friends are sitting there, the other side of the table and grilling you. And you can make sure: practise your pose, sit up straight, look people in the eye, practise your handshake. It might sound ridiculous but, again, you want to be streets ahead. And that's something you need to be thinking about. The quicker you can get rid of those nerves the better.

She also says that being nervous is not a bad thing as it indicates keenness, and that interview-ers are not trying to be mean in any way. In fact it is unlikely that employers would invite you for an interview if they did not believe you were worth their time, so they are usually keen that you do well.

 Activity

You do not have to practise a full interview each time. You could work on first impression, wearing the outfit you would wear, entering the room, shaking hands and taking your seat. When you have finished, ask your pretend interviewer how you did. Check:

- Did you remember to smile?
- Did you walk tall, as Louise suggested?
- Is your handshake firm and positive?
- Did you repeat the interviewer's name? 'Good morning Mr ... Thank you for seeing me.'
- Are you sitting up straight, or perhaps leaning slightly forwards to show interest?
- Have you got any distracting mannerisms?

You could then practise answering the type of questions you might be asked. Check:

- Are you engaging all of the interviewers (if there is more than one)?
- Are you making appropriate eye contact?
- Are you speaking clearly?
- Are your answers clear?

(continued...)

- Are you avoiding irritating 'non' information words such as 'like' and 'you know', as well as 'ums' and 'ers', which may distract the interviewer from your message?
- Are you confident enough to ask for clarification if the question is not clear?

Finally, you can practise making a dignified exit. Check:

- Did you ask one or more meaningful questions at the end of the interview?
- Did you smile, and thank the interviewer(s) for their time?
- Did you walk out as tall as when you came in?

If you have facilities for recording these sessions it is worth doing so. You can then evaluate your performance in the form of a learning log and reflect on ways in which you can bring about further improvements.

Behavioural/'competency-based' interview questions

Employers often like to ask 'behavioural' (also referred to as 'competency-based') questions in interviews. For example, if you have claimed to be a good team player, they might ask you 'Give us an example of when you dealt with a difficult colleague'. This question requires you to give a practical example of how you dealt with a situation.

We have been advising you throughout this book to keep learning logs of situations you have found interesting, challenging, and so forth. These will provide you with a valuable starting point in preparing for behavioural interview questions. Look through all the skills, aptitudes, and mindset qualities you have included in your CV or application form and make sure you have examples that demonstrate your competence in each of those areas. It is important that the examples you give are recent, complete, and genuine. Both with your answers at interview, and when preparing for questions you can anticipate beforehand, remember to use the STAR technique (described in Chapter 9) to guide the structure of your answers and ensure that you include all relevant points.

A further important technique recommended by Peter Cobbe, a human resources expert and personal career coach, is to 'project' yourself into the role during the interview. This means talking as if you are already in the role, and involves thinking carefully beforehand about what you think the employer needs you to do. It also means spelling out what you would actually do in the role, giving examples of yourself doing the things that are needed. In this, it is important to get the tone right, so that it does not sound as if you are making assumptions about being given the job. At the same time, you should be trying to convey a sense of really being there, using present and future tenses rather than the more tentative conditional (I would do ...). For example, supposing you were asked how you would organize an event for the organization, you might start by saying something like:

> Well, first of all I'll ensure that I understand exactly what my boss is expecting and also check with other colleagues who are involved so that I really am clear about what's needed. Then I'll check that the facilities – such as the rooms and equipment – are available at the time and date required. That kind of thing, so that I'm clear about everything before I start doing anything.

The idea is to sound as if you are actually in the situation, doing the job for real.

Very few people can come out of an interview feeling that they were 'perfect', but practising all the above will ensure that at least you give a good account of yourself. Remember that the main thing you should achieve with your answers is to show the interviewers what you could do for their company. Louise Morrisey puts it bluntly:

> A warning: think about what the panel are looking for and why they are looking for it. This is a real position, a real employment opportunity. As nice as it is for you and your career, actually it's the company's needs you should be thinking about. Not so much about what you'll get but what you can bring to the team, what your enthusiasm could do and how committed you'd be and how useful you would be. Focus on what you can do for the company.

Assessment centres

Even where interviewers are trained and experienced, it is generally acknowledged that interviews are not the most efficient predictors of who will be a good employee. It is for this reason that in recent years, assessment centres have become an increasingly popular method of selection. The value of an assessment centre for the employer is that it allows them to evaluate you across a range of skills and competencies. Tests may therefore include:

- an interview;
- a presentation;
- aptitude tests;
- psychometric tests;
- group interviews.

Because of the wide range of skills to be tested you are usually required to attend for at least a full day, and in some circumstances the tests may spread over two days. Even when actual tests are not taking place, your behaviour and interaction may be observed throughout the process, so good advice is to be yourself, but yourself on best behaviour.

In Chapter 9 we introduced Grace. A few days before we spoke with her, she had attended an assessment centre with nine other graduates and went through the following process.

- **Paired with a current trainee**. This gave the opportunity to ask questions about the training scheme, and the day to day experience of working with the company.
- **Individual exercise**. A 30 minute data analysis exercise where she had to state how she would allocate stock to different stores based on her analysis of sales figures.
- **Group exercises**. Two-stage 45 minute group exercise: individually, candidates had to choose a product, score it according to set criteria and then pitch it to the group. In the second stage, the group had to come to a consensus concerning which products to select.
- **Interview**. One-on-one interview. This was mainly a competency-based (behavioural) interview, although it did start with the question: 'Tell me a bit about yourself and how you got to the position you're in now.'

Grace explains why it is important not to see the others as competitors in the group exercise:

> [I]f you single yourself out and don't work with the other people you're then actually making yourself look ... you're sort of sabotaging it for yourself, so I think in those group tasks, you have to work really well with other people and not separate yourself from them and see them as competition. I think it's really important to work well with them and you kind of forget that you're in competition with each other. At the same time you need to keep, in the back of your mind, the things that you want to get across to the assessors.

Grace went on to explain what these points were.

> I knew it was important to speak up quite early on, to have quite a lot of input, to listen to other people's opinions so if someone hadn't really spoken, to say to them 'What do you think?' and make sure everyone's involved, and then also I was told that sometimes it's good to be the person who keeps time, so I tried to be the first person to say that.

Note that Grace was using listening skills as well as good team building skills. She was making sure that she got the fact across that she is: 'easy to work with, that I listen to other people's opinions and also very focused on getting the task done in the time given'.

Psychometric tests

As already noted, interviews are not considered to be the most reliable predictors of suitability for a job, therefore many companies use interviews in combination with psychometric testing. According to Shavic (2002): 'At the time of writing 95% of FTSE 100 companies use psychometric tests to select their staff, as do ... the civil service (and) financial institutions.'

Psychometric tests are designed by experts in the field of occupational psychology and aim to test not just the personality of the candidate, but also their abilities in other areas such as numerical, verbal, abstract, and spatial reasoning. In reality some tests are more appropriate for certain jobs than others, but there is a general tendency on the part of employers to test for verbal and numerical skills.

Originally these tests tended to be pen and paper tests in exam-like conditions. Nowadays it is more likely that they will be administered online, and be used as pre-interview screening.

Because these tests may be unfamiliar to you, it is advisable for you to try some tests out. Your university career's service may be able to give you access to them or you can visit the Prospects website where tests are available <http://www.prospects.ac.uk/interview_tips_psychometric_tests.htm>.

Trying out these tests in advance of an interview can teach you some useful things about yourself and your competencies, and allow you to make an honest assessment of your suitability for certain jobs.

Presentations

As part of an assessment centre or of the interview, it is common to be asked to prepare a presentation on a specific topic. Although this may be nerve-racking, it is your chance to shine as you will be able to prepare and practise before the interview.

Table 10.4 Questions to ask prior to giving a presentation.

The venue	Size of room – will you have to practise speaking loudly so that your voice reaches the far reaches of the room or will it be a small personal space?
The facilities	What technology will be available? Will there be help if you have problems with it?
The audience	How many people might be there? – so you can give them notes What is their interest in attending? – simply to have a chance to see you, or to learn something from you. If the latter, what is their current level of knowledge?
The purpose	Is the presentation for you to demonstrate some area of expertise, or is it simply to show that you can speak in front of a group of people?

A detailed coverage of the art of giving presentations is beyond the remit of this book. However, Table 10.4 may serve to remind you of what you have perhaps already covered, and will provide a checklist for you.

The secret to a good presentation, as with most other things, is knowledge and preparation. If you are told you will be giving a presentation as part of your interview, try and get as much information as possible. The kinds of things it is helpful to know are listed in Table 10.4.

You may not be given answers to all the questions but do get as much information as you can, as the answers should help you decide what aids you will require and be able to utilize for your presentation, and the depth you need to go into.

Preparation

- Make sure you understand what it is the employer is asking you for.
- Research the topic to the depth required.
- Clarify the purpose and aims of your presentation.
- Structure the material appropriately.
- Develop a storyline – a clear theme.
- Collect evidence/examples to support your argument.
- Prepare your materials. Be imaginative, as well as or instead of PowerPoint you can use examples, samples, YouTube, handouts, or demonstrations to enhance your presentation.
- Do not use aids just for the sake of it, they must add something of value.
- Have a fallback plan in case any equipment fails.
- Rehearse and time the presentation.
- Practise – preferably in front of someone who will give you an honest appraisal of your performance.
- If you are using cue cards, number them and fasten them together.

During the presentation

- You will feel less nervous if you STAY (Stop Thinking About Yourself) and concentrate on your audience.
- Take a deep breath.
- Introduce yourself if necessary.
- Nerves can cause you to speak faster than normal, so try to speak slightly more slowly than normal and leave longer pauses between sentences.
- Make sure everyone can hear you – especially if you are in a large space.
- Do not be frightened to move around, take control of the space available.
- Smile and be enthusiastic. If you do not appear enthusiastic, why should your audience be interested?
- Keep to time.

Introduction

- Give the audience a route map, i.e. tell them what you are going to talk about, and why and in what order.
- Give them your take on the topic.

Main part

- Present the facts in a logical order.
- Give your interpretation of the facts you are delivering.
- Produce any supporting evidence in the form of tables, graphs, etc.
- Do not try to include too much information.
- Do not read from notes – use cue cards or other prompts.

Conclusion

- Summarize – tell the audience what has been covered.
- What can be concluded from what has been covered?
- Ask for questions.
- Thank the audience for their attention.

Telephone interviews

Because of the large number of applications they receive, some employers are turning to telephone interviews as a way of narrowing down the number of candidates they call for interview. This method may also be used when applicants live too far away to be invited for a first interview, a situation which is becoming more common in a global business environment.

If you are to be interviewed in this way, there are ways of helping yourself to perform well. The fact that people will not be focusing on your appearance or mannerisms may be beneficial, as they will only consider what it is you are saying.

Be prepared

Preparing for telephone interviews is similar to face-to-face interviews in that you need to do your research into the organization. An advantage with a telephone interview is that you can have your CV and other notes in front of you to consult if necessary.

Before the interview there are some practicalities to deal with.

- Make sure you arrange the call for a time when you will be able to take it. Employers will not be impressed if they have to keep trying and you are not picking up.
- Try and use a landline as reception should be clearer and you are less likely to lose signal (but be sure to turn off any inappropriate answerphone message).
- Make sure your flatmates, family, or friends know that you are on an important call and should not interrupt you. Telephone interviews may be quite short, but they can also be very detailed and can even last up to an hour.
- Have note taking material handy so if a question occurs to you it can be noted for later discussion.
- Have water by you in case nerves make your mouth dry (but avoid chewing, drinking anything else, or smoking).
- If you have the facilities, you could record the call so that you can listen through it again later, both to evaluate your performance and to pick up on issues of obvious importance to the company.

During the interview you have to make up for the lack of visual clues so take particular care to:

- Answer the phone in a professional manner 'Good morning/afternoon, ... speaking'.
- Make sure your voice is enthusiastic throughout the interview and do not forget to smile. People can hear that in the tone of your voice.
- Speak clearly and slightly more slowly than you would normally do.
- Make sure you listen carefully for the cue as to when it is your turn to speak. However eager you are, avoid the temptation to interrupt.
- Take your time answering but acknowledge the question so the interviewer knows you are thinking about it. You could say something like 'That is an interesting question ...'.
- Try to use the caller's name, in whatever format they introduced themselves, to personalize your call.
- At the end of the interview do not forget to thank the interviewer for calling and giving you their time. That will be the equivalent of the handshake you would normally give.

After the interview, if you have not recorded it, take time to make notes about the questions you asked and the answers you gave. Write a follow-up thank you letter, and in that letter make a note of anything that you feel it is important to clarify or emphasize.

 Activity

In your groups draw up a list of the kinds of questions you now know employers might ask. Take it in turns for one of you to go out of the room and be interviewed by mobile phone. The rest of your group can listen on loudspeaker and can give feedback at the end of the interview.

Online interviews

To overcome the disadvantages of telephone interviews, that is not being able to see the interviewee, some employers use Skype, or some other program to talk to potential applicants in situations where it is not possible, or convenient, to meet in person.

As with the telephone interview, you can choose the environment in which you are interviewed. However in this case, as the interviewer can see you and your surroundings, you will need to make sure that what they see is appropriate. For instance, if you are in your home environment make sure there are no distractions such as a TV flickering in the background or inappropriate posters in sight of the camera. It is also advisable to close other programs, such as email, to avoid being distracted by them.

Sound quality with webcams is not always good so try to speak extra clearly. In addition, your interviewer may be in a busy office environment so if you do not hear something clearly, ask for clarification.

Make sure you have everything you need in front of you because, unlike a telephone interview, it will be obvious if you have to get up and look for something. In other respects, your interview will be similar to an in-person interview: as you can be seen, you must dress smartly and be seen to be engaged and interested.

 Activity

If you have access to Skype, repeat the exercise above and note the different issues this raises. Discuss how you can ensure that you perform to the best of your ability in an online interview.

Second interview skills

Being invited for a second interview means that you have obviously impressed your potential employer, which is good news. However, you will not be the only one who has impressed them and this time, you may have to work even harder to impress. This second interview is your chance to build on the good parts of your first interview, and to strengthen any areas you feel you could have dealt with better. If you have taken the time to reflect on your interview in a learning log, this should provide a basis on which to build.

First, try and remember all the questions you were asked, and your answers. Do you remember the response your answers elicited from the interviewer(s)? Hopefully you will have kept a learning log following your interview and reflected on it. You are unlikely to be asked exactly the same questions, but you may be probed on areas where your answers did not give the interviewer sufficient information. Consider how you could expand on your answer giving better or clearer information, and remember to use the STAR technique described above to give examples. You may also be asked more questions on how you would deal with specific situations which they know might occur in the job. The clearer you are about the job description the better you may be able to anticipate these questions.

There are still likely to be surprises. More than once Grace was asked, as she concluded some of her answers: 'In hindsight, is there anything you would change about the way you dealt with that situation?' This might throw you, but remember to keep calm and if necessary take a few seconds to think about your answer. It is actually an opportunity to show how you can reflect on experience and adapt your behaviour accordingly.

You may have observed at your first interview that people are dressed in a casual manner. However, it is still safer to dress smartly for your second interview. People can only be impressed that you are keen enough to put on a good appearance for them.

The advice to be prepared and to have researched the organization is just as important as before. The more you know about them, the better you will be able to tailor your answers to fit their ethos and requirements. Bear in mind that in the interval between the first and second interview, things might have happened to the organization or the sector in which they operate, which it is important to be aware of. Once again, professional or trade journals and news services can help you here, as can any contacts within the company or industry.

Linked to the extra research you do prior to this second interview is the fact that you will probably be expected to ask more, and deeper, questions than at the first interview. Be prepared with several meaningful and penetrating questions in case some of your questions are answered before you get the opportunity to answer them. You may be meeting new potential colleagues in which case this is an ideal opportunity to ask them some relevant questions.

It may be possible to ask a question relating to the presentation topic you have had to present. For example, if the presentation required you to 'Explain what you see as the challenges and opportunities of this role' (a fairly common example), you might ask, at the end of your interview, 'What do *you* see as the main challenges?'

It is likely that this second interview will be to see how well you will fit in with and relate to some of the people you may work with. If you are not given any information about what form the interview might take, it is always worth asking if it is possible to be informed of the format of the interview.

At the second interview you may also be introduced to people who you will work with, perhaps in their work setting. This is where your communication skills, including listening, will play a big part. Asking appropriate questions and showing an interest in what your prospective colleagues have to say is a key skill. In fact meeting the people you are to work with and getting more details of what would be required of you is valuable for you, as it should serve to ensure that the job is as you envisaged it and therefore right for you.

Finally, at the second interview stage it may be appropriate for you to negotiate on prospective salary and conditions of service, so make sure you have given this thought beforehand.

 Activity

In Figure 1.3 we presented a graph showing 'Skills that managers most want young people to have when they start work' [see Figure 1.3 caption] (Woodman and Hutchings 2012).

When applying for jobs it would be as well to bear in mind the importance employers place on these assets. Having now read the above chapter, put ticks in the boxes in Table 10.5 to indicate at what stage you might be able to demonstrate the relevant assets. You could additionally add an 'x' to indicate how employers might assess you. There may be more than one method for each asset. Remember these when applying for your jobs.

Table 10.5 Demonstrating your graduate assets.

	Application form	Interview	Assessment centre	
			In-tray exercise	Team exercise
Creativity/innovation				
Literacy/numeracy				
Teamworking				
Reasoning/comprehension				
Problem solving/analytical thinking				
Communication skills				
Commercial awareness				
Management skills				

Conclusion

It has often been said that looking for a job is a job in itself. In this chapter we have stressed that this is the stage when all the work you have done previously in terms of researching employer requirements and developing and reflecting on your skills and aptitudes should pay off.

There are many places in which employers advertise jobs and your university careers service can help you identify many of these ways. However, you should also make yourself traceable and interesting to potential employers.

Being shortlisted for a job is the culmination of all your hard work. There are many ways employers use to select staff nowadays, but whichever way they use, the key from your point of view is preparation and practice.

What do you think now?

Having worked through this chapter, have you revised your opinion on any of the questions above? How about your classmates? Have any of them changed their opinions?

 Project

Your tutor will give you further guidance on how to work through the project tasks. The material we provide below summarizes the tasks and links them to other parts of this book.
Your group should do a final evaluation of:

- The team stage you think you have reached.
- How well you have managed work allocated to the group.
- How you have dealt with conflicts.
- How well you have managed your time and achieved your aims.
- How well you have answered the question: What do employers want and how can you give it to them?

What evidence has this team process provided you with for your PDP?
Have you written this up in the form of competence statements, using the STAR approach (see Chapter 9)?

Further reading

EMC (2009) *100 Job Search Tips from FORTUNE 500 Recruiters*. <http://uk.emc.com/collateral/article/100-job-search-tips.pdf> (accessed January 2013).

National Careers Service <https://nationalcareersservice.direct.gov.uk> (accessed January 2013).

Shavic, A. (2008) *Psychometric Tests for Graduates*, 2nd Edition. Oxford: How to Books.

11 Career management: creating opportunities

◉ Learning outcomes

By the end of this chapter you should:

- Be familiar with and have considered alternative routes for seeking graduate employment and enhancing your employability, including:
 - Applying for jobs on spec.
 - Publicizing yourself through personal contacts and a range of networking methods.
 - Temping.
 - Offering yourself on trial.
- Have considered ways of going it alone including:
 - Entrepreneurship.
 - Freelance work.
- Be aware of the value of:
 - Staying positive.
 - Using a mentor.

What do you think?

- How easy is it to stay positive in the face of rejections?
- Is applying for advertised jobs the only way to seek employment?
- Is it worth the effort to find a mentor?

Case study

Pat Bensky and Balinder (Bal) Walia are both unequivocal about the fact that they are entrepreneurs. Although there have been times in their lives where they have worked for other people, they have usually simultaneously been working on developing products of their own, mainly in the field of software development.

In 2012 Pat's CatBase (database publishing solution software) company merged with Balinder's Tenthmatrix Information Systems company. Pat took over as Managing Director, with Balinder moving to the position of Chief Technology Officer.

Between them Pat and Bal offer a range of solutions alongside CatBase including Jobshout (a cloud-based job board and candidate management system, originally conceived by Bal), custom website programming and development, bespoke development in 4D software, troubleshooting, and training.

As well as developing software, Pat is a writer and editor and has had books and magazine articles published, while Bal has skills in project management, mentoring, and is adept at understanding business problems and bringing the right technology to bear for their solution.

You can learn more about Pat and Balinder's companies through the following links. They can also be found on LinkedIn.

- <http://www.tenthmatrix.co.uk/>
- <http://www.jobshout.com/>
- <http://www.catbase.com/>

Introduction

Through much of your university course, job hunting for your first graduate job may seem a long way away. The idea of this chapter is to provide you with some food for thought and help you to keep your mind and options open when it comes to looking for employment. Developing a career focus now and throughout your degree will improve your chances of finding your first graduate job. Knowing that you are taking steps towards ensuring your employability in the future is a good way to focus and remain positive. We also recommend that you revisit this chapter later in your course to remind yourself of some of the ways in which you can help yourself even in a difficult job market.

In Chapter 9 we explored applying for advertised jobs. However, according to Tom Millar – a Director with staffing and recruiting company Reed whom we mentioned in Chapter 2 – many jobs are 'hidden' in the sense that employers do not openly advertise them. According to Tom:

> Academics have researched and quantified hidden jobs – 8 out of 10 are hidden, not advertised, not in the media, not even on companies' internet sites as companies don't want to be flooded with applicants. They are generally filled through people with networks. Graduates have generally got less sophisticated networks than job changers so that is a particular disadvantage to them.

Applying for jobs on spec

Tom Millar believes that simply applying for published jobs means that you may be missing many opportunities. He believes that 'These two things – mindset and accessing the hidden market – will increase the probability of getting a job.' We discussed the importance of mindset in Chapters 1 and 2, and through your experience and reflections on project work we hope you are building a strong mindset and are able to demonstrate this to employers.

Tom also pointed out that networking is key to uncovering hidden jobs, and we will discuss the importance of this further in this chapter. The first thing to do is to investigate which

employers are operating in the area where you wish to work. You need to find out as much as possible about their business and you definitely need to trace the name of the decision-maker. A visit to your library will give you access to business directories that detail local companies, and you need also to make sure you know about current trends in their particular industry.

You can then write to employers. Start by succinctly explaining the purpose of your letter or email, and provide evidence of the skills and attributes that you believe they will find most useful. Indeed, in a speculative application it is crucial to make clear what you can do for the employer, not what they can do for you. Draw attention to the particular proposition you can offer in terms of your main strengths.

It is possible that employers may be advertising jobs which are not within your reach. You can, however, learn how the employer presents themselves from these adverts. You may also spot the names of the people in departments in which you are interested. This is important because when you finally apply for work, do not do so unless you can direct your application to a specific person, preferably someone you have a contact number for so that you can follow it up. If you decide to apply by email you might bear in mind Louise's advice, which is to follow up an email application with a well presented postal one. Do your best to find anyone who works at the company and ask them about their company, what the company believes in, and who are the key players that you might approach. If this sounds unnatural, remember that it is something you can do as part of everyday networking, which we discuss below.

One final piece of advice. Should the employer offer you something less than the full time job you wanted, for example part-time, or a short-term contract, it may be worth at least considering that option. After all, as mentioned in the 'Temping' section, if you are in the company in any capacity you have a perfect opportunity to learn more and to prove your worth. You will also be developing experience and this will make you more attractive to other employers.

 Activity

Using some of the methods suggested above, find an employer you might eventually want to work for. Carry out thorough research on them. Identify what you have to offer them and consider how you could provide evidence of this.

You could turn this activity into a real-life application for part-time work, work experience, or an internship.

Creating opportunities through networking

Networking is a very important skill, both in your future career and when it comes to job hunting. In Chapter 4 we mentioned work by Kelley and Caplan (1993) who found that among other things, 'star performers' excelled in their ability to build and draw on both formal and informal networks of people who can be called on to help solve problems and accomplish both personal and professional goals. Often such help comes in the form of information that is passed on and to which one would not usually have access. Spending time and effort building social networks can be seen as a kind of investment that results in your having 'social capital', which Trish Boyles (2012, p. 48) refers to as 'an intangible resource created through social relationships that creates access to both tangible and intangible resources through knowing others'.

However, many people lack confidence when it comes to using networks, or are unsure how to build, and gain benefit from, them. It is not uncommon to hear, for example, 'But I don't know anybody!', meaning that the person does not know anyone in the kind of position that might be able to help. To some extent, this may be to misunderstand how networking works. Andrew – the graduate we introduced in Chapter 9 – explains that the benefits of networking do not happen overnight.

> A lot of people now look for an immediate, positive effect from something but it does take time, and you do have to keep doing these kind of things, because ... it's like a spider: a spider doesn't build a web from one string. As you go round and round and round again you'll be able to find something. So networking is very important and keeping up good relationships with the people you meet I think is also important.

Andrew's comment is in line with an important lesson to learn about employability, which is that if you are serious about eventually gaining graduate employment, you must be proactive, doing things you would not usually do, or have not done before. In the context of networking, this means seeking out and talking with people you would not normally have contact with.

If you are wondering how to go about networking, it is actually quite likely that you will have done it already, but may not have thought of it as such.

 Reflection

Think of when you were choosing the course and university where you now study, and when you were going through the application process. Did you talk to anybody about it? What kind of people were they? Was it easy to approach them? How did it help?

The people you spoke to will most likely have been people you already knew quite well, such as family members, friends, or teachers. Maybe they were friends in the same situation or perhaps they were people you knew who were already at university. This was an example of using your network of friends and acquaintances to gain information or advice that might be helpful to you and, essentially, that is what is meant when people talk about networking.

When you were preparing for university, the kind of networking you did may not have seemed difficult because you knew all the people already. Being an effective networker, however, means being good at establishing positive new connections with people you have not met before. In the context of planning for your future employment, this may seem especially difficult, not least because in the course of your day-to-day activities, you would not normally meet the kind of people who can help. Getting to meet such people therefore means that you have to be proactive and involves doing things that you would not usually do. This can include looking out for and attending employer visits to your university, such as graduate fairs and information sessions on placements, and also conferences or other networking events. It also means looking the part when you attend such events, in other words making an effort to look smart.

Andrew comments that students can find it hard to interact with new people, especially if they are not of their peer age, but he has some suggestions on how to get into conversation with people and offers a few reminders of why networking is important.

Introduce yourself to them, tell them a little bit about yourself, and have a simple conversation just like with anyone else, something that is not difficult. Some people may not necessarily see the value of networking and, if you do network, it may not have direct success, but the more people you know, the more you're going to know, if that makes sense. ... I mean, it may not get you a job, but you may get more industry insights, you may get some inside information, some tips on who's employing and who's not, etc.

Pushing yourself to talk with people you would not normally meet might seem awkward at first, but it will help to develop your social confidence, and this is important at the interview. Working as a volunteer, Andrew had access to various networking events and conferences and is convinced that this helped him to present himself positively.

[T]his is what gives you the confidence so that when you do apply for a job and you do get an interview and you're talking to someone you've never met before, they're like 'Oh this person is so relaxed and so comfortable around people they don't know, they can work here.'

As we have been keen to emphasize its importance elsewhere, listening is also crucial because much of the value of networking lies in the knowledge and insights it can give you. For example, a person may tell you something that does not mean much to you now but at some point in the future it turns out to be useful to know about. Perhaps they tell you that they work in a particular field and later, when you happen to find yourself applying for a position in the same field, you can then get in touch with them again and they might give you information or advice that gives you a significant edge over the competition.

As well as listening, it is important to go to networking events with a clear plan of what you want to achieve, with questions at the ready, and you should avoid simply going along and drifting around without a clear purpose. Like Andrew, Grace was proactive in building up the network of people that might help her and this included talking with people at graduate fairs, where she made sure that she was well prepared.

I prepared a list of questions, and I was only going to visit specific companies, so I made a list of who I was going to talk to first, mainly asking graduates who were on the scheme questions about the job itself, and also about how to stand out, what sort of things did they think they'd done to stand out, ...

There are so many applicants for every position (and) it's really difficult to know what the employers are looking for, so I wanted to ask people who had already got onto the scheme what they thought was the most important.

Virtual networking

Much of this advice, and the points we made in Chapter 9 about managing your digital identity, applies also to virtual networking. We have mentioned LinkedIn elsewhere in this book as its main purpose is to allow people to network. However, simply joining LinkedIn is not sufficient. It is important to keep your profile up-to-date (because people can 'search for talent'). It is also worth searching through Groups to see if there are any that may help you make contacts in your chosen area. Being proactive in 'Endorsing' your contacts' areas of expertise and asking them to endorse yours will help build up stronger online relationships.

 Activity

In each row of Table 11.1, identify people you already know, or know of, who might be able to give advice or information about the activities listed on the left. You might know the actual name of the person or you could simply indicate their position/role and contact details.

Table 11.1 Building up your network.

Employability boosting activity	Person/people I need to talk to or contact about this (name of actual person, or position such as tutor, careers staff, etc.)	Actions needed to add this person to my network
Career planning		
Societies to join		
Part-time jobs		
Promotion possibilities (if already in work)		
Holiday internships		
12 month internships/ placements		
Other		

Temping

Obtaining temporary work can be beneficial in several ways.

- It keeps you occupied (and paid) while looking for a permanent job.
- It gives you more experience to add to your CV.
- It can clarify for you what you really do and do not want to do.
- It helps you deal with new situations and new people confidently.
- It can provide a good 'foot in the door'.

There are many employment agencies on the high streets, also with an online presence, and it is certainly worth exploring these possibilities. Gordon Stribling, who started out working as a 'temp' after graduating, has written about his experience in 'Guardian Jobs' (Stribling 2010), and he mentions some points to remember when seeking temporary work. Because employment agencies receive hundreds of CVs every day, he advises against sending them unsolicited CVs. Instead, he suggests telephoning them in response to a specific vacancy that looks appealing. You'll need to be prepared to explain your suitability and hopefully they will ask you to email them your CV. He also recommends making yourself a familiar name – and face if possible – by keeping in regular contact with the agency, although not so much that you become annoying!

One of your authors is a big fan of temping and has done it on and off for many years to keep her core skills up-to-date. It has led to many opportunities that would not have been obvious in other circumstances. If you approach temporary work with enthusiasm and show that you are hard working, trustworthy, and self-reliant, an employer may well decide that you are too good to lose. After all, the alternative for them is a lengthy interview procedure, which still leaves them with an unknown quantity.

Entrepreneurship

Our book focuses mainly on helping you to understand and develop the attributes needed for employability in general, with an expectation that most university students will aim first for employment rather than starting up their own enterprise. However, some people find the idea of having their own business very appealing, and even if that would not normally apply to you, the difficult employment market might make you consider such a possibility. In general, entrepreneurial activity tends to be undertaken by people aged 35–54, after they have first gained significant work experience (Boyles 2012), so this may be especially relevant for more mature graduates. However, there are signs now of a new trend for younger people setting up in business. Indeed, according to an article in the *Sunday Times Magazine*, 'This is a boom time for Britain's young entrepreneurs', and in the two years after the start of the recent financial crisis, start-ups by young people increased by 15% (Wolfson and Pannack 2013, p. 46). The *Sunday Times* article suggests that there are several advantages to being young when you start your first business. These include starting from a small base, with relatively low investment costs and associated risks, and having strong IT skills and knowledge, which can give the young advantages over people who did not grow up in the digital age.

Moreover, there are many enjoyable aspects of having your own business. Pat and Balinder find that it brings them real satisfaction in being able to be creative and do things that they are passionate about. Indeed, they argue that you can only be successful if you *are* passionate about your business. They also say that it is great not having to answer to other people, and that it is possible to surprise yourself by your own success. Finally, if you are successful, you can earn a lot more than if you were employed and on a fixed salary.

However, setting up your own business is not something to be undertaken lightly, and there are downsides. In addition to the potential risk of losing significant sums of money, it can feel lonely having to make difficult decisions with nobody more senior to take responsibility, and it can mean having to work very long hours.

Being successful in business appears to require knowledge, and also a number of important mindset qualities and skills. We therefore start this section by exploring some of these characteristics before identifying some of the key things you will need to do, and to avoid, if you are seriously considering starting up your own business. Our aim is first to help you understand the kinds of skills, qualities, and knowledge required by successful entrepreneurs, as well as the processes involved in identifying business opportunities and turning these into actual products and services. Secondly, understanding these things will also help you to identify learning needs if you decide that being an entrepreneur is the right career choice for you.

As for really knowing how to run a business, this short section can only give a brief overview. At the end of the chapter we offer some suggested further texts to read, and would

advise anybody who is seriously interested to do a lot more reading and thinking before taking on the financial risks involved in starting up their own business.

 Discussion

With two or three others, answer the following questions.

- What do you think are the characteristics and skills needed to be a successful entrepreneur?
- What is involved in running a successful business?
- Are there any things an entrepreneur should avoid doing?

We will start by discussing some of the literature on entrepreneurship. In this, there appear to be conflicting points of view. On the one hand, entrepreneurship appears to involve having certain kinds of knowledge, skills, and mindsets, with particular emphasis on competencies relating to how people think and process information, and how they act and interact with others. However, a problem with thinking that entrepreneurship requires such a complex set of fairly high level competencies is it may give the impression that being an entrepreneur is only for certain highly gifted individuals. Although it may be true that successful entrepreneurs do *become* special in a number of respects, it is also likely that most start out with only partially developed competencies and may even lack some altogether!

In fact an entrepreneur's ability to spot and develop opportunities may not necessarily be dependent on having any remarkable qualities and skills, but may simply be related to some unique prior knowledge that they already possess. As each of us possesses different knowledge, such an argument suggests that becoming an entrepreneur means tapping into our prior knowledge and that if we can learn to do this, more of us could become entrepreneurs.

Cognitive, social, and action-oriented competencies

The first of the above arguments suggests that entrepreneurship involves a balance between knowledge, skills, and mindset, which has similarities with the qualities needed for employability.

Boyles (2012) carried out a review of the literature and her analysis revealed three main 'entrepreneurial competencies' as follows:

- cognition;
- social;
- action-oriented.

 Activity

If you are not clear what cognition is we suggest you look it up in a good dictionary, for example Oxford Dictionaries online.

Boyles explains that **cognitive competencies** include such things as being alert to and able to recognize business opportunities, and also having a creative mindset which she refers to as 'inventive thinking'. As well as being able to create something new and original, inventive thinking also involves high level thought processes which permit entrepreneurs to apply 'analysis, comparison, inference and interpretation, evaluation, and synthesis to develop new solutions to complex problems' (p. 46).

Social competencies are needed to co-ordinate colleagues and employees, and for engaging with staff, business partners, and customers in the different social processes involved in running a business. They also include having strong 'social capital' of the kind achieved through networking, as discussed earlier. Strong social skills include being able to:

- assess other people;
- adapt to different kinds of people in a variety of settings;
- give other people a positive impression of yourself;
- have good powers of persuasion.

Entrepreneurs' **action-oriented competencies** involve being able and willing to initiate actions, which involves:

- setting goals;
- planning to achieve those goals;
- monitoring and adapting activity in order to be successful.

Boyles' also suggests that entrepreneurs need to possess strong self-management skills and self-efficacy, and to take personal responsibility for achieving success.

In her analysis Boyles linked the above competencies to 'a set of 21st Century Skills, Knowledge and Abilities'.

Table 11.2 may help to clarify for you the different activities you need to undertake as an entrepreneur. It will allow you to consider whether you have the necessary skills, and to plan how to make good any deficiencies.

Table 11.2 Knowledge, skills, and mindset for entrepreneurs.

	Cognition	Skills	Personal qualities/mindset/attitude
Thinking/ knowledge/ understanding	Inventive thinking Business management: business planning; accounting; marketing	Identifying opportunities; critical analysis; comparison; synthesis; creativity; innovation	Alertness to opportunities; confidence; future oriented; tolerance for ambiguity/ uncertainty; tenacity
Acting		Initiating, planning, monitoring, adapting, completing organization skills; ability to apply knowledge	Moderate risk taking; high energy; achievement oriented; flexibility; tenacity
Interacting		Organization; leadership; oral and written communication	Flexibility; tenacity

Prior knowledge

As mentioned in the introduction to this section on entrepreneurship literature, the above set of competencies might appear to suggest that only certain types of people can become entrepreneurs. However, this idea is contested. Indeed, at the level of the individual, there do not appear to be significant, consistently measurable differences between the attributes and behaviours of entrepreneurs and other people (Busenitz and Barney 1997, cited by Shane 2000). Shane and other authors such as Tang and Murphy (2012) also contest emphasis placed on entrepreneurs' superior information seeking and processing skills, which some argue allow them to find information that others would miss.

Drawing on Austrian economic theory (e.g. Kirzner 1997), Shane argues that it is the information that individuals already possess that makes it possible for them to recognize business opportunities, rather than their information processing skills. He suggests the latter are only of use if an individual is already aware that she or he lacks particular information. However, this is different to the process of discovering business opportunities, which Kirzner suggests is more a matter of surprise. Shane argues that the ability to notice opportunities depends on what individuals happen to know already, their *prior knowledge*. In the course of their upbringing, education and work, each individual's prior knowledge is different, and this means that

> [I]ndividuals who have developed particular knowledge through education and work experience will be more likely than other people to discover particular entrepreneurial opportunities in response to a given technological change.
>
> (Shane 2000, p. 465, citing Venkataraman 1997)

These different views on entrepreneurship have important implications, not least because they suggest that many individuals are capable of spotting opportunities, not just a few. What counts is their ability to draw on their experience and knowledge of life and of problems for which an innovation will provide the solution. Such prior knowledge can come from being a customer or from one's experience of work, serving people or knowing how particular markets operate.

In Figure 11.1, we have attempted to summarize the processes by which your prior knowledge can allow you to discover business opportunities and will also shape the way that you envisage related innovations.

Characteristics of the entrepreneur: what people in business have told us

When we asked Pat and Balinder about the qualities that entrepreneurs must have, they emphasized four main points.

The first two qualities are perhaps two aspects of the same thing: willingness to work hard, which means being prepared to work long hours every day, including weekends; and something which Pat calls 'keep-at-it-ness', that quality we also emphasized in Chapter 2 and which is an important part of self-efficacy, or 'grit'. Indeed, having the tenacity and mental strength to keep motivated and to keep trying after experiencing difficulties or setbacks is a key mindset quality needed for employability more generally, as well as being crucial for entrepreneurship.

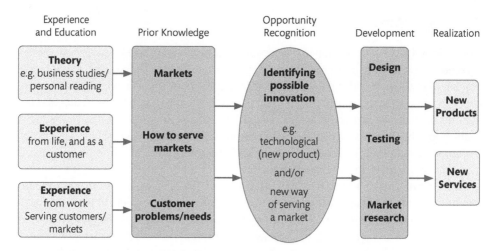

Figure 11.1 Entrepreneurial discovery of opportunities, leading to new products or services (drawing on Shane 2000, Boyles 2012, and Tang and Murphy 2012).

They also stressed how important it is to be very focused. This means being very clear about what your business is offering and what it is not, so that you channel your energy, time, and finances productively and efficiently.

The final quality, emphasized by Balinder, was humility. Intuitively, one might imagine that entrepreneurs must have strong self-belief, so this might come as a surprise. However, humility and self-belief are not necessarily opposites. What Balinder meant was that entrepreneurs should never assume that they know best, or that their products or services must be better than anyone else's, but should always be ready to listen to their customers and be alert to developments that mean they need to change what they are offering or the way that they do this. Showing humility suggests that although it is undoubtedly important to have strong self-belief when setting up and running a business, you must never think you know better than your customers, or that your business is somehow immune to changing market conditions.

Things to do/points to avoid

Helpful advice on points to avoid when running your own business is provided both online and in many text books on entrepreneurship (e.g. Zimmerer and Scarborough 2005), and we refer to several of these below. Pat and Balinder also offered us several pieces of advice that it will be as well to remember.

Marketing

Pat and Balinder started by emphasizing that 'you've got to have the right idea', and much of their subsequent advice relates to different elements of the marketing mix which it is crucial to get right. You will no doubt come across the marketing mix in some of your other modules, but Figure 11.2 provides a summary.

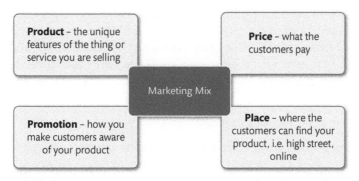

Figure 11.2 The marketing mix.

Place

Deciding on where to locate your business is a key consideration. When Pat and Balinder were working on their own, at some time they each worked from home, and this is where many businesses first start. There are a number of advantages in this, not least of which is the relatively low cost of office space, which typically can be located in a spare bedroom, in a converted loft or garage. However, there can be many distractions in the home, and it may not be the ideal place to bring customers if it is necessary to meet with them. When they went into business together, Pat and Balinder decided to rent an office in a purpose built office building in a business park, where their business not only benefits from high-quality IT infrastructure, but their rent also pays for the added benefits of reception staff and parking facilities.

Price

A common mistake is to think that you must offer your products or services cheaply, without really thinking through the implications. If you look at the way people actually behave, their purchasing decisions are not based purely on whether products and services are the cheapest on the market. If this were the case, they would not eat out in restaurants, or buy more expensive brands of car, watches, or practically any consumer product or service that you care to think of. Pat and Balinder make the point tellingly:

> Don't undersell yourself. If you undercut everybody you may get the custom but you won't make any money and your customers will move on to the next person who undercuts. So price yourself properly.

Product and promotion

As Pat and Balinder's first comment made clear, it is crucial to have the right idea, and to develop this and promote it, you must have a sound understanding of who your customers are and of their needs. Market research is therefore very important, and although family and friends may be a useful source of feedback, the research methods you use must be rigorous because otherwise the information you gather is likely to be unrepresentative.

If you intend to run your own business this is an area you will need to research further using the critical skills discussed in Chapter 3 to expand your knowledge. As a starting

point, we have presented the basic 4Ps of marketing, and you should also consider three more Ps (packaging, positioning, and people, e.g. Tracy 2004). In addition, a more customer focused way of looking at the whole issue was devised by Lauterborn (1990), namely the 4Cs (consumer, cost, communication, convenience). You will be able to decide for yourself the model you are most comfortable working with.

Developing a relationship with your customers

Pat says that she likes to think of customers as her friends. This does not mean that they are like 'best buddies', but seeing them as friends means that both sides develop a sense of commitment about the relationship. Because she sees them as friends, she really wants to understand what makes them tick, and what their needs are and she makes every effort to fulfil these and not let them down. In return for such commitment, her customers remain loyal.

In this brief section, we have only scratched the surface of what it takes to be an entrepreneur and, as we said at the start, it will be important for you to undertake a good deal more reading and thinking before taking the first steps towards having your own business.

Freelance work

In many ways, freelance work is a form of entrepreneurship in that it involves being self-employed. It generally refers to an individual working on specific projects for various companies, and usually involves offering some kind of specialized service. The word was originally made up of two words and referred to medieval mercenaries who put themselves up for hire, along with their lance (a kind of weapon), to whichever army was willing to pay for their services. There are a number of benefits of employing a freelancer for an organization, including being able to take on work for which they may not have staff with the right qualifications or experience, and get it done by a qualified individual without the need to enter into a long-term commitment.

If you are thinking of offering your services in this way, there is a lot of information available on the internet. A good place to start is on the Prospects website (www.prospects.ac.uk) where, under the 'self-employment' section, they have many case studies and articles about freelancing. These include a feature article by Chloe-Louise Lloyd, who gives advice drawn from her experience of freelance work after she graduated (Lloyd 2012). She suggests that it is important to establish a clear working space and also business hours, so that family and friends understand when and where you are working. In particular she emphasizes how important it is to use your social network, and to develop your contacts. This can include keeping in contact with teaching staff and fellow students from university, as they can be a good source of industry information, possibly passing on useful contacts and information.

Offering your services for free on a trial basis

One final suggestion, made by Tom Millar of Reed is to consider offering an employer your services on a short 'free trial' basis. This would be a sign of your confidence in your ability and could provide you with a good way of getting into a company and showing

what you are worth. So far in our interviews with students, we have not come across anyone who has done this, but if you should do so successfully we would really like to hear from you.

Visualizing success

In the current, difficult employment market, the process of job hunting will include rejections for almost all graduates. After all the time and effort that each application requires, this can be very disheartening. Indeed, as each month goes by and employers simply do not get back to you, or they reject you at the final interview after you have successfully made it through earlier stages in the selection process, it can seem as if things will never turn out the way you had hoped. So how do you keep positive in the face of such rejection?

One way is to adopt a method used by athletes who 'visualize' themselves achieving their goal. Costas Karageorghis (n.d.), who is Reader in Sports Psychology at Brunel University, suggests that you start by imagining a pool of light from a powerful spotlight shining on the floor in front of you. Then, thinking about an occasion when you have excelled in some way, picture yourself inside the circle performing brilliantly and use all five senses to capture the nature of such success: what it smells, tastes, looks, sounds, and feels like. He recommends that you should do this several times so that you can reproduce the same feelings when you feel that your confidence is ebbing. He also suggests that certain types of music can influence your mood positively, as can being with successful people, as this can help you believe you can be like them.

Carlotta Olason – who we interviewed at the Sickle Cell Society – also believes in the power of visualization and how what we imagine affects what actually happens, because it can make us give up, or put in extra effort:

> [I]f an individual knows the end of what they want, they reach there. So, for instance, if you think of Usain Bolt, he has his own mind control, so that he knows he's going to win gold, so if an individual has the perception, or has this mindset that they may not get the job ... they won't get the job. ... And they see themselves being rejected. And so your own visualization, your whole perception of you, the real you, your own failure, you've seen it, it's going to happen. ...whatever you perceive is what you're going to get. ... whatever you continue saying is what is going to happen. So a lot of people are like 'Oh I won't get it' – then they won't get it, won't put in that effort. (However,) If you say you're going to get something, you're going to get it.

Finding a mentor

Another way to keep positive is to find yourself a mentor. A mentor is someone with relevant experience who can help by giving you support and impartial advice on your progress towards employment. Mentors can help you think through your job seeking methods and see what needs changing in order to achieve a better outcome.

As a first step check whether your university has a formal mentoring scheme that you can use. If not, then you may have to be more proactive and try to find someone yourself. Your

search could include your family, family friends, acquaintances, and your neighbours. Do any of them have some experience in the area you want to go into? If so, then it may be worth approaching them and asking if they would take you on as a mentee.

You may also find a mentor through digital channels. There may be someone who you have encountered on LinkedIn, for instance, who is working in the area to which you are aspiring. In fact, generally, ask around and keep your eyes and ears open for someone you feel you could relate to well in a mentoring situation.

The main thing is that you should get on well with your mentor. It is important that in a mentoring situation both parties show respect to the others and have clear ground rules about how, and how often they will communicate. Having said that, mentoring need not be an arduous process for either you or your mentor; perhaps a meeting once every few weeks over coffee to report on progress and clarify your thoughts and the occasional phone call when you have a specific question.

 Activity

We suggest you try some of the above suggestions and get yourself a mentor. If you find someone to mentor you who is not used to the process, draw up a set of guidelines for them.
When you have mentoring sessions, make sure you keep a log of what you did and what you learnt and what you needed to learn.

Your mentor may ask you lots and lots of questions, not necessarily because they need the answers, but because in that way they can help you clarify your thoughts. They cannot take action for you, but they can guide you into taking the right action. In fact the essence of mentoring is to help you learn more about yourself and help you focus on taking action that will lead you to your desired outcome. If mentoring is to work well, you must keep an open mind and avoid finding excuses for what you are doing less efficiently than you might. Try and eliminate the word 'but' from your vocabulary, because finding excuses for why you are not succeeding keeps you where you are, rather than moving you forwards to something better.

Even if you are unable to find a mentor through the above methods, there is nothing to stop you arranging to have a peer mentor, perhaps a student who is nearer to completing their university course. We have encouraged students to set up such groups with good results in the last couple of years. The mentee gains from the experience of a more experienced student, and the student as mentor gets valuable experience that can be used as evidence to employers. As peer mentors you can listen to each other's problems and help assist in finding solutions. Peer mentors can help with motivation as they understand the highs and lows of working for a degree, and if they are in a later stage of a course they can flag up possible problems.

In short, a mentor can act as a sounding board and encourage you to take action. What a mentor is not, however, is someone who does things for you. They are not your parents, teachers, or even counsellors. They are people who are interested in your welfare and will help you to greater heights, provided you treat their input with respect.

What do you think now?

Having worked through this chapter, have you revised your opinion on any of the questions above? How about your classmates? Have any of them changed their opinions?

 Project

Your tutor will give you further guidance on how to work through the project tasks. The material we provide below summarizes the tasks and links them to other parts of this book.

You may by now be preparing to apply for an internship, a summer job, or some other work experience.

Reflect on how successful your research into the possibilities has been concerning:

- How ready you are now
- How good your CV is becoming
- How good you are at tailoring your letter of application towards specific job and person specifications
- How much evidence of the employability assets as identified by your group you have gathered

Discuss these issues with your mentor if you have found one. If not discuss them with someone else you trust.

Further reading

Chaston, I. (2009) *Entrepreneurial Management in Small Firms*. London: Sage.

Down, S. (2010) *Enterprise, Entrepreneurship and Small Business*. London: Sage.

Longenecker, J. G., Moore, C. W., Petty, J. W. and Palich, L. E. (2006) *Small Business Management An Entrepreneurial Emphasis*. Mason: Thomson South-Western.

Website

For a general introduction and ideas for getting started, see Jeanne Holden's 'Principles of Entrepreneurship' <http://www.america.gov/publications/books/principles-of-entrepreneurship.html>, where you can access a useful series of one-page primers.

12 Into work: succeeding in the workplace

Learning outcomes

Have an awareness of the steps you need to take when you start your first job and to make the most of your potential, especially:

- The importance of making a good first impression.
- Understanding how the skills such as active listening, problem solving, time management, and emotional intelligence you are developing can help you in your first few days.
- The importance of asking clarifying questions when you are not clear about something.
- How you can demonstrate enthusiasm and keenness.

What do you think?

- Compared with your interview, how important is your first day?
- What is the best way to make a good first impression?
- What things, which were acceptable at university, might not be acceptable at work?

Case study

Ilona Motyer has recently started her second 'proper' job since leaving university, where she got a good degree in English literature. On completing her degree she took some time out to travel as she had not had a gap year. Ilona's first full-time/permanent job, as a teacher, was offered to her by her former school, which testifies to the good reputation she built up while she was there. However, she had many part-time jobs during and following her time at university including bar work, an admin job in an office, and shop work.

Ilona had not had a clear idea of what she really wanted to do when she left university, but after two years of teaching in Sussex she felt the need to return to London and found herself job hunting in competition with more recent graduates. She consulted her former university's careers website where she spotted her current job, and after three interviews she is now employed by a company that headhunts people for senior positions. After several months at work she is able to look back objectively at her first few days at work and share her thoughts and experiences with us. In this chapter you will read about Ilona's and also Anna's first experiences in graduate positions and so gain insights into what starting your first permanent job might be like (we introduced Anna in Chapter 1).

Introduction

You may wonder why, in a book on employability, we are concerned with what happens when you have already got a job. The answer to this is simple: there is a clear difference between getting a job (i.e. employment) and employability, which means continuing to be the person employers want in future. With jobs for life no longer the norm, you need to prepare not just for employment but long-term employability, which is a lifelong, ongoing process. So this first job – even it if is just a temporary job or a work placement – is the start of your career and ought to lead to something bigger and better. However, for this to happen, it is important to understand what is expected of you when you start work. Indeed, because employability also means remaining successful once you are in work, this means continuing to build the assets that impressed your present employer enough to offer you a job. In the first few days and weeks, you therefore need to approach your new job in a mindful and well organized manner.

To help concentrate the mind as you start work, your contract is likely to include a probationary period which allows your employer to give one week's notice if you do not meet expectations. The difficulties you faced obtaining your first job would then be even greater if you had to explain why you left your first job after such a short time.

Throughout this book we have been introducing you to the skills and assets that will help you find and ease you into your first job. In this chapter we will be reminding you of their relevance.

Building on experience

If you have previous experience of work, either paid or voluntary, you will know what starting work can be like. Perhaps your first few days at work left you feeling a little disorientated. Everything seemed new, you did not know anybody, and maybe your seating area, computer access, email account, etc., were still being sorted out. It may have felt that you had not really got anything to do and you might even have felt surplus to requirements.

 Reflection

Think back to the first few days at any job you have done. What did you find hard? What did you need to know? How did you make yourself feel useful?
You may have kept learning logs of these issues. If so, do take time to have a look at them.

How you react to the uncertainty of your first day will probably vary according to your personality and some of the cultural issues we covered earlier in the book. We hope that if you have real problems with change and uncertainty that you will be able to work on this during the rest of your course, so that when the time arises for you to start your first job you will be able to deal with it openly and confidently.

 Activity

Try some or all of the following to see how you feel about uncertainty and change, and to challenge yourself to find ways of embracing it.

● Do you usually sit in the same place for each lecture and tutorial? Try sitting somewhere completely different. Note how it feels to be in a different place. How uncomfortable are you? After you have done this a few times do you feel a bit better about it? Starting a new job will involve you being in all sorts of new environments so this might get you used to being 'out of your comfort zone'.

● Do you always try and sit with the same people in class or for coffee and lunch? Try joining someone else for a change. How did this make you feel? Was it interesting to talk to someone new? Do you remember that we have stressed how important networking is? This often involves approaching new people and finding things in common.

● Are your weekly activities pretty routine? Try and do one different thing each week. Perhaps go somewhere you would not normally go, for example eat in a different place, have food that is new to you, go to a gallery, theatre, museum you have not visited before, read a different kind of book, listen to different music. See how these changes make you feel. Does this innovative behaviour get easier with time?

Making a good start

Some things might appear too obvious to be stated but, as they say, you never get a second chance to make a good first impression, so how you start is crucial.

Table 12.1 lists key issues to bear in mind in your first few days.

Table 12.1 Making a good impression in the first days of a new job.

Do your homework	Remember all the research you did on the company prior to your interview? Make sure you refresh your memory on that, and do more research to update and add to your knowledge
Arrive on time	Just as you did for your interview ensure that you have your travel plans sorted. You may not always be working in the same place as the interview was held so make sure you have your route planned so that you are on time, or preferably early. Companies sometimes give a new starter a later start than the rest of the staff so that the people who will be seeing them have time to prepare. But whatever time it is, make sure you are punctual
Dress smartly	The people who you are working with on a day-to-day basis may not have seen you at interview so you want their first impressions of you to be good. You can observe how other people dress, or even ask about dress code, for future reference
Pay attention	You may be bombarded with information. This is not like a lecture where you can ask your classmates what you missed, or read up the lecture notes. Louise has this to say: 'When you are being asked to do something, try and understand yourself: are you a person who can verbally receive an instruction and remember it, and get it right or are you a person that really needs that in writing ...? If you know that you're not going to remember that, then always go round with a notebook and pen and write it down so that you get it right. If you're not sure of the instruction that you've been given, rewrite it and then run it past your manager again to make sure that you are getting the right message. ... (There's) nothing worse than going off in a direction and coming back with the wrong results or the wrong piece of work.'

Table 12.1 (*Continued*)

Be yourself – on your best behaviour	We mentioned this when discussing assessment centres but it applies equally well for your first few weeks in your new job. No one expects you to be something you are not (in fact if you recall from Chapter 7, 'congruence' is one of Carl Roger's three key requirements). However, you are now in a professional organization and you must tailor your behaviour accordingly
	Making this move from being a student to being an employee can be difficult. As Karl Palachuk points out, the 'other selves' we have been in our life 'were motivated by different principles and had different goals. They had a different purpose for living and a different image of themselves' (Palachuk 2012)
Read the literature	You will very likely be given a staff handbook or company manual, which will give you all the details your employers think you need. For example SupportPlan's (Chapters 6 and 8) Staff Manual includes such things as the company structure, benefits and entitlements, equality policy, discipline and grievance procedures, appraisal procedures, and so forth. Keep such literature handy so that you can refer to it
Listen and watch	The first few days and weeks are your learning time
	Listen to what people have to say. Keep your antennae alert for sub-currents, rivalries, etc., so that you can avoid them
	Use your active listening skills and emotional intelligence to tread a careful path
	Watch how people go about things and emulate what is good
Show enthusiasm	Lance and Tania, who we spoke to in relation to customer facing skills, had this as one of their key requirements of their employees. Employers can teach you all the skills you need, but only you can show the enthusiasm and commitment that will make you a valued employee. Indeed, it is part of the mindset which Ronan Dunne, CEO of Telefónica UK – otherwise known as O2 – told us is absolutely crucial
Start learning people's names as soon as possible	If you work for a large company you will not be expected to remember everyone's name straight away, but there is a limit to how long you can keep asking to be reminded as it suggests that the other person is not important
	Tips for remembering names:
	• Really concentrate when being introduced
	• Repeat the person's name 'Pleased to meet you James'
	• Try and use the name once or twice more during the conversation or at least at the end 'Thanks for all your help James'
	• In an increasingly global business world, you may find that the name is unfamiliar to you. Better to ask for it to be spelled out at this point than have to ask again later
	• Make a note of the name and role as soon as possible afterwards so that you can look it up. You could use Anna's tactic (see below) of putting the names in a seating plan
	• Check whether the company has an intranet with pictures and roles on it. You can then 'revise' the names of all the people you have met, and even get ahead of the game by learning the name of and recognizing key players whom you have not yet met

 Reflection

The above is a long, but not exhaustive, list. If you have parents and friends who are in full-time work, ask them what they look for in new starters and add it to this list and act accordingly.

Your first day

Some organizations have structured induction periods where new starters are paired up with a mentor and have a carefully planned programme which introduces them to everything they need to know. Ilona's first day seemed ideal:

> Normally my job starts at 8.30 in the morning but on that day we started at 10.00 o'clock and we were welcomed, they had a little breakfast for us ... with all the other research assistants and we had a little chat around the circle, you know: where did everyone come from, how long had they been in the organization and what's their job. ... I felt really welcome and it was nice that I started on the same day as two other people so I didn't feel all the pressure was on me. ... I met everyone in the office, had an introduction in to what the work would involve. All pretty casual, to be honest, and then we got to go home early on that day as well.

Other organizations may have a less structured approach. On Anna's first day:

> I was introduced to the team by my new manager. I met lots of new people. Everyone seemed friendly, but it was a quite confusing experience, as I couldn't remember all of their names, not to mention their positions. I was afraid to look foolish on the next day and not be able to remember their names, so I made myself a little list of everyone in the office: where do they sit and what role do they play in a team? I was really interested in the people with whom I would be working directly and with the management team of course.

Notice that, as we have suggested above, the issue of remembering names is one that is really worth addressing, as is familiarizing yourself with company policies, as Anna points out:

> I was asked to go through lots of policies, not all of them seemed to be directly relevant to my position, but I have learnt a lot from them about the organization and the relevant government regulations. My manager liked my enthusiasm in learning about the organization and processes.

We know from experience that students do not always read all the material presented to them but Anna's experience shows that this is a mistake. On the first day or two, if you are not very busy, reading the manual can show that you are still doing something useful. Even if you do not have time at work you should read it at home, as asking about things that are already explained in a manual wastes people's time and suggests a lack of interest.

To sum up, we asked Ilona and Anna (who do not know one another) to give us a list of Dos and Don'ts for the first day (Table 12.2).

 Reflection

Can you see any similarities in their advice? How will you make sure that you can put it into practice when you start work?

Table 12.2 Dos and Don'ts for your first few days: two graduate perspectives.

Ilona	Anna
Try to be cheerful and look approachable	Smile
I tried to dress smartly	Keep a record of the new stuff you learn
Just looking like you are engaged, sort of inquisitive, pleased to be there	Try and understand your role and your position in the team as soon as possible
Show you are keen to knuckle down	Be kind
People tend to give you the benefit of the doubt on the first day because you are expected to be a bit nervous	Show your enthusiasm
	Ask questions – the sooner you find out the answers the better and it's better to ask than to make a mistake
	Try and relax – everyone had their first day once
	Dress smartly
Points to avoid	
You don't want to be late	Don't be late
You don't want to look like things are boring you	Don't judge other people at your workplace

Ground rules

Work is not university. Rather than paying to be there you are being paid for your time, and employers have the right to expect you to spend all your time on your work. How explicit these ground rules are varies from company to company. Ilona's company appear to have a fairly relaxed approach:

> It was explained to us, I guess, a kind of ground rules conversation ... and obviously in your contract as well it says that your work time ought to just be used for things that are, you know, pertaining to the company, and what they are paying you to do. I think that was kind of gone over briefly but it was with one of our peers that was going over it with us, so it was more informal ... it was said that you shouldn't go on Facebook, you shouldn't go on your personal email ... you are not supposed to do that. People do, but just don't take the mickey with how you are behaving.

Although some employers have a relatively tolerant attitude to the use of their equipment for such things as emailing, using Facebook, texting and tweeting, you have no actual right to do so, and while you are using your employer's facilities for personal things you are not doing what you are paid for. It is worth noting that employers can, and often do, monitor your computer usage. Bearing in mind that she is very experienced in recruiting and training graduates in a large organization, you should take note of what Louise has to say in relation to some recent graduate appointees and placement students she has come across.

> [T]hey actually forget that work is work, and it's quite amazing how you can actually waste your day doing absolutely nothing, thinking that you're working on something, and you're not! Actually what you're doing is pinging emails around and nipping onto Facebook and looking onto Ebay. You think that you're clever, and you think that nobody knows this.

They do, and they know. And you might have a very short probationary period. You might have a very short work placement. And you will not get the back-up references that you thought that you were going to get. So, put all that aside. Remember that you are basically selling your hours and use that time really to focus on jobs at hand. You're there for a purpose.

We mention these ground rules in relationship to your demonstrating the right behaviour and attitude in the first few days and weeks. However, if you wish to succeed long term you will need to continue to avoid the trap of mixing up your personal time with your working time. Indeed, it relates to the employability mindset of integrity and honesty, and if you provide your employer with the best possible service you can, they are more likely to reward you with promotion or a good reference when you leave.

Work-life balance

However, some newly appointed graduates have difficulty managing the work-life balance. Louise makes some salutary observations about those who think they can burn the candle at both ends.

[G]raduates who are delighted that they have got a summer placement, a year programme or a first time job and still feel that they can stay up all night, that even though they are starting work half eight, nine o'clock, finishing half five, six o'clock that they can then go home, have some tea ... and then go out in the working week, and go clubbing or see a band ... come in three or four o'clock in the morning, couple of hours sleep and then start work for me. And I can spot it a mile off, you know. I'm not a party-pooper and I love socializing myself but in the working week, you need to make sure that what you're doing in the evening is not affecting your performance at work. And you won't be the first and you won't be the last, but you'll lose your job over it.

So, although you may get away with arriving bleary eyed to lectures, it is unlikely that you will do so long term at work. This requires you to decide on your priorities and act accordingly.

Attendance and time keeping

We have already mentioned the need for punctuality on your first day, but the importance of fulfilling your contractual obligations regarding the time you are at work continues for the rest of your employment. This affects various aspects, including arriving at work on time. Your employer may or may not offer a flexitime system (in fact this might be one of the benefits you negotiated), but whatever hours have been agreed, it is important that you show you respect this agreement.

Similar importance should be attached to keeping to lunch times and any other allowed breaks. You can be sure that in your first weeks, people will notice if you are taking off extra time over lunch, or are frequently away from your desk for no good reason. You do these things at your peril if you wish to survive a probationary period.

Recognizing group ethos

However much information has been given to you before you started concerning company structures and what is expected of you, it is unlikely that you will have got a full picture of the ethos of the groups you will be working with. You may be told what the team is tasked with doing, but how they view themselves and the importance of their activities will only become clear to you as you work with them.

Many of the topics we have covered in this book will reveal their relevance as you start encountering new situations. You might, before you start your new job, take the time to read the chapters on teamworking and refresh your memory of the different roles people take in teams. See if you can recognize people from what they say (Chapter 6). An early awareness of how individuals like to operate will stand you in good stead and help you to perhaps find a useful role for yourself.

 In Chapters 6 and 7 we talked about the destabilizing effect of new members joining a well established team. Now *you* are that person, so your job is to fit in and complement the team as much as possible and as soon as possible.

Simple things can help you become part of a team quickly. If, in the initial stages, you are less busy than your teammates, as you are learning the job, look out for little ways in which you can help and show willing. As Louise suggests:

> In the early days, if somebody says 'I need a bit of help' that means: stop what you are doing and help, and join in. But if for one minute you think 'Why should I do that? The secretary could do that, or the postman normally does that' … whatever it is, you have to understand the importance to that particular job at the time … so it doesn't matter whether you're there photocopying for two hours, the reason you're there photocopying for two hours is because it's needed.

We have also covered negotiating skills, which you may find valuable in finding your niche within the company. And at some point, although we hope not too early, the problem solving and conflict resolution strategies we covered will also come into play.

In several chapters we have discussed cultural issues (especially Chapters 6 and 7). Although we are not suggesting you anticipate problems, an awareness of the items discussed there may help you understand the behaviour of the new people you meet. As importantly, understanding about these issues can give you greater self-awareness. This partly relates to understanding about the values and cultural norms which have shaped your behaviour and expectations, but it is also about recognizing and managing possible feelings you have in unfamiliar surroundings or with people you have never met before. Should you be working abroad, these issues may be of even greater relevance to you.

Getting everything right is a challenge. Try to put into practice what you have been learning in this book, and remember the value of reflection: if things go wrong – but also when they go right – thinking about the contributing factors is valuable and, where there are problems, can help you to find solutions or see how to improve. Remember also to apply emotional intelligence (Goleman 1995), and bear in mind the importance of showing respect, empathy and congruence as identified by Rogers (1978), who we discussed in Chapters 1 and 7.

Smart working

Working hard for your company is admirable. However, the amount of time and effort you put in is not the only measure of your value to the company; your output, what and how much you achieve in your working day is actually of more importance. Smart working is often about being innovative and challenging how things have always been done. Combining hard work and smart working can ensure that you yield the best possible results.

Smart working became feasible when the technology became available to make it possible to work on anything, anywhere, and at any time. From the company perspective, smart working is about getting the organization right.

> This new paradigm is driven by the combination of work environment changes (including different structural context, greater use of IT, and more flexible office layouts) and employment proposition changes (including greater autonomy and discretion for employees).
>
> (CIPD 2008)

If you are working for a company that is trying to introduce such working practices, you may find that the last section applies and you are given free rein to improve working practices. However, even if your company does not have a formal policy on this, one of the reasons they are employing you as a graduate is that they are expecting you to have an intelligent attitude to work.

 One of the ways for getting the best out of your time is to remember the Pareto principle (80:20 rule) we introduced in Chapter 5 in relation to time management.

This means clarifying what are the really important things you are trying to achieve and concentrating on them. In other words you are aiming for maximum results for minimum efforts. For those of you who are perfectionists this may feel uncomfortable. However, with deadline driven work there are times when you have to decide what is good enough and make sure you deliver on time.

Try and work with your natural rhythms. Do not stick to a routine that perhaps suited your predecessor but does not suit you.

Your predecessor might have liked to arrive, check emails, deal with other people's queries, etc. (In fact you might even want to consider whether everything your predecessor did really still has to be done. Systems might have changed, leaving unnecessary procedures being carried out.) However, if you are at your best in the morning, this would mean wasting your most effective working time. It may be better for you to deal with challenging issues in the morning and deal with less important matters in your 'downtime'. Bearing in mind that we all perform better at different times of the day, you might even consider asking your employer if you can work flexible hours if you do not already do so. In fact if you have certain family commitments you are legally entitled to ask to work flexibly (although your employer is not legally bound to allow you to). If you should find this of relevance to you, see Government Digital Service (2013).

Do not forget to make the best use of the technology available. If keeping track of different tasks is a problem for you, set up a reminder system for yourself. Some time ago, one of this book's authors gained special recognition by halving the time it took to do a job simply by

using technology that others had not adopted. Even if your university course does not give much time to familiarizing you with all the common software products, this is something you can be doing in your free time so that you are ready when the need arises.

Intrapreneurship: when to start making suggestions

We discussed in Chapter 11 the possibility that you might run your own business. Many of the same qualities and assets needed for entrepreneurship are also needed in the workplace, where individuals displaying such entrepreneurial qualities are sometimes referred to as 'intrapreneurs' (e.g. Armano 2012).

Part of being an intrapreneur is to be open to change and spot opportunities. Applying these qualities to your job will mean that you will question from time to time whether the way you are doing things is the best possible way and how you might improve your performance (as suggested in 'Smart working' above). To a certain extent, you can probably do this with your own work without asking permission from anyone else. Your employers will be happy enough if you do your work efficiently and in less time. However, the situation might be more tricky when you see ways in which your team or department might be made more efficient by adopting certain changes. Bearing in mind the fact that some people are more resistant to change than others, you may need to be diplomatic but this does not mean that you should not try to improve things. After all, it is the company who are paying you, not your colleagues so efficient operating is important.

Both Ilona and Anna encountered situations where they wanted to see improvements. Anna describes a situation in which she was able to improve efficiency.

> To improve the timely filing of reports, which is one of the key performance indicators, I came up with the idea of a new performance tracking process. When I implemented the new process throughout our office, this enabled my team to identify possible obstacles sooner and as a result, to file more of the reports on time, which increased overall performance of the team. My idea made the process of chasing reports quicker, easier and more effective for colleagues and I received good feedback from my manager for being innovative and pro-active in looking for best organizational solutions.

Ilona's suggested changes were to do with her concern for the environment.

> I'm a real stickler for recycling and things like that, environmental things and I quite quickly started making comments about that. I am quite a challenger by personality type. ... I am perhaps quicker than most people to feel that I am in a position to start making suggestions and I always assume that if my employer is intelligent then they ought to be able to take criticism; basically it would be a negative impression on them as opposed to on me if they weren't able to do that ... so I felt able to make suggestions, and once I had received some training I was keen to offer evaluative feedback about that in order to help them improve in the future.

Ilona did point out that the atmosphere in her office was conducive to making suggestions, and that she felt she was in an environment where people were going to be open to hearing developmental points.

You may not feel as confident as Anna and Ilona in suggesting changes, and we certainly would not recommend that you do so until you have a clear idea of how the company works and how welcome your suggestions might be. You need to have a clear idea of how the system works, and the ramifications your change might have. Nevertheless, Ilona also makes the point that one of the reasons employers wish to employ graduates is that they expect them to have a mindful and intelligent approach to their work.

> So I think it (making suggestions) is encouraged in that office and they do go on about the fact that they want to fill the office with intelligent people so if they are going to say that then they should expect the consequences. (laughingly).

Ethics

The question of ethics in the workplace is a difficult, but important one. We asked Ilona whether she thought the topic had a place in a book on employability. This is her response:

> I think it should be definitely ... we really need to be challenging how things happen in the workplace. I think ethics should be very much at the front of people's mind in terms of how they rate organisations and how they seek to develop the organisation for whom they are working, and that can be something as small as 'do they have recycling bins?' or also the culture of the organisation. Is it a sexist organisation? How much focus is put on whether women are wearing skirts or not? All that kind of thing: it is our responsibility to develop society to be more ethical and business is probably a very good place to start, and we can have more impact on business than we probably can on government policy. So I think it is highly relevant and everyone should have it in their minds when they are going into the workplace.

As we write, there are cases of whistle blowing relating to banking, journalism, and other areas where cases of bad practice have been revealed, some by relatively junior employees. The outcome for these people individually is not always comfortable.

 Discussion

Business ethics is a broad term. Do you agree with Ilona that individuals at work should behave in the way she suggests? Would you add anything?

- Do you think your generation has a responsibility to ensure that the company for whom you work behaves ethically in all respects?
- Do you agree with Ilona that you have more chance of changing business than of changing governments?
- How far do you think you would go to ensure that the company you worked for was behaving ethically?

To a certain extent, how diligently you pursue these issues will depend on your personality, your cultural background, your upbringing, and many other factors, and it is not really possible for anyone else to make these decisions for you. In introducing it here we hope we have encouraged you to at least think about the issues. If you want to delve deeper into the issue we have included a text in the suggested reading.

Conclusion

We have explained that developing employability does not end when you start work. In many ways your new job is where you really have to start showing your true worth to your new employer and building further evidence for future employment. In this chapter we have included advice from two 'new starters' and an experienced employer to cover some of the issues that are important in the early days of your first graduate job. Many guidelines are included to help you in these early days but, in reality, the one piece of advice that comes through from everyone we talked to is to show cheerful enthusiasm in your new role.

What do you think now?

Having worked through this chapter, have you revised your opinion on any of the questions above? How about your classmates? Have any of them changed their opinions?

 ### Project

Your tutor will give you further guidance on how to work through the project tasks. The material we provide below summarizes the tasks and links them to other parts of this book.
Time for a team debriefing:

- How well did you achieve your targets?
- Who needs special thanks?

And ...

- How are you going to celebrate?

Further reading

Armano, D. (2012) Move over entrepreneurs, here come the intrapreneurs. *Forbes.* <http://www.forbes.com/sites/onmarketing/2012/05/21/move-over-entrepreneurs-here-come-the-intrapreneurs/> (accessed 4 May 2013).

Crane, A. and Matten, D. (2010) Business Ethics: Managing corporate citizenship and sustainability in the age of globalisation. London: OUP.

References

Abraham, R. (2004) Emotional Competence as Antecedent to Performance: A Contingency Framework. *Genetic, Social, and General Psychology Monographs*, 130(2), 117–43. <http://www.strandtheory.org/images/Emotional_competence_as_antecedent_to_performance.pdf> (accessed 29 March 2012).

ACAS (n.d.) Mediation. <http://www.acas.org.uk/index.aspx?articleid=1680> (accessed 30 November 2012).

Adair, J. (1973) *Action-Centred Leadership*. London: McGraw Hill.

Adair, J. (2011) *John Adair's 100 Greatest Ideas for Effective Leadership*. Capstone

Armano, D. (2012) Move over entrepreneurs, here come the intrapreneurs. *Forbes*. <http://www.forbes.com/sites/onmarketing/2012/05/21/move-over-entrepreneurs-here-come-the-intrapreneurs/> (accessed 4 May 2013).

Bandura, A. (1994) Self-efficacy. In V. S. Ramachaudran (Ed.), *Encyclopedia of human behavior* (Vol. 4, pp. 71–81). New York: Academic Press. (Reprinted in H. Friedman [Ed.], *Encyclopedia of mental health*. San Diego: Academic Press, 1998). [Online]. Available from: http://www.des.emory.edu/mfp/BanEncy.html. (accessed 16 May 2010).

Bandura, A. (2012) On the functional properties of perceived self-efficacy revisited. *Journal of Management*, 38(1), 9–44. <http://jom.sagepub.com/content/38/1/9> (accessed 18 April 2013).

Bass, B. (1990) From Transactional to transformational leadership: learning to share the vision. *Organizational Dynamics*. Winter 1990, 18(3), 19–31. *EBSCOhost: Business Source Complete* <http://web.ebscohost.com/> (accessed 25 June 2013).

BBC News (2012) Five Minutes With: Jamie Oliver. <http://www.bbc.co.uk/news/uk-20550429> (accessed April 2013).

Becket, N. and Kemp, P. (Eds) (2006) *Enhancing graduate employability in business and management, hospitality, leisure, sport, tourism*. Newbury: Threshold Press Ltd.

Belbin, R. M. (2010) *Management Teams: Why They Succeed or Fail*. 3rd ed. Oxford: Butterworth-Heinemann.

Belbin, R. M. (n.d.) *The nine Belbin team roles*. <http://www.belbin.com/rte.asp?id=3> (accessed 10 April 2012).

Boyles, T. (2012) 21st Century knowledge, skills, and abilities and entrepreneurial competencies: a model for undergraduate entrepreneurship education.

Journal of Entrepreneurship Education, 15, 41–55. EBSCOhost: Business Source Complete. <http://web.ebscohost.com/> (accessed 10 February 2013).

Burgoon, J. and Hubbard, A. (2005) Cross-cultural and Intercultural Applications of Expectancy Violations Theory and Interaction Adaptation Theory. In Gudykunst, W. (Ed.) (2005) *Theorizing about Intercultural Communication*. London: Sage Publications Ltd.

Careerbuilder (n.d.) <http://www.careerbuilder.com/JobPoster/Resources/page.aspx?pagever=2012SocialMedia&template=none&sc_cmp2=JP_Infographic_2012SocialMedia>.

Ceserani, J. and Greatwood, P. (1995) *Innovation and Creativity, Getting Ideas – Developing Solutions – Winning Commitment*. London: Kogan Page Ltd.

CIPD (Chartered Institute of Personnel and Development) (2008) *Smart working: the impact of work organisation and job design*. <http://www.cipd.co.uk/hr-resources/research/smart-working-impact-organisation-job-design.aspx> (accessed 28 February 2013).

Covey, S. R. (1992) *The Seven Habits of Highly Effective People*. London: Simon & Schuster.

Crabtree, B. and Miller, W. (Eds.) (1999) *Doing qualitative research*. London: Sage Publications Ltd.

Dacre Pool, L. and Sewell, P. (2007) The Key to Employability. Developing a practical model of graduate employability. *Education and Training*, 49(4), 277–89. <http://www.emeraldinsight.com/journals.htm?articleid=1610086&show=pdf> (accessed 10 March 2013).

Davies, C. and Lowe, A. (2005) *Kolb learning cycle tutorial – static version*. University of Leeds. <http://www.ldu.leeds.ac.uk/ldu/sddu_multimedia/kolb/static_version.php> (accessed 27 April 2013).

Dettmer, H. W. (2003) *Brainpower Networking using the Crawford Slip Method*. Trafford Publishing.

Doleschal, R. and Mertens, C. (2008) *The impact of learning theories, education programs and culture on teaching and learning styles*. Schriftenreihe des Instituts für Kompetenzförderung. 2 Lemgo: Hochschule Ostwestfalen-Lippe.

Fiedler, F. E. (1967) *A Theory of Leadership Effectiveness*. New York: McGraw-Hill.

Fleming, N., and Baume, D. (2006) Learning Styles Again: VARKing up the right tree!, *Educational Developments*, SEDA, 7.4, 4–7. <http://www.vark-learn.com/documents/educational%20developments.pdf> (accessed 23 April 2013).

G4S (n.d.) Who we are. <http://www.g4s.com/en/Who%20we%20are/> (accessed 12 May 2013).

G4S (2012) *Review of London Olympic and Paralympic Games Security Contract*. <http://www.g4s.com/en/Investors/News%20Events%20and%20Presentations/Announcements/2012/09/28/Announcement/> (accessed 23 November 2013).

Gallagher, K. (2010) *Skills Development for Business and Management Students*. Oxford: Oxford University Press.

Gantt, H. L. (1919) *Organizing for Work*. New York: Harcourt, Brace and Howe.

Gesteland, R. (1999) *Patterns of Cross-Cultural Business Behavior. Marketing, Negotiating and Managing Across Cultures*. Copenhagen Business School Press. <http://cim.dcg.ibs.iscte.pt/Gesteland.pdf> (accessed 30 September 2012).

Goleman, D. (n.d.) Ecological Intelligence. <http://danielgoleman.info/topics/ecological-intelligence/> (accessed 2 May 2013).

Goleman, D. (n.d.) The emotionally intelligent salesman. <http://danielgoleman.info/the-emotionally-intelligent-salesman>.

Goleman, D. (1995) *Emotional Intelligence*. London: Bloomsbury Publishing Plc.

Goleman, D. (2012) Emotional intelligence and customer care. <http://danielgoleman.info/emotional-intelligence-customer-care/> (accessed 12 April 2013).

Goode, E. (2003) Power of Positive Thinking May Have a Health Benefit, Study Says. *The New York Times*. <http://psyphz.psych.wisc.edu/web/News/Positive_thinking_NYT_9-03.html>.

goodreads (n.d.) Quotes: H. Jackson Brown Jr <http://www.goodreads.com/quotes/7992-don-t-say-you-don-t-have-enough-time-you-have-exactly>.

Government Digital Service (2013) *Flexible Working*. <https://www.gov.uk/flexible-working/overview> (accessed 12 May 2013).

Graves, S. and Maher, A. (Eds) (2008). *Developing graduate employability: case studies in hospitality, leisure, sport and tourism*. Newbury: Threshold Press Ltd.

Greaves, L., Mortimer, M. and Wilkinson, J. (2004) *Employability and the Business Curriculum: making sense of the Employer Perspective*, LTSN BEST conference paper, Edinburgh.

Grinnell, J. (2012) The Tao of Leadership: The Emerging Servant Leadership Paradigm. *Ezine Articles*. <http://ezinearticles.com/?The-Tao-of-Leadership:-The-Emerging-Servant-Leadership-Paradigm&id=6802579> (accessed 25 June 2013).

Gudykunst, W., Lee, C., Nishida, T. and Ogawa, N. (2005) Theorizing about Intercultural Communication. An Introduction. In Gudykunst, W. (Ed.) *Theorizing about Intercultural Communication*. London: Sage Publications Ltd.

Hackman, J. R. (2011) Six Common Misperceptions about Teamwork. <http://blogs.hbr.org/cs/2011/06/six_common_misperceptions_abou.html> (accessed April 2013).

Hall, E. (1976) *Beyond Culture*. New York: Anchor Books/Random House.

Harris, R. (2011) *The Confidence Gap. A Guide to Overcoming Fear and Self Doubt*. Boston: Trumpeter Books.

Hillage, J. and Pollard, E. (1998) *Employability: developing a framework for policy analysis. Research Brief 85*. Institute for Employment Studies/Department for Education and Employment. <http://www.employment-studies.co.uk/pubs/summary.php?id=emplblty> (accessed 24 June 2013).

Hofstede, G., Hofstede, G. J. and Minkov, M. (2010) *Cultures and Organisations, Software of the Mind*, 3rd edn. USA: McGraw-Hill.

Holden, J. (2007) *Principles of Entrepreneurship*. America.gov Archive. <http://www.america.gov/publications/books/principles-of-entrepreneurship.html> (accessed 5 March 2013).

Honey, P. (1994) *Teams and Leaders: Trainer's Guide*. London: Melrose Film Productions.

Honey, P. (2001) *Teams and Teamwork*. <http://www.peterhoney.com/documents/Teams-and-Teamwork_QuickPeek.pdf?> (accessed 2 November 2011).

Honey, P., (2004) *Improve your People Skills*, 2nd edn. London: CIPD.

Honey, P., and Mumford, A., (1992) *A Manual of Learning Styles*, 3rd edn. Peter Honey.

IDS (2012) Employment and Unemployment Figures. <http://www.incomesdata.co.uk/pay-employment-data/default.aspx> (accessed June 2012).

Kaniel, R., Massey, and Robinson, D. T. (2010) *The Importance of Being an Optimist: Evidence from Labor Markets*. NBER Working Paper No 1638. <http://www.nber.org/papers/w16328>.

Karageorghis, C. (n.d.). *Sports psychology: self-confidence in sport – make your ego work for you! In Peak Performance*. <http://www.pponline.co.uk/encyc/sports-psychology-self-confidence-in-sport-make-your-ego-work-for-you-39657> (accessed 5 March 2013).

Kazemek, E. (1991) *Ten Criteria For Effective Team Building*. Healthcare Financial Management, 45(9), 15.

Kelley, R. and Caplan, J. (1993) How Bell Labs creates star performers. *Harvard Business Review*, 71(4), 128–39. EBSCOhost: Business Source Premier. <http://web.ebscohost.com/> (accessed 10 February 2013).

Kirzner, I. (1997) Entrepreneurial Discovery and the Competitive Market Process: An Austrian Approach. *Journal of Economic Literature*, 35, 60–85. EBSCOhost: Business Source Complete. <http://web.ebscohost.com/> (accessed 10 February 2013).

Knight, P. and Yorke, M. (2004) *Embedding employability into the curriculum. Learning and Employability Series 1.* York: The Higher Education Academy. <http://www.heacademy.ac.uk/assets/documents/employability/id460_embedding_employability_into_the_curriculum_338.pdf> (accessed 15 May 2012).

Kolb, D. A. (1984) *Experiential Learning: Experience as the Source of Learning and Development.* Prentice Hall Inc. New Jersey.

Langer, E. (1989) *Mindfulness.* Reading, MA: Addison Wesley.

Langer, E., Bashner, R. and Chanowitz, B. (1985) Decreasing prejudice by increasing discrimination. *Journal of Personality and Social Psychology*, 49(1), 113–20. EBSCOhost: PsycARTICLES <http://web.ebscohost.com/> (accessed 3 April 2012).

Lauterborn, B. (1990) *New Marketing Litany: 4Ps Passes; C-Words Take Over, Advertising Age*, 26–8.

Lewin, K., Lippitt, R. and White, R. K. (1939) Patterns of aggressive behavior in experimentally created social climates. *Journal of Social Psychology*, 10, 271–301.

Liu, S., Volčič, Z. and Gallois, C. (2011) *Introducing Intercultural Communication, Global Cultures and Contexts.* London: Sage Publications Limited.

Lloyd, C-L. (2012) A guide to freelance work. Graduate Prospects. <http://www.prospects.ac.uk/features_a_guide_to_freelance_work.htm> (accessed 5 March 2013).

M2 Communications (2010) Leading thoughts. Building a community of leaders. Leadership Now. <http://www.leadershipnow.com/relationshipsquotes.html> (accessed 10 April 2012).

Mackay, H. (1994) *Why don't people listen? Solving the communication problem.* Sydney: Pan Macmillan Publishers Australia.

Martin, J. and Nakayama, T. (2008) *Experiencing Intercultural Communication. An Introduction.* 3rd edn. International Edition. New York: McGraw-Hill Education.

Maslow, A. H. (1943) A Theory of Human Motivation, Originally Published in *Psychological Review*, 50, 370–96.

McSweeney, B. (2002) Hofstede's model of national cultural differences and their consequences: A triumph of faith – a failure of analysis. *Human Relations*, 55, 89–118. <http://www.uk.sagepub.com/managingandorganizations/downloads/Online%20articles/ch05/4%20-%20McSweeney.pdf> (accessed 28 September 2012).

Miller, C., Tomlinson, A. and Jones, M. (1994) *Researching Professional Education.* University Of Sussex.

Office for National Statistics (2011) Graduates earn £12,000 more a year than non-graduates. <www.ons.gov.uk> (accessed 28 June 2012).

Osborn, A. F. (1953) *Applied imagination; principles and procedures of creative problem-solving.* New York: Charles Scribner's Sons.

Oxford Dictionaries (n.d.) *Team.* Oxford University Press. <http://oxforddictionaries.com/definition/english/team?q=team>.

Palachuk, K. W. (2012) We are all many people. Relax Focus Succeed. <http://www.relaxfocussucceed.com/Articles/2002101404.htm> (accessed 9 January 2013).

Prospects (n.d.) CVs and Covering Letters. Example CVs. <http://prospects.ac.uk/example_cvs.htm> (accessed 25 January 2013).

Raskin, N. J. and Rogers, C. R. (1989) *Person-centered therapy.* In Corsini, R. J. and Wedding, D. (Eds), *Current psychotherapies* 4th edn. Itasca, IL, US: F E Peacock Publishers, 155–94.

Rathje, S. (2007) Intercultural Competence: The Status and Future of a Controversial Concept, *Language and Intercultural Communication*, 7(4), 254–66.

Reed, J. and Stoltz, P. (2011) *Put your mindset to work. The one asset you really need to win and keep the job you love.* London: Portfolio Penguin.

Riggio, R. E. (2010) Cutting-Edge Leadership <http://www.psychologytoday.com/blog/cutting-edge-leadership/201006/are-charismatic-leaders-born-or-made> (accessed November 2012).

Rimmington, G. and Alagic, A. (2008) *Third place learning. Reflective inquiry into intercultural and global cage painting.* Charlotte: Information Age Publishing, Inc.

Rogers, C. R. (1978) *On Personal Power: Inner Strength and its Revolutionary Impact.* Philadelphia: Trans-Atlantic Publications.

Salpeter, M. (2012) Using Monster's Semantic Search Tool to Find a Job Fast. <http://money.usnews.com/money/blogs/outside-voices-careers/2012/10/10/using-monsters-semantic-search-tool-to-find-a-job-fast> (accessed 7 April 2013).

Segerstrom, S. and Sephton, S. (2010) Optimistic expectancies and cell-mediated immunity: The role of positive affect. *Psychological Science*, 21(3), 448–55.

Seligman, M. E. P. (1998) *Learned Optimism: How to Change your Mind and your Life.* New York: Pocket Books.

Sengupta, K. (2012) A sorry end for the 'scapegoats' at sharp end of G4S fiasco. *The Independent* 29 September 2012. http://www.independent.co.uk/news/uk/home-news/a-sorry-end-for-the-scapegoats-at-sharp-end-of-g4s-fiasco-8190483.html (accessed 5 November 2012).

Sewell, P. and Dacre Pool, L. (2010) Moving from conceptual ambiguity to operational clarity. Employability, enterprise and entrepreneurship in higher education. *Education and Training*, 52(1), 89–94. EBSCOhost: Business Source Premier. <http://web.ebscohost.com/> (accessed 4 January 2013).

Shane, S. (2000) Prior Knowledge and the Discovery of Entrepreneurial Opportunities. *Organization Science* 11(4), 448–69.

Shavic, A., (2002) *Passing Psychometric Tests: Know What to Expect and Get the Job You Want.* Oxford: How to Books.

Smith, M. K. (1999) The social/situational orientation to learning, *The Encyclopedia Of Informal Education* <www.infed.org/biblio/learning-social.htm> (last update 29 May 2012).

Stribling, G. (2010) An insider's guide to surviving the world of temping. *Guardian Graduate/Guardian Jobs.* 29 November 2010. <http://careers.guardian.co.uk/how-to-survive-the-world-of-temping> (accessed 4 March 2013).

Tang, J. and Murphy, P. (2012) Prior Knowledge and New Product and Service Introductions by Entrepreneurial Firms: The Mediating Role of Technological Innovation. *Journal of Small Business Management* 50(1), 41–62. EBSCOhost: Business Source Complete. <http://web.ebscohost.com/> (accessed 10 February 2013).

Taylor, F. W. (1911) *The Principles of Scientific Management.* Project Gutenberg e-Books. <http://www.enebooks.com/data/JK82mxJBHsrAsdHqQvsK/2010-01-19/1263902254.pdf> (accessed 10 April 2012).

Ting-Toomey, S. (1999) *Communicating across cultures.* New York: The Guildford Press.

Tracy, B. (2004) The 7 Ps of Marketing. Take charge of your marketing efforts and beat the competition with this simple formula. *Entrepreneur. Entrepreneur Inc.* <http://www.entrepreneur.com/article/70824> (accessed 4 May 2013).

Trompenaars, F. and Hampden-Turner, C. (1997) *Riding the waves of culture. Understanding cultural diversity in business.* London: Nicholas Brealey Publishing.

Tuckman, B. W. (1965) Developmental Sequence in Small Groups. *Psychological Bulletin*, 63(6). EBSCOhost: PsycARTICLES <http://web.ebscohost.com/> (accessed 3 April 2012).

Walton, S. and Huey, J. (1993) *Sam Walton, Made in America, My Story.* New York: Bantam Books.

Warhurst, C., Nickson D. and Dutton, E. (2004) *What every employer wants? Skills, attitude and appearance in Glasgow service jobs.* Scottish Centre for Employment Research. <http://www.strath.ac.uk/media/departments/hrm/pdfs/hrm-pdf-scer/media_63275_en.pdf> (accessed March 2013).

Wearden, G. (2012) Senior G4S executives resign over Olympics security failure. *The Guardian*, 28 September 2012.

Wolfson, S. and Pannack, L. (2013) Young, gifted and rolling in it. *Sunday Times Magazine.* 3 February 2013, 46–53

Woodman P and Hutchings P. (2011) *Tomorrow's Leaders*, CMI, London.

Yorke, M. (2006) *Employability in higher education: what it is – what it is not.* York: The Higher Education Academy. <http://www.heacademy.ac.uk/assets/documents/tla/employability/id116_employability_in_higher_education_336.pdf> (accessed 26 April 2013).

Yorke, M. and Harvey, L. (2005) *Graduate Attributes and Their Development, New Directions for Institutional Research*, no. 128, Winter 2005.

Zimmerer, T. and Scarborough, N. (2005) *Essentials of entrepreneurship and small business management,* 4th edn. International Edition. New Jersey: Pearson Education, Inc.

Index